*The Princeton Series in
Nineteenth-Century Art, Culture,
and Society*

JACQUES-LOUIS DAVID

JACQUES-LOUIS
DAVID

Art in Metamorphosis

BY

DOROTHY JOHNSON

PRINCETON UNIVERSITY PRESS

PRINCETON · NEW JERSEY

Library of Congress Cataloging-in-Publication Data

Johnson, Dorothy.
Jacques-Louis David : art in metamorphosis / Dorothy Johnson.
p. cm. — (The Princeton series in nineteenth-century art,
culture, and society)
Includes bibliographical references and index.
ISBN 0-691-03218-1
1. David, Jacques Louis, 1748–1825—Criticism and interpretation.
2. David, Jacques Louis, 1748–1825—Aesthetics. I. Title. II. Series.
ND553.D25J64 1993
759.4—dc20 92-35816

Parts of Chapter I have appeared in a different form in Dorothy Johnson,
"Corporality and Communication: the Gestural Revolution of Diderot, David and
the *Oath of the Horatii,*" *The Art Bulletin,* vol. 71 (March, 1989), pp. 92–113.

Parts of Chapter V have appeared in a different form in Dorothy Johnson,
"Desire Demythologized: David's *L'Amour quittant Psyché,*" *Art History*
(December, 1986), pp. 450–470.

This book has been composed in Garamond by
The Composing Room of Michigan, Inc.

Princeton University Press books are printed on acid-free paper and meet the
guidelines for permanence and durability of the Committee on Production
Guidelines for Book Longevity of the Council on Library Resources

Printed in the United States of America

10 9 8 7 6 5 4 3 2 1

DESIGNED BY LAURY A. EGAN

CONTENTS

LIST OF ILLUSTRATIONS

COLORPLATES

ACKNOWLEDGMENTS

I WOULD like to thank the many individuals, institutions, and foundations that made this book possible. My research was supported over the years by numerous fellowships and grants but I am particularly indebted to the generous Faculty Scholar Award from the University of Iowa that enabled me to complete the writing of this book.

My parents, John and Alice Winter, did not live to see the publication of this work but their support—moral, financial, and otherwise—made it possible. My lasting regret is that I was not able to place the finished book in their hands. At the beginning of my doctoral studies, at the Sorbonne, Louis Grodecki and Anne Prache provided both great encouragement and inspiration. It was the latter, in fact, after Louis Grodecki's untimely death, who pointed me in the direction of Berkeley. My minor field at Berkeley was French literature and I was lucky enough to have studied with Walter E. Rex who read the manuscript and made apposite suggestions—his encouragement, expertise in eighteenth-century matters, and friendship have benefitted me in innumerable ways. I would like to thank two major Davidians, Robert Rosenblum and Thomas Crow, who provided encouragement to someone embarking on the study of this complex artist. I would also like to thank Mary Sheriff for her unstinting support and generosity. I am grateful as well to Svetlana Alpers, Michael Baxandall, Vivian Cameron, Stefan Germer, Hubertus Kohle, Régis Michel, Michael Podro, and Jack Undank for helpful conversations relating to this project. During the past six years the support and encouragement of Wallace J. Tomasini, Director of the School of Art and Art History at the University of Iowa, have been generous and invaluable. The intelligent questions of the students whom I had the privilege of teaching at the University of California, Berkeley, Southern Methodist University, and the University of Iowa often led me to sharpen the focus of my ideas—they have my thanks. Domenick Cagliostro gave technical advice and assistance beyond the call of duty. Many thanks as well to Jane Phillips, staunch friend and troubleshooter in Paris.

To Jacques de Caso, friend and teacher, I owe an incalculable debt. His teaching, scholarship, and integrity have provided models for all of his students. I have benefitted greatly from his personal and intellectual generosity over the years. It is a great pleasure for me to be able to express my gratitude.

At Princeton University Press Elizabeth Powers and Tim Wardell have given invaluable help in preparing this book for publication. It has been a pleasure to work with them.

My greatest debt is expressed in the dedication of this book.

For Jack
συνεργῷ
and in memory of M

JACQUES-LOUIS DAVID

INTRODUCTION
The Method of Metamorphosis

THE FATHER of the entire modern school in painting and sculpture"—Delacroix's generous yet precise homage ascribing artistic paternity to another painter has often been repeated. No artist, however, has suffered more from the marmoreal label of neoclassicism than has David, one of the epochal figures in the origin and development of modern art.[1] Delacroix's designation is justly deserved for David was the first artist to challenge successfully and defy the powerful and procrustean French Academy, an institution whose downfall he helped to bring about in 1793. In spite of official, governmental attempts to thwart him in the early stages of his career, by the mid-1780s David had become the most famous painter in France and, indeed, would soon become similarly celebrated throughout Europe. His atelier would produce many influential artists of the first generation of romantics—the painters Gros, Girodet, Ingres, and the sculptors David d'Angers, Rude, and Pradier (corroborating the neglected element in Delacroix's statement—for David *was* equally the "father" of modern nineteenth-century French sculpture, as I have discussed elsewhere).[2] His impact on the "high" romantic painters—Géricault and Delacroix—was profound. Géricault revered David and had struggled to become a Davidian painter during the second decade of the nineteenth century, while Delacroix's early works depended heavily on Davidian reforms.

In this series of interconnected essays I explore the "modernity" of David which was based on new principles of making art that he formulated as his objectives and ideals. David, unlike his contemporaries and in dramatic contradistinction to the artistic and academic values and norms of his time, chose innovation and transformation as the essential principles of his art; these ideas, in fact, informed throughout his career his entire method of artistic creation. A method of metamorphosis provided the consistent and underlying structure of David's production from his early works in Rome of the late 1770s to his final masterpiece completed in Brussels in 1824. Paradoxically, the principal historical and critical view of David has largely adopted the model of the Academy (which David had already superceded) as a guide to interpretation; that is to say, developments in David's art after he had painted his canonical masterpieces of "neoclassicism" are often seen in terms of decline or apostasy and are often explained in etiological terms. The current study takes as its basis an examination of the transforma-

3

tive principle of change—in subject, style, and conception—that governed David's oeuvre from the beginning to the end of his career and which consistently defied and opposed the monolithic, static structures of the Royal Academy of Painting and Sculpture in which he had been trained. David's fervent embrace of transformation as a method of making art was consonant with intellectual developments and "advances" of the Late Enlightenment (what was defined as historical progress and which would play such a key role in Revolutionary discourse) in such diverse disciplines as physics and chemistry, biology, anthropology, mythography, psychology, and history. Late eighteenth- and early nineteenth-century investigations into, and speculations concerning, the transformation of matter, the evolution of the species, the identification and exploration of psychological stages in the formation of the self, the psychology of myth, the biological model of the waxing and waning of civilizations, and of the organicity of history paralleled and typically informed David's approach to the making of art and his view of himself as an artist in the continuum of history.

Although this study follows David's career chronologically, it is not structured on the putative biographical model that pervades David scholarship and rigidly organizes and privileges his oeuvre according to successive political regimes. Rather, each of these interconnected essays focuses on series of works produced during a pivotal, transformative period in the artist's career and the aesthetic, cultural and intellectual issues, and the problems and questions that revolve around them. There is, perforce, chronological overlapping in chapters 3 and 4 since the gestation of *Leonidas* took place over fifteen years. Every major period of the artist's career is addressed. Since David took as his essential method the principle of metamorphosis, of transformative change in his ideas concerning the genesis and making of the work of art, we witness throughout his oeuvre critical moments when he found wellsprings of inspiration which set his art in a new direction. It is important to emphasize that the principle of metamorphosis governed his entire career. Nothing would have been easier, after painting the canonical *Oath of the Horatii,* than for David to enjoy his power and prestige, endlessly repeating himself while painting in this "perfected" style. But he chose not to. And this experimentation, not unexpectedly, was often met with incomprehension. David, however, accepted this as the price he had to pay for his view of art and with great stoicism (especially in Brussels) he asseverated that posterity would vindicate him. David adopted a "metamorphic model" in the belief that an artist should no longer have a static, unitary, normative style resulting from academic training, a mastery of convention and codes, but rather continually seek to transform his or her art in keeping with the evolution of thought and style concomitant with transformations in cultural and intellectual discourse. The one constant in David's art was, paradoxically, periodical, almost rhythmical change. Some might say that this makes David sound like a Romantic "avant la lettre"—it is a charge I willingly accept for I maintain throughout the book, and especially in the last chapter, that David cannot be judged by the strictures of a neoclassical aesthetic, rather his position must be equally viewed from the perspective of

4

subsequent artistic developments and his role in them. David was never the hoary *laudator temporis acti* often extolled in criticism. He knew the past and used it but he never looked to the past for the essence of his art. His concern was always for the art of the future, whose foundation he consciously saw himself as helping to form. If romanticism was the "permanent revolution," then David was, artistically, the permanent revolutionary. Accordingly, a series of interconnected essays emphasizing the periods of metamorphosis, and a decoding of the novatory intellectual content of David's paintings executed within these periods, seemed to offer the best solution to fixing so protean a figure within the covers of a book.

One of the challenges in writing a study of David's art that seeks to revise, reinterpret, and place works in new contexts is the confrontation with an overwhelming bibliography. Although, in this book, I depend on numerous primary and secondary sources, I have tried to avoid to the greatest extent possible reiterating in the text what is well-known or has been analyzed at length, unless I take serious issue with these prior interpretations. The most recent studies of David's career—those of Anita Brookner and Antoine Schnapper published in 1980 and Warren Roberts' 1989 study of David's art and politics—adopted the monographic format and present an anecdotal narrative in which the artist's biography provides a basic structure for studying his works.[3] In spite of the 1973 publication of D. and G. Wildenstein's essential compendium of primary and documentary sources, *Documents complémentaires au catalogue de l'oeuvre de Louis David*, these monographs tend to neglect a renewed examination of primary material and depend to a considerable extent on the myth and legend of David as codified by Delécluze in his 1855 monograph, *Louis David, son école et son temps*, a book responsible for a great disservice to Davidian studies.[4] Delécluze, who offers an intimate and detailed account of the artist and his students in the atelier, hailed the David of the 1780s while concomitantly denigrating and subverting the advanced and profound artistic qualities and innovative ideas of many of the masterpieces of his later periods. (He promulgated the idea of David as an uneducated artist and even went so far as to assert that the intellectually rich and technically magisterial *Leonidas at Thermopylae* manifests the master's decline.) Delécluze, who entered David's atelier in the 1790s, has always been considered in some sense the voice of authority. His monograph is based on the Vasarian method of biographical anecdote. Thus, he relates in detail and with the absolute authority of the eyewitness, conversations with David, David's comments to his students, thoughts, emotions and ideas concerning art, etc. Yet this eye-witness, whose anecdotes are usually not challenged and, in fact, have often been used as corroborating evidence in later scholarly analyses, was "recording" David's words and ideas 40–65 years after they had been expressed. Either Delécluze had the most prodigious memory in history or we should be led to question his putatively autoptic "evidence" and, indeed, his entire picture of David. A close reading of Delécluze reveals the extent to which he depended upon the early nineteenth-century oral tradition, the stories and anecdotes that circulated concerning David and his school (that often made

their way into journal articles and Salon criticism), but he also leaned heavily upon the 1820s biographies and later memoirs of the artist that have specific political and aesthetic prejudices and need to be read with caution. Then, too, we must remember that Delécluze was a disgruntled student—an aspiring painter in David's atelier who did not make it, who had to leave the profession, and who opted instead for a career as a critic and a man of letters. One important ingredient in his study, therefore, although usually skillfully and subtly occulted (Delécluze assumes in the text the narrative identity of the reverent student warmly recalling his teacher and criticizing him with regret), is a modest desire for a modicum of revenge—Delécluze hoped to have the last word on David. He wanted to create a lasting image of the artist and codify a permanent view that acclaims the eighteenth-century David but charts the progress of his nineteenth-century decline beginning, according to Delécluze, after *The Coronation of Napoleon and Josephine*. Delécluze succeeded splendidly in his undertaking, for since the publication of his study in 1855 scholars have typically depended upon it as though it were a primary source rather than a highly speculative interpretation of David and his school. This in spite of the attempts by David's grandson Jules David to rectify many of what he apparently believed were falsifications of the life and works of the painter.[5] Jules David's massive study of 1880 brings together a considerable amount of the artist's writings—from letters, drafts, notes, and his aborted 1790s autobiography, as well as family papers, memoirs and correspondence to David from his friends and students, in an attempt to present a fuller and perhaps more balanced view. In spite of the significance and usefulness of this study, Delécluze's David has prevailed. This is not to say that Delécluze's study is useless. Far from it. His study is important and offers much that can be accepted when it is corroborated by evidence from letters and documents written during David's lifetime and, most importantly, from the paintings themselves. Thus, when Delécluze is cited in the present text, his ideas are presented with qualifications and reservations when appropriate.

Of all of the twentieth-century English, French, and German monographic studies of David in the format of life and works, the one that depends least on Delécluze is *Louis David* by Louis Hautecoeur, published in 1954.[6] In this biography, Hautecoeur returned to primary documents of the period and tried to eschew, as much as possible, the image of the artist and his work received from the nineteenth century. He chose, for example, contrary to Delécluze's legend of David's nineteenth-century decline, to take seriously David's late works executed in Brussels.

Book-length studies that focused on specific works or periods in the artist's career have been of great utility to David studies. Several have provided detailed, well-documented, and often insightful analyses, such as David Dowd's 1948 study of David's involvement with the Revolutionary festivals, the source of serious and useful political interpretations of the artist and the Revolution; similarly, Robert Herbert's thoughtful and often provocative 1972 study of David's *Brutus* and its reception during the Revolution provides a salient example of the value of a careful investigation into and assessment

of primary sources, including Salon criticism.[7] The most important scholarly book-length studies of David of the past ten years have been catalogues or documentary examinations—Régis Michel's contributions to *David e Roma* and Philippe Bordes' *Le Serment du Jeu du Paume* offer two noteworthy examples.[8] To these must be added Antoine Schnapper's catalogue of the 1989 major retrospective David exhibition held in the Louvre (and, most recently, Arlette Serullaz's useful publication of David's drawings in the Louvre collections).[9] Schnapper's important catalogue provides the most comprehensive collection of images, the most detailed and precise documentary and historical narrative, and the most extensive bibliographic references to date. The entire methodological basis of the catalogue, however, is against interpretation. Thus, little is offered in terms of theoretical, critical, aesthetic, and cultural ideas concerning David and his art.

Following Robert Rosenblum's reassessment of David in his foundational *Transformations in Late Eighteenth-Century Art*,[10] recent years have witnessed a series of essays on several of David's major works by attentive scholars who did engage challenging issues and problems as they thought anew of David and his oeuvre. Thomas Crow inaugurated a reinterpretive interest in David with his 1978 study of pre-Revolutionary radicalism in *The Oath of the Horatii*, in which he demonstrated that it was necessary and fructive to reinvestigate the artist's masterpieces.[11] Since that article appeared, and particularly in the past five years, the art of David has become a focus of interest and a major locus of interpretation in the art historical literature. My own articles of the 1980s on facets of David's early and late career belong to this new direction in David studies.[12] A great deal of the recent literature, much of which emphasizes the political/social content of David's oeuvre, encompasses a broad spectrum of methodological approaches. Thus, to this category belong Albert Boime's provocative investigation of scatology in David's Revolutionary prints and paintings and Norman Bryson's structuralist/deconstructive/psychoanalytic approach to the David of the 1780s—a number of works published in the past two years, in fact, privilege the Revolutionary period and evince similar concerns.[13] Several studies, however, chose to redirect attention to neglected aesthetic and cultural issues in the master's works—Thomas Puttfarken's discussion of the novatory compositional structure of *Brutus* and the critical responses to it and Stefan Germer's and Hubertus Kohle's perceptive analysis of the "aesthetization" of the hero in the *Brutus* and *The Sabine Women* belong to this group.[14] Many of these individuals participated in the colloquium on David held at the Louvre in December of 1989—"David contre David"—organized by Régis Michel to coincide with the David retrospective exhibition (the colloquium papers will be published).[15] Participants represented a variety of methodological approaches but, given the nature of the bicentennial celebration of the French Revolution, the focus of many of the talks, quite expectedly, was on the Revolutionary decade of the artist's career. The colloquium proved what a fertile field David studies remains because of the richness and complexity of the artist's works.

Given the renewed interest in and fascination with the art of David that has

developed during the past few years, it seemed imperative that a reinterpretation and reevaluation of all the major periods of his career be essayed. What I emphasize throughout this study are salient elements of David's aesthetics and facets of his oeuvre that have not been given due valuation. Although each chapter is self-contained, the reader will become aware of leitmotifs throughout. One of these recurrent themes is the impact of sculpture on David's aesthetics. Several of his compositions of the 1780s, including *The Oath of the Horatii*, have been consistently described as "sculpturesque" (a reintroduction into painting of the three-dimensionality and volumes of sculpture). David, however, did far more than attempt to use the model of sculpture to make more solid, powerful, and convincing figures in space. In his paintings of the 1780s he based many of his initial and radical reforms on his intense study of antique sculpture in Rome during his fellowship years of the 1770s. He sought, in fact, to transpose many of the principles and aesthetics of the sculpted figure to the painted image. An essential aspect of David's propaedeutics in his atelier was that sculpture and painting constitute mutually fecundating influences: he wanted to train sculptors as well as painters. In this he was remarkably successful for, as mentioned earlier, he influenced three of the most significant sculptors of the first generation of Romantics—David d'Angers, Rude, and Pradier.

The basic principle of David's own art education—like that of his contemporaries—was drawing, considered the foundation of academic art. David's rejection of the prevailing style of academic drawing he had learned at the Royal Academy, and his adaptation in Rome of a personal drawing style based on the compelling contour of the sculpted figure, also constitute essential aspects of his artistic reform. But David would develop the mode of drawing in ways that widely diverged from late eighteenth-century practice. For as early as 1779 he began to understand and use drawing as a separate artistic register distinct from the expressive field of painting. Throughout his career David would consistently use drawing as a form of experimentation and exploration of ideas, an alternate vehicle for conveying meaning. This direction in his art came to fruition at the end of his career when the drawn composition emerged fully as an independent art form.

David's use of both sculpture and drawing had to do largely with his exploration of corporality. Investigations of these two arts aided him in emphasizing the corporal aspect of his production. One could say that David, throughout his career, was obsessed with the idea of the eloquent body. In all periods of his art there is so much experimentation with corporality that the ensemble of his oeuvre could, not unjustly, be called "the phenomenology of the body." For David believed, as did his beloved ancient Greeks, that the human body was the primary locus of expressivity in art and that it was the artist's duty, therefore, to experiment relentlessly with corporal configuration in order to charge paintings with meaning.

Another extremely important and virtually neglected facet of David's artistic production is his corpus of writings. David did not write extensively, but when he did he

usually expressed himself eloquently and often revealed his ideas about the nature and goals of his own art as well as the art of his time. Thus, another recurrent subject of this study is an examination of the artist's own words about art—his published writings which include his autobiography, public speeches during the Revolution, and pamphlets that accompanied several of his paintings, as well as notes, drafts, and correspondence. The artist's private correspondence is particularly compelling for what it reveals not only about art and aesthetics but about the artist's character, temperament, education, intelligence, and sensitivity. Because of the nature of the current study I can only refer to this body of writing periodically and in the form of excerpts. It deserves, however, to be published in toto in an annotated edition.

In addition to an examination of the significant role of sculpture, drawing, and the import of the artist's writings, the present study investigates David's increasing involvement, particularly in his nineteenth-century oeuvre, in the viewing of the work of art, and his concomitant exploration of the reflexive nature of representation which became signally important to him. His interest in the nature, goals, and reception of representation were informed by his knowledge of contemporaneous aesthetic studies on the interaction between the spectator and the work of art. Similarly, he was intimately involved with late Enlightenment and early Romantic ideas and ideology concerning the reinterpretation of antiquity, contemporaneous developments in archaeology and aesthetics, and innovations in a multiplicity of disciplines including anatomy, anthropology, biology, history, geology, mythography, psychology, etc. Many of the aesthetic and intellectual concerns of his major history compositions, the focus of this study, inform his portraiture as well and his portraits express his modernity to the same degree as other genres of his production. A number of portraits are discussed strategically throughout this book but a reinterpretive examination of this important and neglected category of works—David was one of the greatest portraitists of his own and, indeed, any age—will necessitate a separate study.

The single aspect of David's production that has received the most attention, due to his prepotent position as painter of the Revolution, is the political. In this book I study selected facets of the often subtle and nuanced rapport between art and politics in David's compositions (especially during the Revolutionary and Napoleonic periods). My effort has been to probe the nexus of art and politics and embed it within the context of the rich and multifarious intellectual discourse that informed each of the artist's major works. One of my principal assertions (and one I hope will be assented to by the reader after finishing the book) is that David was an intellectual. His prodigious intellectual interests can be found in all of his paintings. He reached beyond traditional disciplinary boundaries, avidly transmuting a compelling variety of ideas into art. For example, as touched upon above, he not only drew upon a vast array of humanistic studies but we also find him engaged in the "scientific" discourse to enrich his work including psychology, physiology, evolutionary biology, and even geological speculations. That David's paintings express ideas is usually not denied but the quality and high level of thinking in

his oeuvre has never been given its just valuation. True intellectuality is not a quality traditionally granted to David by critical posterity, as it has been so freely and justly to Delacroix. And yet David, whose intellect his family, students, and friends consistently extolled, always viewed himself as a "peintre-philosophe" and concomitantly viewed painting as a form of thinking or meditation—"cet artiste est éminemment penseur" asserted Chaussard.[16] One can sense in all of his paintings the effort of mind that informed their making. And it was beside Delacroix that Baudelaire, that most acute of art critics, placed David in the Pantheon of French art. As Baudelaire appositely asserted, David's art would never be "en baisse chez les gens d'espirit."[17] It is in complete consonance with the great poet's assertion that this book has been written.

I

THE ELOQUENT BODY

"Gestes sublimes" and the Formation

of a Corporal Aesthetic

W E ARE CONFRONTED by two works (*The Death of Seneca*, 1773, fig. 1; *The Oath of the Horatii*, 1784–85, fig. 2) obviously with little in common except the singular fact that they were painted by the same artist in the early period of his career, thereby constituting a spectacular transformation. A comparison of these two works would give us no clue that the same artist who painted *The Death of Seneca* would paint only a few years later *The Oath of the Horatii*. Most art historical accounts gloss over the problematical quiddity embodied in this startling juxtaposition. We are proffered banal generalizations that merely attest to the fact that David, with the *Oath of the Horatii*, changed his style and produced the canonical masterpiece of neoclassicism. But as Emerson would suspect, greeting Whitman at the "beginning of a great career," this career had had a "long foreground." It is precisely the "long foreground" of David's *Oath of the Horatii,* as well as the aesthetic revolution it embodied, that I wish to examine. What David had been laboring long and hard at in the interim between *The Death of Seneca* (1773), one of his early student works of Rococo pastiche, and *The Oath of the Horatii* (1784–85) was the development of a corporal aesthetic. What led the artist in the 1780s to an acute concern, almost an obsession one might say, with corporality in painted representation, to the point where he would audaciously reject the dictums of his arduous years of artistic training and put himself at great risk in terms of his future career? The answer lies partially in David's unique and radical view of his own art historical position and in his redefinition of the role and responsibility of the artist in transforming prevailing institutionalized artistic practices and objectives. For David, unlike his fellow artists at the Academy, was not content to maintain and support the status quo of the French Academy. He did not embrace prevailing academic aesthetic norms in artistic theory and practice. Instead, he chose to challenge these norms and to

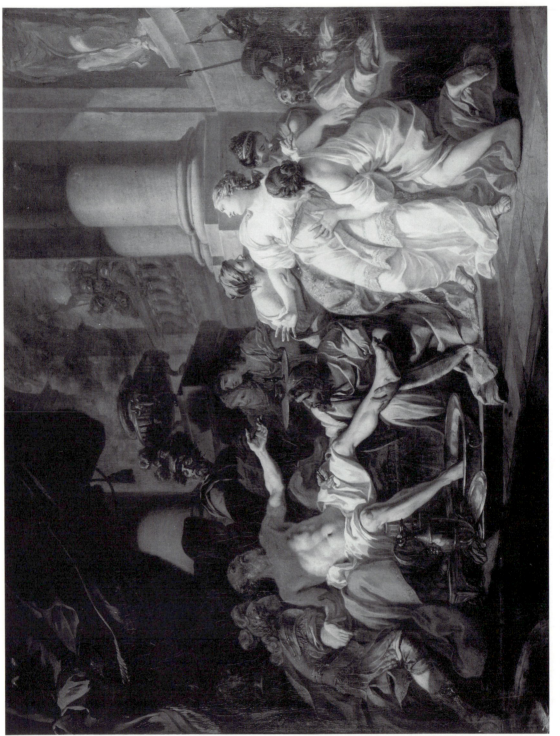

1. David, *The Death of Seneca*, 1773, Paris, Musée du Petit Palais

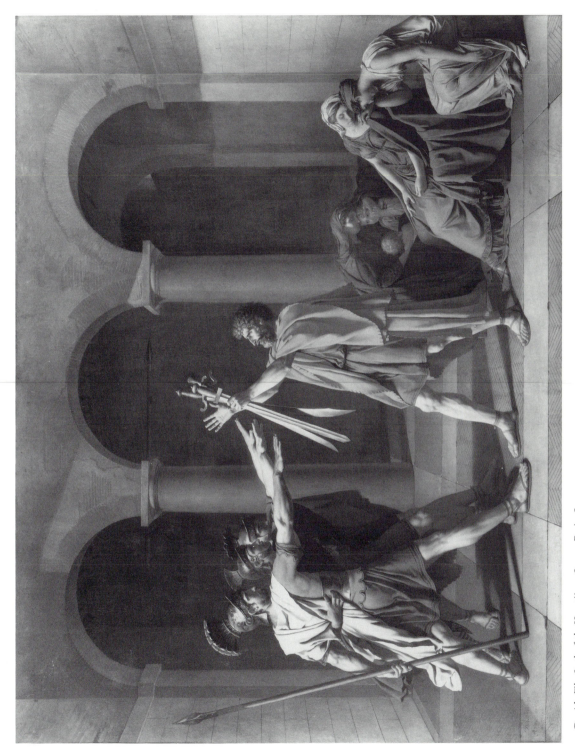

2. David, *The Oath of the Horatii*, 1784–5, Paris, Louvre

offer an innovatory alternative, one that would capture the intellectual and artistic imagination of his peers and contemporaries. This radical challenge was based on the artist's revaluation of the body and his privileging of corporal expression in art.

Traditional accounts of the major directions in the history of corporal expression in French art between the Baroque and Romanticism trace a genealogy that runs from the theories of Le Brun to those of Lavater. The reader moves from the Baroque to the Rococo (still dominated by Le Brun), emerges into Neoclassicism, and then into Romanticism in which the speculations and formulae of Lavater dominate the new era. This genealogy is convenient, for Lavater, with his emphasis upon the face as the primary locus of expressivity, appears to be a direct heir of the authoritarian Le Brun, who imposed his aesthetics of facial expression upon academic teaching in France, a tyranny that was so powerful and absolute that it dominated pedagogy for most of the eighteenth century. In light of general directions in the development of artistic styles in France, this genealogy appears to be accurate—physiognomy was indisputably a principal element in the teaching and making of art from the late Baroque well into the Romantic period and beyond.

However, by attending to the importance of the face as the essential key to meaning and expression in this development, a revolution in style has been overlooked in which the face was diminished in importance and assigned a relatively minor role within the configuration of the body. This dramatic aesthetic revolution, which made a lasting and indelible impact on French art, privileged the entire body over the head. The expressive characteristics of the hands and feet, the posture of a figure, and its corporal configuration rivaled physiognomic characterization. This new, overriding interest in a system of corporal signs, with the face functioning as one signifier among many, was crystallized by David in 1784–85 in his *Oath of the Horatii*, a work that radically challenged the classicized Rococo style, which had dominated French art from the 1750s to the early 1780s. David imposed on French painting a new aesthetic of the body, in which the configuration of the entire human figure radiated meaning and served as the locus of expressivity and communication. This revolutionary, corporal aesthetic, which would dominate French painting in the late eighteenth and early decades of the nineteenth century, was encapsulated by Diderot in one of his most apothegmatic utterances: "il y a des gestes sublimes que toute l'éloquence oratoire ne rendra jamais."[1] Immediately to link the names of David and Diderot seems appropriate for, as we shall see, extraordinary filiations exist between Diderot's theories of gesture and David's gestural inventions in *The Oath*, a painting that manifests the extent to which the artist was attentive to the philosopher's ideas of corporal signs. In his early, intellectually formative period in the 1760s and early 1770s, David came into direct contact with Diderot and his progressive ideas; the philosopher was a frequent guest at the intellectual soirées given by Michel Sedaine, David's tutor, and Sedaine and Diderot had occasion to discuss the aspiring artist's progress.[2] David greatly admired Diderot's powerful intellectual imagination and he would be profoundly influenced by the philosophe's ideas concern-

ing contemporary artistic theory, practice, and the philosophy of art that stood in dramatic contradistinction to prevailing academic norms and forms.

As is well-known, in the mid-eighteenth century, Le Brun's theory and practice of art, in which physiognomy was considered the principal element in artistic expressivity, dominated pedagogy at the Académie Royale. In his celebrated *Conférence sur l'expression générale et particulière*, first published in 1698, which remained an essential handbook for artists during the first two thirds of the eighteenth century, Le Brun insisted that facial expression was the principal means of representing the passions.[3] It is only after his lengthy discussion of physiognomy (accompanied by illustrations of "expressive heads"), and his advice to artists concerning the manipulation of the features to express the various passions, that Le Brun addresses the pose of the body appropriate for each passion. In the brief conclusion that he devotes to bodily form, he rarely gives more than one sentence to "attitude," which he invariably treats in an extremely rudimentary way, offering a basic formula for a codified pantomime that can only serve the locus of expressivity, the face, which always takes precedence over and determines the posture of the body.[4]

It has been pointed out that the institution of a drawing prize for the "tête d'expression" at the French Academy, initiated by the Comte de Caylus in 1759, reveals the extent to which Le Brun's theories of physiognomy still dominated the teaching and making of art at mid-century.[5] This is confirmed by an examination of the prize-winning "expressive heads," which demonstrate the student's dependence on Le Brun's paradigms, even though a live model was employed for this competition.[6] But Le Brun's principles of art were also reaffirmed in dogmatic fashion for aspiring artists at the Académie Royale in 1765 by an influential drawing professor, Dandré-Bardon, in his *Traité de peinture*.[7] In his lengthy section on "expression," Dandré-Bardon updates Le Brun's physiognomic theories by elaborating even further on how the face can be made expressive and by insisting on the face as the near exclusive locus of expression in art.[8]

In the vast corpus of art criticism in France from the 1750s to the 1770s,[9] critics rarely demonstrate an interest in the human figure, but when they do, they, like art theorists and educators, focus on facial expression and consider the expressive content of the body determined by physiognomy. The Abbé Leblanc (an ardent supporter of academic policy), for example, in his *Lettre sur l'exposition des ouvrages de peinture* of 1747, proffers a remarkably sensitive analysis of facial expression in his discussion of Le Sueur's *Alexander and Philip*.[10] He occasionally mentions pose or attitude but, importantly, only in the context of how successfully bodily form serves the expression of the face. The face, in fact, determines how spectators are to interpret the pantomime of the body and clarifies any doubts they may have about the meaning of a possibly ambiguous pose. Numerous examples of a similar type, in which the face is considered the key to the interpretation of emotion and narrative, can be cited in the Salon criticism of this period.[11]

Over three decades later, by around 1780, most critics at the Salons were still

responding to works of art in the same manner. When the human figure in painting was described (a still rare occurence), facial expression retained its hegemony as the dominant element that critics remarked, and physiognomy still held the key to the interpretation of gesture and pose. At this late date, however, the majority of critics did not describe either the face or the body at all but tended to discuss a painting in very general, nondescriptive terms. One of these minor critics who is interesting because of his attitude toward looking at painting is Mérard de St.-Just. In his entry for Ménageot's *Leonardo da Vinci Visited in his Last Moments by François I* (Salon of 1781), Mérard de St.-Just provides an example of this typical mode of responding to painting:

> The composition is beautiful and appropriate; noble and true ideas; large and vigorous execution; arrangement well understood; beautiful harmony; one strolls and the air circulates around each figure; character of each figure well-expressed; beautiful color tone; felicitous choice of drapery; proud, virile, large, easy brush; much harmony, pure and severe style. [12]

Although the critic describes the ability of the artist to characterize appropriately each figure in the composition, he expresses this in a vague manner that reveals nothing about the precise nature or details of the composition itself.

Between 1750 and 1780 art criticism essentially ranged from the Abbé Leblanc's occasional sensitivity to physiognomy (a valuation of the physiognomy of Le Brun) to Mérard de St.-Just's stereotypical discussion—with one principal exception, the writings of Diderot. Diderot, the most progressive, innovative observer of the art of his time, was profoundly concerned with the configuration of the human body in representation. As is well known, his interest in pantomime on the stage was paramount, [13] and his analyses of gesture pervade his discussion of works throughout the Salons. What makes Diderot's position unique and so radical is that he considers the face as part of bodily expression, not as a dominant feature but as one element among many that contributes to pantomimic communication. Diderot, unlike Le Brun and his followers, was not interested in the codified, stereotypical representation of the passions but rather in the subtle, complex physiological and psychological content of gesture and pose. [14]

One of Diderot's most compelling, minute decodings of this extraordinary psychology of gesture appears in his Salon of 1765, in which he analyzes in detail two highly finished sketches by Greuze, *The Ungrateful Son* (fig. 3) and *The Wicked Son Punished* (fig. 4), works characterized by striking and bizarre elements of gesture and pose (elements that were suppressed in the completed paintings). In his discussion of *The Ungrateful Son*, Diderot details how the son's complex emotional relationship to his family is communicated through pantomime:

> He appears violent, insolent and impetuous; by his father's side he has raised his right arm, above the head of one of his sisters; he rises on his feet; he threatens with his hand; he has a hat on his head and his gesture and his face

3. Greuze, *The Ungrateful Son*, 1765, Lille, Musée des Beaux-Arts

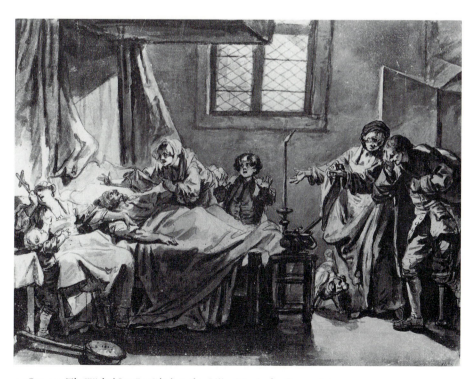

4. Greuze, *The Wicked Son Punished*, 1765, Lille, Musée des Beaux-Arts

are equally insolent. . . . The young libertine is surrounded by his older
sister, his mother and one of his little brothers. His mother embraces his
body; the brute tries to extricate himself and pushes her away with his foot.
This mother appears overwhelmed, grief-stricken. [15]

According to Diderot, every aspect of the son's body language—his posture and stance,
the position of his feet and arms, his hands as well as his facial expression—reveal his
character and his rapport with other family members, whose attitudes similarly express
their multifarious emotional states. Pantomime alone conveys intense drama and mo-
mentous emotion.

Diderot finds even more emotional eloquence in *The Wicked Son Punished*, in which
the son returns to find his impoverished family mourning his father who has just died of
grief:

The body of the older daughter, seated in an old leather armchair, is flung
back in the attitude of despair, one hand brought to her temple, the other
raised, still holding the crucifix that she gave to her father to kiss. One of his
grandchildren, terrified, has hidden his face in her breast. The other, his arms
in the air with fingers separated, seems to realize his first ideas of death. [16]

The most striking aspect of this passage, in which Diderot describes how the psycho-
logical and emotional content of the narrative is revealed though subtle details of bodily
configurations, is his interpretation of the child's raised hands with fingers separated: he
views this as a corporal sign conveying the first apprehension of the meaning of death.
What makes this intense reading of pantomime even more remarkable, however, is that
it is completely atypical of its time. No other critic writing about the Salon of 1765
evinced either a general or detailed response to pose and gesture, in these works or in any
others. [17] Unlike his contemporaries, Diderot focused his attention on aspects of the
body with a profound concentration, examining in these signs alone what the artist
could communicate through corporal representation.

Diderot's heightened sensitivity to pose and gesture remained unique in critical
discourse from the 1750s to the early 1770s. One wonders why the majority of critics
were simply not interested in the meaning of corporal signs. Most, of course, were
unaware of the philosopher's approach to painting (his Salon criticism, although circu-
lated in manuscript form among his friends, was not available to the public at large), [18]
but late eighteenth-century critics also ignored the vast and complex discourse on
gesture and pantomime to which Diderot's overriding interest in corporal expression
belongs. This discourse, which began to emerge by the mid-eighteenth-century in
France in fields as diverse as anthropology, linguistics, pedagogy, and the emerging
social and physical sciences, as well as, expectedly, the ballet and the theater, was
concerned with the origins of pantomime at the dawn of society, its sacred nature and
function in antiquity, and its potent possibilities as a universal language in the modern

world. The fascination with pantomime can be seen as part of a utopian quest (reaching its zenith in the eighteenth century) for a language that would offer direct and immediate communication between all societies, regardless of cultural and linguistic differences.[19]

The antiquarian De Cahusac, in his remarkably lengthy defintion of "Geste" in the *Encyclopédie* (which he adapted from his treatise, *La danse ancienne et moderne, ou traité historique de la danse*, of 1754),[20] conveniently recapitulates a number of these ideals of gesture:

> Exterior movement of the body and the face: one of the first expressions of feeling given by nature to man. Man felt from the moment he breathed; and the sounds of his voice, the diverse movements of his face and body, were the expression of what he felt; they were the primitive language of the universe in its cradle; they are still[the primitive language] of all men in their childhood; *Gesture* is and always will be the language of all nations; it is understood in all climates; nature, with the exception of a few modifications, was and always will be the same.[21]

In the *Encyclopédie*, gesture is defined as a conjunction of the entire exterior form, both the face and the body.[22] Recognized as the first and still only universal form of communication, gesture is then posited as the essential principle in the arts: "It is indispensable to see it [gesture] always as expression: that is its original function; and it is by this attribute, established by the laws of nature, that it embellishes art for which it is everything."[23] It must be assumed that this definition, published in 1760, encompassed all the arts, including that of painting. But the conservative academicians of art and art critics, in their desire to maintain the status quo (which meant consistent support of the physiognomic aesthetics established by Le Brun), were seemingly unaware of the burgeoning interest in pantomime and its potential significance for the visual arts. Diderot, however, free from such academic strictures and concerns, could approach painting from a unique point of view. His search for significant, bodily communication in painting developed in part from his attention to corporal signs in the drama and from his theory of pantomime, which he articulated for his invention of the "drame bourgeois" (particularly in his *Entretiens sur le fils naturel* of 1757 and *De la poésie dramatique* of 1758).[24] In the "drame bourgeois," significant pantomime is juxtaposed with declamation, and silent "tableaux vivants" alternate with spoken scenes.[25] Diderot developed a type of expressive pantomime on stage that did not merely complement and reinforce dialogue but actually replaced it as an alternative form of communication, one that he believed could be as expressive as spoken language and potentially even more meaningful. In the *Entretiens sur le fils naturel*, he wrote:

> I have said that pantomime is a portion of drama; that the author must seriously concern himself with it; that if it is not present and familiar to him,

he will not know how to begin, how to conduct or how to complete his scene with some sort of truth; and that gesture should often be indicated in place of speech.[26]

The significant gesture is an element of primordial importance in Diderot's elaborate theories of drama, and certainly his concern for communication in the theater, both theoretical and practical, led him to the fructive possibilities inherent in the decoding of the purposefully encoded bodily sign.

Diderot was also inspired to attend to corporal signs in painting through his close study of the works of Poussin, the artist whom he repeatedly lauded throughout the Salons and proposed as the great model for contemporary artists to follow. His *Salons* of 1767 and 1769 are especially rich in praise of Poussin; in particular he remarked numerous times upon Poussin's success in representing emotion and idea through the medium of the body in such canonical works as *The Testament of Eudamidas*, *Et in Arcadia Ego*, *The Israelites Gathering the Manna*, and *The Judgment of Solomon*.[27] Diderot was not alone in his high regard for Poussin (although his interpretation of Poussin's pantomimic expressiveness was unique), for, as early as 1747, the anti-Rococo critic, La Font de St.-Yenne had presented the seventeenth-century classical painter as a model for history painters to emulate in order to purge their styles of Rococo excess.[28] After mid-century the works of Poussin (and those of his celebrated "classical" contemporaries such as Le Sueur), became increasingly important as models that artists could look to for inspiration when they were asked to represent themes embodying an *exemplum virtutis*.[29] Poussin was admired as a supremely intellectual artist whose compositions were renowned for their severity, high level of ideas, and moral content.[30]

One of the principal moments of the Poussinist revival in France occurred in 1765 with the exhibition of three paintings that had been commissioned by A. Poisson, the Marquis de Marigny, Directeur-Général des Bâtiments, and his influential advisor, C.-N. Cochin, for the royal château at Choisy. The theme chosen for the series—the benevolence of Roman emperors (an undisguised allusion, of course, to the magnanimity of Louis XV)—reflects the Academy's attempts to reform the direction of history painting by imposing lofty subject matter that would require a suitable ennobling style.[31] The artists who presented completed works were highly esteemed academic painters—Carle Van Loo, *Augustus Closing the Doors of the Temple of Janus* (fig. 5), J.-M. Vien, *Marcus Aurelius Distributing Food and Medicine* (fig. 6), and Noel Hallé, *The Justice of Trajan* (fig. 7). The three paintings are filled with borrowings from Poussin, several even contain direct quotations, but removed from their original context and poorly drawn the figures in these works are exaggerated, clumsy, weak, and insipid. The nemiety of pose and gesture in a profusion of figures occludes rather than clarifies the meaning of the narratives. Diderot was scandalized by the triviality of corporal signs in these paintings of elevated subjects and he bitterly denounced their insignificance of gesture and pose. He ridiculed the rigidity, vulgarity, and poor drawing, the complete

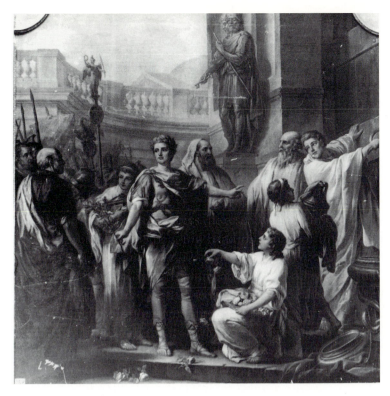

5. C. Van Loo, *Augustus
Closing the Doors of the
Temple of Janus*, 1765,
Amiens, Musée de Picardie

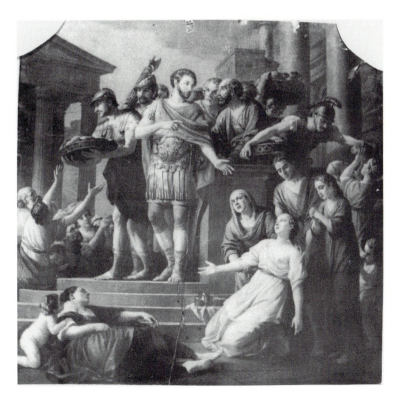

6. Vien, *Marcus Aurelius
Distributing Food and
Medicine*, 1765, Amiens,
Musée de Picardie

7. Hallé, *The Justice of Trajan*, 1765, Marseilles, Musée des Beaux-Arts

impoverishment of expression in both Van Loo's and Vien's depictions of crowds of figures.[32] But he found Hallé's figures particularly incompetent because the artist had reduced the number of protagonists and had concentrated on their pantomime. Diderot wrote of the widow in the foreground who begs the Emperor for justice after the death of her son, that there was "nothing accomplished, either in the hands or in the arms"[33] (her figure is particularly poorly drawn for her broad back and shoulders appear to be those of a male model and her right arm is exaggerated in length and appears disjointed). But Diderot was especially displeased with the vulgar and insignificant depictions of Trajan in which nobility of form was expected:

> M. Hallé, your Trajan, imitated from the antique, is flat, lacking nobility, lacking expression, lacking character. . . . The legs of Trajan are wooden,

stiff, as if he had a lining of sheet-metal or tinplate beneath the material. . . . But it's the arm and hand of this emperor that must be seen—the arm for the stiffness, the hand and the thumb for inaccuarcy of drawing. History painters treat lightly these fine details.[34]

Diderot was angry at the poor drawing and lack of attention to the extremities, which he clearly considered to be important corporal signs, equal in conveying meaning to the configuration and position of the torso, legs, and arms. Subsequent Salon entries are filled with Diderot's anger and disappointment at the incompetence of history painters who depict weak bodies and trivial gestures and poses.

As has been emphasized, in the 1760s and early 1770s, Diderot was alone in his consistent, intense reading of the corporal signs in paintings exhibited at the Salons, but by the late 1770s there was a slight shift in interest in Salon criticism. Although the majority of critics still describe paintings in very general, vague terms (such as those used by Mérard de St.-Just), certain observers begin to ascribe more importance to corporal expression in painting and occasionally to assign it equal value with facial expression. Although very infrequent, these suggestions of a new sensitivity to the importance of the pantomime of the painted figure indicate that a few critics, at last, were beginning to share Diderot's view and had started assiduously examining figures in paintings to see what pose and gesture might reveal.[35]

It is in the early 1780s, however, that one begins to notice a startling, new awareness of corporal expression in Salon criticism, principally in response to paintings exhibited by J.-L. David. The critics began to perceive in David's works a forceful and innovative representation of the body, and they commented on the vigorous, powerfully rendered extremities. In this the critics would finally begin to concur with Diderot, who, in fact, singled out figures in David's early works of the 1780s for their eloquent corporal expressivity. In the *St. Roch Interceding for the Plague Stricken*, for example (exhibited at the Salon of 1781, fig. 8), David's first commissioned history painting,[36] an eclectic work filled with borrowings from Caravaggio, Guido Reni, and Poussin, Diderot criticized the strange, looming scale of the Saint praying to the Virgin and Child that stands in a disjunctive relationship to the foreground figures, but he heralded the beauty in "expression" and drawing and singled out for praise the horrific corporal expressivity of the recumbent, plague-stricken figure who fills the foreground space.[37] The eloquent configurations of the suffering and dying figures prefigure many Romantic works, including those by Gros, Géricault, and Delacroix; the stark, recumbent nude, so admired by Diderot, would be remembered in 1806 by the ardent Republican and art critic Chaussard as one of the most eloquent figures ever painted by David.[38]

At the same Salon of 1781, Diderot also singled out another work exhibited by David, his *morçeau d'agrégation, Belisarius Begging Alms* (fig. 9); here he was disturbed by the corporal configuration of the eponymous hero because although it was quite eloquent, Diderot thought that Justinian's eleemosynary ex-general should not humbly

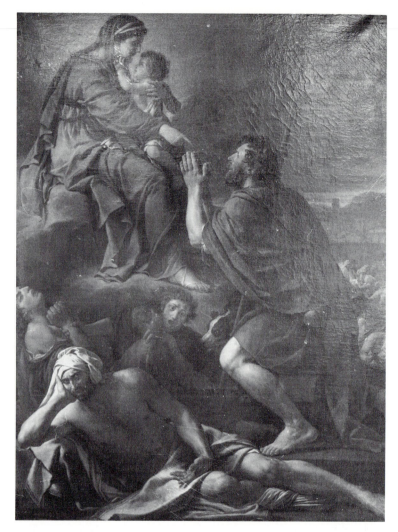

8. David, *St. Roch Interceding for the Plague-Stricken*, 1781, Marseilles, Musée des Beaux-Arts

beg but rather rage against his fate.[39] Other critics, attentive for perhaps the first time to the bodily configuration of figures in painting, highly praised the Belisarius for its corporal expressivity. One critic stated:

> Your Belisarius has equal beauty of expression and execution: he has a very noble character; the arms, the hands are of a beauty and truth that surpass all praise.[40]

In particular, the opened, begging hand of Belisarius, isolated and highlighted in the center of the composition, symbolizes the act of begging itself. The beautifully rendered hand, imbued with great emotional intensity, is detached from other elements of the

composition and seems to express the essential meaning of the narrative. David was here directly inspired by the begging hand of Diogenes in Puget's powerful seventeenth-century relief, *Alexander and Diogenes* (fig. 10), which was visible in the Louvre during this period and had been recommended as an object of study by David's professor, Dandré-Bardon.[41] As we shall see shortly, it is expected that David would look to a sculpted relief for inspiration rather than a painted precedent. The exquisitely rendered outstretched hand of the beggar Diogenes beseeching the Emperor to leave him in peace provides the source for the hand of Belisarius. In fact, the entire configuration of hand, arm, and head of David's figure bears an astounding resemblance to that of Puget's Diogenes.

We know from David's autobiographical notes written in the third person for J. J. Sue in 1793 that he considered Belisarius and his child guide to be particularly innova-

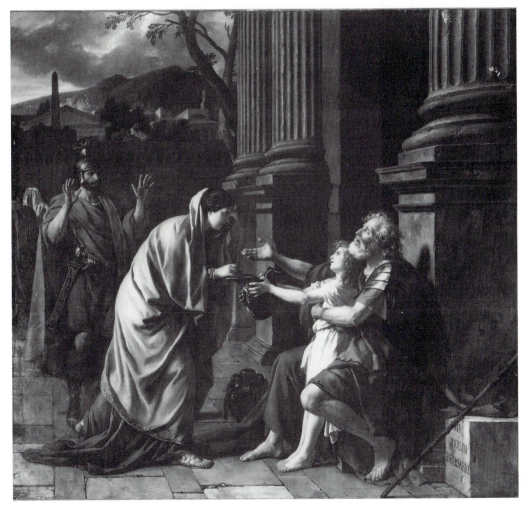

9. David, *Belisarius*, 1781, Lille, Musée des Beaux-Arts

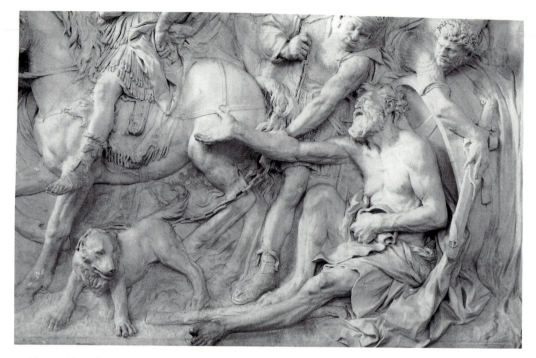

10. Puget, *Alexander and Diogenes*, detail, Paris, Louvre

tory in terms of corporal communication and believed this group constituted an original contribution to a theme depicted in a canonical version by Van Dyck, popularized in eighteenth-century France by Marmontel's novel of 1767 and represented by several of his immediate predecessors.[42]

> In 1781 he did Belisarius begging alms for his agrément at the Academy of Painting and David had the art to render new this subject, so well executed by Vandick, through the new group filled with feeling of the little boy who begs alms and through the singular manner in which the ill-fated Belisarius embraces him.[43]

By dramatically juxtaposing and thereby contrasting the innocent and beautiful child with the aged and heart-rending figure of Belisarius who embraces him, David was certainly thinking not only of surpassing Van Dyck but, a fortiori, of outdoing two of his most serious rivals—Vincent and Peyron—who had both introduced the child into their interpretations of the narrative but with minimal expressive effect.[44]

In spite of this innovatory group, however, that David had singled out as truly original, the composition, like that of the St. Roch, remains an eclectic apprentice work filled with borrowings from and references to earlier artists such as Poussin and demonstrating mastery of academic conventions (such as the pantomime of the soldier who recognizes Belisarius, which is inspired by Le Brun's schematic conventions governing corporal expression).[45] His next work, *Andromache Mourning Hector* (fig. 11), submitted

26

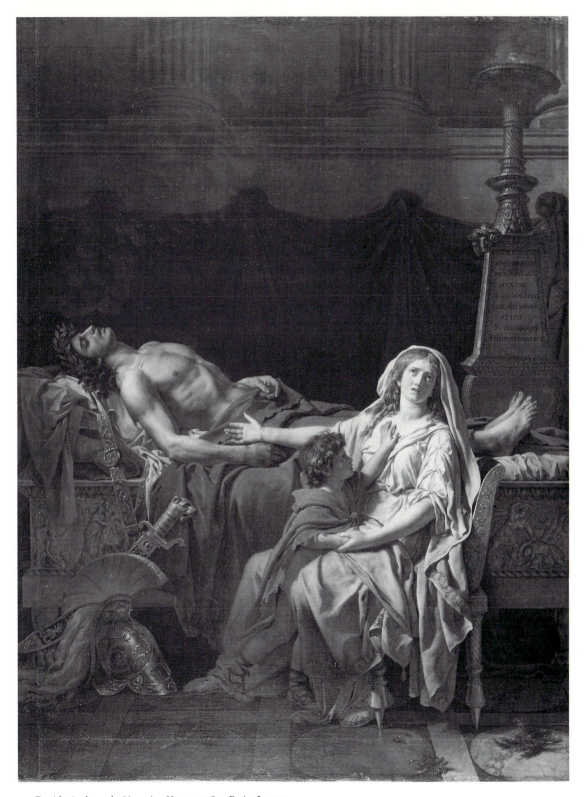

11. David, *Andromache Mourning Hector*, 1783, Paris, Louvre

as his *morçeau de réception* in 1783, like the *Belisarius*, was based on a popular subject in modern painting and was equally eclectic and academic; this work won him full membership into the Academy.[46] As in his two preceding history paintings of the 1780s, in *Andromache Mourning Hector* David used elements of powerful corporal communication to convey his unique interpretation of a popular antique subject—he transformed a theme of public mourning of the death of a hero into one of private, familial sorrow; a Homeric tragedy is expressed through the idiom of the "drame bourgeois," the genre invented by Diderot and written for the stage by David's tutor Michel Sedaine. A grief-stricken wife laments the untimely death of her young husband and like the Virgin of Sorrows (whose iconography inspired David), she foresees the grim fate that awaits her innocent son Astyanax who seeks to comfort her and seems unaware of the cadaver of his father on the bed.

David, who was always pondering the meaning of classical texts, meditated on Homer's characterization of Hector as the archetypal family man and he emphasized the familial meaning in the original title he gave to the painting: *La douleur et les regrets d'Andromache sur le corps d'Hector son mari.* The artist concentrated his efforts on the depiction of the extremely eloquent body of Hector, a figure he wanted to continue to improve upon as late as 1803 when Vivant Denon asked him to give the painting to the nascent Musée spéciale de l'école française at Versailles.[47]

> For more than 18 years I have suffered seeing certain faults that are easy to fix . . . Hector's ribs protrude too much and make him into more of a body of an écorché than that of a hero whom Venus continues to protect after death to the point of preserving the same configuration that he had before he ceased to live. I will add to this the much too dark half-shadows on Hector's arm which is in the light.[48]

David wanted Hector to conform more closely to Homer's description in the *Iliad*, to look less like a bloated corpse in the process of decay, an aspect he had emphasized in several drawings and in the original painting. The figure we see today is, apparently, a "revised" version, a Hector who appears to be almost sleeping rather than dead.

At the painting's first exhibition in 1783, however, the majority of Salon critics, who were usually mute about the configuration of the human figure in paintings, responded with particular fervor to the frightful naturalism of the corpse.

> The painting of the lamentation of Andromache over the body of Hector has a most imposing impact. Hector is appalling because of the character of death, which is perfectly expressed. . . . The greatest severity of drawing and vigor of color characterize M. David. He is the painter who best renders the extremities.[49]

Another wrote:

The cadaver of the hero is lying horizontally on a bed that somewhat resembles a couch. This body has very truthful details. The head and the feet are most beautifully rendered.[50]

These critics found David's depiction of the hero's dead body disturbing and compelling, convincing (i.e., visually true), and eloquent. Both recognized and praised the remarkable representation of the extremities of the corpse. As we can see, the exposed feet, in particular, are isolated and highlighted in an uncanny manner. David has focused the viewer's attention on the feet, corporal signs that symbolize the meaning of death itself. Feet support the body in life and make movement as well as stability possible. In death the feet no longer serve this function, the body collapses into a recumbent, horizontal position and David has evoked this transition from the erect to the supine with great pathos. And, just as he placed the *Farewell of Hector and Andromache* in sculpted relief on the bed below Hector's head and heart, so he placed beneath his feet a depiction of the moment of the hero's death as he collapses to his knees beneath Achilles' murderous attack.

Hector's cadaver, like the recumbent plague victim in the foreground of the *Saint Roch* and the group of Belisarius and his child guide, is an extraordinarily successful attempt at compelling the viewer's attention at a visceral level. In these works, David had begun to explore and experiment with the profound emotional and psychological impact that the image of the body could exert on the spectator. But he could not yet give free reign to this development because these paintings of the early 1780s were still executed to impress the Academy and are filled with compromises, concessions to academic expectations. And, when we look back to David's Prix de Rome entries, such as the *Death of Seneca* (fig. 1) of 1773, which embodies the classicized Rococo or neo-Poussinist style that David had learned at the Academy, we are led to wonder how the artist could have developed so rapidly this new aesthetic of the body, achieved through the representation of powerful, sculpturesque forms. The reconstitution of the human figure and its positioning stood in dramatic contradistinction to academic expectations for the making of the human figure, but seemed directly affiliated with Diderot's ideas of gestural and corporal communication.

David's early pastiches of Boucher for the Prix de Rome competition—*The Combat of Mars and Minerva*, 1771, and *Apollo and Diana Piercing the Children of Niobe with Their Arrows*, 1772, as well as his *Death of Seneca* and his neo-Poussinist *Antiochus and Stratonice*, 1774 (the prize-winning work, fig. 12)—reveal his struggle to master the pedagogical goals of the Académie Royale.[51] Such mastery was, of course, necessary if an artist wished to further his career, for the coveted Prix de Rome, the offical sanction of the student's adacemic achievement and talent, ensured not only a lengthy fellowship in the eternal city, but virtually guaranteed a successful future through public and private commissions and government approbation.

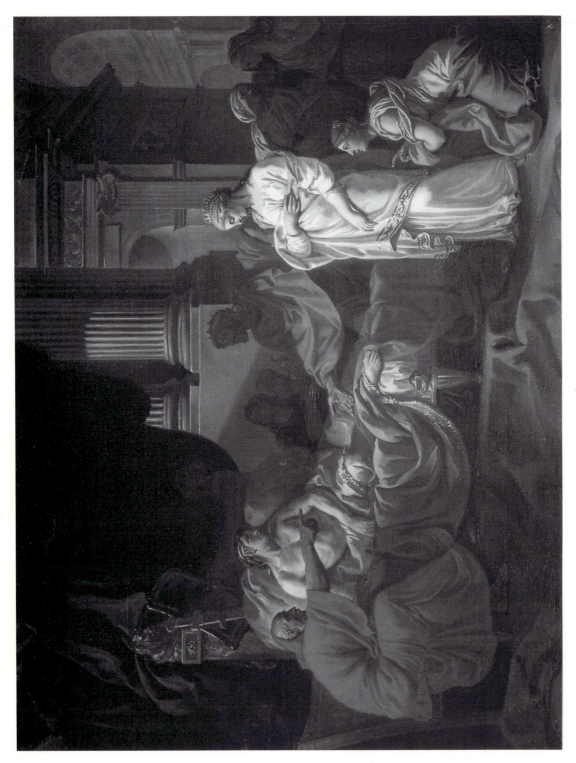

12. David, *Antiochus and Stratonice*, 1774, Paris, Ecole Nationale Supérieure des Beaux-Arts

The figures in David's Prix de Rome competitions manifest the principles of Rococo drawing and composition in which he had been trained. The *Death of Seneca*, for example, is a composition crowded with figures (many fill the foreground space), notable for their great variety and nemiety of gesture and pose, opposition of groups based on contrastive diagonals, masculine versus feminine forms, the draped versus the nude, and an emphasis on animation of details in costume, coiffure, and drapery folds. The figures are placed within a grandiose Roman Baroque architectural setting and are characterized by an emphasis on histrionic emotional responses to the protagonist's suicide. The drawing style of the figures conforms precisely to prevailing academic norms. The shoulders, arms, and legs of Seneca, for example, are formed by sinuous curves that undulate into waves of soft, seemingly weightless muscles, tendons and sinews. Similarly, drapery, armor, helmets, and hair are rendered through animated, rhythmical serpentine curves, which help to convey a sense of movement but make the figures themselves appear too supple, almost flaccid. The style of drawing in which these figures are rendered allows for lightness, elegance, and grace but inhibits any forceful, dynamic presentation of the body.

In his Prix de Rome entries such as the *Death of Seneca*, David, like his peers, wanted to demonstrate thorough assimilation of propaedeutics at the Academy. In order to do so, he produced eclectic works designed to conform to academic artistic prescriptions and objectives as codified by his teacher at the Académie Royale—Dandré-Bardon. In his student works, David attempted to display facility in drawing figures in the "appropriate" academic style and in being able to relate multiple figures and objects within a compositional setting in the representation of a subject based on an assigned literary source. Learned academic norms of technique and skill were valued above invention. It was expected that students would be familiar with sanctioned stylistic and compositional patterns in the execution of assigned subjects which were almost invariably taken from antique sources during David's student years, a period that witnessed the initial flowering of the classical reforms at the Academy.

David's Prix de Rome entries demonstrate a fidelity to both pictorial and literary sources. Like his fellow students, he studied and assimilated both recent Prix de Rome compositions that had been successful and also recent Salon paintings that had been particularly well-received. In his attempt to win the Prize with the *Combat of Mars and Minerva* in 1781 and *Apollo and Diana* in 1782, David had mistakenly emulated the style of an older generation, particularly that of Boucher. As has frequently been noted, his goddesses owe a strong debt to Boucher, an artist David greatly admired but whose style was considered passé by the 1770s. In the *Death of Seneca* in 1773 David made a great attempt to conform to the neo-antique, neo-Poussinist style then favored by the Academy (a style associated with his current mentor Vien); he finally won with *Antiochus and Stratonice* in 1774, a work whose composition and figural vocabulary is restrained and subdued compared with his earlier entries. Numerous precedents for these works can be found. All conform to prescriptions for painting codified by Dandré-Bardon.

13. Le Brun, *Tristesse et abatement de coeur, Conférence sur l'expression générale et particulière*, Paris, 1698

In his treatise on painting of 1765, Dandré-Bardon continually refers to earlier pictorial sources that artists should use as paradigms (not surprisingly, those most frequently cited include paintings by Raphael, Le Brun, and Le Sueur, the heroes of French classical academic reform of the second half of the eighteenth century).[52] Just as fidelity to pictorial sources was expected, so was fidelity to the literary source upon which the subjects were based. In the 1760s and 1770s academic doctrine had revalued and insisted upon the time-honored dictum privileged by the Renaissance of "ut pictura poesis."[53] In his Prix de Rome entries David, like his peers, "illustrates" a text. He also conforms in almost every way to Dandré-Bardon's instructions for making a painting in terms of compositional elements—arrangements of figures and groups, light, color, costume, accessories, etc. Above all the artist places great emphasis on the legible conventions of facial expression which are served or reinforced by exaggerated pantomime and predominate over flaccid corporal forms. This, too, conforms to Dandré-Bardon's prescriptions for "correct" composition which were based on Le Brun's paradigms[54] (stereotypical expressions derived from Le Brun, such as *Tristesse et abatement de coeur* [fig. 13] inspired David's *La Douleur* [fig. 14] which won the prize for the competition of the *tête d'expression* in 1773).

32

14. David, *La Douleur*, 1773, Paris, Ecole Nationale Supérieure des Beaux-Arts

15. C. N. Cochin, *Academy Figure*, Diderot and d'Alembert,
Encyclopédie . . ., Recueil des planches, II, Paris, 1763

The entire making of the human form in David's Prix de Rome compositions depended upon what was considered the most essential element of all the arts—drawing. During the 1750s, 60s, and 70s, drawing was based on principles in which figures were defined through hatching, the reticulative interplay of light and shade, a mode that stressed fluidity, lightness, and suppleness of contour—the total constituting an aesthetic associated with the Rococo style (this is precisely the style so denigrated by Diderot for its lack of strength and expressive impact). These qualities are exemplified in the "Academy figures" that aspiring artists used as paradigms. Two examples are provided in the summary drawing course, *Dessein*, for the *Recueil de planches* of the *Encyclopédie* (published in 1763), a program based on academic training and principles (figs. 15, 16).[55] In these academy figures by Cochin and Fragonard, one would be hard-pressed to find a solid, firm contour. Whether seated or standing, these nudes have a

16. Fragonard, *Academy figure*, from *Encyclopédie* . . ., 1763

limp, rubbery quality and strange texture and consistency, which make them unconvincing as representations of the solid volumes of the human form in space—Rococo painting and drawing would locate great expressive possibilities in other elements. The text that accompanies these paradigms of drawing describes the procedure for sketching a figure in which contour is completely subordinate to the predominant mode of defining form through light and shade.[56] A number of important drawing manuals of the time articulate the same precepts.[57] The most important codification of these principles of sketching figures, however, is found in the treatise of Dandré-Bardon who bluntly criticizes artists who dare to emphasize contour.

It is an error to believe that the beautiful character of Drawing consists in the assembly of outlines produced boldly and decidedly in a hard and robust

style. The suppleness and lightness of contours are the principal qualities of
the character of Drawing, because they participate essentially in the truths of
nature.[58]

David's early student works manifest the extent to which he had mastered the
principles of academic drawing and composition codified by Dandré-Bardon and his
other teachers. His command of this drawing style would help him finally win the Prix
de Rome in 1774 with his *Antiochus and Stratonice*.

It should not surprise us that David's transformation of academic aesthetics and his
dramatic, self-conscious subversion of his artistic education came in the realm of draw-
ing, considered, as we have seen, to be the very basis of French art in the eighteenth
century. This transformation occurred in Rome. When David arrived in Rome in 1775,
he entered into a milieu in which antique sculpture was understood as the apogee of
artistic achievement (largely through the writings and influence of the indefatigable
Winckelmann and his disciple Mengs)[59] and in which a style of drawing prevailed that
was virtually the antithesis of the one he had been taught. This was the "dessein au trait"
or contour drawing, a style used by many of the artists in the international community
in Rome, including two of the most important figures—the father of Italian neoclassi-
cism, Pompeo Batoni, and the apostle of neo-Raphaelism, Mengs.[60] The Scotsman
Gavin Hamilton had achieved great success in his use of the expressive outline style in
his well-known series of representations of the *Iliad* and the *Odyssey*, disseminated
through Cunego's engravings.[61] But perhaps the most celebrated work executed in this
mode was that of d'Hancarville, in his illustrations to the *Antiquités étrusques, grecques, et
romaines.. gravées, avec leurs explications* (1767–76), used by artists as a reference work for
antique subject matter and style.[62] For in Rome, an artistic melting pot during the
second half of the eighteenth century, the revival of antique themes had become associ-
ated with the purity and distillation of the firmly drawn contour, and the French artists
working in Rome who had preceded David in the early 1770s were well aware of the
growing importance of the outline style.[63]

Why did the outline style suddenly become so important and pervasive that it was
embraced by an international community of artists? As Robert Rosenblum has demon-
strated, one principal source for the development of the outline style, particularly in the
popular representation of antique subjects in Rome, is to be found in Winckelmann's
aesthetics of the contour.[64] In his *Gedanken über die Nachahmung der griechischen Werke in
der Malerei und Bildhauerkunst* of 1755, Winckelmann had asserted that the imposing
contour was not to be found in nature but belonged uniquely to the privileged domain of
the artist; he further asserted that in ancient Greece contour and expression were the sole
elements available to the painter.[65] These ideas that David encountered in Rome (the
aesthetics of Winckelmann and Mengs were being discussed by artists, amateurs, and
connoisseurs) had an immediate and extraordinary impact on him. They contradicted
everything he had learned about *dessin* at the French Academy including the "academic

style" of the undulating, broken line as the "correct" way to imitate nature and they also suggested an alternate model for emulation—the sculptors of ancient Greece, models that Winckelmann had recommended as a means to purge the Rococo style with which France had "infected" all of Europe.[66] But these ideas concerning the purity and power of the contour, as embodied in ancient sculpture, reinforced what David could already have heard in France at the salons of his tutor Michel Sedaine where he had encountered Diderot and other enlightenment philosophes. In his introduction to the Salon of 1767 Diderot had written that the ancients, in their sculpted works, had found the perfect contour, the "ligne idéale."[67] In fact, before leaving for Rome David may also have been familiar with the ideas of the most important promulgator of the contour and its sacred essence and meaning—Hemsterhuis—the neoplatonic philosopher and polymath, who was highly esteemed by Diderot.[68] In his *Lettre sur la sculpture*, published in 1769 and reprinted in three editions in France between 1769 and 1804, Hemsterhuis articulated the sacred essence of line and insisted on the divine mission of drawing.[69] An archaeologist as well as an amateur draftsman, Hemsterhuis considered *dessin* the most revelatory form of artistic expression and declared contour itself as the basis of communication in art as well as the principal means through which beauty is experienced. His emphasis on the role of contour in expression corresponds to that of Winckelmann, but Hemsterhuis goes further than Winckelmann because he affirms the capacity of contour to convey immediately both idea and emotion.

> It follows that the artist will be able to attain the beautiful in two different ways: through delicacy and fluidity of contour, for example, he can offer me, in one second, the idea of beauty, but in repose, as in the Medici Venus or in your Galatea. But if, with a contour equally fine and fluid, he can express an Andromeda with her fear and hopes visible in *all of her limbs* [my italics], he will be able to offer, in the same second, not only the idea of beauty, but also the idea of Andromeda's danger.[70]

Thus, according to Hemsterhuis, the expressive line is the direct conduit to the mind and imagination of the spectator.

The extent to which David's personal formulation of the expressive outline and its role in the making of images would embody the ideas articulated by Diderot, Hemsterhuis, and Winckelmann is nothing short of remarkable. David's response to the poignant outline was passionate and permanent. Throughout his long career he consistently remained attached to the purity and precision of the forceful contour which he had formulated in Rome in the 1770s, in spite of continual transformations in his style. For David associated the powerful line, the conveyor of intellectual and emotional meaning, with his celebrated predecessors, the sculptors and painters of antiquity.

That this idea came to him almost immediately upon his arrival in Rome is evinced by his virtual obsession with drawing after antique sculpture. Like his peers, David was required to make landscape and cityscape studies and to sketch works of Renaissance and

37

Baroque masters. But he was also required to sketch after antique statues and reliefs and his contemporaries inform us that he was particularly enthralled by antique sculpture. We know that he spent most of his time in the early years in Rome, in fact, sketching from masterpieces of the classical past and David's friend, Alexandre Lenoir, in his *Mémoires* of David, published in 1835, succinctly described David's conversion in Rome, inspired by his study of anatomy and his emulation of antique sculpture (as recounted to him, he declares, by the artist himself).[71] Lenoir claims that these combined influences led David to become the greatest "dessinateur" of his time. This assessment is telling since, throughout his career, David would privilege the significance of the body expressed through the live model and the sculpted figure from antiquity, as well as privileging the aesthetics of drawing. Significantly, anatomical realism for its own sake (embodied in the écorché) did not play an exclusive role in David's development of a corporal aesthetic in the 1770s and 1780s (for his later valuation of the dissected or "anatomized" sculpted figure in the early nineteenth century see chapter III). During the very period of David's artistic training the usefulness and importance of the flayed figure was being contested in academic teaching and theory. In his *Essai sur la peinture* of 1765 Diderot had vigorously denounced what he saw as the pitfalls and potential abuses of the écorché which he believed, because it revealed what was beneath the skin, would render artists incapable of properly representing the external forms of the live model in nature (in other words, anatomical knowledge would consistently interfere with, undermine, and subvert imitation).[72] Diderot's serious reservations are directly related to the conflicts and debates concerning the teaching of anatomy at the Academy which had suffered serious lapses from the 1740s to the 1770s. Anatomy had not been taught regularly and attempts to re-establish it had been half-hearted and ineffectual. In spite of the availability of sculpted models of the écorché (such as that attributed to Bouchardon which was replaced in the late 1760s by Houdon's celebrated flayed man and its descendents) and the display of the flayed figure in a plethora of newly illustrated anatomy books, anatomy is barely mentioned in the drawing manual of David's teacher Dandré-Bardon (1765) who refers to it in an extremely brief and cursory way; and in the *Encyclopédie* drawing course anatomy is given almost no attention while the live model and the example of sculpture are privileged as the most significant tools for learning drawing (in the late 1780s and 90s, however, the situation would change dramatically—anatomy would become emphasized and even the dissection of corpses would become a significant part of artistic training).[73]

Several drawings apparently related to *The Oath of the Horatii* (fig. 17) reveal that David did, indeed, study anatomy as Lenoir later claimed and that he was aware of the significant revelations of the écorché, but these drawings are curious for a number of reasons. Although they reveal the artist's interest in the structure and placement of tendons and muscles, the emphasis nevertheless remains on the eloquent contour of the body. In other words, as though heeding Diderot's warnings David did not let his analysis and vision of the interior of corporal structures interfere with his painted

17. David, *Drawing of a Leg*, Paris, Louvre

representation of the organic whole; even in his anatomical studies, the contours and exterior structures struggle not to dissolve or give way to what lies underneath the skin (the exception to this being his depiction of an actual corpse in the process of decay—his original figure of Hector in *Andromache Mourning Hector* which he transformed in the early nineteenth century in order to make it look less like an écorché). David would use to great expressive effect his anatomical understanding of muscles, tendons, and veins (probably learned through the dissection of corpses, as well as through the study of scuplted models), especially in the figures of Horatius and his sons in *The Oath* where these elements bulge and protrude under great tension and strain; he clearly, however, privileged the live model and antique sculpture in order to develop his eloquent and powerful contour style. A number of drawings executed in Rome demonstrate that David actually depicted live models as antique figures (figs. 18, 19), thereby revealing his complete conflation of the sculpted prototype with the model in nature (on these drawings in which figures sometimes assume positions of recognizable sculpted types David, significantly, recorded the important distinction between the models in art and those in nature—he writes on them "sur nature," "d'après nature," "pris sur nature"— whenever he drew directly from antique statues or reliefs he typically cited his sources or identified them as sculpted examples).

39

18. David, *Figure dressed all'antica*, sketch, Paris, Louvre

David's vast corpus of drawings constitute a significant and still undervalued element of his oeuvre for, as we shall see throughout this study, drawing for the artist became a distinct register of art, one which allowed for considerable freedom of intellect and imagination. David had a lifelong commitment to the sketch which he used as an expansive medium to allow for the exploration and development of innovatory ideas. Many of his so-called preparatory sketches for his major compositions are not preparatory at all but represent alternate possibilities for the expression of ideas. David is often audacious and experimental in his sketches. In Rome in the late 1770s, as a result of his study of antique sculpture, he evolved and developed a unique aesthetic of the sketch as an artistic register distinct from painting. David's extant Roman sketchbooks reveal that he was predominantly interested in drawing after antique statues and bas-reliefs

and it is particularly in these sketches that we discover a personal interpretation of the contour style.[74] It is significant that David would turn primarily to examples of antique sculpture in order to develop a highly personal, forceful, and energetic contour style (drawing and sculpture, because of their dependence on the contour, were naturally closely aligned). David was encouraged in this direction by the French sculptors he befriended at the French Academy in Rome, including Dupasquier, Giraud, Quatremère de Quincy, Roland, Suzanne, and Lamarie, all of whom impressed upon him the value of the contour in the sculpted figure.[75] In 1850 one of David's biographers, Miette de Villars, recorded the now celebrated anecdote of a conversation in Rome between the sculptor Lamarie and David. David observed Lamarie drawing and noticed that he defined his figures exclusively through the means of contour. When he asked if Lamarie was going to shade his figure the sculptor replied, "Do you believe that drawing resides in a few hatchings, more or less well-made? Drawing is completely in the contour, put everything that you want into it."[76] The anecdote reveals that even as late as the midnineteenth century David was remembered as having learned the outline style from sculptors and sculpture. The artist, of course, consistently acknowledged his debt to sculptural aesthetics, which he would establish as a guiding principle of his school.[77]

19. David, *Figures dressed all'antica*, sketch, Paris, Louvre

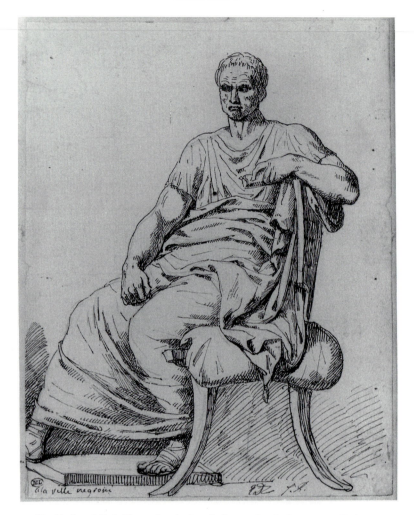

20. David, *Seated Male Figure after Antique Sculpture*, sketch, late 1770s, Paris, Louvre

In Rome David executed a vast number of sketches after antique sculpture which are remarkable for what they reveal about the artist's responses to his models.[78] David's numerous contour drawings of statues, such as his representations of seated male figures (fig. 20), demonstate that he did not copy figures, rather he freely and self-consciously interpreted them (sometimes, as we have seen, he represented live models in imitation of sculpted examples). Although sources could be identified for many of his figures, the drawings themselves invariably diverge from their sources. Through attention to details, such as hair, hands, and feet, David transposes the medium of static marble into fluid representations infused with movement and life, revealing again his attempt to integrate the sculpted example with the live model. A modification in the tilt of the head, a softened shoulder, an extended foot, an opened hand or clenched fist, all of these

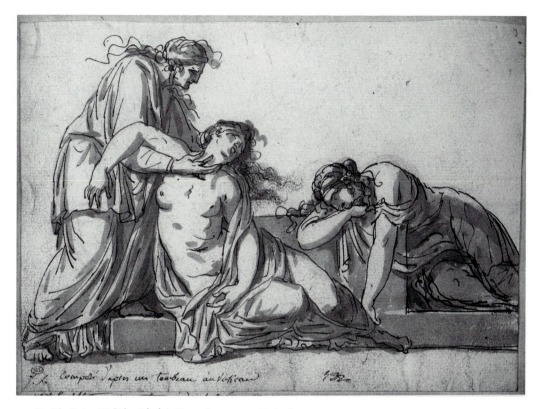

21. David, *Dying Niobids with their Nurse*, late 1770s, Paris, Louvre

seemingly minor details make the figures appear as if they were based on the live model rather than on stone paradigms. Roland Barthes, in a recent study, analyzed the visceral impact produced by the energy of the line when it describes a human form.

> line . . . always refers to a force, a direction; it is an *energon*, a work which makes legible the trace of its pulsion and its expenditure. Line is visible action.[79]

David certainly recognized the importance of the *energon* of the line, its dynamic pulsion and the possibility of the forceful contour to convey both the substance and the energy of the human figure. Whereas sculpture constitutes an actual presence—the forms and volumes of the figure in space—the contour can capture and animate the subject of sculpture. Contour, for David, was "visible action."

Some of David's most eloquent contour drawings executed in Rome are inspired by reliefs found on antique scarcophagi, such as his *Dying Niobids with their Nurse* (fig. 21). In this poignant funerary group, David transmitted the sculpturesque quality of form to the two-dimensional image, through an intense focus and concentration on the expressive contour. But, although the figures have a sculpturesque defintion and, as in antique

reliefs, are isolated against a neutral background (which compels attention to the figures themselves), they have none of the rigidity and coldness of stone. For David has imbued his figures with life, through attention to detail, such as the delicate curls of wavy hair, the finely rendered hands and feet and through softness of flesh which he conveys with great subtlety while retaining a firmness and strength of contour. In these drawings David explores how the contours of the body, through overall configuration and finely wrought detail, can immediately communicate meaning (we are reminded of Hemsterhuis' belief that contour was the essence of communication in art).

In Rome David became obsessed with achieving an absolute purity of line which he believed would indicate purity of expression. He described his method of "distillation" to achieve purity of line to his student Delafontaine.

> I made and remade incessantly, beginning at a point of triviality and refining my lines until finally my contours almost had the grandeur, purity, finesse and grace that I found in beautiful antique figures and that I admired in the author of the stanze and the Loggias.[80]

22. David, *The Martyrdom of St. Sebastian*, after Veronese, late 1770s, Paris, Louvre

23. David, *The Martyrdom of St. Peter of Verona*, after Lamberti, late 1770s, Edinburg, National Gallery of Scotland

It is telling that David would refer to Raphael as well as to figures of antique sculpture because, like many artists of his generation, he believed Raphael had perfectly combined the antique and nature, two of the principal goals he had set for himself as well.[81] But one wonders to what extent David was actually inspired by the Renaissance master in the early period of his career. The Roman sketchbooks reveal that David's various drawing styles depended on the model from which he was working. Virtually all of his sketches after antique sculpture are rendered in a pronounced, firm, and eloquent contour style. But his drawings after "modern" masters such as Guercino, Guido Reni, the Caracci, Veronese, etc., executed usually in wash and pencil, exhibit a vacillation in style that suggests an experimentation with the visual impact of contour versus chiaroscuro in the creation of volume and form (figs. 22, 23). The contrastive drawing styles reveal that David did not reject outright what he had learned at the Academy, rather he used the medium of drawing to explore new directions in his art and, in particular, to experiment with the expressive effects of the contour style based on his study of sculpture.

45

24. David, *Head of St. Michael*, after Guido Reni, late 1770s, London, Victoria and Albert Museum

Further evidence of David's ties to his education and the conflicts he experienced are provided by his studies in Rome of expressive heads. We have seen how David still privileged the expressive head in his apprentice works of the early 1780s, one of his most consistent concessions to academic expectations. A number of beautiful drawings based on figures of celebrated Italian masters survive that indicate David was compiling a sourcebook in Rome for "passions composées," a repertory that he planned to use later in his painted compositions. This "hunt" for expressive heads in the great paintings of the past was most likely recommended by the French Academy in Rome, since the *tête d'expression* was, as we have seen, considered the most essential element of painting.

25. David, *Veiled Head of a Woman*, after Daniele da Volterra, late 1770s, London, Victoria and Albert Museum

David's *Head of St. Michael* (fig. 24), after Guido Reni, which he defines as "Colère noble et elevée" (noble and high-minded anger) at the bottom of the sketch, or his *Veiled Head of a Woman* after Daniele da Volterra (fig. 25), "la douleur empressée de secourir" (sorrow eager to give help), provide examples of this compilation. But the antidote to these expressive heads can be seen in David's many contour drawings of antique heads (fig. 26). As the drawings after antique examples reveal, David recognized that the sculpted heads were notable for their aloofness, reserve, and restraint in expression. His encounter with the reserved facial expression of antique sculpted heads must have led him to question the value of the *tête d'expression*: the example of sculpture proffered an alternative

47

26. David, *Studies of Antique Heads*, late 1770s, Album no. 7, fol. 9, Paris, Louvre

to an empty academic convention of painting. The "expressionless" faces of antique sculpted figures led David to meditate on how meaning was conveyed in such figures through corporal configuration alone.

The academy figures based on antique subjects that David sent as "envois" back to Paris reveal that by the late 1770s he was in the process of rejecting the "expressive head" as the principal means of communication in a painted composition. In his academy figure sent to Paris from Rome in 1778, entitled *Hector*, the face is barely visible (fig. 27). Seen from below in an inverse position, the facial expression is greatly diminished in importance in favor of the heightened impact given to the body as a whole. David, influenced by his intense study of antique sculpture, was exploring ways of making the human figure eloquent without resorting to the use of the expressive head as the key to meaning.[82] In his final envoi, again an antique subject, *Patroclus* of 1780 (fig. 28), he does away completely with the *tête d'expression* by depicting the figure from the back. In this study David compels the spectator to interpret the figure entirely through its corporal expression. In this eloquent figure of a dying warrior seen from the rear the artist demonstrated that the *tête d'expression* could be done away with altogether. The human figure no longer needed a conventional expression of a codified "passion" in order to convey meaning. The entire body, in all its expressive power, functions as the

27. David, *Hector*, Academy Figure, 1778, Montpellier, Musée Fabre

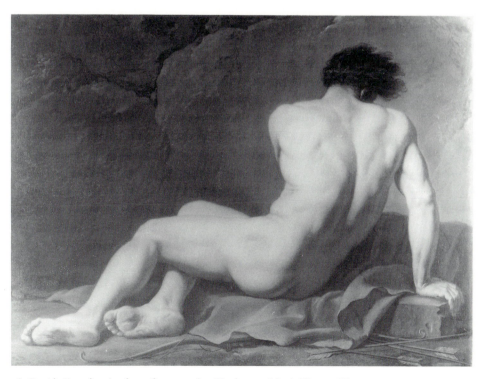

28. David, *Patroclus*, Academy figure, 1780, Cherbourg, Musée Thomas Henry

49

principal vehicle of communication. David's envois inspired by antique subjects use in common the powerful contour to describe form; the *Hector* and the *Patroclus*, in particular, are in a different realm from the type of figures David painted for his Prix de Rome entries. He successfully created figures that are sculptural, monumental, and powerfully expressive. These figures have a dramatic volume and solidity.

The most significant work, however, that David completed in Rome before returning to Paris is a highly original and compelling finished monumental drawing whose original destination remains unknown: the *Funeral of a Hero* (figs. 29, 30) of 1778–1780. This remarkable work represents the slaying of a warrior placed between Athena and Herakles on the left and the Fates on the right, followed by the funeral procession of the warrior (the death of the warrior, detached from the frieze, is located in Grenoble; the funeral procession is in the Crocker Art Museum in Sacramento).[83] The *Funeral of a Hero* constitutes the most dramatic and important manifestation of David's developments in *dessin* with his devaluation of the expressive head and his new privileging of expressive corporal communication. The drawing demonstrates, as well, the artist's decision to embrace the aesthetics of the sculpted bas-relief, rather than painting, as a model for artistic reform.

Monochromatic friezes inspired by the subjects and styles of Roman reliefs had been an established genre in Italy since the early Renaissance and had experienced a pan-European revival in the second half of the eighteenth century.[84] All'antica sculpted friezes were very popular in architectural decor and painters occasionally did such friezes as painted substitutes for sculpted reliefs. At the Salon of 1779, for example, Brenet had exhibited a frieze in this genre representing the *Battle Over the Body of Patroclus*; David's close friend, the sculptor Dupasquier (who became a "cause celèbre" when he was expelled from the French Academy in Rome), was working on an all'antica frieze in the 1770s (his monumental drawing, preserved in the Louvre, measures twenty meters in length).[85] Dupasquier's drawn frieze provided the closest model for David in terms of a monumental horizontal format but the subject was *The Triumph of Marcus Aurelius* and the style completely differs from that of David. For David's frieze is linked directly to the personal contour style that he had been developing in his drawings after antique sculpture.

In this remarkable composition David has produced what can only be described as a visual threnody, so powerful is his exploration of death and grief. The episode that precedes the the funeral procession is particularly moving (fig. 30). Athena and Herakles impassively observe as one hero is about to slay an adversary who has fallen to his knees beneath him in a pose of great pathos. The fallen warrior appears to offer his vulnerable flesh to the murderous sword. Above his ankle dangles the thread of his life held by the weaver of Fate Clotho who looks down at the hero with anxiety and compassion. The thread is about to be cut by Atropos while Lachesis lanquidly observes the length of life that is about to end.

This scene of the fallen warrior is completely self-contained and distinct from the

29. David, *Funeral of a Hero*, 1778–1780, Sacramento, Crocker Art Museum

30. David, *Funeral of a Hero*, 1778–1780, Grenoble, Musée des Beaux-Arts

realm of the funeral procession. Like the figures inspired by antique reliefs, the figures in the funeral procession, placed on a narrow ledge at the very edge of the picture plane, are silhouetted against an abstract ground, the pose and gesture of each studied and executed with great care. Each figure is alone with his or her individual response to the death of the hero, without interaction with adjacent figures. David eloquently conveys the experience of mourning the death of a loved one in which the survivors are emotionally isolated, each suffering alone in grief. The most emotionally expressive is the father who cries out as he cradles his son's head (fig. 31) and peers into the face of the dead youth with a tormented grief that cannot comprehend this absence of life in one so young and beautiful whom he loved. The other family members and friends turn away from one another, shield their eyes or look down in sorrow. Even the nude male dancers, performing a gymnopedia, whose hands touch in a disturbing, twisted fashion, are strangely isolated and self-contained (fig. 32). And the seated female mourner at the far right of the procession with her back turned towards us (fig. 33) is the emblematic summation of the melancholy state that follows the loss of the beloved. Her sorrow is conveyed through the massive stillness of her form—she is seated on the ground, earthbound, an image of spiritlessness and emotional lassitude. David focuses on individual figures who are conveyed through expressive contour. Facial expression is minimal—David has privileged instead corporal configuration, pantomime, and posture to convey the emotional content of the subject. As Jacques de Caso has succinctly stated: "Most remarkable are the facial expressions betraying only subdued emotion; David chooses to convey strong feelings through utterly unamibiguous stances and gestures."[86] The simplicity, severity, stillness, and restraint of the composition, and the intense focus on a group of monumental figures, reveal that the antique sculpted relief had taught David a powerful new expressive language of corporal communication.

The example of antique sculpted reliefs may also have inspired David to reject the time-honored dictum of "ut pictura poesis," a method of "invention" in composition upheld by the Academy in the 1760s and 1770s and, as mentioned earlier, insisted upon by Dandré-Bardon in his treatise on painting. No direct literary source exists for the *Funeral of a Hero* and this experiment in narrative attempted first in the genre of drawing, like David's experiments in the expressive possibilities of the contour style, directly influenced his subsequent paintings of the 1780s. Although seemingly Homeric, the subject of the frieze cannot be linked to any specific episode of the death of a hero. What David has created, in fact, is an archetype of the death of the hero, an emblem that symbolizes all heroes who die in battle. The goddess of war Athena and the deified warrior Herakles preside but do not intervene—death is fated, preordained. The Fates perform their respective functions of spinning, measuring, and severing life. One man falls to the sword of another. This is a universal image that occurs in a self-contained, timeless realm, the image of death about to occur is bordered and bounded by the gods and the fates. With the dancing male figures we enter the realm of time that becomes narrative and sequential, which, unlike the self-contained depiction of the

31. David, *Frieze in the Antique Genre*, detail

32. David, *Frieze in the Antique Genre*, detail

33. David, *Frieze in the Antique Genre*, detail

death of the hero, can be read from left to right. And the dancers seem to provide the metaphorical link between the two realms, which can be considered in temporal terms as the realms of chronos and kairos. Two gaze backwards to the timeless image, the frontal figure appears paralyzed between the two realms and only one lunges forwards as if to pull the others with him into the realm of time, the temporal progression of the funeral procession.

In the *Funeral of a Hero* David may have been inspired by Homer but instead of enslaving his representation to a specific literary episode, he was able to give freer reign to his imagination. The mode of drawing and the model of sculpture helped to liberate him from the constraints associated with academic, painted composition. But David was also following, once again, the prescriptions of Diderot who as early as 1767 had declared "Ut pictura poesis non erit."[87] Although the theory of "ut pictura poesis" had been mildly challenged rather early in the eighteenth century by the Abbé du Bos, the Academy had continued to use it as a theoretical and practical basis for the choice of subjects in history painting. But Diderot, like Lessing in the *Laocoon* (which was not translated into French until 1804 when it was considered so important that it was read aloud at the Classe des Beaux-Arts of the Institut), consistently and adamantly insisted upon the distinction between painting and poetry.[88] Diderot had asserted that artists should not literally follow texts but should rather use sources in literature only as inspiration for their art. He repeatedly recommended that artists, in particular, should invent pictorially and depart from their literary sources; ideas in Homer and Virgil, for example, should "fermentent dans leur imagination."[89] In his Salons of the 1760s Diderot consistently objects to artists who slavishly and literally follow antique texts and he rigorously opposed the Comte de Caylus's *Tableaux tirés de l'Iliade, de l'Odyssée d'Homère et de l'Enéide de Virgile* of 1757 in which the author made no distinction between the poetic and the pictorial and had recommended to artists to follow literary sources.[90] Caylus's text, promulgated by the French Academy as a means to classical reforms, became a sourcebook for French artists of the 1760s and 1770s (as the major Salon paintings of the period attest). It is not surprising that Diderot opposed these academic norms and was making a case for "ut pictura poesis non erit" during the very period when David came into direct contact with the philosophe's ideas.

The Funeral of a Hero, a composition in which so many novatory ideas are introduced, appears even more remarkable when we compare it with a painting of a similar theme that David executed during the same period—his complex, turbulent, confusing, and histrionic oil sketch of the *Funeral of Patroclus* of 1779 (fig. 34). This work is closely related to an earlier composition, the *Combat of Diogenes*, which was equally filled with a plethora of figures and groups engaged in a confusing variety of actions.[91] The *Funeral of a Hero* provides the antithesis to the painted *Funeral of Patroclus* in virtually every way. In this vast, swirling panoramic oil sketch in which multiple scenes from Book IV of the *Iliad* are represented as simultaneous events, David may have been seeking to recreate the aesthetics of Polygnotos's lost mural paintings known principally

34. David, *Funeral of Patroclus*, 1779, Dublin, National Gallery of Ireland

through Pausanias' literary descriptions.[92] But David rejected this as an alternative to prevailing conventions of academic history painting and favored the model of sculpture instead.

The succinct, laconic corporal language of *The Funeral of a Hero* and its narrative invention, which diverges from literary sources, provide the critical link between David's early style in the Prix de Rome entries and his eclectic apprenticeship works of the early 1780s, the *St. Roch, Belisarius,* and *Andromache*. These latter paintings, however, remain transitional for, although corporal signs begin to emerge in a more dramatic, intense manner (as several critics of the time had noted), David had not yet fully integrated the pantomimic language of the *Funeral of a Hero* into his painted compositions. He would finally bring to fruition his experiments in pantomimic expressivity and corporal communication based on the model of sculpture in his great masterpiece of 1784–85, *The Oath of the Horatii* (fig. 1, colorplate I). The impact of *The Oath* was so revolutionary in the aesthetic realm that it radically altered the way artists made art and the way critics perceived it. As is well-known, the fame and influence of *The Oath*, which created a sensation at its exhibition in Rome in 1784 and in Paris in 1785, spread rapidly throughout Europe.[93] Artists, critics, and the general public at once recognized something entirely distinctive and new in this work that placed it in a separate category from other major paintings of the time. Modern historians have often referred to this as a pivotal work, one that signaled a decisive departure from the predominant, classicized Rococo style. Robert Rosenblum, who described *The Oath* as representing an "irreparable cleavage between an old and a new world," and other critics as well mention the stylistic and compositional elements that distinguish it from contemporaneous productions—the frieze-like disposition of a very limited number of figures placed in a stage-like setting, the sculpturesque definition of form, and the bicameral opposition of gender groups, the angular, masculine vigor of Horatius and his sons contrasted with the passive submission of the curvilinear forms of the women and children.[94] Modern critics also emphasize the forceful expression of moral fervor conveyed through a convincing revival of an antique vocabulary of setting, costume, and accessories.

All these characteristics are certainly present in the painting and alone would constitute a decisive break with the compositions typical of the time, several of which have been briefly examined here. But David had done much more than revive a composition based on the model of the antique bas-relief and contrast distinct groups of opposing forms: he had rediscovered a dramatic means to express feeling and idea through the almost exclusive means of an intense focus on the human figure. David was finally successful in integrating into the format of painting the corporal signs he had invented in the *Funeral of a Hero.* One of the most dramatic and radical creations of the painting was its expressive pantomime, for almost all of David's stylistic and compositional innovations were created and employed to focus attention on the eloquent gestures and poses of the figures. In this painting, David redefined for the artists and critics of his time how a painting could communicate powerfully—through the medium of the

human figure itself. It is through the eloquent corporal signs that he conveys the essence of a highly distilled narrative: the oath sworn by the three Horatii to their father to fight to the death to defend their country, contrasted with the submission and melancholy of the women who intuit the disastrous outcome for their family. Although David invented a moment not found in any literary or pictorial precedents, his composition alludes to the extremely complex familial ties of the antique narrative that had been brilliantly reinterpreted by Corneille. Camilla, seated to the far right, daughter of Horatius and sister of the oath-takers, is engaged to one of the Curatii whom her brothers have sworn to kill. After the battle, only one of her brothers is left alive. Because she mourns the loss of her fiancé, her brother, upon his return from battle, slays her. The patriarch Horatius then pleads with the Romans not to penalize his son, their hero and savior, for his sororicide. At one point, David contemplated depicting the conclusion of this brutal story, the brother's murder of his sister Camilla and the paternal absolution of this horrible act (fig. 35), but he was putatively dissuaded from this by his friends who were worried about the moral implications of a father sanctioning the slaughter of his daughter by his son.[95] As in the *Andromache*, David seized upon the

35. David, *Horatius Defending his son*, drawing, 1784, Paris, Louvre

59

essential meaning of a narrative that revolves around the disruption of the familial unit. What is most remarkable about the final painting is that it successfully conveys a complexity of meanings and interrelationships within the family, in a direct and immediate way, through the body alone, virtually without the aid of facial expression. In his first independent history painting, David finally rejected the vehicle of the expressive head and decisively broke with the prevailing academic aesthetics of Le Brun.

It is not surprising that the body language of *The Oath*, which crystallized the language of gesture that Diderot had posited as the most essential element in the theater and the visual arts, is what so profoundly affected David's contemporaries. The pantomime of this painting was truly revolutionary and constituted the real center of the rupture between the old and the "modern" style, a style that would give birth to a new age both in painting and sculpture. When the *Oath* is placed alongside history paintings of the 1760s and 1770s, including David's Prix de Rome entries such as the *Death of Seneca*, one can see immediately the striking differences in the way the body is formed and becomes a powerful instrument of communication. Clarity and brilliant definition of volumetric forms in space characterize the figure, in which certain key elements carry an uncanny expressive force. One's gaze is directed to the central focus of a transfixing hand, highlighted against a dark neutral ground. The father's authority, his absolute control over the destiny of his sons, which is emblematized in the power of this hand, is also emphasized by David in the original title of the painting: *The Oath of the Horatii in the Hands of Their Father*. The opened right hand, which symbolizes authority as well as the appeal to a higher allegiance to which the sons and the fathers swear, is contrasted with the eloquently rendered left fist of Horatius, which clenches the sharp blades of the heavy iron swords in a seemingly effortless and painless fashion. Visual evidence suggests, in fact, that we are witnessing a mesmeric drama in which such extraordinary feats of physical prowess, even in an older man, are possible. According to Mesmer's theories, which enjoyed immense popularity in Paris in the 1770s and 1780s, a magnetic fluid pervaded the universe and was found in objects as well as in all living beings. This invisible fluid could be marshalled and controlled by an enormous feat of human will and could be directed as an agent of control over objects, animals, and other humans through the emanation of the fluid from the eyes and hands. Thus, an extraordinarily powerful individual could "magnetize" objects, such as a sword (metal, in fact, was considered a prime receptor and conductor of magnetic fluid), and could induce a trance-like or mesmeric state in those who received it from someone transmitting the magnetic fluid to them: those receiving it would perforce submit to its power.[96]

Mesmer claimed that this fluid could also be transmitted directly from the stars to the head of the magnetizer.[97] Is this not what we observe in the painting? The father seems to be in a trance as he looks and points towards the heavens from which he receives the magnetic fluid in the form of light that strikes him (this light, which is very difficult to discern in reproductions, is quite striking when one stands before the painting). Horatius, who receives this mesmeric power from above, seems to be in the act of

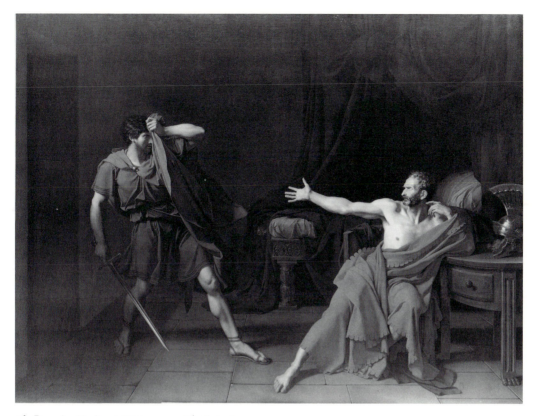

36. Drouais, *Marius at Minturnae*, 1786, Paris, Louvre

"magnetizing" the swords that he holds so effortlessly in his left hand—these objects thereby becoming invested with his will. The sons are similarly attempting to transfer their own force of will to the weapons—the objects that will ensure their success or failure in battle—by projecting magnetic fluid through the eyes and fingers (a favorite means of magnetization as described in contemporaneous pamphlets). David has cannily combined a powerful gesture of oath-taking with mesmeric theory. David was familar with mesmeric theories and their potential use in painting for, in the early 1780s, his pupils, particularly Drouais, were depicting a variety of religious and historical subjects as mesmeric events. And Drouais, in his celebrated *Marius at Minturnae* (fig. 36) of 1786, produced a painting which could be described as an emblem of mesmerism—it was understood as such by Balzac who, in the early nineteenth century, reminded his readers of this legacy. Executed under David's direction, the painting depicts the aged Marius "magnetizing" the Cimbrian soldier who has come to kill him, thus stopping the attack through the "magnetic" fluid that emanates from his fingers and gaze. David himself would create another overt mesmeric drama late in his career in the *Anger of Achilles* of 1819 (see chapter V, fig. 123, colorplate VII). We do not know to what extent David believed in magnetic fluid, but he certainly believed in the principle of mesmeric

power, that the force of personality and will can exert profound influence over the actions and responses of others. In his letters, for example, he continually refers to his own force of will as the principal agent of his survival and artistic success.[98] David must have realized that the representation of a mesmeric event in *The Oath* would contribute to the painting's success and compelling impact for, at the time of its execution and exhibition, mesmerism was enjoying an enormous vogue in Paris and was a widely discussed and debated topic in cafes and literary salons.[99]

David, like the majority of his contemporaries, was fascinated by popular ideas concerning magnetic fluid and magnetization because such theories, however outlandish they may seem today, were a persuasive means of explaining the mysterious powers of the self, how an individual asserts his will over others. Force of personality was recognized as very real, its effects were observable in everyday life, but its source and function were mysterious. Thus, at the dawn of modern psychology, when the Romantic idea of the self was beginning to emerge, mesmerism provided an appealing model for understanding and accounting for certain aspects of human behavior. During this very period in the late eighteenth century, competing physiological and psychological versions of the self provided alternate ways of perceiving what made the individual unique. In subsequent chapters we will have occasion to discuss a number of these prevailing ideas and theories and how they came to influence David.

On an essential level, then, *The Oath* is a painting about will and the use of will to sacrifice ultimately the self and extensions of the self—the family—to political ideals. Observers at the Salon were particularly enthralled with this emblematic depiction of the will embodied in the brilliant pantomimic invention of the oath-takers that diverged so dramatically from well-known representations of oaths at the time.[100]

As has been noted, most writers at the Salon demonstrated an almost complete reversal of the values of the preceding decades, and enthusiastically responded to the new intensity and vigor of corporal communication they perceived in *The Oath*. One attempted to describe the terrible significance of the allegiance of the sons, expressed through the rhythmic thrust of their outstretched arms: "The group of the three Horatii is characterized by an imposing style and a frightful movement because the three arms are all directed towards the same object, THE WEAPONS."[101] Another understood the corporal configuration of the sons symbolically.

> I will agree that it is a great conception and that it is executed as boldly as it is skillfully and I am as entranced as you are with the action of the Horatii, who embrace each other during their Oath, a sublime and symbolic expression of their union, of the sacred and courageous friendship that unites them, and of the common object that brings them closer and links them to one another until death, these three warrior brothers.[102]

A third critic, identified as Gorsas, tried to analyze the means by which David represented the complex interrelationship between the father and his sons.

Aristarchus made me observe with how much soul M. David had rendered the eagerness of the brothers to swear that they will go to conquer or die for their country, and the profound feeling of joy that filled the old Horatius seeing he had sons so worthy of him, a feeling indicated with so much energy in his features, in his eyes, in his attitude and above all in this simple expression, that perhaps would have escaped any other artist but M. David, that of clasping in his hand with emotion the swords with which he is going to arm his sons.[103]

Similar analyses of *The Oath*, in which observers attend to details of the body and how they communicate, permeate Salon criticism in 1785. One observer summed up the overwhelming reaction to the vigorous corporal signs of the painting in the following terms.

If we give a prize to the most vigorous history painting, we owe it to M. David. His Horatii are children created by genius. This painting has the nobility, the simplicity, the drawing, the distinctness, the energy and the truth of the greatest artists . . . The figures exist outside the canvas. We can almost see the blood circulate in their veins.[104]

One can only be astonished at this critical awakening to an entire range of corporal communication, which deepened the proleptical response to *Belisarius* and *Andromache* and replaced the virtual absence of such an interest in the previous decades. A number of critics sought to find an appropriate means of describing what they perceived as a new gestural language in *The Oath*. One reviewer enthusiastically claimed that the painting had to be experienced because its full impact could not be adequately described in words.

One must absolutely see it to know the extent to which it merits being admired. . . . [It is] a composition filled with energy, sustained by a power-ful and frightful expression, that contrasts superbly with the despondency that prevails in the group of the women. Finally, if I judge the reaction of others by my own, one experiences in seeing this painting a feeling that elevates the soul, and if I can use an expression of J.-J. Rousseau, it has something *poignant* that attracts you.[105]

This critic, alluding to the compelling and mysterious psychological impact of the composition, cites the imposing vigor that informs the male characters, an effect heightened by their contrast with the passive dejection of the women. Contemporary observers had not seen such vigorous male figures in the works of David's immediate predecessors.

There were other extremely significant reasons, however, for the overwhelming response to the new, invigorated representation of the human form in *The Oath*. For, in

this work, David offered, particularly in the male figures, paradigms of physical strength and vigor that corresponded to an adamant moral fervor and certitude. And he did so during a period in which fears concerning the physical and concomitant moral degeneration of the French people were not only prevalent but at a new height. These fears and suggested remedies permeated the discourse of many disciplines but can be found principally in writings on natural history, education, and sociology. These writings are filled with alarm at the physical degeneration of individuals of all ages and classes in contemporary society (although the aristocracy was a prime target for criticism). This degeneration was understood to have been caused by generations of physical decline, neglect, laziness, and laxity. An absence of physical exercise and attention had led to weakness, disease, and deformity, necessary conditions for the development of moral debility and depravity.[106] Most of the writings, however, that criticized the condition of the contemporary body in modern society were educative and prescriptive—the body and the concomitant moral faculty could be regenerated if men and women consciously attempted to emulate the strength and dynamism of their robust predecessors. The influential and celebrated naturalist Buffon, who was used as a principal source for those seeking to regenerate the "declining" French populace, had described such male and female avatars in "De l'age viril" of his *Histoire naturelle* of 1749. In this work he described the biologically ideal male and female in the following terms.

> The body of a well-formed man should be square in shape, the muscles should be severely expressed, the contour of the limbs sharply drawn, the features of the face sharply defined. In the woman everything is more curved; the forms are softened, the features are finer. Man has force and majesty; grace and beauty are the appeal of the other sex.[107]

These essences of the ideal male and female body posited by Buffon and analyzed into simple, contrastive differences in contour—square and round, sharp and soft, severe and refined—with force and majesty opposed to beauty and grace, are precisely what David has depicted in *The Oath*. But the painter also followed Buffon's description of the communicative signs of the body.

> In both everything announces that they are the masters of the earth. In man, even in his exterior, everything signals his superiority over all other living beings. He holds himself straight and upright, his posture is one of authority. His head points up towards the sky and presents an august face on which the character of his dignity is imprinted—the image of the soul is painted there by his physiognomy. The excellence of his nature permeates all of his physical organs and animates the features of his face with a divine fire. His majestic carriage and his firm and vigorous stride announce his nobility and his rank. He only touches the earth with his most distant extremities and only sees from afar and seems to disdain it [the earth]. His arms were not given to him

to function as pillars of support for the weight of his body. His hand was not meant to dig in the earth and to lose through repeated contact the delicacy of touch of which it is the principal organ. His arm and hand are made to serve more noble purposes, to execute the orders of his will, to grasp things at a distance, to push away obstacles, to prevent encounters and the shock of harmful things, to embrace and hold onto whatever pleases him and to make it available to his other senses. [108]

Buffon claims that the superiority and nobility of both sexes over other animals is based on their corporal configuration: posture, attitude, face, stride, and gaze. The arms and hands of the human being do not grovel in the ground but serve noble purposes instead—first and foremost to execute the orders of the will. And Buffon, like other writers of the period concerned with the body and gesture, includes the face as one corporal sign among many. In the figures of the Horatii, David has created archetypal images of the ideal male that correspond remarkably to Buffon's prescriptions. The dynamism and vigor of these figures express, as well, a fervent and compelling moral capacity and will. Buffon, like many natural historians, physicians, and medical philosophers and educators of the period, believed that man could be restored to his primeval state of strength through conscious effort. Regeneration was possible. Thus, David offered to the public physical and moral models of perfection that could, with great effort and will, be emulated. It was widely believed that such models could have been found in certain periods of Greek and Roman history. Exempla of human physical perfection could be seen in antique sculpture and read about in ancient literature. Winckelmann was, of course, the principal source for describing and analyzing the beauty of the Greek body manifest in antique sculpture, his thoughts on this subject were reiterated continually and consistently in French aesthetic writings from the late eighteenth century to the early decades of the nineteenth century. [109] But lyrical and compelling descriptions of the heroic body were also to be found in one of David's principal sources of inspiration during the early part of his career—Homer—who continually marveled at the structure and function of the human form.

Buffon's archetypes of human perfection and the revaluation of the ideal and heroic body had a profound influence on educators of the period who were extremely concerned with modern physical and moral degeneration. Many writers lamented the weakening of the body in contemporary society and that it was visible in the debility of its contours. One of the most insistent was C. A. Vandermonde who, in his *Essai sur la manière de perfectionner l'espèce humaine* of 1761, describes the degenerate human body in alarming terms: "Our body languishes, grows weaker and loses its beautiful proportions received from nature."[110] Another French educator, J. H. Ballexserd, who wanted to save the populace from its current degeneration, wrote in *Dissertation sur l'éducation physique des enfants* (Paris, 1762) that "the human species is degenerating gradually in Europe" and that "the beautiful Greek statues" would no longer have living embodiments.[111] And

J. Verdier, in his *Cours d'éducation . . .* (Paris, 1772), claimed that physical deformity was not an unlucky accident of nature but the result of successive generations in which the human body had weakened. He prescribed a regime of intense therapeutic exercises to restore a new corporal energy to affected individuals.[112] These and many other writers of pedagogical literature, including those who published in the 1780s, such as Verdier fils and A. Riballier,[113] believed in a direct corollation between degeneration and regeneration. A society of individuals willingly behaved in certain ways that led to physical degeneracy. They could reverse this process, however, and through great effort regenerate their weak constitutions. Physical perfectability was possible.[114] Thus at the most basic political and cultural level, David's *Oath* was a revolutionary call to a type of physical (and concomitant moral) regeneration and perfectability of the self. For the powerful body emblematized virtue and strength of character. The fears of widespread physical degeneration that were leading to a collapse of society were directly tied to what was seen as political and social degeneration. The idle rich, the aristocrats and those they supported, were directly linked causally to the general decline of the French population. And only a renewed and invigorated corporal cultivation could reverse this dissolute process. The magistrate, philanthropist, man of letters, and nobleman, Baron A. de Montyon, in his remarkable sociological study of the French population, *Recherches et considérations sur la population de la France* of 1778 (published under his pseudonym, Moheau), offered the most damning indictment of the current state of aristocratic debility.

> If one compares the strength of the former French chevaliers to those who have inherited their name, if one weighs the armour they wore in combat, which their descendants can barely lift, one is tempted to believe that the human race has degenerated in France, at least in the class of people of quality. And this assumption does have some validity if one considers that successive generations of men, softened by indolence, necessarily produce men that are less strong than their ancestors. Fortunately, nothing announces this degeneration in the strength of the people.[115]

According to Montyon, the only social class not affected by this terrible degeneration and physical weakness was that of the "people" whose legacy to their children was physical strength. The "people," thus, as early as 1778, provided one hope for the regeneration of the French nation. When writings such as Moheau's are seen as the proper intellectual contexts for David's masterpiece, it is easy to see how *The Oath* does literally *embody* pre-Revolutionary radicalism.[116] In *The Oath* David countered prevailing fears of physical and moral degeneracy that seemed to threaten the very structure of French society, with emblematic images of regenerate man. In his subsequent major history paintings of the 1780s he would continue to explore corporal communication to convey new ideas and images of the self.

In his next major work after *The Oath*, *The Death of Socrates* (fig. 37), executed for his

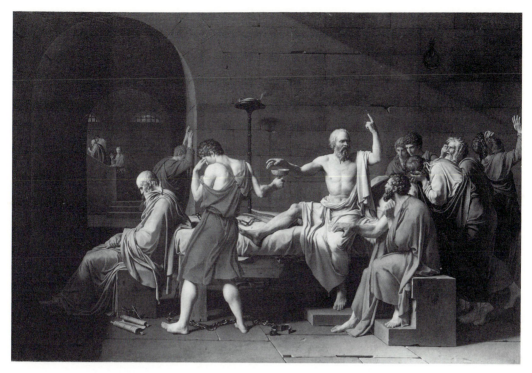

37. David, *The Death of Socrates*, 1787, New York, Metropolitan Museum

friend Charles Trudaine in 1787 but based on a composition he had already formulated in 1782, David creates a masterpiece of pantomimic eloquence and expressivity which represents Plato's historical vision of Socrates' last moments on earth.[117] David depicts Plato (who was not present at the historical event of Socrates' death) seated at the foot of the bed, an elderly man absorbed in profound, melancholic meditation. Socrates' most devoted disciple, Plato, near the end of his own life, has been evoking the scene in written words, and this has clearly led to sad reflections (the pen and quill are placed next to his manuscript on the floor and his mouth is covered—he is literally and figuratively silenced). Plato has conjured up in his imagination the image of Socrates' last corporal moments on earth and it is through means of his imaginative vision that he places himself within the scene.

Critics at the Salon did not understand the role of Plato (whom many could not even identify). They, nevertheless, hailed the great corporal eloquence of the painting and almost unanimously praised the variety and contrast in pantomimic expressivity among the disciples (who, David reveals, cannot be consoled by their mentor's comforting words on the immortality of the soul—they are too attached to his corporal presence).[118] Most observers, however, were completely enthralled by the compelling depiction of Socrates himself. It is easy to see why. David conveys Socrates' superior

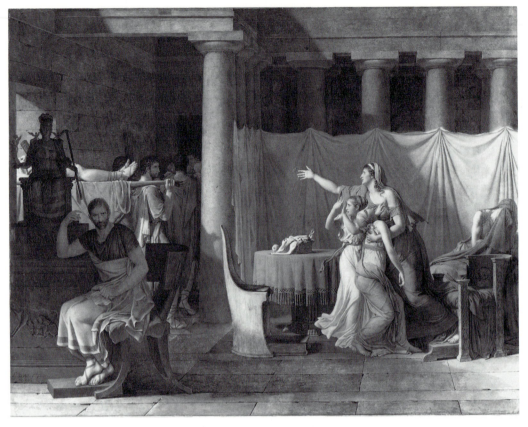

38. David, *The Lictors Returning to Brutus the Bodies of his Sons*, 1789, Paris, Louvre

moral character and rectitude through his remarkable physical vigor and upright carriage. Unlike his disciples, who are clothed, Socrates is depicted as a heroic nude, partially draped in what will be his winding sheet. Although he is seventy, his torso, arms, and legs are those of a powerful, middle-aged man. The eye is immediately drawn to the luminous and forceful corporal signs of this figure and the disciples' grief; despair and anxiety are admirably conveyed in their corporal configuration as well.

In his last painting of the decade, *The Lictors Returning to Brutus the Bodies of His Sons* of 1789 (fig. 38), David would continue to explore the possibilities of corporal expression. He depicts Brutus after he has performed his function as a political leader and condemned his sons to be beheaded for conspiring to overthrow him. He is presented, in David's words, as a "man and father," seated in his own home.[119] He has his back turned to the gruesome spectacle of his headless sons carried in on biers—a horrific sight that only the mother has courage enough to look upon. David represents the mother, the only figure who can face harsh reality directly, highlighted in brilliant light. As the heroine of the composition—like the pivotal figure in a sculptural group (she has often

been compared to Niobe), she upholds her terrified daughters—with her opened right palm illuminated against a dark ground like that of Horatius in *The Oath*—she seems to present in an accusatory manner the terrible sight of the fragmented bodies of the sons. The most troubling and complex figure, however, in this heart-rending familial drama, is the filiocide Brutus himself—several critics had hailed David for placing the "anti-hero" and "unnatural father" in shadow, a metaphor for the darkness of his spirit (David had proudly written to Wicar that the critics had praised him for this brilliant invention which was later celebrated for its genius by Chaussaud).[120] The twisted and tortured body of Brutus is a masterpiece of corporal expressivity. He seems to suffer terribly from conflicting emotions, conveyed through his tightly clenched fist (which grasps the letter that revealed the treachery of his sons) and in his extraordinarily cramped, tense feet and his taut neck, shoulders, arms, and torso. The body has become an emblem of anquish.

In these paintings, David's concentration on the execution of the body, his attention to meticulous details of form and expression, exerted an overwhelming impact on the way French art was made and perceived. After the appearance of *The Oath* at the Salon, critics used it as a standard by which to judge all other paintings. They suddenly began to focus their attention on the pantomime of figures in painting, an aspect they had ignored or considered subordinate to physiognomy until David's daring reforms. This mode of seeing would dominate critical discourse from the appearance of *The Oath* through the second decade of the nineteenth century.[121] Similarly, after 1785, artists, now interested in all aspects of corporal communication, sought fervently to emulate David's corporal and gestural sublime. As late as 1813, one of David's pupils, Paillot de Montabert, wrote a lengthy and detailed treatise on gesture, *Théorie du geste dans l'art de la peinture . . .* , in which, basing his ideas on David's corporal reforms, he analyzed gesture as a sacred sign and the most powerful means of communication in art.

> Gesture, considered as one means of expression, must be recognized at the same time as being the most powerful of all. This is easy to prove. Neither physiognomy, which resides in the facial features, neither color nor chiaroscuro, neither attributes nor the site, etc. is able to produce this great power and moving force which is the result of pantomime alone.[122]

Paillot's Davidian theories of gesture were destined to have a long life in the nineteenth century for he incorporated his treatise into his nine-volume *Traité complet de la peinture* of 1829 which would serve artists in France as a handbook for decades to come and help assure the success of David's revolution in corporal communication and gestural aesthetics.[123]

II

PAINTING WORDS AND DEEDS

The "Grands Hommes" and the Representation of Revolution

PERHAPS no greater insight into David's art and significance has been offered than his depiction on the Pantheon pediment by his student and admirer, David d'Angers (fig. 39). In the 1830s, the celebrated Republican Romantic sculptor depicted the painter on the new pediment he executed for the Pantheon, the former church of Ste.-Geneviève, which had been dedicated as a monument honoring illustrious French individuals during the French Revolution and reconsecrated to this purpose during the July Monarchy. David was the only artist represented in the composition in which the "grateful country" (La Patrie reconnaissante) honors her "grands hommes." No greater posthumous honor could have been bestowed upon David. We should remind ourselves of why he deserved such an honor. David d'Angers, one of Louis David's most brilliant and successful students and an impassioned Republican who believed ardently in the ideals of the first Revolution, revered his teacher and mentor not only as a great artist but as an individual who, like himself, embraced Republican ideals of liberty, equality, and fraternity; throughout his career the sculptor remembered David as the embodiment of a "Republican" artist.[1] It is significant that David d'Angers studied with David during the First Empire, a period during which historians typically present the Emperor's "First Painter" as a turncoat, a leading participant in the Revolution who, for reasons of personal aggrandizement, had become a slavish follower of Napoleon and had turned his back on Republican ideals. In his writings David d'Angers presents a very different picture and his testimony suggests that David continued to embrace Republican ideals and espouse them to his students long after the Revolution had passed. The sculptor, who was often intractable but never pharasaical when it came to his fervent Republican beliefs, never mentions betrayal of any kind in connection with the painter he revered (more will be said about this complex issue in chapter IV).

39. David d'Angers, *Pantheon Pediment*, detail, 1837, Paris

But in representing his mentor on the Pantheon pediment David d'Angers has done more than produce a tribute to the painter's Republicanism. The sculptor has revealed great percipience by placing David, palette in hand, directly behind the great philosophical intellects, Rousseau and Voltaire, the "fathers" of the Revolution.[2] David, who, as we have noted, always considered himself a "peintre-philosophe," would have been pleased by his propinquity to these great Enlightenment thinkers. The sculptor has produced a hieratic image of the artist as thinker, a cornerstone of civilization, a "grand homme." There is an eloquent and apposite symmetry in portraying David as a "grand homme" since, beginning with the Revolution and continuing throughout his career, he was often directly concerned with the concept of the "grand homme" and the idea of commemoration. And commemoration, perforce, involves an intricate nexus of political considerations.

The problematics of commemoration would act as a catalyst for the transformation in style that we witness in David's paintings and projects of the early 1790s. In his

paintings of the 1780s, David had been led to overturn the prevailing mode of painting because of his new vision of a corporal aesthetic in art. The artistic innovations of the early 1790s, which signaled yet another transformation in style, were directly inspired by new objectives the artist embraced. As we shall see, these goals had to do with David's almost obsessive involvement with defining, interpreting, and commemorating the "great events" and "great men" of the French Revolution; he viewed himself as a pictorial historian responsible to posterity for representing the Revolution.

David's position in Revolutionary ferment led him into the labyrinthine politics of the period and many specialized studies have been written detailing the relationship of his art made during this time to politics.[3] I am, as all scholars, indebted to these studies, but I believe David's art of the Revolutionary period has not yet been understood in all its cultural resonance. While the commitment of the artist to political life is unquestionable, one fundamental element that has not been given just attention is precisely the relationship of his oeuvre of the early 1790s to the vast discourse of the time concerned with the theories and aesthetics of commemoration. David was an artist's artist and it is indispensable to situate his work within the context of artistic discourse.

From 1789 to 1794, in the midst of what has been identified as the Revolutionary maelstrom that resulted in untold cultural upheaval, when art as every other element of society was in unprecedented flux, David was known as an "artiste engagé," an ardent Republican profoundly devoted to the ideals of the French Revolution. As is well-known, in the late 1780s, when civil unrest was brewing, David was part of liberal intellectual circles, such as those of the Trudaine brothers, Mme de Genlis, and the Duke d'Orléans, and many of his friends belonged to the Société de 1789 and the Société des amis de la Constitution.[4] However, although David was involved with the political and cultural upheavals that began in earnest in 1789, his official political career as a deputy to the National Convention was brief (1792–94) and was largely devoted to his significant involvement with the arts on the Committee of Public Instruction.[5]

After July, 1789 David did, indeed, have an unprecedented opportunity for an artist to effect artistic change and he made the most of it. His relentless mission to establish a democratic organization and community of artists to replace the rigid, hierarchical bastion of "aristocrats" began in the autumn of 1789 and culminated several years later with the final abolition of the Academy in August of 1793.[6] His first political acts of the Revolution were directed, in fact, towards transforming the structure of the arts under the Republic; he wanted to make art "Republican," that is, democratic and to extend its ideals to the national artistic community. His Republican fervor was intensified by his own long-standing loathing of and resentment for the Academy. He proclaimed that the Academy's system of privilege and inequality, the embodiment of the oligarchic Ancien Régime, had caused him and his fellow artists great suffering and humiliation. As has been noted from David's time to the present day, his political involvement under the Republic, from 1792–1794, was intense and was related to a considerable extent to art and aesthetics. This ended only with the fall of Robespierre on

9 Thermidor, 1794 (shortly thereafter David was imprisoned and his own life was in jeopardy). During this period the artist not only actively worked for the suppression of the Academy, after his election as deputy to the National Convention on September 17, 1792, he was also involved as a principal figure in the restoration and preservation of works of the new museum, in the creation of new sculptural and architectural monuments for the Revolution and in the transformation of buildings and gardens (he also consistently strove for support of the arts and artists in a time of great fiscal crisis).[7] Of course, since the early nineteenth century he has been best-remembered during this period as the organizer and co-ordinator of the most memorable Revolutionary festivals, vast, multi-media pageants for which the population of Paris wore costumes specifically designed by David to visualize and embody Republican ideas. Symbols and emblems were privileged in these pageants in which crowds moved from site to site and participated in "stations" of the Revolution. These didactic and celebratory parades were organized so that vast numbers of participants could visit important historical and symbolic sites and experience sublime views of colossal, allegorical representations— Mona Ozouf has described the many facets of these festivals in detail.[8] In addition to the parades, David also organized comparable events that celebrated the modern citizen-hero—namely, the state funerals and pantheonization rites of the fallen heroes of the Revolution.[9] This elevation of simple citizens to the heroic was a radical new departure in the history of commemoration in France, a reversal of traditional practices of homage reserved for royalty and the elite.

David was perceived by his friends and associates, and by the public, as a political artist, one who had dedicated his art to the commemoration of the great individuals and events of the Revolution.[10] His public addresses and correspondence from this period reveal that he perceived himself in much the same way, i.e., as an ardent Republican and patriot who communicated his fervent beliefs through his art.[11] That David viewed himself as an "artiste engagé" is revealed in virtually all of his public addresses to the National Convention as well as in his personal letters; these important documents (usually not examined seriously) provide evidence of David's artistic and political commitments and demonstrate that he was primarily concerned with aesthetic and artistic problems and decisions that were directly related to the nascent French Republic.[12] One of the most typical and revelatory passages is found in his first address to the National Convention on October 26, 1792, shortly after he became a deputy. David proposed the commission of a commemorative funerary monument and a medallion to honor the heroic dead of Lille and Thionville who had defeated the Austrians. He concluded his speech by suggesting that similar medallions be struck to commemorate all such great events of the Republic.

> I wish that my proposal to strike medallions be realized for all the glorious and auspicious events of the Republic that have already taken place and will take place; this in imitation of the Greeks and Romans who, through their

series of medallions, have not only given us knowledge of remarkable events, knowledge of the *grands hommes*, but also of the progress of their arts.[13]

The passage reveals several of the most significant aesthetic objectives that virtually obsessed David during the early 1790s: namely, the nature and goals of commemoration concerned with the nation's "great events" and "grands hommes," and the high level of achievement that should be, of necessity, associated with this type of commemoration. (It is not surprising that David looked to the model of antiquity—a primary source of inspiration for him since the 1770s as well as the chosen source for an entire vocabulary of modes and forms invented to express Revolutionary emblems and ideas).[14]

From the very outset of the Revolution David became intimately involved with issues and problems concerned with commemoration, specifically in the representation of the "grands hommes" of France. In the fall of 1789, in fact, he received a commission from the king of Poland to execute a mini-Pantheon or portrait gallery of "français illustres."[15] David's immediate involvement with the theme of "français illustres" in 1789 would remain constant for the next five years of his career. In all of his major projects for history paintings—*The Oath of the Tennis Court*, the Revolutionary martyrs *Lepelletier de St. Fargeau*, *Marat* and *Bara*, and in his plans for architectural and sculpted monuments—David was influenced by a vast discourse concerned with the nature and meaning of the "grands hommes" of France that had witnessed a steady development during the eighteenth century and had burgeoned during the Revolutionary period which self-consciously sought to identify and define contemporary "heroes," and which consecrated a sacred precinct in which to honor them, the Pantheon.[16] For a brief but intense period of several years, David devoted himself to erecting encomiastic monuments honoring the illustrious individuals and events of the Revolution in painting, sculpture, and architecture as he transformed himself into a self-conscious pictorial historian of the new Republic. As such he faced very difficult choices concerning what and whom to commemorate and how. The problematics of the interpretation of ancient history that he had confronted in the 1780s now became the problematics of representing contemporary history, one of the most complex and compelling issues for French artists working in the Revolutionary period.[17]

In the autumn of 1789 David was asked by his friend Filippo Mazzei to oversee the creation of a portrait gallery of famous French men and women to be executed for the king of Poland (the final series, which included depictions of eleven women, was shipped in September of 1791).[18] David employed his students to paint over sixty portrait busts for King Stanislaus-Augustus who requested the illustrious figures of the reign of Louis XIV, (principally ministers and military heroes, with a few eighteenth-century individuals to be included as well). David, perhaps on the advice of his friends, seems to have persuaded the king to include great modern "heroes" of the eighteenth century, many of whom were still living, and several of whom had helped to bring about the French Revolution. The eighteenth-century figures who formed part of the final

portrait gallery included d'Alembert, Bailly, the Abbé Barthélemy, Buffon, Crébillon, Condorcet, Diderot, Helvetius, Mirabeau, Necker, Piron, Rousseau, Turgot, Voltaire (and, not surprisingly, the American "grands hommes" and revolutionaries Franklin and Washington). It is telling that David shipped a self-portrait with the group of eighteenth-century "français illustres," thereby testifying to the artist's self-conscious awareness of his own historical position and the place he believed he had already assumed amongst the "grands hommes" of France.

David's involvement with this commemorative series to which he added illustrious modern and contemporary heroes—Enlightenment philosophers and polymaths, as well as government leaders, orators, and one artist—led directly to his meditations on the meaning of the "grands hommes" and the kind of commemoration appropriate to them. The rise of nationalism in eighteenth-century France had led to the growing cult of the "grand homme," the illustrious individual who had contributed to the development and amelioration of French culture and civilization. Discussions of the "grand homme," which permeated the discourse of many disciplines, are found extensively developed in what was the newly popular genre of the literary éloges, in theoretical treatises concerned with the encomiastic monuments of the picturesque gardens, and in the projects for new kinds of cemetaries, especially those devoted to creating didactic monuments to heroes (Bernardin de St. Pierre's remarkable project for the Elysian fields is one of the most fully developed and described).[19] To these must be added the extremely important project for a series of monumental effigies devoted to the depiction of the "grands hommes" of France initiated by the Directeur Général des Bâtiments, d'Angiviller, in 1775.[20] The cult of the "grand homme" in eighteenth-century French thought culminated in the transformation of Soufflot's Church of Sainte-Geneviève into the Pantheon, decreed by the Convention in 1792 and given to the sculptor and theorist Quatremère de Quincy to execute.[21]

The vast corpus of writings on the "grand homme" in the eighteenth century, which most encyclopedistes had meditated upon, was inspired principally by classical literature—Plutarch's *Lives* was a major source and provided, in fact, the direct inspiration for Turpin's popularization of these ideas in his *La France illustre ou le Plutarque français* of 1775–1780.[22] These writings were concerned with what constitutes a "grand homme," what qualities, characteristics, actions, activities, words, and legacy identify and define the individual who has contributed to the amelioration of French civilization and culture; this redefinition of the "grand homme" had a direct impact, of course, on the type of encomiastic representations or monuments that would be best suited to honor such an individual. As we shall see, David, in his own depictions of the "grands hommes" of the Revolution, would contribute to prevailing notions of the illustrious national and cultural hero in an extremely innovative way.

David's letters and public speeches of the 1790s are filled with references to the "grand homme" and to concomitant ideas and categories of genius, history, and heroism[23]; most of his public and private statements reveal that the *Encyclopédie* provided a

source of inspiration for his formulations, as it did for so much of the discourse on the "grands hommes."

> A hero is defined as a man steadfast in difficulties, intrepid in peril and very valiant in combat; these qualities are linked more to temperament and to a certain configuration of the organs than to nobility of spirit. The great man is something very different—he joins the majority of moral virtues to talent and genius; he has only lofty and noble motives for his behavior. . . . The title of *hero* depends upon success, that of the great man does not always depend upon it. His principle is virtue which is as unshakeable in prosperity as in misfortune.
>
> In short, humanity, gentleness and patriotism conjoined to talent constitute the virtues of the great man; bravura, courage, often temerity, knowledge of the art of war and military genius characterize to a greater extent the hero.[24]

In the *Encyclopédie* the hero is defined as a type of exemplary military man, a man of courage, bravura, and action whose "heroism" arises from his temperament and physical characteristics and depends upon the success of his endeavors rather than nobility of spirit. In dramatic contradistinction, the "grand homme," who has talent, genius, and moral virtues (which include humanity, gentleness, and patriotism) and whose very principle is to uphold virtue, is motivated only by noble ideas and remains steadfast in both good and unfavorable circumstances, whether he succeeds or not. The actions and behavior of the "grand homme" are always informed by his virtuous principles and ideas and it is virtue—this almost abstract, ennobling quality—that renders him great.

David, who was profoundly influenced by the language of sculpture and sculptural debates, would have been particularly attentive to the embodiment of these ideas concerning the "grands hommes" in d'Angiviller's sculpted series. When formulating his series in the mid-1770s, d'Angiviller was inspired directly by the *Encyclopédie* definition of the "grand homme." In his address to the Academy concerning the commissioning of this sculpted series, D'Angiviller emphasized their function as embodiments of history that will teach virtue and patriotism: "Most will have subjects of historic deeds suited to inspire virtue and patriotic feelings."[25] He reiterated these ideas in a letter to the King's "First Painter," Pierre.[26]

In his formulations D'Angiviller was also inspired by another entry in the *Encyclopédie* that contributed to the definition of the "grand homme"; this was the entry on "sculpture," based on the writings of Falconet. In this entry sculpture is defined as the most significant repository of the history of man's virtues and weaknesses and, because of its potential didactic significance and impact, it is posited as the art that should be devoted to the commemoration of the "hommes illustres."

> Sculpture, he said [Falconet], like history, is the most enduring repository of the virtues and weaknesses of men. If we have in the statue of Venus the object

of a dissolute cult, we have in the statue of Marcus Aurelius a monument famous for its homage rendered to a benefactor of humanity.

This art, by showing us deified vices, renders even more striking the horrors transmitted by History while, on the other hand, it reveals to us the valuable characteristics of these extraordinary men, who should have lived as long as their statues do; these characteristics inspire in us this feeling of noble emulation that teaches the soul virtues that have saved them [the extraordinary men] from oblivion. . . . Thus, the most noble goal of *Sculpture*, seeing it from the moral point of view, is to perpetuate the memory of illustrious men, and to proffer such efficacious models of virtue that those who practice virtue will no longer be objects of envy.[27]

The "moral" objective of sculpture, thus, was to inspire others to emulate the models of virtue commemorated in sculpted form.

It is not surprising that David, when he was confronted with the problems and issues inherent in the representation of the "grands hommes" of the Revolution, should turn again to the art of sculpture for inspiration and for models of emulation, since, as we have seen, sculpture had been the artistic mode responsible for the aesthetic revolution he had effected in the 1780s. This was certainly true of his first major project for a history painting—*The Oath of the Tennis Court* (fig. 40)—the oath had been taken on June 20, 1789 by 629 members of the nascent National Assembly who swore to unite until a Constitution was formulated and the nation's regeneration thereby assured.[28] David conceived of this group of patriots, ordinary individuals from many walks of life, as embodying the qualities of "moral virtue" and "noble motivation" found in the "grands hommes." And he represented the principal participants in the foreground within the compositional framework of a sculpted relief.

What is most striking visually about the compositional structure of the *Oath of the Tennis Court,* in fact, is its similarity to the structure of a sculpted pediment (a remarkable feature first signaled by Jacques de Caso).[29] The astronomer and speaker Bailly, the mayor of Paris, who reads the Oath, is placed at the apex of a pedimental design with the most celebrated and significant participants flanking him to the left and right in a descending scale that also concurs with that of figures in a pediment. David d'Angers recognized this salient feature of the composition for in the early 1830s he chose to transpose it to an actual pediment he planned for the Chamber of Deputies (fig. 41) which was to have *The Oath of the Tennis Court* as its subject; the sculptor believed Louis David's composition could not be improved upon.[30]

David, in his first major historical composition of the Revolution, chose this unusual design based on the model of sculpture because of the meaning and use of the sculpted pediment as it appears on secular and religious public buildings, for the pediment relief serves an extremely important didactic and ideological function; it communicates in a direct and perpetual manner to the "people" since it is typically placed on public view at an important civic site.[31] In *The Oath of the Tennis Court* David

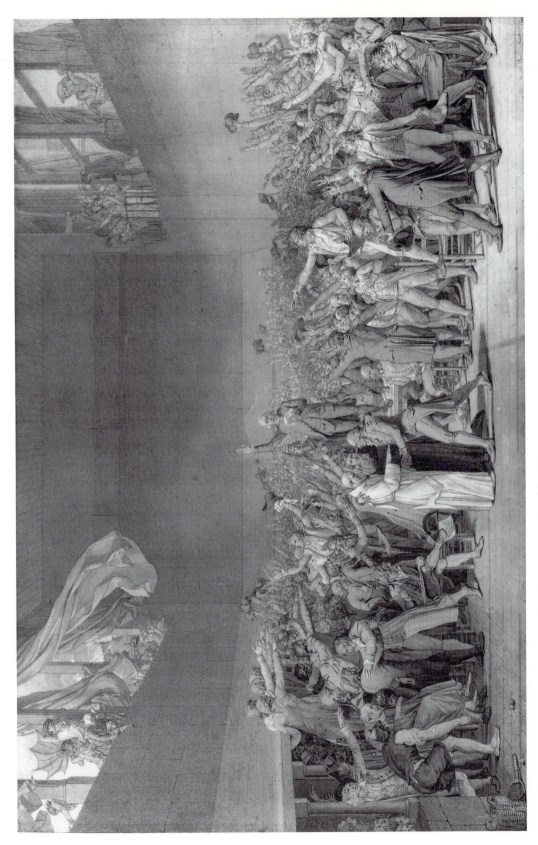

40. David, *The Oath of the Tennis Court*, 1791, Versailles, Musée National du Château

41. David d'Angers, *Pediment for the Chamber of Deputies*, drawing, 1830s

wanted to allude directly to the ideological and didactic function of the pediment relief, thus explaining the unusual position of the participants in the foreground. The placement of these individuals and groups diverged dramatically from the circumstances of the event that had been described in detail and published by those who had been present at the Tennis Court in Versailles (David, like many of his contemporaries, was very familiar with these accounts).[32] The unusually unheroic, diminutive, and ordinary figure of Bailly faces the viewer of the painting rather than the crowd of deputies whom he actually faced as he pronounced the oath. David depicts a number of these deputies to the left and right of Bailly (including Barère, Rewbell, Thibault, and Maupetit de la Mayenne to the left and Robespierre, Sieyès, Dubois Crancé, Gérard, Mirabeau, and Barnave to the right); the remaining figures and groups are behind him, an unexpected configuration for an oath-taking that diverged from accounts of the historical circumstances and one that was criticized for these reasons by several observers of the sketch at the Salon.[33] In addition, the three clergymen, Dom Gerle, the Abbé Gregoire, and Rabaut Saint-Etienne, who were not present at the actual oath, are depicted locked in a fraternal embrace pronouncing the oath in front of the table on which Bailly stands. David chose the unusual format of the sculpted pediment with Bailly at the apex, facing spectators of the work, in order to involve the viewers in a direct and compelling way by placing them in the position of the deputies to whom Bailly addressed the oath. In so doing, David makes the civic meaning and significance clear. The National Assembly— 630 diverse members of the Third Estate—represent the people, and the oath of 629 of them to assure the making of the Constitution is a legislative act that confirms for the people a representative voice in the government, a privilege they had never before enjoyed. David depicts Bailly addressing the oath to the people (the spectators of the painting) directly, thereby including them in this momentous event in French history. An article written by an intimate associate of David's, published in the *Journal de Paris* on June 10, 1791 (after the sketch had been exhibited in David's atelier), praises this participatory element.[34] But at its exhibition at the Salon of 1791, one critic eloquently articulated the new and exciting mode of viewing and heralded the kinetic element of spectatorship in the following terms.

> Frenchmen, run, fly, leave everything, hurry to be a witness to the oath of the Tennis Court, and if you are not set on fire and consumed by patriotic flames at this ardent foyer, be assured that you are not worthy of liberty.
>
> But already the crowd is huge and not everyone who wants to can draw near; one must await one's turn in order to have the honor of participating in the taking of this oath.[35]

The critic describes the experience of the work as individualized and personalized. David compelled the spectators to approach one by one and become participants in the event rather than passive onlookers. The sketch was exhibited at eye level beneath *The Oath of the Horatii* (David wanted to emphasize the analogy between the antique and the

modern oaths which shared a fervent, patriotic meaning) and one can only imagine the impact that the monumental painting would have had if it had ever been completed.

By choosing to commemorate *The Oath of the Tennis Court* in a vast, monumental format that alluded to the didactic, ideological functions of the secular pediment relief, David was asserting that this event—when the representatives of the Third Estate decided to unite as a legislative body to assure the creation of a Constitution—comprised the most significant moment of the Revolution itself. David, like many of his close friends and associates of this time (including André Chenier, Barère, Mazzei, and the Trudaine brothers), fervently supported the Constitution as a means of implementing the rights of citizens that had been brought about by the Revolution.[36] The Constitution would make these declared rights into laws.

His belief in the importance of the Constitution to the "new" French nation was so strong that as late as March of 1792, a brief period of reconciliation when the Constitutional Monarchy still seemed likely to succeed, David was working on a commission from Louis XVI to represent the king and the dauphin in an emblematic portrait of the Constitutional Monarchy. Several drawings for this project survive, most of which represent the king educating the dauphin by showing him simultaneously the constitution and the crown. In this particular example (fig. 42), the dauphin is engrossed in reading the Constitution.[37] It is extremely telling that David would be working on such a commission at this date for it reveals yet another episode in the continual fluctuations in his attitude towards the Monarchy. In the spring of 1792 David, like many fervent revolutionaries, seemed to believe that the king would support the Constitution and the rights it ensured, and that the real hope for the success of a Constitutional Monarchy lay with the dauphin. This particular "homage" to the Constitution, however, would not be realized; changes in events rendered it abortive. But, as we shall see, David would continue for many years to attempt to realize his representation of the *Oath of the Tennis Court* on a monumental scale.

In a letter to the president of the Assemblée Nationale, dated February 5, 1792, in which he accepted the government's request to welcome the youthful Franque brothers into his atelier, David asserts his belief that the Oath of the Tennis Court signaled a turning point not only in French history but in human history as well.

> Oh my country! Oh my dear country! We will therefore no longer have to try to find subjects for our painting in the history of ancient peoples. Artists used to lack subjects and needed to repeat themselves, now subjects will lack artists. No history of any people offers me anything as great or as sublime as the Oath of the Tennis Court which I must paint. No, I will not have to invoke the gods of the myths to inspire my genius. French Nation! I wish to propagate your glory. People of the universe, present and future, I wish to teach you this great lesson. Holy humanity, I wish to remind you of your rights, through a unique example in the annals of history. Oh, woe to the

42. David, *Portrait of the King and the Dauphin*, 1792, Paris,
Louvre

artist whose spirit will not be inflamed when embraced by such powerful
causes![38]

In this remarkable letter David, in a few brief lines, indicts the Academy which
supported subjects chosen only from ancient history, rejects such subjects in favor of
contemporary French national history which he promulgates as being of universal and
timeless significance (in other words, France will serve as a moral beacon for "human-
ity"), and reveals his profound belief in his own importance as an historian who singles
out such significant moments to commemorate for posterity.

By the time this letter was written in 1792 the government had begun to support

the painting of contemporary history in a non-allegorical mode but when David began work on the *Oath of the Tennis Court,* in the summer of 1790, the depiction of such subjects in large-scale painting still violated norms and conventions (popular imagery, such as prints and genre painting, were the "appropriate" vehicles for mere "illustrations" of this kind).[39] Thus, by choosing in 1790 to commemorate what he considered the key moment that inaugurated the Revolution, David was once again taking a bold initiative and in so doing setting an example for his fellow artists. David's choice of subject and significant moment reveals that he had already clarified his ideas concerning the commemoration of contemporary, historical events as well as the "grands hommes," the great individuals of his own period, who had been involved in their making. And the *Oath of the Tennis Court* manifests to a remarkable degree the artist's crystallization of his developing ideas concerning the representation of history itself, a subject in which he had been profoundly involved since the beginning of his career. The choice of a contemporary event and contemporary individuals as being worthy of commemoration in terms of historical significance (to the present as well as to posterity) implies complete confidance in one's own historical self-consciousness and objectivity. Of course, David had immediate precedents upon which to depend for inspiration, not only from well-known examples in British art but especially projects and paintings honoring the great moments of the American Revolution undertaken in the 1780s by artists such as Trumbull. David was familiar with some of these initiatives.[40] The precedents notwithstanding, one can only imagine that it was extremely difficult for David to reject prevailing artistic norms governing the choice of appropriate subjects in history painting, norms he had largely embraced in the 1770s and 1780s.

What led David to take such a bold step, to reject powerful academic structures and strictures concerning subject matter and theme? It should not surprise us that it was Enlightenment theories of history itself that empowered the artist to represent a significant moment from France's immediate history, to choose to turn himself into a pictorial historian of the French Revolution and to take as his goal the commemoration of its "great events" and "great men." David, like the majority of his friends and associates in the intellectual circles to which he belonged, was certainly conversant with the eighteenth-century redefinitions of history effected by the great philosopher of history, Voltaire, along with others, including Diderot, Garnier, and Marmontel.[41] The contributions of these thinkers largely reshaped the role of the historian in late eighteenth-century France and helped to define what constituted historical narrative (parallel developments, of course, occurred concurrently in England and Germany). Due to the efforts of Voltaire and his fellow philosophes, history was no longer viewed as an autonomous succession of chronological events. The historical chronicle was replaced by the historian's self-conscious choice and interpretation of significant events. The historian, in fact, was redefined as a philosopher who reconstructs the order of history from a unique perspective, a vantage point from which to select, judge, and view. The detached philosophical observer perceives historical events as self-contained entities removed

from the continuum of reality, and offers them as meditative experiences to readers. Voltaire, like Hume and Gibbon, emphasized the important role of the narrator in constructing and recounting history—history, thus, developed into a genre akin to fictional narrative or theater.[42] David, as a history painter, was involved with many of the same issues and problems confronting the historian-philosopher (the relationship of history painting to new ideas of history was emphasized by several authors of the period, including the playwright Marmontel, who, in his entry for "Histoire" in *Eléments de littérature*, compared history to history painting in terms of selection of a significant moment, interpretation of narrative and "historical" perspective).[43]

In addition to his difficult and problematic decision to represent on a monumental scale a "significant" moment singled out by the artist from a complex series of political events that inaugurated the French Revolution, David was also compelled to confront problems engendered by the depiction of a contemporary historical event that was not "illustrious" or "great" in the usual sense of individual or group heroic actions performed in the midst of dramatic, internecine conflict or confrontation, particularly in battle (themes that had become popular especially in paintings by British and American artists). Instead, in *The Oath of the Tennis Court* he celebrated the intellectual and moral grandeur and heroism of a large and disparate group of ordinary individuals from varying walks of life, individuals who constituted the Third Estate and who made a collective decision to unite as a National Assembly and thereby to dedicate themselves to the regeneration of a nation through the creation of a constitution.[44]

David, like an Enlightenment philosopher and historian, chose to examine contemporary events from a singular perspective and, after much thought, selected the significant moment that seemed of the greatest moral and historical value. He did, indeed, have a specific idea concerning the momentous Oath of the Tennis Court, for, in his depiction of the event, he was inspired by his acute realization that, in pronouncing the oath, this group of disparate individuals unite into one body—the legislative body—and, united in this way by their patriotic vow, they manifest qualities of a collective "grand homme." Metaphorically, then, the National Assembly becomes the "grand homme" as defined in the *Encyclopédie*—as one who conjoins talent and genius to moral virtue and acts solely from noble motivations. Each ordinary individual who took the oath, by this very act was transformed into an illustrious historic figure, a "grand homme" worthy of homage and commemoration; and together, the 629 oath-takers functioned as one "grand homme" through the new legislative body they formed at the moment of the oath. David chose to represent this very instant, when the legislative body is brought into being—e pluribus unus—by the pronouncing of the oath.

As the finished drawing reveals, David did everything in his power to make this moment of judicial , moral, and historic transformation thrilling. He sought to depict with great drama and tumult, the oath that signaled that, for the first time in their history, the French people would be represented in the government and would become a principal force in determining their rights, principles, and their own regeneration. David chose to represent the instant when the spokesman, the mayor of Paris Bailly,

standing on a table, has just finished reading the solemn oath; at this moment the deputies, many with their arms and hands outstretched in the oath-taking, pronounce the oath fervently in their turn (the only refusal was that of Martin Dauch who is depicted seated to the far right with his arms stubbornly folded—he was opposed on the basis that he could only swear to an oath sanctioned by the king).[45] The oath that we observe being pronounced with varying degrees of excitement, enthusiasm, and fervor went as follows.

> We swear never to separate from the national assembly and to reunite any-where that circumstances necessitate, until the constitution of the realm is established and consolidated on solid foundations.[46]

The majority of the figures are depicted, in a variety of poses, in the act of pronouncing the oath; a few have already pronounced it. This latter group includes Sieyès, who defined the Third Estate—he sits and philosophically meditates. Barère acts as the historian and records the words and the event as he witnessed it. To the right, Dubois-Crancé and Barnave, who have apparently already taken the oath, assume solemn poses and seem filled with religious feeling. Some of the most dramatic and fervent oath-takers are the great orators of the Revolution—Mirabeau and Robespierre, whose rhetorical poses are extremely impassioned and dramatic. The eloquent, central, image of three clergymen in the foreground who take the oath while locked in a fraternal embrace—Dom Gerle, Abbé Grégoire, and Rabaut de Saint-Etienne—is particularly compelling because, like a sculpted group, which it resembles, it is self-contained. The entire composition is filled with individual, isolated figures as well as interlocking groups that, taken as a whole, brilliantly convey the dynamics of a vast crowd excitedly united for one purpose.[47]

David depicted this great event of solidarity and unification as providential. The dramatic forces of nature—thunder and lightning—converge with a transformative moment in human history, indicating that a superior order, one of fate and destiny, orchestrates both.

A remarkable feature of the composition is that of implied noise—not only is a large crowd simultaneously proclaiming an oath (Bailly had described the enormous boom of his voice alone as penetrating to the street), a storm rages outside, wind whips the curtains into the room, and lightning strikes the royal chapel of the Palace of Versailles presaging the Revolution to come. Many members of the crowd of spectators, wind-blown at the windows or huddled in the galeries below, are also open-mouthed—exclaiming, shouting, cheering, or pronouncing the oath themselves; others look alarmed and are perhaps aware, as the deputies were, of the imminent danger for the Assembly—the king could have ordered his soldiers outside to fire upon them and end abruptly their meeting and lives. (The more enduring danger was implicit, of course, in the defiant act of the oath-taking itself—for the group of deputies had dared to oppose itself as a legislative and representative body to the king and court).

David wanted the viewer of his composition to be overwhelmed by imagining the

sound of hundreds of voices accompanied by thunder and lightning; he envisaged, in fact, one of the noisiest compositions in the history of art, for *The Oath of the Tennis Court* is a eulogy to the extraordinary impact of words, an expression of a profound belief in language as the intellectual instrument that sets and determines the course of the Revolution. For David, the spoken oath constituted a sacred and solemn bond as significant and binding as the signatures subsequently appended to the written document.

The Oath of the Tennis Court, thus, constitutes the apex of David's interest in depicting spoken and written language, a major element of his history paintings of the 1780s. In the compositions that precede this work, David consistently established a dialogue between spoken and written language. In the *Belisarius*, the blind general and his child guide are depicted open-mouthed, in the act of begging for alms. What they declaim is inscribed on the wall next to Belisarius—"Date obolum Belisario." In *Andromache Mourning Hector*, the widow, open-mouthed, either pleads to or reproaches the gods, her concerned child Astyanax seeks to comfort her with tender words and a gentle caress. These spoken words are juxtaposed with the Greek inscription on the candelabra from the last book of Homer's *Iliad*, which records the narrative moment of Hector's funeral but also makes explicit Andromache's state of mind. Three sons fervently listen to their father as he pronounces the oath in *The Oath of the Horatii* (no written words, however, enter this composition). In his subsequent compositions, David depicts Socrates pronouncing his final testamentary words on immortality while, at the foot of the bed, Plato, who interpreted and commemorated the event, has put down his pen and scroll and is lost in profound melancholy and meditation. Finally, in *Brutus*, the written and spoken words are poignantly juxtaposed. Brutus is distracted from his grief by the exclamations of his horror-stricken wife while he clutches in his hand the written document that revealed to him the treachery of his sons. In all of these works David is concerned with representing language, and in most he juxtaposes speech with the written word. It should not surprise us that the forms of language would continue to interest him during the Revolutionary period (and beyond) for the origins, development, and capabilities of language were ideas dear to the philosophes. Several of the principal thinkers of the period, whose ideas were known to David—including Condillac, Diderot, and Rousseau—were extremely concerned with the philosophical implications of the spoken and written word. The forging of a new, democratic language would become one of the great projects of the Revolution which witnessed a rebirth of oratory and rhetoric[48] (David's speeches to the Convention reveal that he considered himself something of an orator during this period).

David makes the dialogue between the spoken and written word intimate and explicit in *The Oath of the Tennis Court*. Bailly still clutches the paper from which he has read the oath and we observe its tumultuous repetition in the oaths of the deputies. David's notebooks, filled with drawings of the figures from the *Oath*, reveal his double interest in expressive pantomime and speech. In his studies of hundreds of individu-

alized and differentiated figures, many are open-mouthed (fig. 43). The drawings reveal an intense concentration on a great variety and range of pantomimic expressiveness combined with depictions of speech, which is transposed to the final sketch of the composition. Individuals as well as small groups, usually of two to four, take the oath or respond to it. The drawings also reveal that David took great pains to ensure that his enormous crowd of deputies also remain individuals. Each deputy responds differently even though all are inspired by similar fervent patriotic emotions. David emphasizes that the individual does not relinquish his identity to the group but rather consents to unite for a common cause. This striking aspect of the composition—individuation in unity—was signaled as a major achievement of the work by several astute observers of the time.[49]

Because of rapid and seemingly incessant changes due to the unfolding of the Revolution, changes in political ideas and ideals and the fluctuating status of the

43. David, *Drawing, The Oath of the Tennis Court*, Versailles, Carnet de Versailles, f.37v and f.38r

individuals originally involved in the oath, David never transposed the finished drawing into a monumental, completed painting (for similar reasons the engraving he worked on after 1791 in collaboration with Vivant Denon was never completed—the history of the realized engravings throughout the early nineteenth century is striking for what it reveals of the periodic reprivileging of this significant moment of the French Revolution).[50] David worked on his painting of the *Oath of the Tennis Court* intermittently for several years in a huge space—the former Church of the Feuillants—given to him by the government for this purpose in the summer of 1791. A fascinating fragment survives (fig. 44). Its precise chronology and dating cannot be established (the terminus ad quem, however, is 1803 when the canvas was removed from the Church of the Feuillants which was about to be demolished and was taken to the Louvre). Many issues and problems concerning possible transformations in iconography, theme, and style cannot be resolved for we can only speculate on David's changing attitudes toward the individuals to be represented, who were being discredited and disgraced one after another during the early 1790s. Nevertheless it is revelatory to compare this fragment with the completed drawing of 1791 to observe some of the significant changes in composition that David intended to make. The animated, vigorous and compelling portraits of the deputies whose faces have been completed (Dubois de Crancé, Gérard, Mirabeau, and Barnave), and the exquisite and eloquent pantomime of their figures (sketched in the nude, as was David's practice), convey some idea of the expressive power that the final painting would have had. It is clear from the fragment that David intended to emphasize physiognomic expression combined with subtle psychological characterization in the portraits of the deputies who share a common patriotic fervor and to unite this type of expression with extremely eloquent pantomime (some of the hands, in particular, are equal in brilliant definition and expressive power to those of the *Oath of the Horatii*). But what is most striking and remarkable about the fragment is the transformation in the deputies to the right-hand side of the composition. The pantomime of these figures corresponds to that of the sketch but several who were proclaiming the oath in the sketch have now fallen silent, including the most celebrated Revolutionary orators—Robespierre, Gérard, and Mirabeau. This dramatic change from the original sketch suggests strongly David's disillusionment with the spoken word, a disillusionment that would be shared by so many by the mid-1790s.[50] Others in the composition still speak but the orators are silent. Their fervent poses, their corporal expressions alone, convey that their oaths are truly heart-felt. This transformation from the representation of the spoken oath to silence marks a significant step in David's oeuvre, for, from this moment on, the majority of his principal protagonists will be stubbornly silent. This holds true even for subsequent antique heroes whom he will depict, some of whom are directly associated with recitation, such as Homer himself. As the Revolution progressed and David saw so many of his heroes fall, he recognized the emptiness of the spoken word, what Rousseau described as the perversion of language, its fraudulency and pernicious dissimulation.[51] The lies and illusions of language that became part of the general

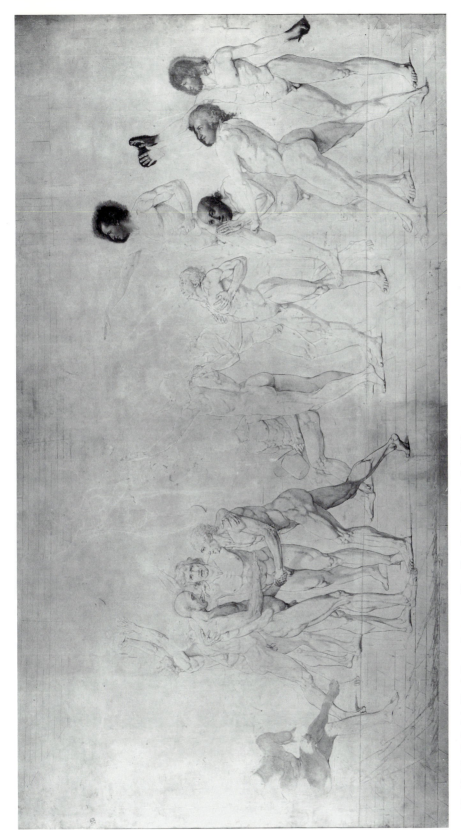

44. David, *The Oath of the Tennis Court*, fragment, Versailles, Musée National du Château

discourse on the "truth" of the Revolution, are consistent themes as well of David's public and personal letters from prison in 1794 and 1795. He proclaims his regret that he had been so taken in by the rhetoric of virtue of individuals such as Robespierre whom he had supported and revered.[52] But he also repeats that everyone had been deceived by this rhetoric; he was not alone in being duped by the eloquent words of the great orators of the Revolution.

David's bitter disillusionment with many of the "grands hommes," deputies who had participated in the momentous oath-taking and thereafter revealed themselves not to be great individuals at all but rather traitors to the cause, including key participants such as Bailly, Barnave, and Mirabeau, led him to decide to delete them from the composition when he was thinking of attempting to have it commissioned by the Directory probably in 1798. In the draft of a letter to the Minister of the Interior, David emphasizes that the event itself still provides the greatest subject in world history ("*a more beautiful subject cannot be found in the history of any peoples who have preceded us*"), but in a postscript he writes that he cannot represent participants who revealed themselves to be "extremely insignificant to posterity."[53] David will not depict individuals who proved not to be "grands hommes" after all but rather the event itself, in which the legislative body collectively manifests the qualities of the "grand homme," still a turning point in national and world history worthy of commemoration on a monumental, one might even say, sublime scale (David states in the draft that this would be the largest painting on canvas ever made—approximately 32 × 22 feet—although he does not mention a possible destination for such a colossal composition).

While he was working on his project for the monumental *Oath of the Tennis Court* in the early 1790s, David had even further opportunities to meditate on the nature and goals of commemoration of the "great events" and the "great men" of the Revolution for he took it upon himself to create iconic images of the martyrs of Revolution—Lepelletier, Marat, and Bara. These sepulchral images, like the *Oath of the Tennis Court*, involved the representations of contemporary figures whom the artist believed worthy of homage; they also were inspired to a considerable extent by the discourse concerning the goals and language of sculpture. For all three martyr paintings David had sculptural precedents in mind and he was thinking in terms of the format and ideas that informed the commissioned sculpted series of "grands hommes" inaugurated by d'Angiviller in the mid-1770s. The period during which the martyr paintings were executed—1793–1794—also witnessed an intensification of Pantheonization rites (with which David was often directly involved), which necessitated, of course, the choice of contemporary "grands hommes" worthy of such honors; a great deal of ink flowed concerning the appropriate determinant qualities and actions that should govern the choices.[54]

We remember that d'Angiviller, in his selection of the "grands hommes" of "modern" France (meaning, principally the seventeenth century), had in mind the sculpted depictions of single figures, represented at a significant moment in their lives and careers, one act or activity that would manifest their greatest contributions to the

amelioration of civilization. As mentioned earlier, the essential function of such figures was to teach virtue and patriotism. In addition, these would be individuals recognized and celebrated by the nation for their virtues, talents or genius. The issues involved in this series of "grands hommes," which were being executed and exhibited at the Salons throughout the 1780s—the choice of an individual who embodied the appropriate qualities, the significant moment, and other artistic decisions such as costume versus nudity, portrait likeness versus idealization of features—all these factors and choices had a determining influence on David's depictions of the Revolutionary martyrs. David's artistic ideas in his martyr paintings, in fact, were profoundly informed by the intense sculptural debates of the period concerned with choices, types, and formats in the commemoration of the great individuals. A brief examination of two salient examples from d'Angiviller's series, which influenced David, will make clear the filiations between the sculpted "grands hommes" and the depictions of the martyrs of the Revolution. Two works executed for this series in the 1780s can serve as paradigmatic examples of the issues involved—Julien's *La Fontaine* of 1783 (fig. 45) and his *Poussin* of 1789 (fig. 46). David was particularly attentive to the profoundly different, even oppositional, alternatives in the representation of the "grands hommes" proffered in these statues— the principal contradistinctions involved costume versus heroic nudity and verisimilitude versus idealization of features and forms. Julien, one of the sculptors whom David knew and admired, had been commissioned to depict the famous classical seventeenth-century French writer and an equally famous painter of the same period whose reputation, as we have seen, had soared during the second half of the eighteenth century (inspired by the Enlightenment definitions of the "grand homme," d'Angiviller had added writers and artists to the list of ministers and military men).[55] *La Fontaine* is a recognizable portrait likeness; his face is depicted with great attention to physiognomic details. Dressed in the costume of his time, which is elaborate and particularized, he is seated in a relaxed and informal manner in a natural setting from which he draws inspiration as he is meditating on a fable he is in the process of writing. In dramatic contradistinction, Poussin's facial features are generalized and idealized; he is depicted as a semi-draped, heroic, muscular nude, intensely involved in a moment of genius when he has begun his sketch for his masterpiece—*The Testament of Eudamidas.* Julien was severely criticized for his use of idealizing, classical nudity which rendered the figure of Poussin timeless and universal (in contrast, costume serves to locate the individual historically); heroic nudity here is also used metaphorically to express ideas of virtue and truth. David was aware of the controversy surrounding this figure and also of the debates that had been inspired by another statue that had created a scandal— Pigalle's *Voltaire* of 1776 (fig. 47), a privately commissioned work that had dared to represent a contemporary as a "grand homme" in flagrant violation of a governing convention that only posterity could recognize and determine whether a non-aristocratic individual was great enough to be worthy of a sculpted apotheosis.[56] Equally shocking was the unexpected graphic naturalism of the work—Voltaire is not an idealized nude

46. Julien, *Poussin*, 1789, Paris, Louvre

45. Julien, *La Fontaine*, 1783, Paris, Louvre

48. Blanchard, *Jean-Paul Marat, l'ami du peuple*, c. 1792, Paris,
Bibliothèque Nationale

47. Pigalle, *Voltaire*, 1776, Paris, Louvre

but a weak, emaciated elderly man with a collapsing skeletal structure and sagging flesh and muscles. Like Julien's *La Fontaine,* however, the face of Voltaire is a portrait likeness. Resemblance, recognizability, was of distinct importance in the commissioned series of "grands hommes" (Pigalle's *Voltaire* was, of course, in dialogue with this series).[57] D'Angiviller had stipulated that he wanted sculptors to adhere to portrait likenesses in their statues, but at the same time he wanted to distance the series from any notion of mere portraiture, an inferior category in the academic hierarchy of genres. The primary goal of portraiture was defined as conveying resemblance or likeness, a role insisted upon in the *Encyclopédie,* as well as in art dictionaries of the time.[58] For d'Angiviller, what distinguished the sculpted portrait from the historic genre of the "grands hommes" was its transcendent didactic and moral content, the goal of the entire series was to teach; the sculpted effigies were to serve as images worthy of emulation, to inspire people to virtue and patriotism.

This differentiation between mere portraiture and the portrait as history, also directly influenced David, who, in his paintings of the Revolutionary martyrs, wanted to distance himself as much as possible from the "lesser" category of the portrait and to align himself instead with the genre of history. He never called his depictions of the martyrs "portraits" but significantly always referred to them as history paintings. We find this in his autobiographical notes written for J. J. Sue in 1793, as well as in his list of complete works that he drew up in 1822, in which he places the *Lepelletier* and *Marat* under the heading "Tableaux d'histoire" (he is very careful in his list to distinguish portraits from other kinds of paintings).[59] What made these history paintings rather than portraits was the emphasis on a significant moment that would embody and convey meritorious actions, virtues, talents, or genius of great individuals of the nation, which accords well with the Enlightenment's formulations of "grands hommes." But David distanced himself even further from the category of mere "portraiture" by rejecting completely an emphasis on portrait likeness in his depictions of all three martyrs and by representing them as nudes. The features of Lepelletier de Saint Fargeau, Marat, and Bara are idealized to the point where they can no longer be recognized as contemporary individuals (portrait likenesses of Lepelletier and Marat [fig. 48] made at the time reveal how far David diverged from physiognomic resemblance). David thereby transposes these individuals to a universal, timeless realm and removes them from the individuation and flaws of ordinary people in everyday life (that this was a self-conscious decision is demonstrated by David's brilliant portraits of the period in which naturalism and astute psychological characterization predominate). Through idealization of both faces and corporal forms David asserts that the martyrs are uncommon individuals whose patriotic acts and contributions for which they were assassinated, rendered them transcendent. It is also extremely telling that the significant moment he chose for all three figures was the moment of death, thereby asserting that it was their deaths and what they died for (namely, Revolutionary ideals) that rendered them great. David has, in fact, appositely transformed all three martyrs into "symbols perfected in death." In these

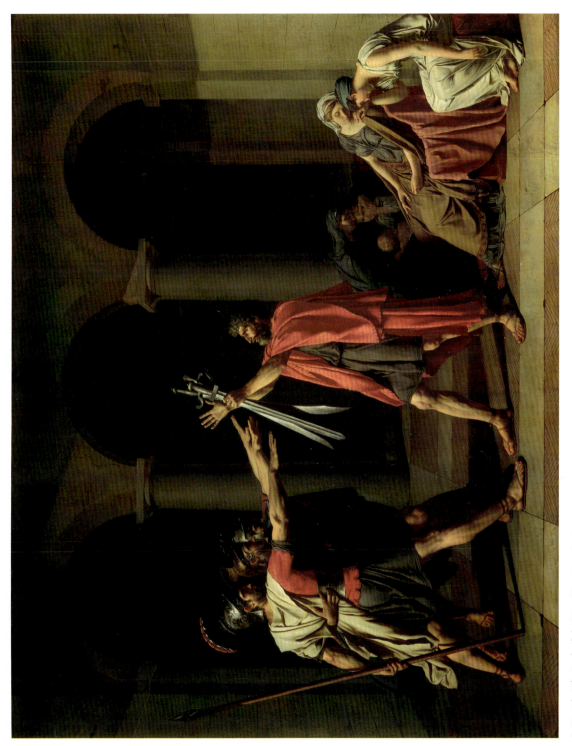

I. David, *The Oath of the Horatii*, 1785, Paris, Louvre

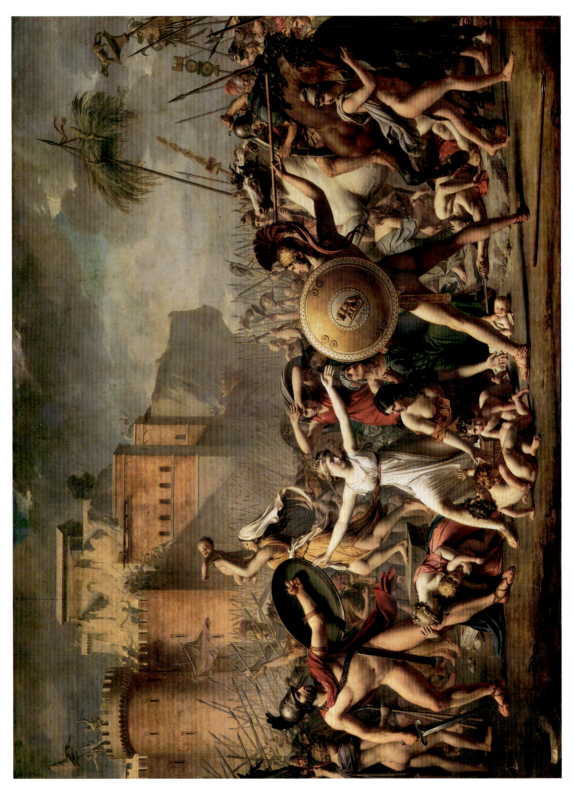

II. David, *The Sabine Women*, 1799, Paris, Louvre

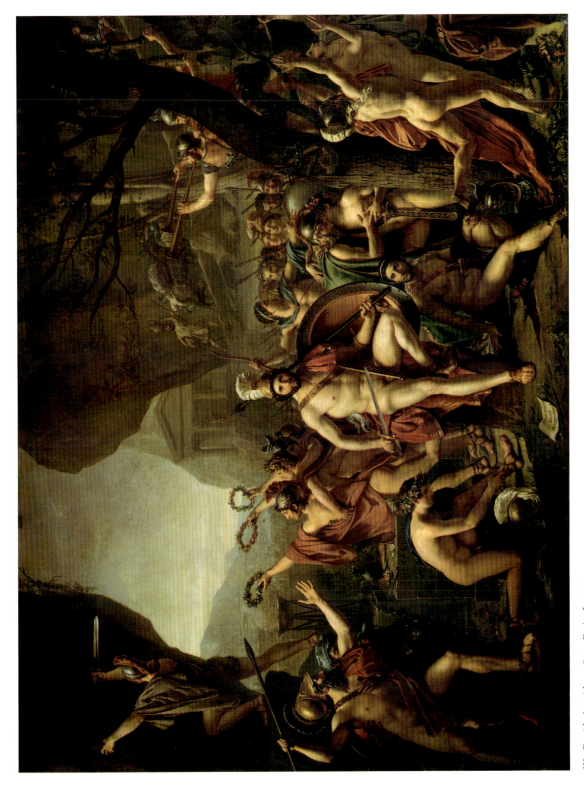

III. David, *Leonidas*, 1814, Paris, Louvre

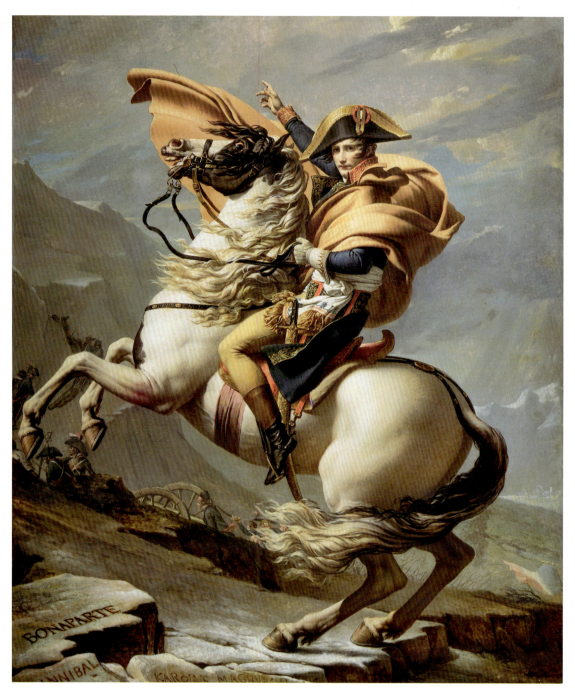

IV. David, *Napoleon Crossing the Alps*, 1800, Malmaison

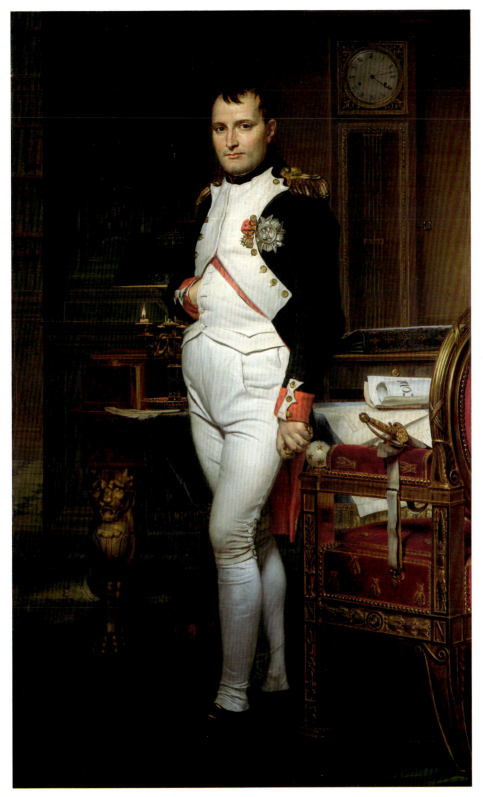

V. David, *Napoleon in his Study*, 1812, Washinton, D.C., National Gallery of Art

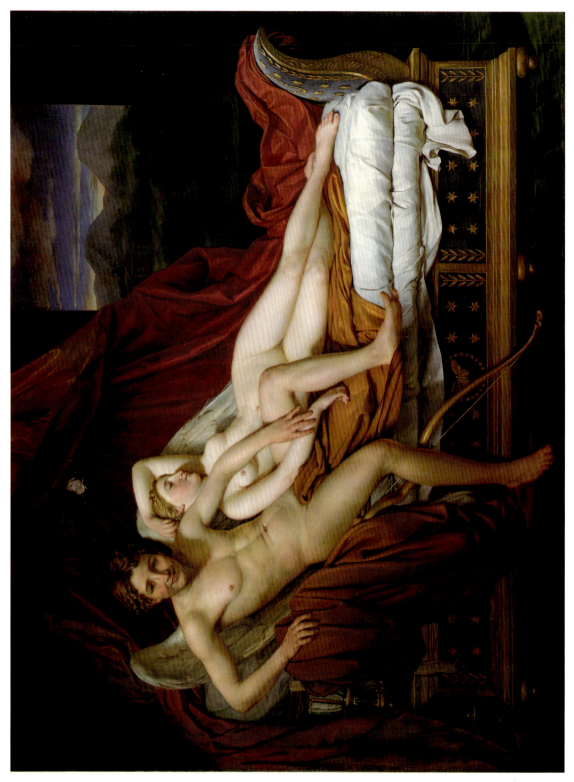

VI. David, *Amor and Psyche*, 1817, Cleveland, Cleveland Museum of Art

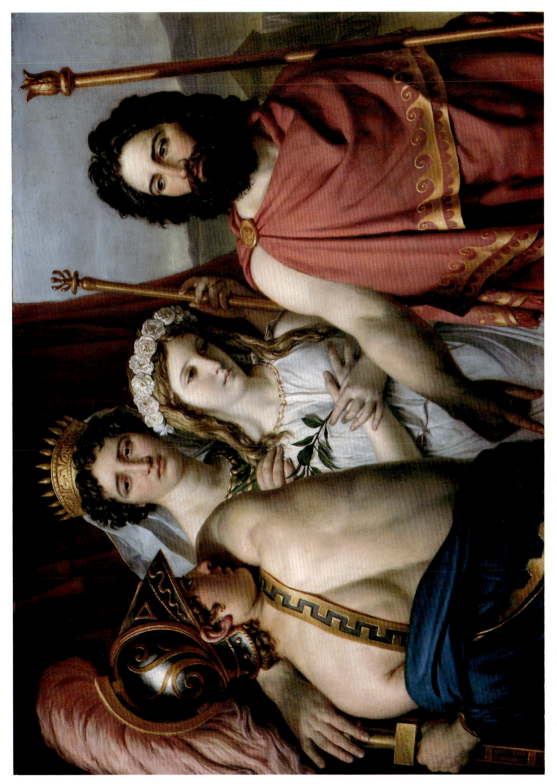

VII. David, *Anger of Achilles*, 1819, Fort Worth, Kimbell Art Museum

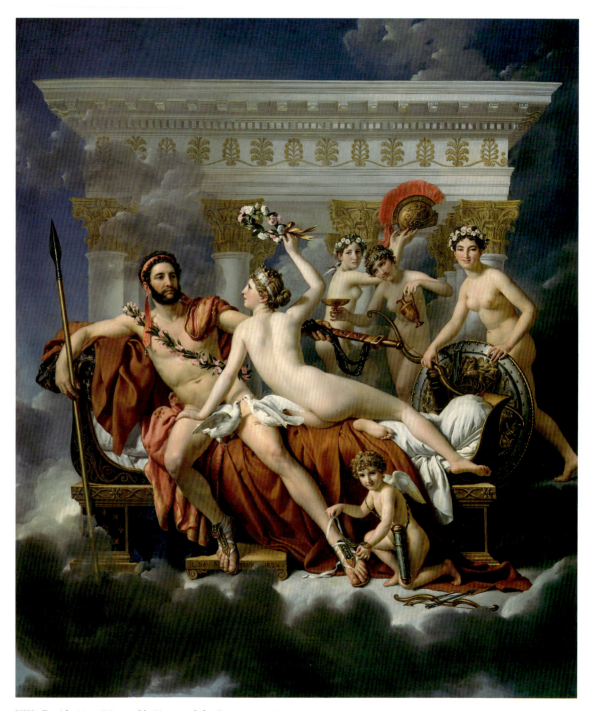

VIII. David, *Mars Disarmed by Venus and the Graces*, 1824, Brussels, Musées Royaux

representations, in which the figures are nude and idealized "all' antica," David seems to have had in mind the *Encyclopédie* definition of the antique hero as a "demi-dieu," a "grand homme" who becomes worthy of a sidereal apotheosis after death.

> Hero, otherwise called demi-god. Illustrious men whose great actions led them to be placed after their death in the heavens were generally given this name. . . . The promotion of heroes to the ranks of the gods was the result of the doctrines of Platonic philosophy which taught that the souls of the great men were carried up to the stars, the habitual abode of the gods and through this they became worthy of the honors rendered to the gods themselves, with whom they lived.[60]

In his depictions of Revolutionary martyrs, David was very much concerned with promoting the "cult" of these "grands hommes" who were worthy of the status of the demi-gods through the great actions for which they died. For all three martyrs, all of whom were assassinated, David not only organized funerary rites and painted encomiastic icons, he also contributed other types of commemorative honors for them as well (the artist planned at least one other martyr painting, the representation of Dampierre, who was fatally wounded at the battle of Raismes, but this project is known only through a drawing).[61]

In his first elaborate commemoration of a "martyr to liberty," the "grand homme" Lepelletier de Saint Fargeau (figs. 49, 50), David contributed four distinct means of honoring the liberal aristocrat who had embraced the ideals of the Revolution and had been stabbed to death by a royalist on January 20, 1793 for having voted for the death of the king.[62] David, at the behest of Chénier, organized the public funeral; he then proposed that a marble sculpture be made of Lepelletier as he had appeared at the funeral on a type of deathbed, he offered his painted icon as a gift to the Convention (this was not a commissioned work but one that David himself chose to paint), and he gave a eulogy. Thus, he wanted to honor Lepelletier by funerary rites, in sculpture, painting, and in the form of a literary homage—an "éloge" (the Convention decided to engrave and widely disseminate the image after David completed it—the same would be done for the *Marat* and planned for the *Bara*).[63] For the funeral Lepelletier's semi-nude body, with the fatal knife wound exposed, was exhibited on a type of fictive deathbed placed on the pedestal of the recently demolished statue of Louis XIV in the Place Vendôme (fig. 51).[64] The funerary lying-in-state was thus conflated with the image of a sculpted monument, one that replaced the former statue of the king. The actual body served as its own effigy. By displaying the body in this way, a public ceremony was imbued with private and personal connotations for, as mentioned earlier, the image of the deathbed and the legacy of the dying had a significant place in late eighteenth-century French culture.[65] The deathbed scene was of great importance in particular to the developing bourgeois family because it constituted a testamentary event—the dying individual, lying in bed, surrounded by those closest to him or her, offers a final legacy. Greuze had

49. A. Devosge, *Drawing after David's Lepelletier de St.-Fargeau*, Dijon, Musée des Beaux-Arts

popularized the theme in painting in several depictions of contemporary middle-class deathbed images and it had become one of the most popular subjects in French history painting during the second half of the eighteenth century which abounded in representations of antique heroes and heroines on their deathbeds.[66] As is well-known, most deathbed paintings were directly inspired by Poussin's great representations of the theme in *The Death of Germanicus* and *The Testament of Eudamidas*. David, like so many of his contemporaries, wanted to depict historical individuals who died well, leaving a final moral and/or intellectual legacy to those who survived them. We remember that one of his earliest monumental projects was to depict the great deathbed scene of the funeral of Patroclus and, in the 1780s, he represented the deathbed several times, in

50. P.-A. Tardieu, *Engraving after David's Lepelletier de St.-Fargeau*, Paris, Bibliothèque Nationale

Andromache Mourning Hector and the *Death of Socrates* (as well as, indirectly, in the *Brutus*, in which the sons, tragically, do not die well and cannot leave a moral legacy).

The idea of dying well (dying virtuously, for a just cause), and leaving a moral and/or intellectual legacy, of course, directly inspired David's depictions of the Revolutionary martyrs. In two of the works, he created a fictive deathbed scene in which the great individuals who sacrificed their lives for their country could be honored by their fellow citizens who could thus contemplate the meaning of the sacrifice. In the *Lepelletier*, David's invention of a deathbed image, which is directly filiated with the actual funerary display of the corpse, replaces the ignominious conditions of death by brutal murder that this individual suffered. According to Chénier's plan, in collaboration with David, for Lepelletier's funeral the body was presented to the public semi-nude on a deathbed, thereby substituting the violent death by stabbing with a peaceful image that suggests a more harmonious end; presented in this way, semi-nude "all' antica," the image alludes to the *conclamatio,* the antique version of the deathbed but also to iconic images of Christ as a Man of Sorrows, displaying his wound for the meditative reflections of the mourning faithful.[67] Published accounts of the funeral reveal that by exhibiting the body in this way, by making a private deathbed image public and by introducing

97

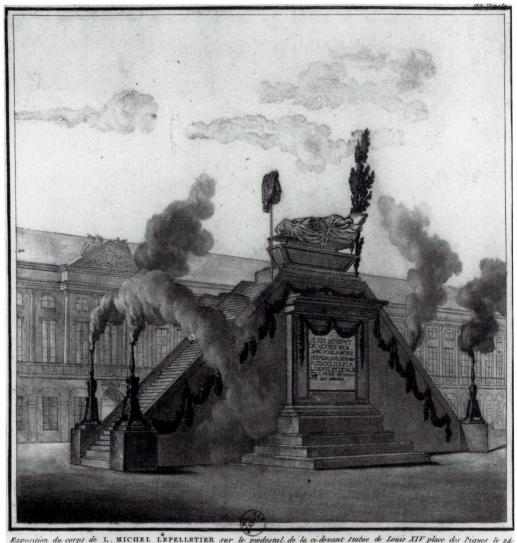

Exposition du corps de L. MICHEL LEPELLETIER sur le piedestal de la ci-devant statue de Louis XIV place des Piques le 24. Janvier 1793, jour où il reçut les honneurs du Panthéon. Né à Paris le 29 mai 1760. Député de la ditte ville aux états Généraux de 1789. Député du Département d'Yonne à la Convention Nationale de 1792, assassiné par Paris, ancien garde du Corps de Louis Capet, le 20 Janvier 1793, chez le Citoyen Fevrier, restaurateur au jardin de la Révolution.

Se Vend à Paris chez le Citoyen Allais, Rue de la Barillerie Maison du Citoyen le Cler Apothicaire.

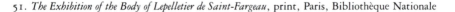

51. *The Exhibition of the Body of Lepelletier de Saint-Fargeau*, print, Paris, Bibliothèque Nationale

ideas of antique and Christian heroism and martyrdom into the lying-in-state (in a public square steeped in political history and signficance), David and Chénier had collaborated to create a new genre in funerary rites.

The innovative approach to the display of the uncovered body with a large, gaping wound left visible had the desired effect; the viewers of this new spectacle, most of whom

did not know Lepelletier, publically wept for him. Lepelletier's death was made personal and memorable while at the same time his final legacy was widely publicized. The "people" would now know that Lepelletier had happily died for them in the cause of liberty. Banners at the funeral proclaimed his putative last words, his final testament to the people and the nation: "I am satisfied to shed my blood for my country. I hope that it will serve to consolidate liberty and equality and to make known its enemies."[68] One observer noted that the viewing of the body was especially fraught with emotion for the public because Lepelletier appeared to be still alive.

> It appeared he was not dead. One could see his wound which was three fingers wide. This created a touching spectacle that caused many to weep and I could not hold back my tears. Never before has the body of a dead man been displayed this way in public. This is a new spectacle. It is a burial of a new kind.[69]

By making monumental the image of Lepelletier's reclining body on a deathbed that crowds could come to venerate on a public square David prolonged the illusion of the "significant moment" of death and thereby asserted that this moment embodied Lepelletier's contribution to history—he died for the ideals of the nation, for liberty and equality; his virtue made him worthy of an apotheosis.

On January 25, 1793, the artist proposed to the National Convention that Lepelletier's apotheosis be commemorated in a more lasting way, in a monument sculpted in marble that would represent the martyr on his deathbed as he had appeared at his funeral.[70] This was a rather unusual idea for an encomiastic monument as Lepelletier's statue apparently was not intended to adorn a tomb or even a cenotaph and, although he was to be depicted lying on a bed, the statue was not conceived of as a *gisant*. This suggests that David may have intended this monument as part of the series of "grands hommes" begun by d'Angiviller (he did not indicate where this statue might be placed).

That David thought immediately of creating a sculpted monument for Lepelletier provides further evidence of the influence exerted upon him by prevailing sculptural ideas and ideals concerning commemoration of the "grands hommes." After his proposal for a sculpted monument to Lepelletier he began his own history painting of the subject which he completed in several weeks; he presented it to the Convention in March of 1793.[71] This work, destroyed in the nineteenth century by Lepelletier's heirs (aristocrats who were scandalized by his regicidal vote), is known through a drawing by David's student A. Devosge (fig. 49) and a damaged engraving by P.-A. Tardieu (fig. 50). Lepelletier is depicted on his deathbed, idealized as an antique, heroic, athletic nude (very reminiscent of David's Hector). He is also perfected and whole—there is no wound visible in either copy of the painting. In the copies of the composition, however, blood drips ominously from a sword that hangs above Lepelletier, suspended by a single hair. Quoting David critics have frequently noted that this is the sword of Damocles which symbolized for the artist the lethal weapon of the tyrants, a weapon that alludes,

as well, to the instrument of the assassination. The sword pierces a fragment of a piece of paper on which can be read the words that were responsible for the martyr's murder: "je vote la mort du tyran." Here again, words play a critical role in the composition. Lepelletier died for these six words, which expressed heartfelt patriotic and Revolutionary emotions and ideas. If we compare the copies of the composition to engraved effigies of the time we see that David assiduously avoided any individualized, portrait-like features in the figure of Lepelletier. He transformed him into an antique hero, a "demidieu," a "symbol perfected in death." It is not the features of the hero that will be transmitted to posterity (this would fulfill the function of a mere portrait), but rather the patriotic meaning of his death. David made this intention explicit in his eulogy for Lepelletier that he offered to the Convention on March 29, 1793.

> I will have accomplished my task if one day I impel an elderly father surrounded by his large family to say: Come, my children, come see one of your representatives who was the first to die to give you liberty. See how serene his features are—that's because when one dies for one's country one has nothing to reproach oneself with. Do you see this sword suspended above his head which is only held up by a hair? Well, my children, this indicates what courage it took for Michel Lepelletier, as well as his generous colleagues, to condemn to death the infamous tyrant who had oppressed us for such a long time, because at the slightest movement this hair broke and they were all inhumanely immolated.[72]

David's address reveals his desire to clarify and elucidate the symbolic and emblematic meaning of his painting, which would serve as a constant reminder of the violent and bloody oppression of tyranny, one of whose agents murdered Lepelletier. To this end David used the emblematic element of the sword of Damocles—it refers to the real sword that killed the martyr but also stands for the metaphorical sword of tyranny. It is also in this address that David clarifies what he perceives as his own role as the interpretor of this death, his function as pictorial historian who ensures that the lasting commemorative values will be communicated to posterity. David would organize a private and then a public exhibition of *Lepelletier sur son lit de mort* along with his next martyr painting, *Marat a son dernier soupir,* in a place described as "a type of funerary crypt where they were admired for six weeks," before sending them to the destination for which they were intended—the meeting room of the National Convention.[73]

David's next representation of a Revolutionary martyr, the doctor turned Revolutionary journalist, Marat (fig. 52), which was painted only six months after the *Lepelletier*, is a much more complex image and has been the subject of a considerable amount of analysis in recent years.[74] David had visited Marat on July 12, 1793, just one day before Charlotte Corday assassinated the "ami du peuple." The National Convention immediately called upon David who was then a deputy to organize the funeral and to commemorate the "martyr" in a painting. David again thought in terms of multiple and

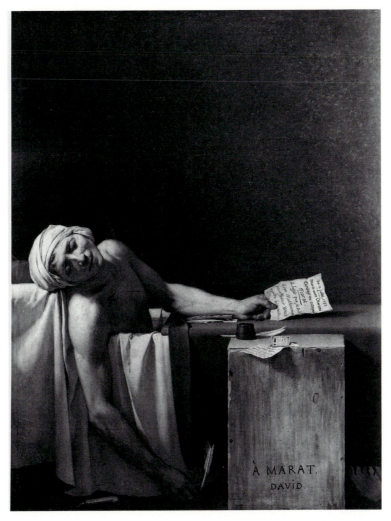

52. David, *The Death of Marat*, 1793, Brussels, Musées Royaux des Beaux-Arts de Belgique

simultaneous forms of commemoration: the mortuary preparation and display of the body at the funeral, the funerary rites and burial, a painted representation at the moment of death in the bathtub, an engraving of Marat's face as a type of death mask for which he drew the model (fig. 53), an exhibition of the painting together with that of Lepelletier for purposes of public veneration, a eulogy, and a request for pantheonization.[75] As far as we know David did not plan a full-length sculpted figure as he had for Lepelletier. In addition, the painted composition was going to be engraved and thus disseminated to a broad public.

David's idea for the funerary display of Marat's body in the former Church of the

53. David, *Head of the Dead Marat*, 1793, drawing, Versailles, Musée National du Château

Cordeliers was even more unusual than that of Lepelletier's corpse. On July 15, 1793, David made the following address to the Convention.

> The day before Marat's death, the Jacobin society had sent Maure and myself to hear his latest news. I found him in a pose that struck me. Near him he had a block of wood on which ink and paper were placed and with his hand emerging from the bathtub, he was writing his final thoughts for the good of the people. Yesterday the surgeon who embalmed his body sent someone to ask me how we would exhibit the body to the gaze of the people in the Church of the Cordeliers. We cannot uncover certain parts of his body because you know that he was leprous and that his blood was diseased. But I thought it would be interesting to offer him in the pose I had found him in, writing for the happiness of the people.[76]

Similar to the Lepelletier, David began his multifaceted commemoration with the ritual display of the corpse. In the funerary ritual he conceived of the corpse itself as a form of

representation, an idea directly related to the art of funeral sculpture. Only Marat's corpse would be manipulated into a position that resembled those chosen for the sculpted "grands hommes"—he would be seated in his bath as he had been at the very end of his life, writing for the "good of the people." That David thought of using the body of a citizen as its own effigy is quite extraordinary historically—it disrupts in a radical way traditional attitudes and conventions governing funerary rituals. For David the public's encounter with and experience of the dead body took precedence over established funerary rites and commemorative practices for ordinary individuals in which the body was virtually occulted. The artist capitalized upon the impact of the gruesome sight of the corpse which would function as a didactic sign to inspire pity, horror, and veneration. He made the displayed body, in fact, into an awe-inspiring symbol of the meritorious qualities of the individual's life which ended abruptly in the midst of a final act of virtue.

David had to renounce his idea of displaying Marat's body as though the journalist were still alive because of the rapid decomposition of the corpse. The body was laid out instead in a more traditional reclining position, with the knife wound exposed (as in the Lepelletier). Subsequent to the exhibition of the body David was directly involved with the burial rites. After a simple and austere funeral, Marat was buried in the garden of the former Church of the Cordeliers. On July 16, 1793, when David informed the Convention of these changes, he also offered a brief eulogy in which he compared Marat to the great philosophers of Greece and Rome.

> He will be buried today at five o'clock this evening, under the trees where he liked to teach his fellow citizens. The sepulchre will have the simplicity befitting an incorruptible Republican, who died in honorable poverty. From the depths of a vault he showed the people its friends and enemies: dead he will return there and his life will serve as an example. Cato, Aristides, Socrates, Timoleon, Fabricius and Phocion, you whose respectable lives I admire, I did not live with you. I knew Marat and I admired him as I do you, posterity will grant him justice.[77]

David envisaged a burial appropriate to an antique "hero," that is, in a type of sacred wood (the garden of the Church of the Cordeliers), where prospective devotees could come and venerate his memory by pausing to meditate at his tomb. The funeral David organized was extremely simple, befitting, as he stated, the "incorruptible Republican" who died in poverty, serving the people. With this burial David proffered his own significant contribution to the multiplicity of projects for the creation of an Elysian fields for the burial of illustrious individuals who had served the nation (as mentioned earlier, part of the discourse of the time on the cemetary movement).

On July 14, 1793, Guirault, a member of the Convention, had asked David to commemorate Marat in a painting. When he offered the finished canvas to the National Convention in November 1793, the artist, in an impassioned eulogy, requested that

Marat be given the "honors of the Pantheon." In the speech he asserted that he had painted Marat in response to the demands of the people whom the journalist had diligently served. He now called upon the people to venerate the icon he had created in honor of their fallen servant.

> Hurry up everyone! the mother, the widow, the orphan, the oppressed soldier, all of you whom he defended in peril of his own life, approach and contemplate your friend; he who watched over you is gone. His pen, the terror of traitors, his pen falls from his hands. Oh despair! Our indefatigable one is dead. . . . he has died without even having the means for his own burial. Posterity, you will avenge him, you will tell our nephews the extent to which he could have been rich if he had not preferred virtue to wealth. Humanity, you will tell those who called him bloodthirsty that Marat, your cherished child, never caused you to weep.[78]

David eloquently describes Marat as an individual who willingly renounced wealth in order to defend virtue, who became one of the poor himself, and, although indigent, was consistently generous, giving whatever he had to them. The only consolation for the people is that posterity will vindicate the actions of its devoted "enfant cheri" (we know, of course, that Marat was a much more complex and compromised figure than David's eulogy asserts, and the artist's defensive tone confirms that many Republicans were not saddened by the murder of the "friend of the people").

In light of the ambiguous position of Marat in French culture and politics at this time we might expect that David's painting would be ambivalent and problematic. In the painting, David combined two objectives that are rarely compatible—the idealization of the hero with the grisly, revolting details of his ignominious murder. No more eloquent description has been offered of these elements in the painting than that of Baudelaire.

> The *divine* Marat, his arm hanging from his bathtub holding slackly his last pen, his chest pierced with the *sacriligious* wound, has just given up his last breath. . . . The water of the bathtub is red with blood, the paper is bloody, on the floor lies a large kitchen knife soaked in blood; on a pitiable wooden stand that constituted the working table of the indefatigable journalist, one reads: "To Marat, David." All of these details are historical and real, as in a novel by Balzac. The drama is there, alive in all of its deplorable horror, and through a strange tour de force which makes this painting David's masterpiece and one of the great curiosities of modern art, there is nothing trivial or ignoble about it. This work is the bread of the strong and the triumph of spriritualism. Cruel as nature this painting possesses completely the perfume of the ideal. Where was this ugliness that holy Death so quickly effaced with the tip of his wing? Marat can henceforth defy Apollo, Death has just kissed

him with his loving lips and he lies back in the calm of his metamorphosis. In this work there is something tender and poignant at the same time; in the cold air of this room, on these cold walls, around this cold and funereal bathtub, a soul soars.[79]

David chose a compositional format similar to the one he had proposed for the funerary display of the corpse, an image that would embody Marat's final legacy—the "grand homme" seated in his bath, writing for the good of the people. But the significant moment here immediately follows the stabbing—Marat at his last breath dies in his bathtub, soaking in his own blood (David's original title was *Marat a son dernier soupir*). In his left hand Marat holds a letter of presentation from Charlotte Corday (who did not, in fact, use this letter to gain access to him), and in his right a pen that strikes the floor in the active position of writing and is adjacent to the bloody knife, the weapon used to kill him. On top of the simple writing table—a worm-eaten wooden box (as many have noticed, a visual analogue to a tombstone), in which David inscribed his dedication—"A Marat, David"—the artist has depicted another pen and inkwell along with an assignat and letter, written by Marat, that asks that money be given to a poor widow and her children. Marat, lying on white drapery, is placed in a coffin-shaped bathtub which is covered with a green cloth. Light dramatically strikes him and illuminates his head and shoulders. The non-specific background is unexpectedly intense. This fuscous, indefinable region that cannot even be described as a wall, is characterized by a dramatic interplay of light and shade. Rhythmic, sometimes violent brushstrokes appear to vibrate and compete with one another, expressing tumult in an image that is otherwise still. The composition, which resembles in some ways a sculpted relief in which figures and objects in high relief are attached to a generalized ground, is disturbing at a visual level because of the impact of the slumped body which only half reclines, placed within the very narrow ledge of the foreground plane; this device greatly diminishes the psychological distance between the spectator and the dying figure. The horizontal configuration of Marat in his coffin-bathtub is combined with a vertical format—that of the portrait—one more appropriate for the depiction of a standing, full-length figure—Marat occupies only approximately half of the space. The dark void depicted in such an agitated style that serves as a background seems oppressive and renders the space claustral. In addition to this narrowly confined space the colors themselves provoke great discomfort, even physical malaise. The range of livid greens, yellows, and browns, tones that sully the white cloth around Marat's head and the drapery that lines the tub, is punctuated primarily by the sickly red of the blood mixed with the bath water. The colors that help to convey the ideas of contamination and impurity also emphasize and make palpable the presence of putrefaction. David chose to commemorate for posterity a gruesome, nauseating image of the necrotic flesh of the dying Marat which, combined with the idealized beauty of the face, provokes a terrible uneasiness in the spectator. In so doing he self-consciously sought to revolt and horrify

the viewer who witnesses this appalling death. David proffers the new experience of the Revolutionary "grand homme"—in place of the apotheosis incarnating a moment of heroic action or intellectual or artistic achievement we have instead the horribly murdered martyr who sacrifices his life to the just cause. As Jacques de Caso has appositely noted, this close-up view of the corpse of an ordinary citizen constitutes nothing less than a radical innovation in portraiture, a dramatic rupture with the conventions and norms governing the secular portrait.

In the *Marat* David took great pains to distance the image from traditional portraiture. He eschewed the actual historical setting and circumstances that he knew well (including Marat's boot-shaped bathtub); he idealized and made regular Marat's facial features and transformed the sickly, thin body, covered with sores, into one that, in its contours and musculature, is heroic and powerful. Like Lepelletier, Marat is transformed into a heroic nude, "all' antica." But this only contributes to the ambiguity of the image and the viewer's intellectual malaise—heroic nudity is not typically combined with bloody details of a violent death. It has rightly been noticed since David's time that like the *Lepelletier*, the position of the body and the exposed wound recall not only the antique *conclamatio* but many precedents from Christian iconography of Christ as the Man of Sorrows as well as that of the martyred saints.[80] The image is, of course, also like that of the Lepelletier, related to the theme of the hero displayed on the deathbed. But it is difficult to contemplate it in calm reflection as we can the Lepelletier, because we are overwhelmed with the sickly violence so emphasized by David, who has taken pains to underscore Marat's vulnerability. Sitting naked in his bathtub, Marat was taken by surprise and completely unable to defend himself. By emphasizing the naturalism of the appalling details and the sparseness of Marat's surroundings, as well as by placing him so close to the spectator, David has compelled the viewer to participate in this horrific moment. We are the devoted friends of the "ami du peuple," who bear witness to Marat's final legacy at the moment of death. But what is this legacy?

Marat's legacy, his significant contribution that merits his commemoration as a "grand homme," is related, of course, to his writing—he has literally died with pen in hand. And the position of the hand holding the pen actually functions as an emblem of the act of writing itself, for which David is commemorating Marat. The dual visual sources of this emblematic configuration of pen and hand demonstrate the extent to which David wanted to emphasize the importance of writing and even writing as a subversive activity. First, the image quotes a technical plate from the *Encyclopédie* entry, "Art d'écrire," which emphasizes the function of the hand in the art of writing (fig. 54). By referring to this eloquent emblem David associates Marat with the radical political enterprise of subversive publications.

But there is another association that pertains as well. The *Encyclopédie* illustration was taken up and used for great dramatic effect in a powerful engraving of January 17, 1793—at the apex of the Revolution—"Louis le traître lis ta sentence" (fig. 55), that manifests the idea of the "writing on the wall" from the Old Testament. This time the

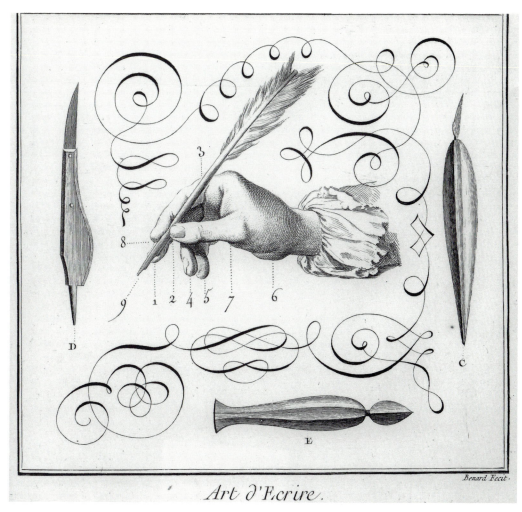

Art d'Ecrire.

Benard Fecit.

54. "Art d'écrire," *Encyclopédie . . .*, Paris, 1763

ruler who did not heed the writing on the wall was not Balthazaar but the ill-fated Louis XVI. By echoing this print, David has identified Marat with Old Testament prophecy. And much in Marat's character and career would suit this identification. In his painting, David does not hesitate to allude to Marat's dealing in death (even if it was the death of "traitors"). As has been noted, the painting is replete with images, symbols and the grisly details of the death of the martyr who literally lies in a bath of blood. The painting, in fact, is oppressive in its repeated allusions to death-related images— the morbid colors, the bloody bath, the coffin, the tombstone, the shroud. This is a painting "much possessed by death" and certainly refers to the omnipresence of death during the Terror (Marat's role in the Terror is, of course, well-known). David does not, thus, turn away from the harsher aspects of Marat's career and while Marat may in

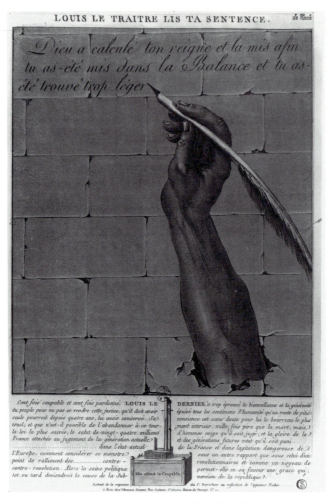

55. *Louis le traître, lis ta sentence*, Paris, Bibliothèque Nationale

certain respects be likened to Christ (and much has been made of this analogy), he recalls as well the vengeful figures of the Old Testament.[81]

In the painting, however, we are not dealing with the word of God but the words of men. And, for the first time, David, who, as we have seen, was so consistently concerned with the representation of language, has created an homage to the written word and, at the same time called into question its inherent values. Marat's contribution to the Revolution and to history was realized through his writing, and writing, along with oration, of course, were activities highly privileged by the Revolution which realized many of its principal goals and achievements in a seemingly endless, self-generating discourse. In his depiction of Marat, David juxtaposes three types of writing and written values in a hierarchical vertical format: at the top is Charlotte Corday's treacherous letter

in which she uses a beseeching tone asking for Marat's help; just beneath this letter is Marat's sincere and heartfelt letter and assignat in which he helps to save the lives of a poor family; and, finally, below the assignat is David's dedication on the wooden table-tombstone. Two forms of writing bespeak sincerity, but placed at the top of this "hierarchy" of words is Charlotte Corday's deceptive letter. This structure provides further evidence of David's growing uneasiness with language itself, for it makes explicit the capacity of language to "sound" sincere, while seeming sincerity masks lies and deception. On a profound level, then, the painting constitutes a meditation on language as a powerful instrument to bring about evil as well as good, to clarify and illuminate as well as subvert and deceive. Has not this very duality also been implicated in the historical fortunes of the painting of Marat? In fact, the duality that pervades this work (e.g., the heroic idealized figure lying in a bloodbath) calls into question the multivalent, if not ambiguous, nature of David's representation, indeed of representation itself or any signifying system. David shows that the signifying system of writing could be usefully subversive, as in the case of the *Encyclopédie* and much of Marat's writing; it could subvert the falsehood of the Ancien Régime. But writing could also subvert (as in Corday's letter), the truth of the Revolution. We remember that when he painted *Marat at His Last Breath* in 1793, David and vast numbers of his contemporaries had already been profoundly disillusioned by the capacity of language to deceive—some of the greatest orators of the early days of the Revolution such as Mirabeau had been revealed to be traitors who had used eloquence as a mask. David, because of his avid interest in history, both ancient and modern, was probably familiar with Thucydides' brilliant passage on the atrocities, treacheries, and betrayals that result from internecine civil war. In this passage Thucydides describes the stresses that a language undergoes in unstable and turbulent times of national crisis: "To fit in with the change of events, words, too, had to change their usual meanings".[82] It may appear quite remarkable that David, as an artist, would interest himself in questions about the nature and function of language. But it is entirely consonant with his intellectual and philosophical approach to painting.

David would diverge dramatically from the composition, style, and content of the *Marat* in his depiction of the dying child Bara of 1794 (fig. 56), his final painting of a martyr of the Revolution.[83] Even though he again chose the liminal moment of death, David depicts the nude Bara writhing in his final throes, the struggling, supine figure evoking great pathos. Unlike the Marat, no wounds are visible although the child had been repeatedly stabbed. David probably represented the death as bloodless, and therefore less violent and horrific, in view of the destination of the image, which was to be disseminated to primary schools through engravings (a gruesome and bloody figure would have been more likely to inspire nightmares in children than emulation of virtue).[84] David had been commissioned to represent the Republican child hero who, according to a legend fabricated by Robespierre, had been stabbed to death in the Vendée by royalist brigands for refusing to shout "Vive le roi!" (once again the key role of

56. David, *Bara*, 1794, Avignon, Musée Calvet

language is at issue).[85] The artist was also in charge of pantheonization rites to be held late in the summer of 1794, a festival never realized due to the fall of Robespierre on July 28 of that year.[86]

The format of the canvas and the organization of the composition is horizontal— David used every device possible to emphasize the prone position of the child who cannot drag himself any further along the ground. Bara's crumpled, frail legs are akimbo and already lifeless and he has made a supreme effort to raise his thin chest and arms in a final moment of moral and spiritual ascendency that inspires him. David represents a moment when the child martyr experiences his last thoughts before dying, clearly sublime thoughts that permit him to elevate slightly his upper body and bring an expression of rapture to his features. Bara dies in ecstasy because of the final seconds of imagination and thinking when his heart and mind are filled with love of family and country (he presses to his heart the tricolor cocade and a letter, probably either from or to his mother). The most vivid element of the composition is Bara's beautiful, ecstatic face, the animate curls of his hair are wonderfully expressive of the fervent emotion that accompanies his last breath. The face is also the most completely painted part of the body, which further serves to make it a focal point of the composition. The sensual, rapturous face contrasts dramatically with the diminutive, puny, underdeveloped body which is completely sexless and amorphous, almost larva-like—an apposite metaphor for this young life which was cut short at such an early stage of development (the figure is not hermaphroditic, as has sometimes been claimed, because there are no visible sexual characteristics and the frail and pathetic body, unlike the beautiful face, is completely unsensual).[87] Bara is still a child and his fallen, crumpled body is extremely eloquent and moving in its vulnerability and innocence—he is reminiscent of a slain animal. And the royalist "hunters" who have killed their unarmed and hapless prey can be glimpsed to the far left of the composition, leaving the child to die in the dust. Bara is not depicted as an idealized, heroic, nude as were Lepelletier and Marat, but his nudity conveys a similar, universal meaning. In accord with an alternative iconographic tradition of antiquity and the Renaissance, Bara's nakedness emblematizes innocence, purity, and truth. His life, like his body, will never be developed, but he dies innocently uncovered, hiding nothing, and in so doing imparts to current and future generations the great legacy of his youthul courage and virtue.

Like the figures of Lepelletier and Marat, the Bara was inspired by ideas that govern the sculptural monument, particularly funerary sculpture. This figure, however, unlike those of the two preceding martyr compositions, in format and pose, recalls earlier sculptural representations of Christian martyrs (Maderno's well-known *Saint Cecilia* has been posited as a significant source) as well as *gisant* figures from tombs.[88] The figure was actually given a sculptural incarnation by David d'Angers—his moving representation of 1839 (fig. 57) constitutes yet another eloquent homage to his teacher.[89] Instead of the final moment of struggle when the animating breath of life leaves the mortal coil, David d'Angers chose the subsequent moment when death has brought complete relaxation of

the muscles and peace to the facial features. In the sculpted figure the child's face radiates joy and happiness, the aftermath of the ecstatic death he experiences in David's painting. To an even greater extent than in David's painting, David d'Angers emphasized the great pathos of the frail and thin body, whose incipient decay, recognizable in the sagging muscles and flesh, makes the image even more heart-rending. The sculptor elucidates and clarifies what he perceived as Louis David's objectives in terms of the meaning of the work: namely, the pity we feel and the tenderness for the tragic death of a child—a growing individual whose life has been cut short, who will have no future. (Louis David exhibited the unfinished painting for many years in his atelier in the Louvre and it is likely that he came to view the composition as complete in terms of its meaning, for the incomplete canvas may have come to emblematize the incompleteness of Bara's life and perhaps, as well, the incompleteness of the Revolution which, David realized, remained fragile and undeveloped like Bara, in spite of its fervent ideals and objectives.)[90]

In the martyr paintings, as in the *Oath of the Tennis Court*, David was profoundly influenced by the aesthetics of sculpture. It therefore seems appropriate to conclude this examination of David's transformative aesthetics during the Revolution with his project for an actual sculpted figure—the Colossus of the People—that he invented for the Fête de la Réunion of August 10, 1793, one of several festivals he organized.[91] Unlike most of his temporary monuments created for the festivals, including statues and reliefs, David imagined his colossus commissioned and cast in bronze so that it could serve as a permanent emblematic expression of the power of the people. The discourse for this project testifies, perhaps to a greater extent than any other of his Revolutionary works, to David's profound involvement with and meditations upon the art of sculpture. It also reveals his continued reflections on the meaning of the "grands hommes" and on the juxtaposition of the written word and the effigy in the Revolutionary period.

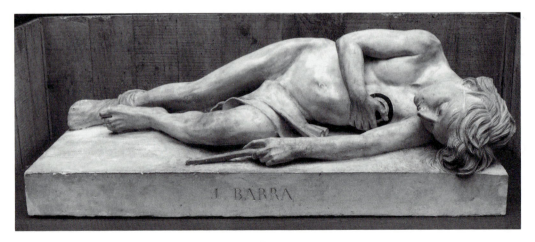

57. David d'Angers, *Bara*, 1839, Angers, Musée David

The Colossus of the People was one of three colossal allegorical statues designed by David that marked three of five distinct "stations" of the Fête de la Réunion, a celebration of equality, liberty, and fraternity that the artist had organized and dedicated to the French people as a vast human family (described in an eloquent report to the Convention, presented on July 11, 1793).[92] The three sculptures created by David included a seated figure of Nature pressing from her breasts the waters of regeneration, located at the site of the Bastille, the starting point of the festival; a statue of Liberty erected on the debris of the "pedestal of tyranny" at the third station, the Place de la Révolution (where the king had been guillotined); and a colossal figure of the French people at the fourth station, the Place des Invalides. The Colossus of the People, represented in the act of slaying the hydra of federalism, was perhaps the most powerful and violent public monument envisaged during the early Republic. In an address to the Convention David described his initial plan for the pageant figure in the following terms.

> In the middle of the square, at the peak of a mountain, the French people will be placed, represented in sculpture by a colossal figure, gathering together in its arms the departmental fasces. Ambitious federalism, emerging from its filthy swamp, with one hand pushing back the reeds, attempts with the other to detach part of it. The French people perceives this, takes the club and strikes it, forcing it to return to its stagnant waters, never to emerge again.[93]

This description of the Colossus of the People forcefully and violently clubbing the monster of "federalism" which arises from its swamp, concurs with eyewitness accounts of the temporary monument at the festival and was represented in an engraving entitled "The French People Overwhelming the Hydra of Federalism" (fig. 58). While this transient figure was well suited to the ideological objectives of the festival (one of which was the defeat of federalism), when it came to proposing a more permanent public monument in sculpture David transformed this dynamic and violent conception into a static, iconic allegorical "giant" that recalls Quatremère de Quincy's colossal group of *La Patrie* planned for the Pantheon; David's enormous figure was certainly terrifying in its implications.

> I propose to erect this monument, made up of the broken debris of these statues, on the square of the Pont Neuf, and to seat on top of it the image of the giant people, the French people. This image, imposing in its character of power and simplicity, will have on its forehead, written in large letters— Light; on its chest—Nature, Truth; on its arms—Strength; on its hands— Work. While in one of its hands the figures of Liberty and Equality, pressed against one another, and ready to traverse the world, demonstrate to all that they rely solely on the genius and virtue of the people. This standing figure of the people holds in its other hand this real and terrible club, of which that of the antique Hercules was only a symbol.[94]

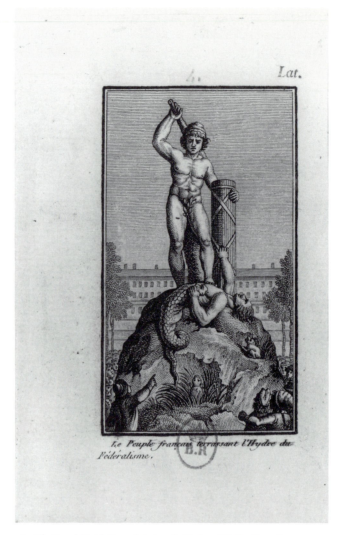

58. *The French People Overwhelming the Hydra of Federalism*, August,
1793, Paris, Musée Carnavalet

David envisaged the colossus as a sublime and threatening force—a gigantic "People" holding a colossal, *real* club. David's description suggests that he conceived of the monument as a type of real allegory, the image of the people was *not* intended as a Hercules representing the people but was to be a colossal figure of a powerful man of the people who in his strength and attributes (such as the club) recalls and refers to the prowess of Hercules.

A drawing by Moitte (fig. 59) conforms most closely to David's description of his colossus given in an address to the Convention on November 7, 1793, in which he proposed a competition for the commission of his monument.[95] At this time, David discussed his revised ideas for the figure and emphasized further its allegorical signifi-

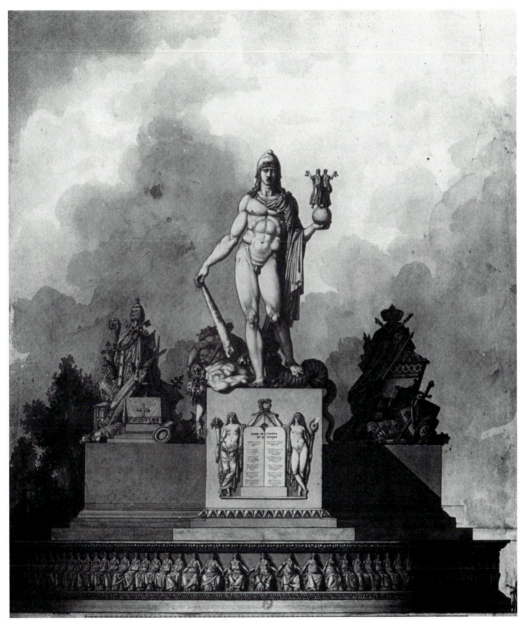

59. Moitte, *Project for a Monument to the French People*, drawing, Paris, Bibliothèque Nationale

cance through a description of its pediment which was to be constructed from the debris of royalist monuments and effigies. Moitte (like others who entered the competition) represents a powerful and towering heroic nude colossus as a type of Hercules who crushes the hydra of monarchy underfoot and who holds gracefully a huge club in his right hand; in his opened left palm we see figures of Liberty and Equality astride a globe.

The colossus wears a cape and phrygian bonnet and is placed on a complex pedestal which includes, in relief, the Declaration of the Rights of Man. Behind the figure, to our left, is an amorphous stack of trophies of the papacy, to our right trophies of the monarchy, all of which the people have conquered. The terrifying scale of Moitte's colossus is made clear by the miniscule human figure to the far right who gazes up in awe at this towering effigy, the literal embodiment of the people. Moitte's colossus, however, does not include the words that David planned to have sculpted onto the figure, perhaps one of the most extraordinary features of his project. David envisaged simple words for this gargantuan figure (which would have been a frightful presence in the city—fifteen meters high—a true embodiment of the Burkean sublime), to be depicted, of necessity, in colossal letters on different parts of the body—a type of advertisement for ideal humanity: "Enlightenment" for the head; "Nature" and "Truth" for the heart; "Strength" for the arms; and "Work" for the hands. This provides yet another example of the dialogue between word and image that was so important to David in the 1780s and 90s, here brought to a monumental sculpted figure. The words make explicit the allegorical content of the figure who emblematizes an ideal of the people that combines enlightened intellect, sincere emotions, and hard labor. The words clarify the function of the "body" of the people: head and heart work in conjunction with strength and labor. The contiguous figures of Liberty and Equality placed in one hand would necessarily be small indeed and fragile (as they appear in Moitte's drawing) compared to the magnitude of the colossus. Such a figure of the people protects liberty and equality but is clearly also capable of easily crushing them should he diverge from the tenets inscribed on his body. David wanted to inspire awe and terror with his vision of the colossus as a manifestation of pitiless masculine strength, domination, and intransigency, ready to club to death and crush its adversaries. It would serve as a continual reminder to the people of their awesome strength and collective power but it would above all serve as a terrifying reminder to would-be tyrants, to those who might try to rise again against the people (the transcendent political meaning of the monument with its clear message to monarchy, expressed in such a simple and powerful manner, helps to explain its long life in the nineteenth century, when Romantic writers and sculptors, including David d'Angers, dreamed of realizing David's project).[96]

The only surviving example from David's own hand of a depiction of a colossal French People as a type of Hercules armed with a club comes from his drawings for a purported "opera curtain" (figs. 60, 61), a project whose history and exact date are obscure and whose precise destination remains uncertain (David's friend, Alexandre Lenoir, who owned one of the drawings, recounts that it was designed for an opera set).[97] David depicts the triumphant People as an antique Herculean figure holding a massive and monumental club; between his legs stand the female figures of Liberty and Equality holding the fasces and pike. The People as Hercules is seated in a triumphal chariot pulled by massive oxen, which he shares with other allegorical figures. The chariot crushes beneath its wheels royal insignia and garments; its train is composed of martyrs

of liberty from antiquity to modern times. The function of the People is made explicit by depictions of citizens who rush with swords to slaughter a fallen king and his minister. The winged Victory with her long spear assures the outcome of the People's triumph.

The statues and reliefs that David invented for the Revolutionary festivals (as well as all types of emblematic and symbolic objects and costumes), his proposals for permanent monuments such as the Colossus of the People, and his projects that exist in drawings, such as those for the opera curtain, reveal that he fully endorsed the allegorical and emblematic mode of expressing ideas that characterized Revolutionary and Republican rhetoric and thought. His speeches to the Convention also depend heavily upon the metaphorical and allegorical language of the Revolution. Yet, in spite of his profound and consistent involvement in this allegorical mode of representation, this type of symbolic vocabulary of forms, used so consistently in the paintings of his contemporaries, was virtually absent from his paintings of the "grands hommes" of the Revolution (the exception being the sword of Damocles suspended over the body of Lepelletier). Why was David so unrestrained in his use of Revolutionary symbols and allegories in his projects for public monuments, yet so unwilling to employ them in his paintings of the "great men" and "great events" of the Revolution? We know that in his painted oeuvre prior to the Revolution David eschewed depicting allegorical figures and, indeed, in his entire painted production from the early 1770s to 1824 he only once planned to introduce an allegorical figure into history painting—a winged Victory for the *Distribution of the Eagles*—see chapter IV.

David separated the realm of painting from that of the sculpted public monument, as well as from that of objects, emblems, and decor created for public festivals and public consumption and dissemination. He realized the importance and efficacy of Revolutionary and Republican allegory and symbol for the purpose of public instruction. The basic, repetitive, and well-known allegorical vocabulary invented for the Revolution which constituted a pervasive imagery (including the fasces, the pike, and the phyrigian cap, to name but a few popular motifs), appearing, as it did, on seals and coins, and in prints and pamphlets, as well as on public objects, emblems, costumes, monuments, etc. communicated abstractions and political ideology in a simplified, condensed, and direct manner. Such didactic imagery helped to shape, structure and unite this community in a common political, cultural, and social cause. But David demonstrated that an allegorical vocabulary of figures and forms was not suited to the depiction of the "great men" and "great events" of the Revolution. The commemoration of contemporary individuals, citizens who participated in the making of modern French history necessitated a different type of representation, a transcendent, idealized depiction of a "grand homme" which would emphasize the contribution of the individual who embodied heroic qualities of moral virtue. If citizens of the French Republic meditate upon such commemorative effigies of the "grands hommes," they can be inspired to emulate these individuals who, like themselves, may have begun as ordinary people but who rose to great actions, thoughts, words, and deeds, through their moral and intellectual efforts and through a

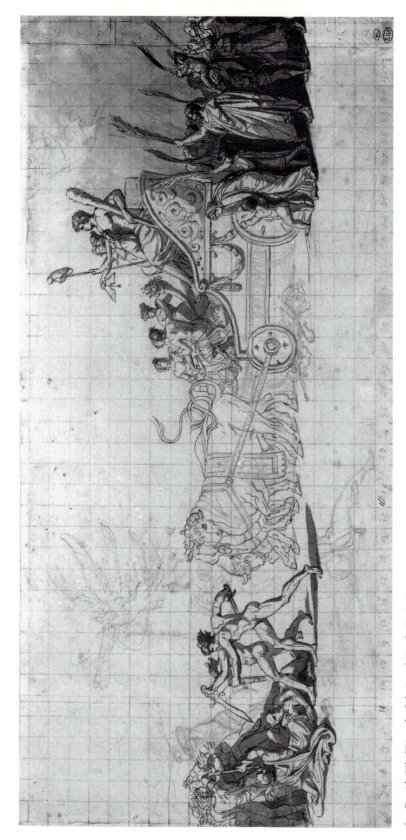

60. David, *The Triumph of the French People*, Paris, Louvre

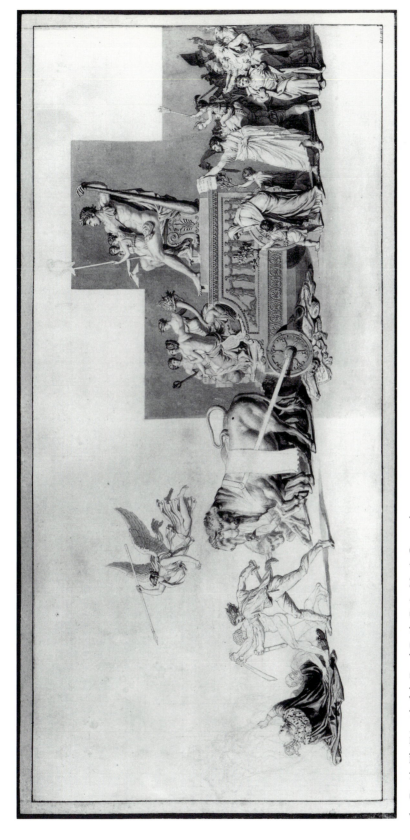

61. David, *The Triumph of the French People*, Paris, Musée Carnavalet

mighty will fueled by patriotic devotion. The people may be inspired and uplifted by the monument of regeneration or the Colossus of the People but these allegorical figures embody ideas; citizens do not emulate or aspire to imitate allegories. They can only try to become like other individuals whom they admire or revere. This was the function of David's paintings of the "grands hommes" of the Revolution. Every citizen could identify with the fervent oath-takers of the *Oath of the Tennis Court*; every citizen could meditate upon the icons of the Revolutionary martyrs and understand that these individuals suffered and died for the people and the cause of liberty, equality, and fraternity. As in portraiture, David intended the communication between the painted image and the spectator to be direct and psychologically compelling.

David, ever the philosophical painter, realized with an almost pre-Socratic tenacity that commemoration (which always involved, in some sense, the freezing of the temporal dimension) posed more exigently the problem of finding fixity amid fluctuation. David understood that the art of the past had developed a vocabulary, namely that of the symbolic, to deal with this dilemma which was posed with singular urgency during the Revolutionary ferment, a time when both the past and the future of society were called into question. He examined past uses of symbol and emblem and offered his own contributions to the art of commemoration. In making art for the occasions of Revolution he strove to produce compositions that would mark the "intersection of the timeless with time."

III

———◆———

THE ART OF CIVILIZATION

The Sabine Women and *Leonidas*

at Thermopylae

DURING his successive imprisonments, first in the Luxembourg (August 2–
December 29, 1794) and then in the Quatre Nations (May 29–August 3, 1795),[1]
disillusioned by the chaos of contemporary events and, concomitantly, the potential
disintegration of society (a recurrent theme of his correspondence at this time),[2] David
decided once again to re-evaluate and redirect his art. His imprisonments turned out to
be, aesthetically speaking, fructive ones, paradoxically allowing his transformative
vision free reign. As for a Stendhalian hero, prison could be for David a place of
intellectual freedom as well as a place to redirect the will—prison functioned as a
chrysallis. David's meditations in prison led him to experiment with new themes and
subjects from antiquity, his primordial source of inspiration for transformation. In his
next two monumental works, conceived of as pendants, *The Sabine Women* (fig. 62,
colorplate II), begun during his first imprisonment, and *Leonidas at Thermopylae* (fig. 66,
colorplate III), David created compositions that engaged so many of the aesthetic issues
and intellectual debates of his time that they deserve to be called aesthetic manifestos.
Through these compositions he would make known his thoughts on current aesthetic
concerns such as physiognomy, the use and function of nudity in painting, corporality
and the canon of proportions, space and perspective, the metaphorical role of the setting
or landscape in amplifying meaning, and the significance of the spectator's position in
viewing a work of art. And he brought to bear on all of these questions evidence culled
from a wide variety of the intellectual discourse of his day—evolutionary and anthro-
pological tracts, geological, biological, anatomical and physiological speculations,
histories of antiquity, and psychological discoveries, demonstrating once again the
supreme intellectual complexity and fervent mind embodied in these two paintings.

The monumental *Sabine Women*, 1794–99, along with its pendant, *Leonidas at*

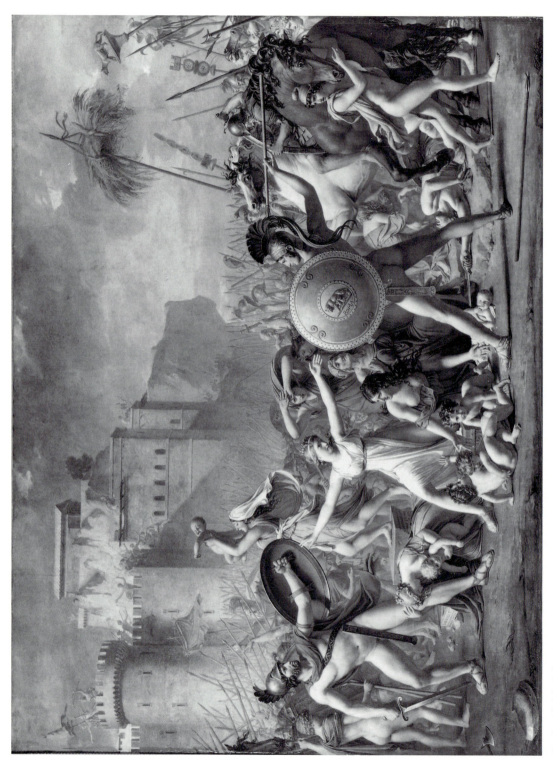

62. David, *The Sabine Women*, 1799, Paris, Louvre

Thermopylae, 1799–1814, together express a remarkable nexus of ideas concerned with the history of culture, art, and aesthetics and share a common subject—both represent liminal moments when the fate of Western civilization hung in the balance. David reveals in each composition the way in which a great individual makes the critical difference in the history and development of civilization. In the *Sabine Women* the impressive concilatrix Hersilia risks everything—her life and that of her chidren—to stop an internecine war. She leads the Sabine women to the battlefield and places herself between the opposing leaders, her intervention assuring the successful foundation of Rome. In *Leonidas at Thermopylae* the king of Sparta meditates on his decision to sacrifice himself and his personal guard of 300 men in order to assure the triumph of Greece in the Persian Wars. In both paintings, conceived of as works to be meditated upon at length, David engaged in daring and innovative stylistic and compositional experiments in order to assert his new ideas concerning the nature and meaning of civilization and its history.

David, in prison, came to reflect on the nature, origins, development, and survival of civilization. He had witnessed first-hand the precarious situation of his own civilization and had been led to meditate on the structures, institutions, and individuals that lead a civilization to collapse or, alternatively, survive (a natural outgrowth of his reflections on the "grands hommes" which, as we have seen, had occupied his thinking during the Revolutionary period). The idea of the significance of civilization and its history, indeed, its triumph, was, of course, dear to eighteenth-century philosophers, and many late Enlightenment thinkers, well-known to David and his contemporaries, were obsessed by the theme (the works of Gibbon, Herder, and Condorcet proffer but a few prepotent examples).[3] The subject of the triumph of civilization in art was also of import during the Directory. While working on *The Sabine Women* David was probably familiar with Réattu's complex and arcane *Triumph of Civilization* begun in 1793.[4] Réattu employed a traditional allegorical language and an iconographical framework to represent the triumph of civilization in France. But David, although he was conversant with the plethora of historical and political allegories of the 1790s, consistently rejected the mode of allegory in painting. Instead of personifying abstract qualities or ideas, he chose to embody them in the representation of a singular, fateful, historic-mythical moment. David eschewed the abstract vocabulary of personified ideas because he wanted, as we have seen, to compel the spectator at the psychological and visceral levels; allegorical modes prevalent at this time precluded such intense personal and emotional involvement. David's ambitious concerns with the impact on the spectator in his development of a new theme in these monumental paintings, compelled him to experiment further with composition and style. Thus, the *Sabine Women* and the *Leonidas* engage the twin themes of civilization and aesthetics. It is not surprising that his representations of the theme of civilization would be interwoven with and expressed through aesthetic innovations, for David believed that art and aesthetics constituted one of the most significant underpinnings of civilization itself.

One of David's most daring innovations in his reinterpretation of the theme of civilization in the *Sabine Women* is his celebration of the intervention of Hersilia, the central focus and heroine of the composition (in his explanatory and descriptive pamphlet which accompanied the exhibition, his first attempt to offer a public explanation and defense of one of his paintings, David diverged from the antique sources and made Hersilia prominent as spokesperson and leader of the Sabine women).[5] This heroic woman, clearly a "grande femme," takes a terrifyingly courageous stand and thereby alters the course of civilization. The radiant and luminous heroine, dressed in white, whose face and figure recall in some ways that of Athena, goddess of wisdom and the intellect, intractably places herself between Tatius, leader of the Sabines, to the left, and her young and arrogant husband Romulus, ruler of Rome, to the right. Swirling around and behind the three protagonists in the foreground we see the Sabine mothers with their babies amidst the confusion of the confronting armies. The battle takes place in front of the citadel of Rome, on the emerging architectural foundations of the city itself. Thus, David demonstrates dual efforts in the building of a "civilization"—the architectural foundations function as a base for the more intricate, less tangible, but certainly no less solid, foundation of familial ties and bonds (the city and civilization itself are thereby conjoined). The Sabine women, kidnapped and raped by the Romans, have now become wives and mothers (David rejected the ignominious theme of the rape known to him principally through Poussin and other examples in Baroque art). Their familial responsibilities conjoined to maternal and conjugal love (which David emphasizes as the motives for their behavior in his pamphlet) have inspired them, under Hersilia's leadership, to rush passionately to the battlefield and stop the war that would have severed them from their ancestral families. This startling image of savage and primordial maternity which enthralled the first viewers of the work, several of whom analyzed it at considerable length, still fascinates observers today.[6] Conciliation leads to an extension of the family which now unites two peoples. The broadening of such ties greatly enhances the survival of both groups and furthers the development of civilization itself. The foundation of Rome was eloquently and memorably described by Virgil.

> This was the life of the Sabine people of old, this was the life of Romulus and Remus. Thus it was, to be sure, that Etruria grew strong and Rome became the most splendid thing in the world, surounding her seven hills with a single wall.[7]

A central theme of the painting, therefore, is the significance of women's primordial and essential role in the creation of civilization. In his depiction of the Sabine women, in fact, David expresses a number of prevailing late eighteenth-century ideas concerning the nature of women and their behavior in primitive societies. During the final decades of the eighteenth century, the "true" nature of women was a subject of much controversy, inspired principally by the writings of Rousseau in *Emile* and *La Nouvelle Heloïse*.[8] As is well-known, Rousseau defined and described at length his ideas

of the "natural" woman—the mother—whose only concern was for her children to whom she sacrificed all else and whom she breast-fed and lovingly cared for. Writers such as Laclos further elaborated upon these ideas and proffered the example of the "natural" mother in primitive societies as an exemplar for contemporary women to follow.[9] Physiologists and physicians entered the debate in a major way, offering biological reasons for the "true" nature of women whose character, temperament, and fulfillment in life are determined by their reproductive organs.[10] The physiologist Roussel, a major figure in this movement, described at length what he believed were the biological principles that defined the distinctly female personality. Because of their biological situation, women act according to their feelings rather than rational analysis and are led by intuition rather than by ideas.[11] We might say that this is true of the Sabine women as David represents them—they are certainly frenzied and distraught mothers who behave in ways that befit the primitive, biological mother, with the exception of Hersilia who is more akin to the male heroes with whom she is associated stylistically and compositionally. Like Romulus and Tatius she is sculpturesque, poised, calm, and self-contained. She manifests, in fact, what were described as the biologically masculine qualities of reason and intellect (hence, her role as a type of domestic Athena, the goddess who, significantly, defended the polis as the fundamental societal unit of civilization). Hersilia has risen above the condition of the "natural" woman to become a shining exemplar of moral virtue and fortitude, a "grande femme."

In order to emphasize this new theme in his art—the genesis of a civilization in which women play a pivotal role—David distanced the work, in composition and style, from his canonical masterpieces of the 1780s based on antique themes. Although he still profoundly emphasized the body, eloquent pantomime and corporal communication, he now made explicit allusions and references to precedents in ancient art, particularly in the depiction of the three protagonists. Critics denigrated him for this type of "borrowing," but, of course, David never borrowed outright or copied figures. As was his custom, he transformed his sources, thereby creating forms that were original and uniquely his own. Never once did David fetishize ancient art; instead, he viewed it as a catalyst that would advance the modern. In his pamphlet, David recommends a transformative emulation of the ancients, a revaluation and revision of prevailing ideas concerned with antique artistic practice and meaning in artistic forms, in order to ameliorate modern painting which he clearly feared was degenerating into a superficial, static, and lifeless imitation of the antique.[12]

One of David's tenets (which he often repeated to his students) was that the modern artist should be in eloquent colloquy with the sculpture of the past and it is not surprising that, in seeking an innovative compositional structure, David would turn again for inspiration to this art—here, the sculpted relief—which informed the rectangular format of the canvas as well as the placement of figures and groups. As in a highly detailed, dense, and picturesque sculpted relief in which certain forms are almost three-dimensional and others are displayed with varying degrees of flatness according to

their importance or, alternately, their distance from the viewer, David made the three protagonists in the foreground—Hersilia, Tatius, and Romulus—emerge from the tumult and chaos of the surrounding crowd through their sculptured forms and dynamic stillness (the pronounced relief qualities, later denigrated by Guizot, had a profound impact on the works competing for the Prix de Rome in the early years of the nineteenth century). [13]

David adapted these effects and devices which have such a dramatic impact in the painting from the art of the relief, in order to emphasize to the greatest extent possible and to make the spectator acutely aware that this was a pivotal and epiphanous moment in the development of civilization, a moment when time stood still, when the future of a civilization hung in the balance and when the family would assert itself as one basic foundation in its development. David's message concerning the genesis of civilization and the central role of the family seems direct but, quite expectedly, the painting was interpreted in light of the contemporary political situation in France by a German observer, F. de Meyer, and by the ardent Republican Chaussard (who offered a brilliant and lengthy analysis of the entire composition). Meyer viewed the work as an anti-war painting when he saw it in 1799, while Chaussard understood it as a plea for the reconciliation of the French people who had been torn asunder by the Revolution (this latter interpretation still permeates much of its historiography even today). [14] According to both Meyer and Chaussard David concurred with their respective interpretations and, of course, both were right—the painting is anti-war and pro-reconciliation. But on a deeper, philosophical level, the work transcends current political, social, and cultural situations and events, for David, who always thought in terms of posterity, seeks to convey a type of universal message to the entire human family. The expressive mode of the painting is not simple political allegory but cultural metaphor. In the *Sabine Women,* thus, David sought to redirect the very goals of history painting itself which would no longer merely represent great deeds but also their foundational ideas.

Another device in this painting used in the production of meaning, one closely aligned to David's sculptural thinking, is corporal expressivity. In the *Sabine Women* David again privileges corporal communication, here in the representation of a large crowd of figures—the protagonists, the frenzied women, the warriors of opposing armies and the children—all of whom are individualized and differentiated to a remarkable degree. David relies upon physiognomy conjoined to an extraordinary range of expressive pantomime in order to convey extreme and varied psychological states. This is true even in the depiction of the children each of whom has a distinct character and temperament that seems to echo that of the adults (late eighteenth-century pedagogical ideas emphasized the child's emulation of the parents); the unfettered nudity of most seems to refer to Rousseau's prescripts for raising the natural child, but that several crawl on all fours suggests their feral nature and, by extension, the bestial qualities in human nature that only civlization can suppress and transform, also of concern to late eighteenth-century childhood education. [15] Most remarkable is the red-haired bellicose

63. David, *The Sabine Women*, detail

child wrestling another who calls out for help; the contorted, wrathful face looks out at the viewer with belligerence and hatred (fig. 63). Equally singular is a much younger infant, still in swaddling clothes, who lies prostrate on the ground in a terrifyingly vulnerable position—a broken sword, of which he is quite naturally unaware, lies menacingly at his head (fig. 64). He also looks out at the viewer, but quizzically, as though inviting us to meditate on the meaning of the image. This philosophical infant who emblematizes the dawn of life is contrasted with an adjacent dead warrior—life's end. One of David's principal concerns was to represent the evolution of the life cycle within the familial structure and its significance for the survival and continuity of civilization itself (if the battle continues, the youngest generation, the children, will be destroyed). He presents figures from all stages of life—from infancy to extreme old age (the oldest is the prominent elderly woman who bares her breast to Romulus). In this work David privileges adolescence, a stage of human development that was being redefined in France in the 1790s—he frames the entire composition with the magnificently rendered nude ephebic grooms whose position within the work puzzled many critics, including Chaussard (the valuation of the adolescent in David's *Bara* as well as in mythological paintings of the 1790s has recently been studied in some detail).[16] Tatius' groom is calm, thoughtful, and self-contained, psychologically removed from the

64. David, *The Sabine Women*, detail

tumult and potential tragedy of the scene, while Romulus's groom strides away from the central group yet looks back at them with concern (fig. 65) (David poignantly juxtaposes the face of Romulus' groom with that of his horse who echoes the groom's psychological and emotional state).

It is telling that the nudity of the adolescent grooms and that of the children did not disturb David's audience—their nudity could be viewed naturalistically or as a metaphor for their innocence. Nudity in such figures still seemed within the bounds of convention and "appropriateness." At this moment, however, which witnessed incipient concerns with the boundaries and definitions of what was "moral" in art, critics did

65. David, *The Sabine Women*, detail

denounce the nudity of Tatius and Romulus as immoral and antihistorical (claiming that antique warriors did not enter into battle nude). [17]

In his pamphlet David published an eloquent defense of the nudity of the heroes on aesthetic grounds:

> An objection that has already been made to me and which will certainly be reiterated, concerns the nudity of my heroes. The examples that can be cited in my favor from what remains of ancient art are so numerous that the only difficulty that I would find is having too many to choose from. Here is how I

respond to this. It was customary usage among painters, sculptors and poets of antiquity to represent nude gods, heroes and in general men whom they wanted to depict. Did they wish to represent a philosopher? He was nude with a cape over his shoulder and with the attributes of his character. Did they want to represent a warrior? He was nude with a helmet on his head, a sword attached to a shoulderbelt, a shield on his arm and ankle boots on his feet. Sometimes they added drapery when they judged that it could enhance the grace of a figure. . . . Since I believe I have responded in a satisfactory manner to the reproach that has been made to me, or that can be made, concerning the nudity of my heroes, I would like to be permitted to call upon artists. They know better than anyone how much easier it would have been for me to clothe them [the figures]: let them explain the extent to which drapery would have given me an easier means of making my figures project from the canvas. I think, to the contrary, that they will be appreciative of the difficult task I imposed upon myself, penetrated with this truth, that whoever can do the most [difficult thing] could do the least [difficult thing]. In a word, my intention, in making this painting, was to paint antique customs with such precision that the Greeks and Romans, seeing my work, would not find me alien to their ways of doing things.[18]

David asserts that he is following his antique predecessors, artists who customarily employed nudity in the depiction of historical, legendary, and mythological male figures. The precedents came from *art*, not life. He wanted his public to be aware that he was not illustrating an historical narrative, rather he transformed this narrative into a personal vision, and thereby transported it to the realm of art and the imagination. In *The Sabine Women* David announced a principal direction in his nineteenth-century oeuvre: namely, that he will turn away from the idea of art as a window on the world, an illusion of nature, an idea that had prevailed since the Renaissance, and will explore the metaphorical, symbolic, and imaginative possibilities in the painted image. This idea would become even further emphasized in *Leonidas* in which the spectator is always acutely conscious that she or he is viewing an imaginative vision filled with cultural and aesthestic allusions and ideas. In his defense of the warrior's nudity in the *Sabine Women*, David also expresses great pride in his technical mastery—he knew he had created a tour de force characterized by its difficulty and complexity. This is a further means of privileging the role of the artist in his own creation. A burgeoning idea of aesthetic freedom led David to violate the conventions of history painting and the narration of history itself to depict a variety of spectacularly beautiful male nudes brought together on a battlefield. Here the type of heroic, idealized nudity used by David, so germane to the debates on classical and modern art of the time, functions as a metaphor of radiant truth and an example of the autonomy of the artist. Of course, it is also powerfully erotic. David naturally understood that the spectator would not immediately think of

symbolic values when first viewing the male nudes (although Chaussard seemed to think this was the case and elaborated at great length on sublime physical beauty as an emblem of moral beauty and truth).[19] As in his previous paintings in which the male nude is privileged, David expected the viewer to respond initially at a visceral level, to feel the powerful physical and psychological attraction and impact of such forms and to marvel at their corporal radiance (similar to Pindar's "aigla," the divine light that bathed Olympic champions).

If David privileged the male nude in this way one wonders why he modestly clothed the Sabine women (only a few have bared or partially bared breasts, including the heroine herself). David realized that if Hersilia and her fellow Sabines were fully nude the entire impact of the painting would be altered. He has done everything in his power to emphasize their maternity—though certainly a sensual maternity—all have large breasts filled with mother's milk (even the elderly woman bears her voluminous breasts to Romulus as a plea for charity and mercy, a topos that originated with Homer). But, although he took pains to make the viewer aware of their erotic, maternal appeal, David eschewed an overt emphasis on their sexuality. To have the viewer focus on this would have detracted greatly from ideas he wished to convey of the transcendent powers of maternal, conjugal, and fraternal love (a theme he insists upon in his pamphlet as primary). Of course, eros is a dynamic and underlying force in the painting—the electrifying and beautiful bodies of both male and female figures serve as a compelling reminder that the family unit and all life originates with the sexual impulse. It is not surprising that a number of critics and theorists circa 1800 in France analyzed the purposeful, erotic power of the nude in art and its overt stimulation of sexual desire. One of the most important was the extremely influential archaeologist and theorist Emeric-David, who wrote:

> For us love has become the supreme judge of beauty. Rich in inventions which chance or science have given us, we have neglected the principal agent of our will, the majestic, sensitive, agile, robust body with which nature has en-dowed the being that it destined to rule the earth; the irresistible attraction that forces the two sexes to seek each other out and unite; this imperative drive for pleasure that does not choose; in which friendship, vanity, hope and admiration, disguise or beautify the faults that otherwise would thwart desire; . . . One could say that the body of man was formed only to obey the law that commands us to reproduce.[20]

In addition to his neoteric interpretation of this theme and his introduction of anti-historical, visionary, and imaginative forms into monumental history painting, in which the realms of time and the timeless are conjoined, David, as mentioned earlier, experimented with a compositional structure inspired by the sculpted relief. Rather than rely on his previous dramatic oppositions of individuals and groups (often separated by a void), David interwove the presentation of the protagonists with subsidiary vi-

gnettes and to a considerable extent gave equal attention to each individual represented. Most critics denounced him for this inexplicable "democratic" method,[21] but Chaussard hailed it, along with the nudity of the heroes, as one of the great innovations that rendered the painting a masterpiece.

> In addition he [David] felt that the interest, or rather the magic of a subject, was in the choice and number of accessory ideas it awakened. Here what a number and what greatness of accessory ideas.[22]

The intertwining of the divergent figures and groups in the composition is made more intense and complex by virtue of the interstices of the foreground figures through which one glimpses startling, dramatic, or lyrical vignettes, fragments of figures or groups that form subsidiary narratives and lead the spectator to question the nature of activities taking place behind the protagonists. One sees several principal vignettes and many minor ones. These unusual glimpses of activities or responses only half-seen can best be viewed by standing close to the painting. They recede in importance and form part of a dense and tumultuous middleground when one steps back far enough to view the entire composition at a glance. David intended the viewer to approach the painting closely and study the vignettes or anecdotes that contribute to a fuller understanding of the significance of the confrontation. He was so concerned with the multiple ways of viewing the painting, in fact (an idea that also was inspired by the domain of contemporary sculpture which witnessed very lively debates over fixed versus multiple viewpoints), that he rented a large exhibition space and charged admission, thereby eschewing the normative mode of making works known, i.e., through the Salon. The paid exhibition, which lasted from 1799 to 1804, brought David great financial success and public acclaim, but also inspired much negative criticism and resentment.[23] Despite persistant accusations that appear in the historiography, even today, David was not simply concerned with financial gain. He spent many long years working on the monumental canvas at his own expense—the work was not commissioned and had no specific destination or buyer. In bypassing the Salon and potential sale of the painting through this mode, in eschewing the academic exhibition, David privileged the significance of the viewing of his composition which was to be experienced under carefully controlled conditions and viewed alone from differing vantage points.

Several perceptive observers recorded the nature of the viewing conditions which they recognized as extremely important. In one of the earliest reviews, the art critic and amateur, C.P. Landon, described these conditions in considerable detail.

> The exhibition room is perfectly illuminated: those who like to appreciate the most delicate correction of forms, the finesse of tone, the feeling in the execution, the precision of details in the costume and accessories, can easily approach this beautiful work as much as they want to. Further away, one can easily take in the entire composition in one glance; *further away still* [my

THE ART OF CIVILIZATION

emphasis] a mirror that reflects it [the composition] from twice the distance away produces such an illusion that often one is about to forget that one has before one's eyes a work of art.[24]

Landon describes the ease with which the spectator can approach the composition in order to appreciate the great subtlety and beauty of details. This painting, unlike David's preceding works, invites this type of up-close viewing, even necessitates it. The viewer can then retreat to a greater distance to embrace the entire composition. From this perspective, the view completely changes as the overall complexity is meditated upon. Finally, there is a third way to view the composition. David set up a mirror at a distance which reflected the entire painting—other perceptive critics, such as Chaussard, also singled out the importance and position of the mirror that reflected the whole composition at a distance.

A mirror, placed at the *far end* [my emphasis] of the room, repeats and reflects the scene and the illusion. It is here that one sees the extent to which the painter has been true. The color of the figures is indistinguishable from that of the spectators.[25]

Chaussard emphasizes the distance of the mirror from the painting (signaled by Landon as well), that it repeats and reflects the image and the illusion of the battle itself which he discussed in a preceding paragraph and that the color tones of the figures are so true to life that they can be mistaken for those of living beings.

It is extremely telling that Chaussard mentions that only the color of the figures in the painting's reflection could be likened to that of the spectators for, in so doing, he hails the artist's remarkable ability to make flesh tones that appear true to life (we note that there is no mention of corporal configuration in this passage relating to the mirror reflection). The effect of the naturalistic skin-tones is more pronounced in the distant mirror which, in its reverse image, proffers an essentialized reformulation of the painting. A misreading of this sentence in Chaussard led one analyst to imagine that the spectators at the exhibition saw themselves intermingling and interacting with the painted figures in the mirror reflection—this resulted in a dubious interpretation of the type, meaning, and function of the mirror in the viewing of this work. In a recent article it was asserted that the mirror was a "psyche," an upright, vertical mirror on a pivot used in the boudoir that became popular during the 1790s—we are not told, however, of any of the critics of the time who identified it as such and I know of none who did (the only documentary evidence offered is that David owned a psyche—further research would have revealed that he, like many other artists of the time, used the psyche as a banausic device for establishing perspective in painting).[26] All the critics, in fact, use the term "glace," not "psyché," to refer to the mirror and, during this period, "glace" was defined as a rectangular mirror of very large dimensions (David would use this very type of mirror again in two later exhibitions of different paintings—*The*

Coronation of Napoleon and *Mars Disarmed by Venus and the Graces*).[27] This only makes sense for the narrow vertical shape of the psyche makes impossible the reflection of the enormous rectangular painting of the *Sabine Women,* which is 5.22 meters long and 3.85 meters high, and the critics do indicate that the whole composition was reflected in the mirror (none suggests that the reflection was partial or fragmentary). Had David placed a psyche, this new boudoir mirror, in his innovative exhibition of the *Sabine Women* critics would have denigrated it if not laughed at it outright. The comic entry of the boudoir into a public exhibition space would have been irresistibly risible. Observers would have immediately perceived that a vanity mirror destined for intimate, personal use does not belong in a public exhibition of a monumental painting—such usage would have violated norms governing private and public spheres and would have elicited considerable comment. Once the mirror has been tendentiously posited as a psyche we are led—because of the psychological resonance of the name—quite predictably, to a Lacanian exegesis. And we are asked to imagine that spectators trooped before the psyche in order to see themselves in it intermingling with a section of the crowd of painted figures—a singular phenomenon that critics would also have commented upon at length had it actually taken place (not one mentions such an occurrence). Whatever the type of mirror utilized, however, the idea that David wanted fully dressed spectators in modern clothing to see themselves, fragmented, as part of this antique battle scene which included nude male warriors is scarcely credible. That would be to introduce a carnival funhouse element to the viewing of *The Sabine Women* which is totally discordant with the tenor of the work (we remember that in his pamphlet David stated that his "intention in making this painting was to paint antique figures with such precision that the Greeks and Romans, seeing my work, would not find me alien to their ways of doing things"—an effect that would not be possible if figures dressed in modern clothing were darting about). Such an assertion not only contradicts what critics of the time had hailed as the perfect "illusion" achieved in the mirror reflection, it defies common sense as well. When one turns one's back to a painting to gaze directly into a mirror and, a fortiori, a mirror placed at a considerable distance from the painting, one sees oneself with the painting in the background, not as part of a painted composition.

David used the mirror in the *Sabine Women* and in two subsequent monumental works that differ radically in subject matter and mode—*The Coronation of Napoleon* and *Mars Disarmed by Venus and the Graces*—as an aesthetic and epistemological, not a sociological, demonstration. Both Landon and Chaussard hail the perfect illusion achieved in the distant mirror (critics would later proffer identical responses to the *Coronation* and *Mars Disarmed by Venus*). David wanted to demonstrate, through this perfect and undisturbed reflection of the entire composition, that his painting was a unitary whole and completely flawless—this use of the mirror as an indicator of compositional quality in a reflection that captured a pristine reformulation of the reversed image was part of traditional academic practice whose locus classicus was found in Leonardo da Vinci's *Treatise on Painting* (reprinted in French in 1715, 1796, and 1803). The mirror as a test of

compositional perfection continued to be promulgated by critics and theorists of the time. In their *Dictionnaire des arts de peinture, sculpture et gravure* of 1792, Watelet and Levesque quoted extensively Leonardo's advice concerning the use of the mirror in painting—Millin succinctly encapsulated these ideas in his art dictionary of 1806: "Leonardo da Vinci and Félibien advised painters to consult a mirror to recognize more easily the flaws of their works" (David's pupil and follower Paillot de Montabert continued to support this practice in his extremely influential *Traité de peinture* of 1829).[28] David's installation of the mirror, as Landon and Chaussard both recognized, was a challenge to the spectator to find any imperfection in the composition. In addition to demonstrating compositional perfection in the *Sabine Women*, David used the mirror as a serious aesthetic device (here and in later exhibitions of his paintings such as the *Coronation of Napoleon* and *Mars Disarmed by Venus and the Graces*) to allude to a multiplicity of meanings since the Renaissance attached to the notion of reflection, including art as the mirror of nature. We have seen how in this composition David has begun to challenge the conception of art as illusion of nature. In fact, David provides us with the perfect emblem of the reflexive nature of art. Art is no longer the mirror of nature, art mirrors itself, that is, art mirrors art.

The conditions of exhibition, which gave the spectator space and ease of viewing from multiple vantage points, along with the introduction of the mirror reflection of the composition in its entirety at a certain distance, reveal how concerned David was with the meaning and nature of viewing itself. He thereby hoped to increase the meditative possibilities of his composition. The viewer is compelled to a kinetic experience of the work of art—she or he is invited to scrutinize details at close range, to step back and take in the entire composition, and then to gaze at its reverse image in a distant mirror. Thus, the spectator can take time to reflect on the complexity of the subject and its possible meaning, on technical details, finesse of execution as well as on the significance of the interspersal of vignettes. Chaussard informs us that one of David's intentions through the execution of the *Sabines* was to move the viewer to a type of religious experience, to help induce, through the conditions of exhibition, a state of deep meditation that would lead to a transformation of feeling and thought.

> Moreover, this religious silence that they observed [the group of spectators], whether it was because of the interest of the scene and its majestic dimensions, or whether it was because of the reputation of the famous man and the magic of the execution that was so imposing, and this profound meditation on the faces of the spectators that I observed continually, no doubt flattered the artist more than the loudest applause.[29]

This fits with the aesthetic considerations that pervade this painting (the passage also calls into doubt the comic element of the funhouse mirror which certainly would not have been conducive to religious silence). As the great nineteenth-century art critic Théophile Gautier asserted in his perceptive analysis of the *Sabine Women*: "Everything in this remarkable composition is well thought-out, studied, examined and pushed to the

limits of perfection of which the artist was capable."[30] David knew that for a painting to be overpowering it must be charged with meaning and be informed by profound aesthetic ideas. The effect *The Sabine Women* had on its audience was carefully planned. And, as we have seen, David brought to bear on this painting, as he would on his next monumental project—*Leonidas at Thermopylae*—an almost febrile use of aesthetic and intellectual investigations.

David conceived of his monumental pendant for the *Sabine Women*, *Leonidas at Thermopylae* (fig. 66; colorplate III), around 1798; he began work on it almost immediately but did not complete it until 1814, making constant changes in the composition until the moment before he exhibited it in his atelier with the *Sabine Women*. The two works, which David thought of originally as sharing thematic, intellectual, and artistic concerns, do have in common an almost identical format and set of dimensions, a theme—the triumph of civilzation—and a profound interest in artistic experimentation. To a far greater extent than in the *Sabine Women*, however, David, in the *Leonidas*, explores a daring range and breadth of new aesthetic ideas distilled into an extremely rich, dense and fertile image. The painting is so complex and compressed in terms of artistic ideas, and so bold and innovative in terms of aesthetic experimentation, that it puzzled many of David's contemporaries; several, such as Delécluze, were so surprised by its devices and effects that they believed it signaled the artist's decline.[31] In actuality, the composition reveals David at the height of his intellectual, imaginative and artistic powers.

Under continual interruptions by the Napoleonic commissions, David struggled with the composition for fifteen years; during this period his ideas on art developed in significant directions. He profoundly meditated on the meaning of art and its possibilities for expression. He responded, in particuliar, to new anatomical, biological, evolutionary, and psychological ideas concerning human history, development, and behavior and, under the influence of these ideas, came gradually to reject certain conventions of "classical" standards and norms in the representation of the human figure. One of the most significant elements in the composition, for example, is the universal privileging of a type of male nude that no longer conforms to classical ideals of beauty.

The evolution of this fascinating and difficult painting, which spanned the entire Consulate and Empire periods, renders it one of the most thought-provoking examples of David's works. It fulfills admirably one of the artist's new prescripts for the making and experiencing of a work of art, namely, that art is a form of meditation. The painting, in fact, expresses an intimate nexus of novatory artistic and cultural ideas and constitutes a significant and powerful aesthetic manifesto.

When David first began work on the *Leonidas* he thought in terms of representing another epiphanous moment in the development of ancient civilizations, that moment when the "grand homme" Leonidas, the king of Sparta, decided to sacrifice his life and those of his private army of 300 men to defend the pass at Thermopylae against 600,000

66. David, *Leonidas at Thermopylae*, 1814, Paris, Louvre

Persians. This act of transcendent courage and self-sacrifice, which constituted a turning point in Greek history and led to the saving of Greek civilization (its triumph in the Persian War), instills profound reflections in Leonidas. Instead of a fierce and dynamic warrior preparing for battle, David has represented a meditative leader, engrossed in contemplation. Leonidas, who sits and ponders his decision, forms the central focus and still point in an otherwise highly animated composition, in which his men engage in varied activites as they prepare for the imminent battle in which all will inevitably die. We are here far from the world of the family and the heroines who played leading roles in the *Sabine Women*. What saves civilization in this instance are the bonds of male friendship and fraternal love, conjoined to obsessive patriotic responsibility; contemporary interpretations of antique sources focused on male bonding, love, and devotion as the most necessary social structure in Sparta where most men spent virtually their entire lives serving in the army in defense of their country. In *Leonidas at Thermopylae,* David took a subject popular in literature, the theater, and politics during the late eighteenth and early decades of the nineteenth century (Leonidas and the 300 Spartans were originally interpreted as great patriotic and Republican heroes and had been heralded as models for the Revolutionary cause),[32] and transformed it into a meditation on civilization, triumphant as a result of masculine friendship and devotion.

Because of the elapsed time from its genesis to its final exhibition—approximately fifteen years—the development of the composition is extremely difficult, if not impossible, to reconstruct. The vast number of drawings that survive, most not dated, add to the difficulty of the task. Delécluze, who offered the most detailed and comprehensive account of the painting's development, identified two principal stages, those of 1800–1802 and 1812–1814, (this "evolution" was recently modified by S. Nash and A. Schnapper).[33] Evidence from David's letters of the period, however, suggests that the artist continued to meditate on the composition and resented the many distractions that prevented him from completing it (this is also claimed by his earliest biographers writing in 1824–1827).[34] The most direct evidence for the final stages of the painting is provided by David's pupil Suau, who wrote long letters to his father from 1811–1813, in which he recounted the latest developments in the completion of the work.[35] One revelatory aspect of these letters is Suau's description of David's constant changes in the figures, his reworking and repainting that continued until the year of completion and exhibition. On October 6, 1813, Suau wrote: "Very often he effaced entire figures, made and remade entire groups, in such a way that all of this slowed down his work."[36] These continual changes indicate David's hesitancy and indecision. His ideas concerning the depiction of the human figure had undergone radical changes since he had begun work on the composition circa 1800 and he struggled to express his new formulation of this most significant element of history painting. He continued to struggle as well with the complex and important landscape in which the figures are situated. For, in this painting, David emphasizes the landscape that plays a major role in the meaning.

In spite of the lyrical beauty and importance of the landscape setting, however, the

space of the composition is oppressively constructed. The large number of foreground figures, most of which overlap, are uncomfortably compressed into a claustral space distinguished from the distant background spaces by the ominous dark cliffs of the mountain pass. In the far distance one can discern with difficulty the miniscule, vague hordes of the Persian armies, then the sea, mountains, and sky beyond. Dawn is breaking and the light is still indistinct in the distance. A different kind of light illuminates the heroes who are constricted in the narrow space of the pass at Thermopylae which is destined to be their tomb. Leonidas, the central figure, whom David identifies as the "king of Sparta" in his *Explication du tableau des Thermopyles* (distributed at the exhibition), is enthroned on a rock. He is distinguished from all the remaining figures by the prominence of his position (although seated he is still the tallest figure in the composition), by his physical immobility, and by his introspective state. The remaining figures are engaged in activity with the exception of Agis, Leonidas' brother-in-law, who is seated beside him on the ground, literally and figuratively in his shadow, holding an upturned helmet in his hands, thereby referring to and embodying the Belisarius motif—the vicissitudes of fortune. Agis looks up towards Leonidas pensively as though aware of the hero's thoughts. He is seated on the edge of a chasm, an opening in the earth that will soon be his tomb. In his pamphlet David tells us, in fact, that the imminent death of his friends is the subject of Leonidas' reflections.

> Leonidas, king of Sparta, seated on a rock in the midst of his 300 brave men, meditates with a type of tenderness on the imminent and inevitable death of his friends.[37]

In his *Explication*, David identifies the painted moment—that which immediately precedes the battle in which the three hundred Spartans rush to seize their weapons in preparation for battle—and, for the first time, he describes one of his paintings in considerable detail. Agis is seated near Leondias and awaits his orders. Two youths (on the far right) rush to seize their arms which are suspended from the tree. Behind Leonidas a chief devoted to the cult of Hercules, "civilizer of the known world," preserver of civilization, accompanied by a high priest, organizes his group of soldiers. The youth tying his sandal and the boy embracing his "father" are relatives of Leonidas whom he tried to send away from battle; they refused and decided to fight (the letter Leonidas gave to them with his orders lies in front of his right foot). One warrior uses his sword handle to inscribe in Greek characters on the side of a cliff the Spartan message to their people and to posterity. David translates this message literally as "Stranger, go tell the Lacedemonians that we have died here, obeying their orders." Four friends, their arms intertwined in a final embrace, take this oath to die for their country as they raise their crowns of flowers. Behind them, in the far distance, the opposing armies can be vaguely discerned. To the left in the foreground a blind warrior whom Leonidas had also sent away, is led back at his own behest by his slave. He prefers to die with his fellow

soldiers. On a road in the middle distance the slaves and mules return to Sparta with the equipment and instruments used in the sacrifices to Hercules and Aphrodite (whose altars are identified in the foreground). David wrote that the supplies and all that not concerned with battle were dispatched because: "Henceforth the Spartans will have nothing further to do with mortals: they are going to dine with Pluto."[38]

In his description of the painting, David provides an important key to understanding one level of meaning for he emphasizes repeatedly that the figures embrace for the last time, that many are intertwined, and that all are interconnected through the bonds of friendship and the common cause—to die for the country to which they are devoted. Leonidas meditates on the imminent death not of his soldiers but of his "friends"; four "friends" take an oath to obey the dictum being inscribed on the cliff, and the blind Euryotas wants to die with his "companions in arms." In his concluding paragraph David affirms the theme of devotion that informs the entire composition.

> The devotion of Leonidas and his companions produced a greater impact than the most brilliant victory. It taught the Greeks the secret of their strength, the Persians that of their weakness. The Spartans numbered 300 men, the Persians had more than 600,000.[39]

David implies that the fraternal bond of love and friendship that unites the soldiers is, by extension, the same bond that unites all the citizens of a country. As in the *Sabine Women*, the message to his fellow citizens is clear; passionate devotion to country is necessary for civilization to survive. The type of devotion that enables the Spartans—the king and his private army—to sacrifice their lives so willingly and without hesitation, is the secret of their strength; their deaths will lead to victory for the Greeks in this war and to the ultimate triumph of Greek civilization.

David took the final paragraph of his pamphlet from an extremely erudite and still neglected study that constituted the principal source of inspiration and cultural information for his reinterpretation of Leonidas and the Spartans—the Abbé Barthélemy's *Voyage du jeune Anacharsis en Grèce*.[40] Written over a thirty-year period and published in 1788 this rich, lengthy, and dense book, which George Steiner has called "the source of much of romantic hellenism" and "one of the major works in the history of European taste,"[41] proffered a late eighteenth-century reinterpretation of many of the most well-known antique literary and historical accounts of ancient Greece. The fictional narrator, Anacharsis, recorded his widespread travels around the Greek isles. He recounts most of the important historic events, such as the Battle at Thermopylae, as they had been told to him by various guides he encounters along the way, but he also describes in great detail the topography of each island, country, or city-state, as well as the mores, customs, traditions, institutions, and dress of the peoples of these various nations. This book, one of the most fascinating and important late eighteenth-century visions of Hellenism, remained extremely popular throughout the first half of the nineteenth century and was considered a scholarly source of ancient Greek history and customs.

David depended on it almost exclusively for his understanding of the Spartan character as well as for details of their customs and traditions.

Barthélemy offers a lengthy and detailed account of the Spartan temperament and morality, principally based on his interpretations of Plutarch and Xenophon. Following Plutarch he singles out Lycurgus, the philosopher-king whose laws provided a complete moral and political system for the Spartan people. Lycurgus' basic principle was to instill in all citizens an overwhelming, imperious, and impassioned love of country accompanied by a love of liberty: these ardent emotions and ideas completely dominated every aspect of their lives (understandably David would have been enthralled by this description).[42] The men spent their entire lives in the army to protect their freedom and way of life. And all citizens, both men and women, were directed in life by the following principles.

> A healthy and robust body, a spirit free from sorrows and needs, this is the happiness that nature intended for the solitary man; union and emulation among citizens is what men who live together should aspire to.[43]

The Spartans, therefore, are a people completely governed by moral principles and laws; and the citizens, renowned for their remarkably strong character, will, and courage constitute a type of ideal nation (as mentioned earlier, this image of the Spartans had a significant influence on Rousseau and predominated during the Revolutionary period).

Barthélemy's lengthy eulogy of the character of the Spartans directly inspired David (interestingly, Flaubert would also be obsessed by the theme).[44] Barthélemy also devoted lengthy passages to the mores of the Spartans, their government, education, religion, and military service—in his painting, David alluded precisely to many of the details described in these chapters. That he directly quoted Barthélemy in his pamphlet on *Leonidas* reveals that David read attentively his descriptions of the health, strength, and vigor of Spartan citizens (national requirements) but he was particularly interested in the descriptions of male bonding and friendship among the youths which was instituted and organized by the Spartan government. Young men would function as mentors to the younger boys whom they would choose based on erotic attraction. According to Barthélemy's understanding of the sources, however, this type of friendship and mentorship could not lead to sexual relationships—he writes that any breach of this law would lead to infamy and even the death penalty.

> In addition, the slightest stigma imparted to a union that had to be sacrosanct and which is almost always [sacrosanct], would cover forever the guilty party with infamy, and which would even be punishable by death, according to the circumstances.[45]

Thus, Barthélemy relates, what began as erotic love would lead to transcendent, indelible bonds of fraternal love which would form the basis of the unified moral strength of the army.

It was then [when they were twelve years old] that they began to establish the special liaisons little known in foreign nations, purer in Lacedemonia than in other Greek cities. Each of them is allowed to receive the assiduous attentions of a virtuous young man who is attracted to him by the allure of his beauty and by the more powerful charms of his virtue of which beauty appears to be the emblem. Thus, the youth of Sparta are divided into two classes as it were: one is composed of those who love, the other of those who are loved. The first group, destined to serve as models for the second group, carry to the point of enthusiasm a feeling that supports the most noble emulation, and which, with the transports of love, is nothing in essence but the passionate tenderness of a father for his son, the ardent friendship of a brother for his brother.[46]

Eros and philia, therefore, constituted the dominant forces in this military society. Barthélemy emphasizes that these bonds were established by strong sexual attraction to youthful male beauty and led to feelings of passionate love that, he claims, could not, by custom and law, ever be physically fulfilled; as a result, according to Barthélemy, sublimated sexual passions and erotic attraction developed into tender and fervent fraternal love. David was inspired by this account in his depiction of several Spartans—the four intertwined youths who swear an oath (reminiscent of the fraternal embrace of the three Horatii brothers) and, in particular, the youth who embraces an older man—these intense and loving embraces are characterized by a gentle and almost courtly tenderness. In several drawings for what would become transformed into the group of the youth and the older man (whom David describes in his pamphlet as "father and son"), the artist made very explicit the nature of the mutual sexual attraction of two Spartan soldiers by having them embrace passionately (the accolade of the soldiers, thus, becomes erotically charged) (figs. 67, 68, 69). In the painting, however, he transforms this overt display of homoerotic attraction into philia. Once again, as in *The Sabine Women*, but here more dramatically, David explores the primordial relationship between eros and civilization. The embraces of the male figures, who are depicted in an extremely tangible and sensual manner, are emblematic of the profound love upon which the entire army (and thereby the whole male population of Sparta) is based. And we remember that David wrote in his *Explication* that Leonidas meditated with tenderness on the imminent death of his "friends," all of the soldiers with whom he will fight and die.

Barthélemy also describes with eloquence the Spartans' acceptance of death to which they were unswervingly resigned[47]; this stalwart acceptance, which characterized the very young as well as the elderly, provided David with further evidence of the strength of the Spartans' moral convictions and their stoic emotional restraint and control which is so beautifully expressed in many of the figures in the painting (though not all are characterized in this way).

Thematically, the composition is inspired directly by accounts of the mores of the Spartans, but David also attended to Barthélemy's descriptions of their rituals on the day of battle. Immediately preceding battle, for example, sacrifices were offered and hymns

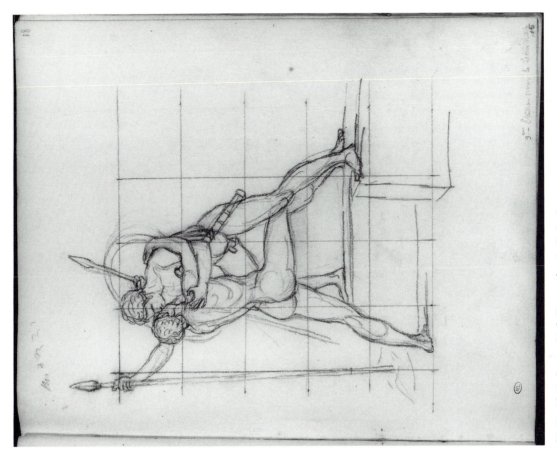

68. David, *Embracing Male Figures*, sketch, Paris, Louvre

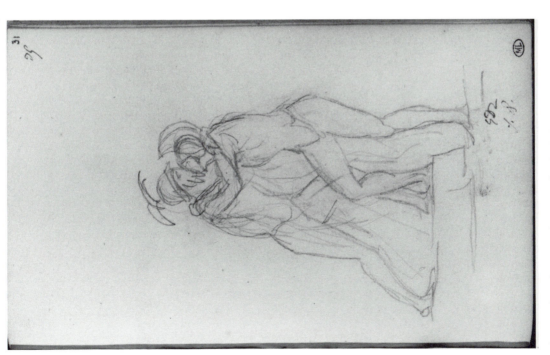

67. David, *Embracing Male Figures*, sketch, Paris, Louvre

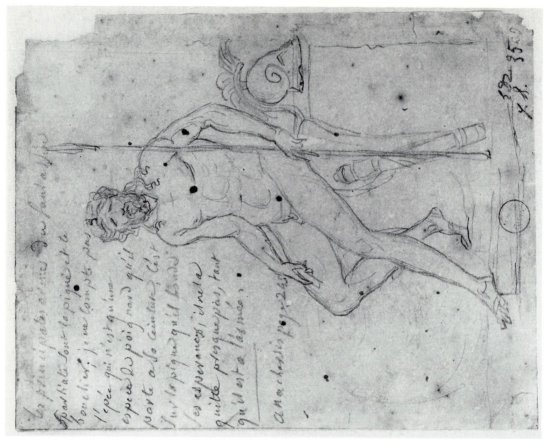

70. David, *Leonidas*, sketch, Montpellier, Musée Fabre

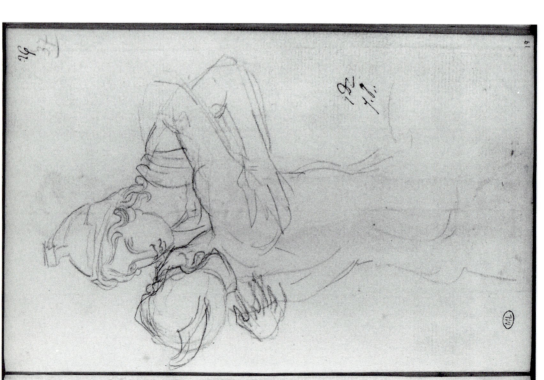

69. David, *Embracing Male Figures*, sketch, Paris, Louvre

sung by the soldiers who were crowned with flowers.[48] David imagines that a double sacrifice has just been completed, one to the warrior Hercules, from whom the kings of Sparta were believed to be descended, and the other to Aphrodite, the goddess of love. It is fitting that David conceived of this ritual sacrifice to Aphrodite in conjunction with that of the hero Hercules because the Spartans are dually motivated by an ardent love of each other, an erotic yet transcendent love, as well as by their love of country and their devotion to fierce combat. In David's painting some of the Spartans still wear their crowns of flowers, others, such as Leonidas himself and the chief and troops devoted to Hercules, are already armed and wear helmets, while several are about to arm themselves (i.e., Agis who holds his helmet and the two youths to the far right taking down their weapons from the tree branches). A lyre crowned with laurel adorns the massive oak tree (Barthélemy relates that the mountains of the pass were covered with oak trees),[49] reference to the god of music, poetry, reason, and enlightenment, Apollo, and an indication of the religious hymns that have just concluded.

David has also followed quite specifically Barthélemy's descriptions of the Spartan warriors' cloaks and weapons.[50] On a striking and disturbing sketch of Leonidas (fig. 70), David copied the following passage verbatim from Barthélemy.

> The principal weapons of the foot-soldier were the pike and the shield; I do not include the sword, which was but a type of knife that he carried on his belt. He placed his hopes in the pike, he was almost never without it, as long as he was in the army.[51]

David identified this passage by source and page number, further direct evidence of the influence of the *Voyage du jeune Anacharsis* on his composition. In this drawing, and in most of the studies for the composition, David depicts the Spartans nude rather than clothed. In this, too, he may have been influenced by Barthélemy's text (although, as we shall see, many other elements contributed to this decision), for the antiquarian repeatedly states that nudity was a customary mode for the Spartan males (as well as the youthful females who, as youths, fought one another in mock battles completely nude), a custom that originated with the great reformer Lycurgus himself.

David was inspired by the account of the Spartans in the *Voyage du jeune Anacharsis*, but this was only one element that contributed to his formulation of the composition. Barthélemy described at length the battle at Thermopylae and emphasized, quite expectedly, Leonidas' great heroism as well as that of his men. But he did not describe the moment chosen by David nor did he describe the figure of Leonidas, as David has depicted him. One of the composition's most brilliant and extraordinary inventions is Leonidas himself, which was singled out by critics of the time for its "sublime" expression. Here David achieved new levels of psychological intensity and complexity expressed through the face (fig. 71). Many critics were enthralled by the nexus of emotions and ideas conveyed through physiognomy; Boutard wrote that one saw in this meditative expression "a feeling of compassion conjoined to a firmness of steadfast resolve."[52]

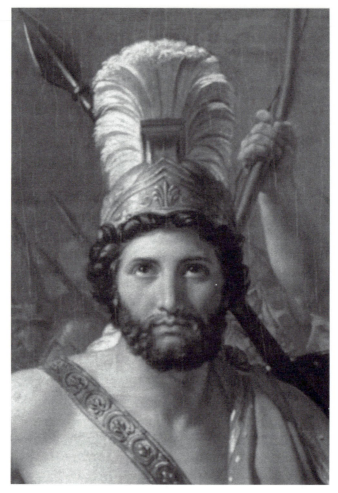

71. David, *Leonidas*, detail, Louvre

In her rather extraordinary pamphlet on the painting, notable for its impassioned tone, the Countess Lenoir-Laroche also singled out the face of Leonidas.

> In this sublime head, all expressions are combined, it is the *justem et tenacem*, the virile man filled with courage. All the grandeur of his country is present in his *profound soul*. The call to battle directs his gaze towards heaven with a fixity that expresses the entire extent of his devotion.[53]

Similar sentiments of great praise for the sublime and religious expression of the head of Leonidas were repeated by critics who viewed the work at its first exhition in 1814, at its second exhibition at the Galerie Luxembourg in 1819 (after it was purchased by the Restoration Government along with *The Sabine Women*), by David's early biographers in the 1820s, by his friend A. Lenoir in 1835, and by Delécluze in his

monograph of 1855.[54] Most observers of the painting noted that David had concentrated his attention on the expressivity of Leonidas' face and had achieved an extraordinarily subtle conjunction of the resolute and fixed expression of the mouth, the stillness and rigidity of the facial muscles, with the mobile and fluid eyes that look upwards in an almost accusatory manner, as if the hero were wondering why this immolation had to take place. This thought seems to cross the minds of several other figures in the composition—such as the oath-taking youth behind Leonidas who has turned his head away in dismay as well as several of the followers of Hercules, who express a range of emotions from worry, anxiety, and fear to fatuousness and arrogance. Most of the Spartans are filled with fervor and concentrate on the activity at hand with intensity and complete absorption (such as the youth tying his sandal, the blind Euryotas, and the young soldiers taking their weapons down from the tree); others, like Leonidas, are absorbed in thought but their imminent death and those of their companions seem to lead to fear and hesitation. None equals the brilliance, subtlety, and ineffable quality of Leonidas' expression.

It is worth considering in detail how David came to such a complete revaluation of the expressive head, for it represents just one more neglected transformation in the history of French art effected by David. During the first decade of the nineteenth century David had begun meditating more profoundly on the possibilities for complex psychological expression in the face. His concerns correspond to a dramatic revival of interest in France in physiognomy as the seat of spiritual, intellectual, and psychological revelations. Between 1805 and 1809 the physician Moreau de la Sarthe published a new annotated ten-volume illustrated edition of Lavater during a period when modern psychology was emerging as a discipline.[55] Philippe Pinel, for example, published his *Traité médico-philosophique sur l'alienation mentale, ou la manie* in 1801 while psycho-physiologists who emerged from the school of Vitalism centered in Montpellier, such as Cabanis, Maine de Biran, and Bichat, were publishing compelling treatises on the interrelationship between the mind and the body, the soul and the will.[56]

This revival of interest in medical and philosophical writings on inner states as they are manifested in exterior form found their parallel in propaedeutics at the Institut. The redefinition of the expressive head in French art education, in fact, and the results for painting, have been virtually overlooked; David's role in this reformulation was paramount. David had been one of the first members appointed to the new Classe de Littérature et des Beaux-Arts at the Institut National des Sciences et des Arts, founded in 1795 to replace the former Academy according to Danou's plan. The artist helped redirect art education based on his own aesthetic ideals. His involvement with the new system was intense.[57] The Classe des Arts met every five days and in the minutes of almost every meeting during the early years of this new organization we find David's signature. He was not only present at most meetings, he also figured prominently on major committees that determined propaedeutics at the Institut.

One of the most significant of these early committees on which David sat met in

1795 and was in charge of reformulating art education in Paris and in the provinces. One of the principal goals of the committee was to ameliorate and transform the conventions governing the "expressive head" that had been instituted by Le Brun in the seventeenth century (see chapter I) and to replace the elementary stereotypes with more meaningful, profound, and complex expressions. The Committee report, signed by David along with Dufournoy, Julien, Regnault, Vien, and Pajou, stated the following.

> Le Brun wrote a *Traité des passions* related to his art in which he tried to describe the diverse effects that they [the passions] produced on the exterior of the human body. Whatever merit can be recognized in this truly elementary book, it is easy to imagine that it can still be improved upon and above all accompanied by a better choice of forms and a greater number of examples in order to follow the soul in the slightest modifications of its emotions.[58]

The Committee denigrates "this truly elementary book" for its simplicity and its limitations. Le Brun's paradigms are no longer adequate for the purposes of "modern" expression.

The Committee's call for a modern replacement of Le Brun's treatise, one that would provide more suitable—that is, more subtle and complex models for students to study and emulate—seems to have been answered by Gault de Saint-Germain. In 1804 he published *Des passions et de leur expression générale et particulière sous le rapport des Beaux-Arts* with engravings of heads adapted principally from celebrated Italian Renaissance, seventeenth-century, and occasionally eighteenth-century French masterpieces.[59] If we compare just one example, *Le Rire* (fig. 72) from Gault's publication, a head of a satyr adapted from a painting by A. Coypel, with Le Brun's *Le Ris* (fig. 73), we see the extent to which a much more subtle, complex, and ambiguous facial expression has replaced the schematic, simplified head from the seventeenth-century publication. In the 1804 expressive head it is not only the facial features that contribute to the subtlety of expression, but the entire configuration of the head, the angle at which the face is turned and its position relative to the neck and shoulders. This characterizes all of the expressive heads of Gault's edition. In Gault's figures the complexity of a psychological state replaces the simplified emotions of Le Brun's stereotypical paradigms. Two particularly remarkable examples, *Le Désir* (fig. 74) and *La Sécurité* (fig. 75), make clear the importance ascribed to the structure of the head in contributing to the communication of inner states which are seen to be confluent with temperament, character, age, sex, and race. In these heads the emphasis is not only on individual and particularized psychology but on racial type as well. A study of Gault's engravings reveals the significant impact they asserted on the repertory of figures in the works of Romantic painters such as Géricault and Delacroix.

David's support of the new definition of the expressive head, which took into account all of these elements, led to an overriding concern of the students at the Classe des Arts with representing interior states of being, emotion, and thought. And the

73. Le Brun, *Le Ris*, from *Conférence sur l'expression générale et particulière*, Paris, 1698

72. Taessaert, *Le Rire*, in Gault de Saint Germain, *Des Passions et de leur expression générale et particulière sous le rapport des Beaux-Arts*, Paris, 1804

LA SÉCURITÉ

Tiré du tableau représentant le portrait de Raphaël et de son Maître d'Urinet.

Peint par *SANZIO RAPHAEL.*

Élève de Pietro Vannucci, dit le Perugin.

75. Taessaert, *La Sécurité*, 1804

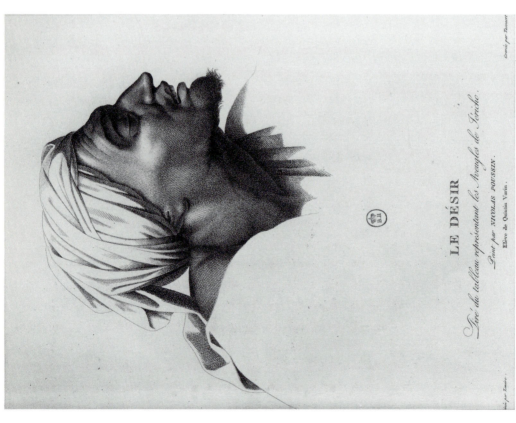

LE DÉSIR

Tiré du tableau représentant les Aveugles de Jéricho.

Peint par *NICOLAS POUSSIN.*

Élève de Quintin Varin.

74. Taessaert, *Le Désir*, 1804

assigned subjects for the reinstated annual competition for the "tête d'expression" revealed circa 1800 a primary interest in the depiction of introverted, psychological states in the portrayal of an individual. A significant change in the choice of subjects from the eighteenth-century competitions reveals this radical shift in interest. From the 1760s to the 1780s, *La Douleur, La Joie, L'Attention, La Gaieté* (fig. 76) were typical categories of the annual competition. By 1800, however, we find *La Profonde vénération* (fig. 77) and *Le Sommeil agréable* (fig. 78), subjects that demonstrate a new awareness of, and fascination with, elusive psychological and even physiological states.[60] In these "têtes d'expression," which combine in an unusual manner antique and modern elements in dress and coiffure in the depiction of recognizable individuals whose features are clearly particularized, the upper body plays a distinct role. These are not, in fact, "heads" of figures but depict the torso to a cut-off point just above the waistline. By offering a view of the upper body, the aspiring artist reveals how this essential part of corporal expression contributes to that of the face (principles, of course, directly derived from David). This attempt to express psychology through exterior signs, the semiology, of the face and torso are the essence of Davidian reforms in the newly reformulated expressive head.

This new and intense privileging of subtle physiognomy becomes one of the most significant elements in the *Leonidas*. And, in this composition, more than in any other of his previous paintings, David subtly represented the interrelationship between head and body in what we might call physiological terms. The depiction of the body itself has certainly undergone dramatic transformations from the corporal expression of the figures in *The Sabine Women*. As in the *Sabine Women*, David has used recognizable prototypes in a number of figures. The embracing group of the "father and son," which, as many drawings reveal, underwent numerous transformations from homoeroticism to philia, was inspired by a pair of embracing soldiers from the *Column of Trajan*. The youth reaching for his weapons from a tree, balanced on the ball of his right foot in a graceful, balletic motion, recalls Giovanni da Bologna's *Mercury* (as critics of the time noted). It has frequently been observed that the entire figure of Leonidas is taken from an engraving of Ajax in Winckelmann.[61] If David, however, still adhered to his new principle of the prototype he believed was purely ancient "Greek," he introduced in the *Leonidas* odd and disturbing canons of proportion which, even more remarkably, differ from figure to figure. The most important figure, the hero Leonidas, has the most distressing and odd proportional ratio of head to body—the body is extremely elongated. The acceptable "classical" ratio circa 1800, based on the measurement of Greek sculptural examples and much discussed in late eighteenth-century treatises of art, was quite different. This classical canon was promulgated by Francois-Anne David who published measured examples of Greek sculpted figures (fig. 79) in his *Eléments du dessin ou proportions des plus belles figures de l'antiquité* of 1798, a manual used widely by artists of the time.[62] In his proportions of Leonidas, however, David rejected this canon and seems to have exaggerated instead the proposed proportions of the ideal male in life and in art. In his manual, F.-A. David proffers the differences between the "live" canon and the antique sculp-

76. Bonnieu, *La Gaieté*, Paris, Ecole Nationale Supérieure des Beaux-Arts

77. Guillemot, *La Profonde vénération*, Paris, Ecole Nationale Supérieure des Beaux-Arts

78. Lebel, *Le Sommeil agréable*, Ecole Nationale Supérieure des Beaux-Arts

tural canon, following earlier paradigms such as those found in the drawing manual published in the *Encyclopédie* in 1763. In these earlier examples, the scale of the human model (fig. 80) and Greek sculpted models vary considerably (fig. 81). This telling disparity between the ideal proportions of the live model versus the model in antique sculpture inspired David to employ multiple canons of proportions in the painting, ranging from 8 to 1, 6 to 1, 5 to 1, and 4 1/2 to 1 and creating a disturbing impression on the spectator. Critics of the period who recognized this disparity and plurality (without overtly stating it—they were simply made uneasy by the differing depictions of the figures) attributed it to flaws in perspective—figures who were constructed according to different rules could not possibly be sharing the same space.[63] The perceptive critic Miel himself was puzzled by these "errors" in drawing; another observer lamented that the Spartans were supposed to be well-proportioned and wonders why the figures appear either too small or too large for the space they occupy.[64] Boutard asks why David painted such disturbing bodies after the great beauty of corporal expression in the *Sabine Women*.[65] Others avoid commenting on the figures, preferring instead to find what was praiseworthy in the composition.

Two of David's early biographers of the 1820s, Thomé and Coupin, who highly praised the sublime physiognomy of Leonidas, equally denigrated the "formes communes" of the bodies they found to be very "un-Greek."[66] In 1855 Delécluze tried to account for the disparities in the depiction of corporal forms by attributing the more beautiful forms to the first campaign in the development of the painting. David had begun the painting as a "poète" but completed it as a "prosateur."[67] Delécluze blames the "prosaic" characteristics, what others called the "formes communes" (departures from idealized, perfected beauty), on the interruptions of the Napoleonic commissions David suffered from the time he began the painting to its period of completion. He further suggests that the lyrical beauty that remains in what he claims to be the earlier figures (such as the three entwined youths and the "father" embracing his son) has been replaced by a vulgar naturalism in the later figures (i.e., the blind warrior and the youths to the far right taking down their weapons from the tree). But is the composition really a combination of early and late or do we believe Suau, the pupil in David's atelier during the completion of the *Leonidas*, who, as mentioned earlier, wrote to his father in 1813 that David was continually effacing and repainting many figures?[68] It may be impossible to unravel the chronology of the figures in the painting over the fifteen-year period, but we do know that David made an important decision to retain, in the final painting, a plurality of styles whose canon of proportions varies as well, which he knew would surprise and disconcert his public.

David could certainly incomparably paint the classical nude—as everyone had seen in the figures of Romulus and Tatius and their grooms in *The Sabine Women*. He deliberately renounced this mode in *Leonidas*. And, in his decision to do so, he seems to have been following the innovative ideas concerning proportion in ancient Greek sculpture eloquently expressed by the archaeologist and theorist Emeric-David in his

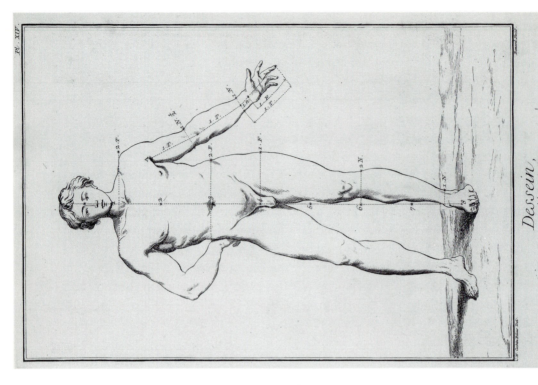

80. Cochin, *Proportions générale de l'homme, Encyclopédie . . .*, 1763

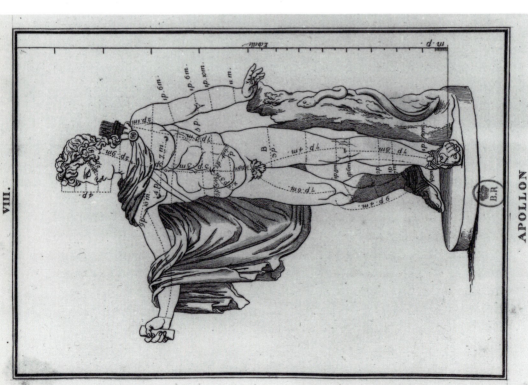

79. François-Anne David, *Apollo, Elémens du dessin ou proportions des plus belles figures de l'antiquité*, Paris, 1798

Pl. XXXIV

81. Cochin, *Proportions de la Statue d'Antinoüs, Encyclopédie . . .*, 1763

seminal treatise, *Recherches sur l'art statuaire* of 1805, a work that exerted an enormous impact on art and art theory throughout the nineteenth century.[69] In his lengthy discussion of proportion in *Recherches sur l'art statuaire*, Emeric-David denied that there was one single canon in Greek art. He declared that this was an impossibility since the canon would, of necessity, be altered with any change in the type of figure (age, sex, character) and position (sitting, kneeling, running, etc.). Emeric-David asserted instead that every ancient Greek artist created an individual canon of proportion based on a variety of live models and according to the requirements of his chosen subject—i.e., age, sex, constitution, pose, gesture, etc. And he recommended that modern artists do the same.

> Following the example of the Greeks, every artist himself can create his own proportions. The greatest difficulty does not lie in making them but in making use of them productively.[70]

David was directly inspired by this idea, for in the *Leonidas* he not only created his own individual canons of proportion but he used these multiple canons as a pictorial device that would contribute to the meaning. For the use of the multiple canon of proportions not only makes the figures into distinct individuals who differ in their very construction, it also makes the painting a world apart, distinct from nature even though so much in the composition appears to imitate the natural world closely.

Another startling aspect of the figures is their heavy, earthbound, sensual forms which appear dense, material, and firmly fixed in the terrestrial realm. The earthiness, sensuality, and heaviness of the figures express poignantly the theme—the earth will soon consume the soldiers' bodies, it will become their tomb as they dine with the cthonic gods. In struggling with the apposite mode of depicting Leonidas and his companions, a wrenching struggle according to Suau, one in which David was beset by continual changes of mind, the artist was (as we have come to expect) very likely reflecting upon recent discussions in the sciences and the arts concerning the body as an expressive instrument of character and temperament. One very significant study of the body that sought to unite the arts and sciences was written and illustrated by a physician from Montpellier, Jean-Galbert Salvage. His treatise, *Anatomie du Gladiateur combattant, applicable aux beaux arts . . .* , known in manuscript form as early as 1804, was published in 1812.[71] The frontispiece (fig. 82) alone serves as an emblem of the arts and sciences working in conjunction to improve one another and the world. Salvage's project had an important impact on prevailing aesthetics for he had made an écorché of a plaster cast of the celebrated *Borghese Gladiator* in order to demonstrate that the work was based on an intimate study of anatomy. He then made illustrated plates that would reveal the figure's skeletal and myological structures just as one would find in an anatomy book (figs. 83, 84). With this study Salvage hoped to provide irrefutable evidence that ancient Greek artists did not merely observe the body and imitate what they saw but

82. J.-G. Salvage, *Frontispiece, Anatomie du Gladiateur Combattant, applicable aux beaux-arts* . . ., Paris, 1812

that they analyzed it scientifically through dissection. In his prospectus for his study published in 1804, Salvage stated the following.

> In order to complete this study I have *anatomized* a plaster cast, a very good copy of the Gladiator, in order to convince those who have for a long time doubted that the ancients knew the mechanism of the human body that this figure is beautiful only because anatomical principles have been faithfully observed and that in order to achieve a similar masterpiece art and science must work together.[72]

David was a direct supporter and promoter of Salvage's work, for he was part of the Committee that had enthusiastically approved the study which had been submitted to the Classe des Arts in 1804 and had adopted it for propaedeutical use. The report, signed by David and other members of the committee (Bervic, Houdon, Joachim le

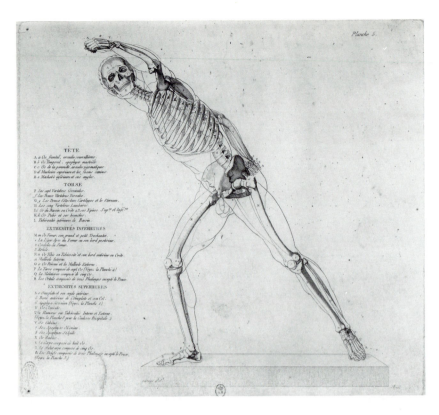

83. J.-G. Salvage,
Gladiateur anatomisé,
Skeletal System, from
*Anatomie du Gladiateur
Combattant* . . .

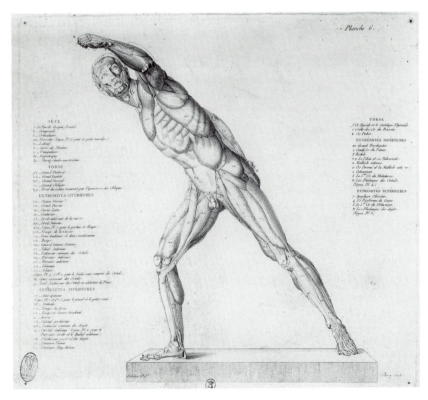

84. J.-G. Salvage,
Gladiateur Anatomise,
Myological System, from
*Anatomie du Gladiateur
Combattant* . . .

Breton, Moitte, Regnault, and Vincent), hailed the study and described it in the following way.

> By reducing this plaster cast to the state of an écorché, M. Salvage has sought to prove that this statue is truly beautiful only because anatomical principles have been faithfully observed, and that it is impossible to make similar masterpieces if one does not unite the positive science of anatomy to the genius and talent of the artist.
>
> Your committee thinks that M. Salvage's engraved drawings of the écorché of the Gladiator could be very useful to the study of drawing and principally to the studies necessary for painters and sculptors. We also think that up to this point nothing has been made with such precision in this genre and that the author deserves to be encouraged. The conjunction of anatomical knowledge with the talent of the draughtsman are necessary for these types of works and it is because they have never been united to a sufficient degree that we do not have satisfactory basic works of this nature.[73]

David paid close attention to Salvage's plates, which so convincingly demonstrated the degree of anatomical perfection in the *Borghese Gladiator* but he also looked carefully at Salvage's study of motion and stasis which constituted an equally important part of the study. In fact, David seems to have been directly inspired by Salvage's plate *De la statique du corps humain* (fig. 85), which illustrated his discussion: "the movement of the Gladiator, on leaping, dancing, on the pirouette and on the equilibrium of the body" ("Du mouvement du Gladiateur, du saut, de la danse, de la priouette et de l'équilibre du corps"). Salvage explains the structural mechanisms that govern "Standing," "Walking," "Running," and in this engraving he represents the stages of movement from a static to a running position as well as dance movements and positions (which he discusses in detail since they are vital to his analysis of equilibrium). In *Leonidas* David has used a number of different positions described and illustrated by Salvage that depend upon corporal equilibrium. The four intertwined youths and the one reaching up for his shield on the tree are variations, for example, on pirouette or "running" movements. The figure of the blind Euryotas, in a lunging movement, the warrior delicately balancing himself on the cliff in order to inscribe the Spartans' last oath, the youth tying his sandal, the boy embracing the old man who leans his weight on his left leg and has his knee raised, the young soldier who echoes this position to the far right of the composition, all these figures depend upon a delicate sense of balance and equilibrium. On one level, in fact, the painting is a celebration of the multiplicity of complex positions and movements made possible by the skeletal and myological structures of the body itself. And David has brilliantly combined elements of both stasis and movement, in posture and counter-posture, in this strange and compelling portrayal of a crowd of nude male figures who are characterized by the variety and complexity of their multiple positions. The compendium of corporal possibilities displayed in this painting and, indeed, in David's entire oeuvre, bears comparison with the corporal experimentation of

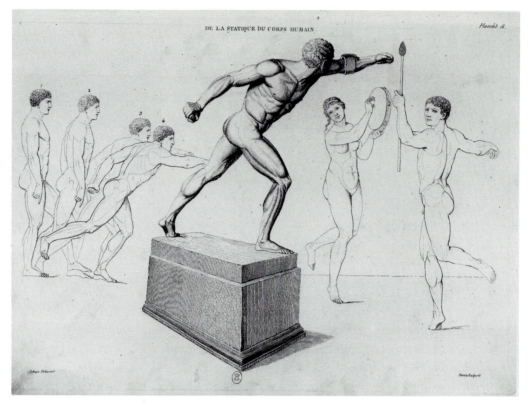

DE LA STATIQUE DU CORPS HUMAIN.

85. J.-G. Salvage, *De la statique du corps humain, Anatomie du Gladiateur Combattant* . . .

Degas and Rodin. The latter, in fact, shared with David the same obsessive quest for a virtual phenomenology of the body. Leonidas himself expresses the perfect union of stasis and movement, thought and imminent action—he does appear as though he is about to spring into action and propel himself with his flexed left leg from the rock on which he is seated (Miel had noticed and perceptively described this captivating corporal configuration).[74]

Salvage was one of many individuals working on these ideas; his study belongs to a much broader aesthetic debate in the early nineteenth century concerning Greek concepts of the human figure. One of the leading figures in this debate, as mentioned earlier, was Emeric-David whose *Recherches sur l'art statuaire* created a sensation and was destined to become the most influential handbook on sculpture in nineteenth-century France. The lengthy theoretical part of Emeric-David's study was concerned almost exclusively with Greek ideas of the human form. He affirms what Salvage's study sought to prove, namely that the Greeks knew anatomy and understood the interior structure and functioning of the body as well as its exterior (what he called the "dessus" and the "dessous").[75] In a passage that supports Salvage's findings, he states that modern sculp-

tors, like their Greek predecessors, must begin with the skeleton, the center and origin of all movement.[76] Emeric-David supports his thesis by offering examples from ancient art that reveal this concern of the Greeks for the skeletal structure, namely an image of Promethus, the first sculptor, who fashioned a figure of a man from clay, depicted modeling a skeleton.[77]

Emeric-David's claim that the Greek sculptors knew anatomy and used it as the basis of their art leads him to then make a lengthy and detailed argument against the "beau idéal" as a governing principle of Greek art. The Greeks were concerned with representing the "beau visible," the "beau réel," that existed in nature, not in an abstract realm removed from it.[78] In constructing such an argument Emeric-David opposed outright those ideas of his rival, the archaeologist and theorist Quatremère de Quincy, a remarkably influential figure at the French Academy during the early nineteenth century and an indefatigable supporter of the "beau idéal." Quatremère was so infuriated by Emeric-David's rejection of the "beau idéal" as a fundamental principle of Greek art that he replied in an acerbic article published immediately after the *Recherches* appeared, entitled "Sur l'idéal dans les arts du dessin."[79] In this direct attack on Emeric-David, Quatremère asserts the predominance in the greatest works of Greek sculpture of an ideal, intellectual beauty, a beauty that can only be imagined in the soul and cannot be found in nature. Nature can only produce an inferior, flawed human figure and therefore the artist of antiquity only used the live model as a beginning, a base that he could then elevate to match his ideal of beauty.[80] Emeric-David had denigrated in explicit terms this concept of "supranatural" beauty which, he claimed, was a modern misunderstanding of the antique.[81]

Contrary to Quatremère's ideas on the "beau idéal" Emeric-David asserts that nature does provide the true model of beauty in those who developed their bodies to the utmost degree of strength and perfection—Greek warriors, who provided Greek society, including artists, with their ideas of beauty. David, like most French artists of the time, must have carefully read Emeric-David's eloquent descriptions of the bodies of Greek warriors, how they were formed, and the impact they made upon the imagination.

> They fought hand-to-hand. The vigor of their limbs and the accuracy of their movements by determining the success of individual combats decided that of the battles.
>
> In early times one had seen that a tall and robust man could turn back, according to the expression of the poets, batallions of heroes, that in several moments a rapid runner could bring the important news of a victory. With the same ease it was noticed, in observing the exteriors of these useful men, that their strength, suppleness, quickness and their particular aptitude for different exercises, depended on their differences in structure. Instinct recognized the beautiful. . . . Public interest and the emulation of warriors led to great value being placed on corporal qualities.[82]

In order to be victorious, Greek warriors had to be powerful, robust, supple, light-footed, and agile. These characteristics, therefore, became the hallmarks of beauty and were highly developed by performing in athletic games and sacred, pyrrhic dances—the dances of war that combined gymnastic exercises and the movements of warriors in battle. In fact, dance itself was an integral part of military and athletic training as D. S. Carne-Ross has eloquently described.[83] David adhered to these ideas in his *Leonidas*, for many figures are light-footed and engage in graceful, agile dance-like movements, all appear supple, robust, and powerfully strong. David also attended to what Emeric-David described as the "signs" of the body, for the beauty of exterior form was an indication of inner, moral beauty.

> the divine flame that moves in us, piercing the envelope that contains it, reaches the surface of all of our limbs and shines. One cannot doubt that the habitual state of the soul is visible on the exterior of the body.[84]

Using antique sources such as Plato, Aristotle, and Anaxagoras, Emeric-David sought to demonstrate that the Greeks learned to read the signs of the body, for the face, torso, limbs, and even the extremities expressed the individual's intelligence and moral character.

David must not have been surprised to see these arguments in print for they confirmed what he had been trying to communicate through corporal signs since the 1780s, all the while firmly believing that he was revitalizing a principle of Greek art. These ideas that he had continued to develop and implement are brought to a new level of intensity in *Leonidas*. He must have also heeded what Emeric-David described as the basic motor for all corporal expression and action—the will.

> What is the body of man? It is an instrument destined to carry out the plans of very well-ordered wills, gifted with organs that, following the degree of their sensitivity, bring to the spirit more or less accurate ideas, and which submit to needs whose satisfaction is in itself a cause of pleasure. If this instrument is constructed in such a way that it executes the movements that the will prescribes with promptness, vigor, accuracy and without encumbrance, if all of the parts of which it is composed, filled with feeling and life, harmoniously lead numerous ideas towards the interior, it is thus clearly more perfect than any other [instrument] because it can procure and give to others greater and purer enjoyment.[85]

The fascination with the will and its interrelationship with the body, as well as speculations on its sources and its effects, which, as we have seen, developed in the late eighteenth century and were consistent concerns of David's since *The Oath of the Horatii*, pervade as well his masterpiece, *Leonidas* (these ideas and concerns, of course, would become prominent interests of French Romanticism). David understood quite clearly that the impassioned defense of the pass at Thermopylae was, above all, a triumph of will.

David's painting was also informed by recent discussions of the relationship be-
tween mind and body, physical and moral man, and the role of the will that had been
analyzed at length by the physiologist and vitalist Cabanis, whose objective was to unite
physiology and ethics. Cabanis' *Rapports du physique et du moral de l'homme*, Paris, 1802,
had been summarized in 1802 in the *Décade philosophique*, the popular journal read by all
those interested in the world of ideas.[86] The basis of Cabanis' treatise was that "le
physique et le moral se confondent à leur source," that the body and moral characteris-
tics were inseparable. The physiologist contended that the body, in its differentiations of
sex, age, and temperament, was subject to differing conditions of diet, climate, health
and illness, etc. but, because of a governing intelligence, which Cabanis distinguished
from instinct, man could change his physical proclivities. His will, therefore, acted as
an important intercessor in what would otherwise be biological determinism.[87]

These new ideas concerning the structure, biology, and physiology of the human
body and their relationship to moral ideas informed David's *Leonidas* at every level. For
David was confronted with the problem of trying to account for the decision of Leonidas
and the 300 Spartans to die without hope of escape, a type of mass suicide undertaken for
moral reasons—for love of country and the good of their fellow citizens whom the
warriors are dedicated to protecting. This helps to explain Leonidas' pronounced expres-
sion of firm resolve—his will, his moral ideals vanquish the biological drive for self-
preservation (an idea analyzed at length by Lamarck during the first decade of the
nineteenth century).[88] David's decision to depict Leonidas in this way reveals the final
outcome of an artistic struggle, for David wrestled with many variations of the figure of
Leonidas, several antithetical to the figure we see in the painting. In what Jules David
identified as the first idea for *Leonidas at Thermopylae* (fig. 86) we see the hero as the
central figure in a composition in which only one or two figures would survive in the
final version. Although sketched in an abbreviated fashion, we see that at an early stage
in his thinking about his composition David conceived of the Spartan warrior-ruler as a
hesitant, indecisive figure whose slumped posture and relaxed, extended legs, in con-
junction with the empty, almost puzzled expression of his face, is far from the resolute
hero of the painting. This is the same Leonidas that we have seen in the drawing from
Montpellier (fig. 70), in which David depicts the body of an older man, one whose
posture makes him appear burdened and tired, whose facial expression reveals worry,
indecision, and puzzlement. This negative, anti-heroic expression is even more pro-
nounced in another early drawing of the composition (fig. 87) in which Leonidas appears
completely introverted, melancholy, and withdrawn. His heavy, motionless figure is
fixed in a seated position for his knees and his ankles are crossed. David rejected this
irresolute hero in his final composition and several late drawings reveal that he decided
to replace him with a frontal, dynamic figure whose upright posture helps to convey
inner resolve. In one of these late drawings (fig. 88), Leonidas emerges as the determined
leader, differentiated from his men in size (he is proportionately a giant in comparison to
them), and by the complete frontality and directness of his pose. David has also replaced
the long, attenuated torso of the earlier drawings, which contributed to the expression

86. Jules David, *First Idea for the Leonidas at Thermopylae*, engraving after a lost drawing by David, *Le peintre Louis David 1748–1825*, vol. II (Paris, 1882)

87. David, *Sketch for Leonidas at Thermopylae*, Montpellier, Musée Fabre

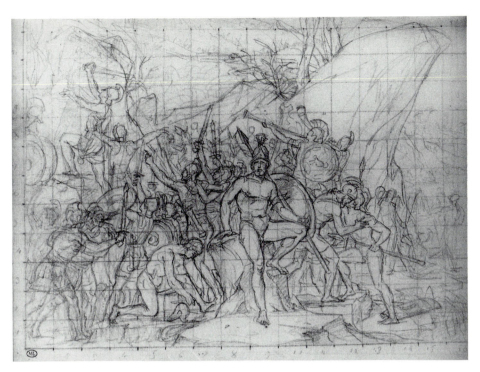

88. David, *Sketch for Leonidas at Thermopylae*, Paris, Louvre

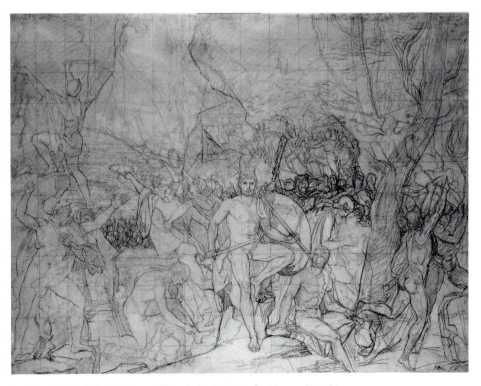

89. David, *Sketch for Leonidas at Thermopylae*, New York, Metropolitan Museum

of dispiritedness, by a thick, dense, muscular torso, clearly inspired by the Belvedere torso, whose tension conveys great reserves of physical strength. The face of this Leonidas is more thoughtful than stupefied but still expresses worry and concern. It is also interesting in these drawings to witness the transformation of certain principal figures and groups. For example, in one of the earliest drawings, to the left of the composition, an older man is about to kiss a young soldier in an embrace that is clearly homoerotic (fig. 87). In fact, reminiscent of the separate drawings of this group looked at earlier, the two appear to be kissing one another on the lips in a final good-bye. In the later drawing (fig. 88), this group, now on the right-hand side of the composition, has become transformed into a different type of narrative emblem, one that will be retained in the final composition—namely, the "father" presses his hand to his "son's" heart as the youth whispers in his ear a final adieu (the gesture was interpreted by Miel as the son telling his father he is courageous in the face of death and that his heartbeat has not quickened).[89] Similarly, the youth tying his sandal, present in both of the earliest drawings (figs. 86, 87), is moved from an erect standing position on the right hand side of the composition to a kneeling, crouching position to the left of Leonidas (fig. 88).

Two finished drawings that are close in terms of the compositional structure, position, and placement of figures,[90] nonetheless form an extraordinary and startling contrast and reveal that David was experimenting with opposing canons of proportion and style (figs. 89, 90). In the drawing in the Metropolitan Museum (fig. 89), Leonidas and the foreground figures are depicted in a classical, idealized manner in terms of facial expression. Leonidas's features are regularized, perfected, and beautiful; his face is much more harmonious and reserved in expression than in the final, painted version. This is true of the remaining warriors as well, whose profiles conform to the classical Greek type with the contour of the forehead flowing into the straight shape of the short nose in a smooth and continuous manner. The proportions of head to body adhere to a canon of one to five or one to six and the torsos of the figures, less fleshy than in the painting, are more rectangular and angular. We see the virtual antithesis of this in the Louvre drawing which appears to be a parody of the more classical norms of the Metropolian drawing. The figures tend to be short, thick, and squat, their heads are either too broad and large for their bodies (as in the figure of Leonidas) or too small (as in Agis). The bodies are thicker, more dense, less angular, and even lumpy (as in the case of Agis). Most are characterized by a heaviness and clumsiness that is disconcerting. But the figure of Leonidas is perhaps most shocking of all because he is brutal looking, awkward, and ugly, and his facial expression is that of one who is blunt and foolish. This strange drawing is related to a small oil sketch of the composition (fig. 91) purchased by the sculptor David d'Angers at the 1826 inventory sale of Louis David's work (the sculptor had been David's student while the painter was working on *Leonidas*, a composition that influenced him greatly—the inscription on the back of this sketch certifying it as an original provides compelling evidence that it was not done by a pupil, as has been

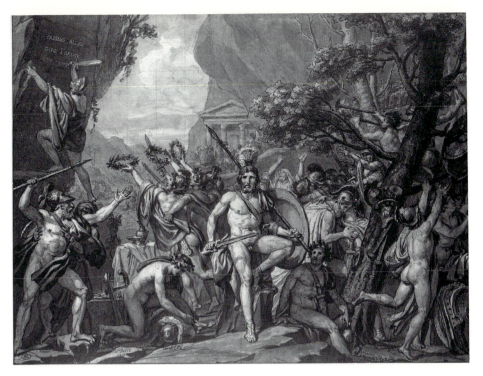

90. David, *Sketch for Leonidas*, Paris, Louvre

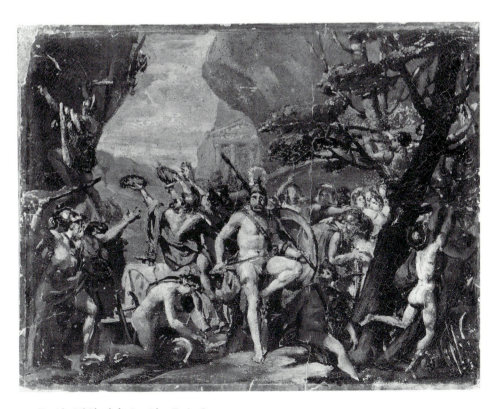

91. David, *Oil Sketch for Leonidas*, Paris, Louvre

previously claimed, but that it was, indeed, painted by Louis David himself).[91] In this sketch, the figure of Leonidas is extremely disconcerting because he appears almost as a monster. His eyes are set high in his face and he has a low, narrow forehead with a long, heavy jaw and a small chin. He looks heavenward as he will in the final version but the face is almost a caricature in its simplification of forms and is troubling in the fluidity and lack of distinctness of the features themselves which are completely blurred (an effect easily achieved in this medium but certainly one that was neither a necessary effect nor an accident). Here David consciously made a Leonidas that was a type of parody of the strong and powerful, morally resolute warrior. In the figure in the oil sketch Leonidas is also somewhat thick and squat and, as in the Louvre drawing, has no neck, which, of course, contributes to his odd and brutish appearance (the graceful, firm neck and shoulders of the Leonidas in the Metropolitan Museum drawing are close to those in the painting).

In the Louvre drawing and the oil sketch, David was clearly exploring in the medium of the sketch (this quasi-independent, experimental register for him) the impact of certain aesthetic effects; one is led to wonder why. For what reason did David transform Leonidas into a type of ape-man, a brutish counterpart to the beautiful and elegant figure of the painting? Since the artist remained so interested in theories of the body, he may, in fact, have had in mind recent scientific investigations into the development and evolution of man, issues hotly debated in Paris from 1800 to 1810, which paralleled concurrent studies of geological history.[92] Lamarck was, of course, the leading figure in these explorations and, as early as 1802, in his *Recherches sur l'organisation des corps vivans*, he had provided a fully developed theory of transformism, the gradual transformation of all life forms based on the "marche de la nature," a model of nature as a dynamic structure in which life experienced a historical progression from the simplest to the most complex forms.[93] In 1809 Lamarck developed his theory of the ape man in *Philosophie zoologique*, but this theory had already been promulgated by Charles White in England in 1799 and J. J. Virey in France in his *Histoire naturelle du genre humain, ou Recherches sur les principaux fondemens physiques et moraux* of 1800.[94] Virey's study, in particular, had received widespread attention and Salvage, in his treatise on the *Gladiator combattant*, had referred to Virey as a principal authority on the relationship between physical and moral man.[95] Significantly, Virey used Sparta as an example that served to explain how natural selection works.[96] Nature, Virey claimed, resembles the Spartans who chose only the healthiest and strongest babies to survive and exposed the weak ones to the elements from which they died. Thus, survival of the fittest meant those who are most physically robust and capable, not necessarily those endowed with the greatest intellect.

David may have had these ideas in mind when he executed the sketches of the brutish Leonidas and his physically powerful animal-like men. For in both sketches he emphasized the sensual, physical natures of the figures. This helps to explain why their heads are either diminutive or, as in the case of Leonidas, large but vapid, almost devoid

of intelligence. David did not retain these disturbing expressive features in the final composition but was influenced and inspired by the range of expressive possibilities these sketches revealed. Thus, in his final version he did preserve certain effects—the thickness, sensuality, and heaviness of the torsos and limbs of certain figures and a plurality in the canon of proportions. Leonidas becomes elongated and has a small head in comparison to the length of his body while other figures such as Euryotas are rather squat and short. All of the figures seem to be informed by recent ideas concerning the body in the discourse on human development and evolution. These had been cogently expressed by Bichat in his *Recherches physiologiques sur la vie et la mort* of 1805 who asserted that man's grandeur and perfectibility, his physical temperament and his moral character, were all based on the organic life of the body (this recalls Cabanis who, we remember, had stated that the moral and the physical are confounded at their source).[97] David expresses this in a profound way in *Leonidas at Thermopylae* for he makes us aware of the physical, organic, material nature of the body by depicting the heaviness of flesh and muscles and tissue, by emphasizing the elasticity of the skeletal structure which controls movement, posture, and carriage, by insisting on the dynamics of the body as well as on its density and on the variety of configurations (each individual seems to have his own canon of proportions as well as unique physiognomic configurations). Yet this mass of organic material that constitutes the body is nonetheless controlled and directed by the will, by moral ideals and values. For the healthy, robust, vigorous warriors, a superior race of men because careful selection and insistence on survival of the fittest had led to purity of blood lines (as Barthélemy had made explicit), these "supermen" chose death over life, an idea that runs counter to nature and to health and strength (Bichat had defined life as the sum of all forces that resist death).[98] A principal and elemental theme of *Leonidas* is the triumph of the moral will over the exigencies of the body. Thus, David's insistence on making the painting inspissated with images of and allusions to death. The spectator is not allowed for an instant to forget that these men are making the supreme sacrifice and we are expected to respond viscerally to their impending doom.

If David was influenced in his *Leonidas* by new scientific and aesthetic theories concerning the physical structure, physiology, psychology, and moral character of the human being, he was equally inspired by new ideas concerning the nature and meaning of landscape. For in this painting David ascribes a principal topographic, emblematic, and symbolic role to the landscape into which the figures are integrated. Most observers of the painting noted the importance and beauty of the landscape and privileged it by describing it first as a primary element of the composition.[99] That David considered it of utmost importance is evinced in a letter he wrote to his Russian friend, Count Youssapoff, on May 31, 1814.

> I am completing a pendant to my Sabine Women. It is the pass at Thermo-pylae and Leonidas at the head of his 300 Spartans.[100]

It is telling that David identified the painting as the "pass at Thermopylae and Leonidas," thereby giving the location—the natural setting—pride of place. A series of surviving sketches for the composition reveal the great variety of choices in the landscape setting with which David experimented (Delécluze describes David's almost obsessive attention to as topographically accurate a landscape as possible).[101] It appears that in the earliest stages of the composition, probably close to 1800 (fig. 86), David conceived of the mountain pass as a dense mass of rocky cliffs cradling the Spartans who were placed on a narrow ledge in the foreground. In another drawing, perhaps made during the same period (fig. 87), he introduces sparse trees on the mountainsides that signal the opening in the cliffs—the pass—to the far right. The barren, rugged cliffs are prominent in both sketches and serve to focus attention on the figures in the foreground. Their powerful, massive shapes and density suggest a parallel with the obdurate Spartans who have vowed not to abandon their position in the pass. These drawings suggest that David was thinking in terms of the landscape in its relationship to the character of the Spartans, for he, like his contemporaries, believed in recent theories concerning the impact of geography, geology, and meteorology on the character and temperament of the world's inhabitants, in the historic past as in the present. Buffon's study of geologic history in his *Epoques de la nature* of 1779 had inaugurated a vast body of "scientific" writings on the subject, just as Saussure's *Voyages dans les Alpes*, 1779–1796, inspired more precise and "scientific" observation, detailed analyses, and illustrations of natural phenomena in the burgeoning travel literature of the period.[102] This vigorous period of fascination with, and investigation into, nature and the earth with a pronounced interest in the sublime, was expressed extensively in literature as well, beginning with Rousseau's *La Nouvelle Heloïse* and including Bernardin de St. Pierre's extremely important *Etudes de la nature* (1784), as well as his popular novel, *Paul et Virginie* (1789); to these must be added Chateaubriand's *Atala* (1801) and *Le Génie du Christianisme* (1802). One of the principal and recurrent themes of these works (and a vast number of others) was that throughout history, geography and climate largely determined the formation of character.

The putative influence of landscape and climate on artistic development had been, of course, of great interest to artists and theorists since the mid-eighteenth century. These ideas had been cogently expressed by Winckelmann who described clement climate and geographical beauty as a means of explaining what he imagined to be the supreme physical beauty of the Greeks themselves and the beauty of their works of art (in other words, corporal beauty and strength, a natural product of the beauty of climate and landscape, is also the principal factor in the creation of beautiful works of art).[103] Winckelmann's ideas were later elaborated upon and led to much more complex theories based on more detailed and accurate accounts of geography, topography, vegetation, and meteorology. Thus, in the *Voyage du jeune Anarchasis*, David's principal source for the *Leonidas*, as we have seen, the Abbé Barthélemy was careful to offer a detailed description of the terrain and climate for every country that his eponymous hero visits and typically

makes parallels between the character of the land and climate and that of the inhabitants. He ascribes, for example, the fierce Spartan character in large measure to the rugged mountainous landscape and sparse vegetation. [104]

David's friend and supporter Chaussard also makes explicit the link between moral character and landscape in *Leonidas*. In his pamphlet on *The Sabine Women*, he spoke at length of David's new project in which he hoped the landscape would play a leading role. In a long and ecstatic passage he offers an eloquent plea for the sublimity of landscape as a setting for sublime actions. [105] Chaussard's rapturous description of the sublime landscapes in Greece that produced sublime inhabitants and inspired great artists must have encouraged David in his early ideas for the landscape setting of *Leonidas,* in which initially a chain of barren mountain cliffs served as an imposing backdrop for the fierce warriors.

At a certain point, however, David rejected this idea in favor of a different though still emblematic landscape in which the pass itself would be privileged (a series of drawings suggests successive stages from the chain of cliffs to the pass of the painting). [106] The pass of Thermopylae (literally the "hot gates"), in the final painting appears as a strange, irregularly shaped void that contrasts significantly with the ominous, dark, looming mountainsides and the density of figures compressed in the foreground. The pass, in fact, is central to the meaning, for it functions emblematically as a liminal zone—figuratively between life and death and literally between the plains and the sea beyond and the desolate, dark cavern, with its numerous crevices and pits, of the foreground, which is soon to be the Spartans' tomb. Allusions to the grave are numerous: the blind Euryotas, for example, is about to step into a ditch and the toes of his left foot curl desperately around the edges of this crevice in a striking and disturbing manner, as if he were clutching the earth with claws. Agis sits in a dark pit that is reminiscent of a newly dug grave. And the words being inscribed on the cliff, the final testament of the Spartans, recall inscriptions on tombstones. The Spartans are, indeed, gathered together in their tomb, the cavernous and rocky earth on which they were raised and which helped to determine their fierce and staunch character. In this "sublime" landscape David brilliantly uses the darkness and foreboding of the mountain pass at dawn to help convey this idea.

Miel perhaps more than any other critic understood the emblematic meaning of this *paysage moralisé* (a device David would use again in his *Amor and Psyche* of 1817), with its many details that alluded to death.

> The background presents a steep mountain and rocks jutting out as precipices. To the right, in the foreground, is an oak tree, symbol of strength, further back are several poplars consecrated to Hercules from whom the kings of Sparta descended. In the distance and half-way up is a temple of Greek architecture that prevents this austere simplicity from degenerating into aridity. This is the temple of Ceres where the Amphyctions held their gather-

ings every year. This is the location of the scene, solemn as the action that is going to take place there. These leaves, fallen from the trees that are partially stripped of their verdure that is vanishing, this lyre, suspended and mute, these crowns woven with poppies, narcissus and hyacinthus, flowers consecrated to the gods of the underworld, do not all these signs of destruction and annihilation announce with a very energetic eloquence the death of the 300 heroes and do they not appear to associate nature with their [the Spartans] fate?[107]

Miel notes that the presence of the temple and the evidence of the sacrifices the Spartans have just made, in conjunction with the brooding and solemn landscape setting, combine to convey the religious, solemn, and funerary meaning of the painting.

By stressing the landscape elements of the painting, David gives us his valuation of the importance of landscape painting. We see clearly, however, that he would not agree with his student Girodet that landscape was a "category of universal painting to which all others are subordinate because they are contained within it."[108] The human figures remain the focus of the composition, but the landscape does assume a significant role in conveying meaning. More important, however, we once again see David engaging in a hotly contested aesthetic debate of the time (the significance of landscape in the academic hierarchy of genres was a subject of frequent argumentation during the Napoleonic period and finally led to the creation of a Prix de Rome in the category of landscape in 1817).[109] David brings to bear on this issue a body of intellectual discourse, in this case new geologic and metereologic theories.

We have seen that this sort of intellectual richness, which led Chaussard to say of David "cet artiste est éminemment penseur,"[110] pervaded both *The Sabine Women* and the *Leonidas*. And we have seen how David ravenously searched for the leading ideas of his time in order to produce paintings inspissated with meditative meaning. David wanted to leave virtually none of the aesthetic problems or questions of his day unconsidered. And the answers that David offered to questions posed by nudity, physiognomy, corporal configuration and the classical canon of proportions, space and perspective, were largely informed by the asseveration of personal vision. David believed that it was the artist's obligation to find his own way in these matters.

We have, in fact, rather epiphanous evidence that comes to us through student responses corroborating this credo. A leitmotif of the letters and published comments of many students who studied in David's atelier during these years is concerned with the often disconcerting freedom David left them in matters of ideas and artistic considerations. He would give them help in problems of technical mastery but they had to follow their own paths of intellect and imagination.[111] The widely divergent styles and careers of his most well-known students—Gérard, Girodet, Gros, and Ingres—as well as the unorthodox groups that flourished in his atelier such as the Primitifs and the Trou-

badour painters, amply attest to the fructive freedom of individual development engendered by David. David may have disagreed with the directions many of the students embarked upon, but he did not coerce or stifle them. His atelier and system of artistic education were the opposite of procrustean. The pervasive tone of the student remarks is admirative or, indeed, reverential. The students knew that, as both the *Sabine Women* and the *Leonidas* abundantly demonstrate, David was the incarnation of the freedom of the intellectual imagination.

IV

—◆—

"IN BORROWED ROBES?"

From Homage to Subversion in
the Napoleonic Paintings

D AVID'S LIFE coincided with that of Napoleon and he was fortunate enough to be appointed a major figure in fashioning the iconography of the nation's new leader. The confrontation between the two produced a complex and ambiguous episode in French cultural life. Their rapport—their mutual esteem and suspicion—provides a fascinating story which recalls, inevitably, the tempestuous relationship between Renaissance patrons and painters. As a result of this friction David would produce several compelling masterpieces. These paintings, however, have been much neglected—very few interpretive studies are to be found. These works have generally been seen both as evidence of David's craven acceptance of the Emperor and rejection of his Revolutionary ideals and, concomitantly, as realistic and rather uninspired documents of Napoleonic history—David in his vaunted role as autoptic recorder of First Empire pageantry. The burden of this chapter is to show that these valuations of David are reductive and false. David once again used a body of his work to meditate deeply on philosophical, political, and aesthetic problems. He again manifested the extent to which he deserves the apellation "peintre-philosophe."

In the Napoleonic paintings David engaged fervently debated issues and problems of the time concerning allegory, the nature and function of portraiture, and the theory of history painting. He again drew inspiration from previous periods and modes of artistic production to transform his painting from, in this case, expectedly, Renaissance predecessors, but also, rather surprisingly, Gothic art and architecture. The resultant Napoleonic art differed greatly from his contemporaneous Hellenic masterpiece, *Leonidas at Thermopylae*, which was truly sui generis in as much as it evolved over a fifteen-year period that encompassed the Consulate and Empire. From 1800 to 1815, in fact, David developed, for the first time in his career, a striking plurality of styles (once

more he manifests his metamorphic method). The divergent styles of the *Leonidas* and the Napoleonic paintings reveal the extent to which David experimented with modes to accord with differences in subjects, functions, and the destinations of his paintings. This experimentalism which accelerated in his early nineteenth-century production reached its crescendo in Brussels.

While he exhibited *The Sabine Women* and worked on the *Leonidas* circa 1800, David, appointed artistic director to the First Consul, became extensively involved with Bonaparte's projects for the arts, including the design of costume, interior decor, architectural and sculptural monuments, and a plan to reform the arts.[1] For a brief period he resumed, to a considerable extent, the role he had enjoyed during the early years of the Revolution. In addition, he was asked, along with a team of artists, to help shape and determine a mythic image of Napoleon, initially as First Consul, then as Emperor.

When Bonaparte chose David as one of the artists who would commemorate him and help disseminate through representations new ideologies and political, as well as personal, goals, he compelled David temporarily to turn away from projects for the reinterpretation of antique art and to think differently about subject, style, and type of communication. With the Napoleonic commissions, David relinquished artistic freedom to a considerable extent. He had painted the monumental *Sabine Women* and the *Leonidas* without commissions. He now was faced with a very different set of problems and decisions in his representations of Napoleon. The figures, subjects, settings, costumes, etc. were largely determined for him by Napoleon and his family, friends, or ministers (especially influential was Vivant Denon who became the Emperor's director of the arts and who interfered consistently and on every level with the great number and range of Napoleonic commissions, including those by David).[2] Since the paintings were commissioned by governmental officials and were overseen by advisors, this entailed fixed boundaries, limited choices, and a specialized set of precedents in terms of iconography and style, as well as interference. After completion of some of the paintings David was asked to make significant changes—additions and deletions—by those for whom he was working, a situation, as one might expect, that he deeply resented.

At each stage of his political career Napoleon established a new set of ideals and goals that he wished to see visualized and objectified in painting and sculpture.[3] Perhaps to an even greater extent than his predecessors among European monarchs, Napoleon blatantly viewed art as a tool to manipulate public opinion and thought of his painters and sculptors as a small, select private army who, through their weapons of representation, helped to determine and shape public response to the new leader. As we shall see, David used the limitations and restrictions imposed upon him to create a mythic history of Napoleon. The image we have of this powerful individual has been forever fixed by David who was conscious of his role as historian. He realized that his depictions of Napoleon would be seen as records of events, as painted documents. Initially, this situation gave David a sense of responsibility and mission but also of personal power. In

his long report to the minister Daru on June 19, 1806 concerning the four monumental Napoleonic commissions for the ceremonial pageants, David wrote:

> I will be punctual in fulfilling the commitments I have made to his Majesty. I understand only too well the importance of such works. What painter, what poet could ever be in a better position than I: I will glide into posterity in the shadow of my hero.[4]

Although expressed in humble language (appropriate to a subordinate and employee of the Emperor), the passage reveals that David viewed the commissions as a great opportunity and that he was confident that his representations of Napoleon, as well as his greatness as an artist, would survive for future generations.

Yet, as we shall see, these monumental canvases (only two of the four commissioned works were completed after several years) are difficult to assess, for a close examination reveals multiple and often contradictory messages about the leader and his newly invented imperial court and realm. The completed paintings, in fact, express the artist's progressive disillusionment with the Emperor. At first David, like the majority of his contemporaries, adulated Bonaparte, heroic general, savior of the French nation, and he revered the First Consul, upholder of Republican ideals and author of the Civil Code. Once Napoleon assumed the mantle of Emperor, however, David experienced a conflict between his admiration for the heroic individual, whom he believed had contributed greatly to the French nation as a Republic, and his repugnance for the new Monarchy which would come to suppress Republican objectives and ideals. The political and ideological conflict was compounded by financial disputes. After accepting the Napoleonic commissions, David embarked on a long struggle to receive payment for his works.[5] Letters reveal that he blamed Napoleon's ministers and advisors, especially Vivant Denon, for the payment problems—he believed they had tried to create a schism between him and the nation's leader.

In his Napoleonic imagery David resumed his reflections on modern history, on the representation of modern heroes, heroic deeds, and ceremonial rites. In so doing, paradoxically, he became involved, to a greater extent than ever before, with the traditional language of allegory and symbolism (the subject of heated debate circa 1800), with ideas and imagery related to the Christian and medieval revival, and with sources, symbols, and metaphors associated with age-old monarchical iconography. David's paintings of Napoleon as First Consul and then as Emperor have long been considered the most "realistic" or "naturalistic" of his works.[6] It would be a mistake, however, to view these paintings only in this limited way. David's corpus of Napoleonic works are steeped in symbolism and embody multiple layers of metaphorical meaning. He not only represents the Emperor as participant in historic events, he offers a profound and often highly critical commentary on Napoleon as well. It is this salient element of David's Napoleonic paintings that has been virtually overlooked.

David's depictions of Napoleon can be divided into two principal categories: the

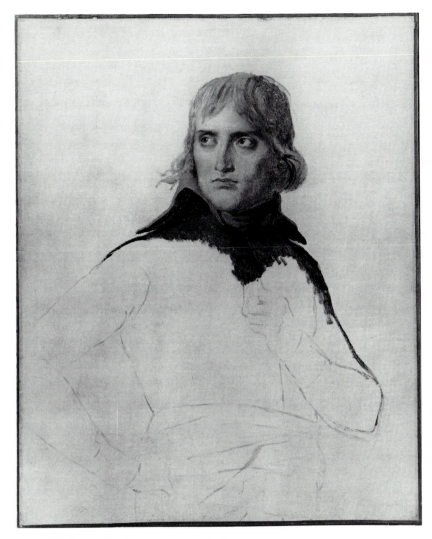

92. David, *General Bonaparte*, c. 1797, Paris, Louvre

monumental, encomiastic portraits of Bonaparte as a "grand homme," and the ritual portraits and depictions of ceremonial events which revive imperial iconography and style. His first portrait, which was never completed, dated circa 1797, provides the most simple, direct and penetrating study of the General's individual character, expressed forcefully through physiognomy (fig. 92). David presents the young, heroic Bonaparte, with no official or ceremonial trappings, before he embarked on a political career. The remarkable strength of character, determination, and will of the military leader is brilliantly conveyed through the shape and position of the head and the facial features. Bonaparte's rigid, square jaw, his stubborn mouth, and the resolute, displeased expression of his eyes, together with the turn of his head (he appears to look backwards),

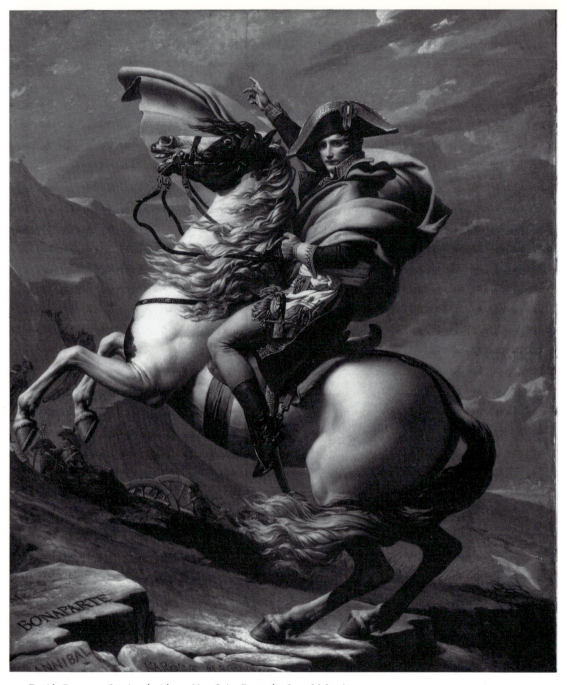

93. David, *Bonaparte Crossing the Alps at Mont Saint Bernard*, 1800, Malmaison

suggest that his innermost thoughts are concerned with preceding events but also with the tasks that lie ahead.[7]

This intense and psychologically penetrating portrait prefigures what may be considered David' most brilliant and successful depiction of the nation's young leader—*Bonaparte Crossing the Alps at Mont Saint Bernard* (fig. 93, colorplate IV), completed towards the end of 1800. In this equestrian portrait, commissioned by Charles IV of Spain for his "Salon des grands capitans" in the Royal Palace in Madrid,[8] David united once again the genres of history and portraiture (as he had in his depictions of the Revolutionary martyrs) and created an apotheosis of the modern "grand homme" who is represented literally and figuratively at the summit of his military career. The spontaneity and informality of the earlier portrait of General Bonaparte are here replaced, however, by a highly contrived language of symbol, allegory, and metaphor embedded in an aesthetic of naturalism (I will discuss only one version, considered to be the original painting, today at Malmaison—David executed four others with minor variations on the original, each with its own rather complicated history).[9]

Like so many of the Napoleonic commissions in both painting and sculpture, the genesis of the subject and the decisions concerning the iconography of this work are not known but we may assume that the choice of imagery entailed negotiations between David, Alquier (Charles IV's ambassador to France), and Bonaparte.[10] The composition was of great propagandistic value to the First Consul and was ideally suited to its destination—a room filled with representations of celebrated military leaders in a neighboring country that was of great political importance to the new leader of the French nation (as is well-known, the image departs dramatically from the historic reports of the event; for practical reasons, Bonaparte crossed the precipitous peaks of Mt. Saint Bernard on a mule, not on the beautiful stallion of the painting and did not accompany the troops, but followed them with some delay). The choice of a mythologized moment of great military significance—the First Consul's audacious and impulsive decision to cross the Alps and assure a French victory against the Austrians at Marengo—provides an opportunity for presenting the First Consul not as a civic leader but as a courageous and powerful military hero, a supreme commander, a legendary figure already inscribed in history, comparable to his renowned predecessors Hannibal and Charlemagne (whose names accompany his on the foreground rocks). The mythologized leader subjugates the sublime and terrifying elements of nature in order to lead his army (and, by extension, his people) to victory. Bonaparte here comes to personify abstract ideals of leadership, heroism, and destiny just as the artillery men struggling up the mountain slope, carrying the tricolor flag (which was also not part of the historic event), can be understood, allegorically, to represent the new French Republic. The entire composition may be understood, in fact, as a type of "real" allegory—the event, the individual and the group he leads that are celebrated in the painting transcend the specificity of the historic setting to embody abstract qualities and political ideals.

The equestrian figure recalls many renowned antecedents in painting and sculpture of a monarch astride a magificent steed—examples by Rubens, Velasquez and especially Bernini come to mind. But, as is known, the most important and immediate prototype was Falconet's famous *Peter the Great*, the object of considerable controversy in late eighteenth-century sculptural debates and well-known to David and his contemporaries through engravings—David had sketched the group in one of his notebooks of the 1780s (fig. 94). David was looking again to the model of sculpture for primary inspiration, especially since the sculpted equestrian carried such historic weight and power. David anticipated that the viewer would recognize the category to which his composition belonged and its metaphorical meaning: namely, the leader of the people depicted as military commander and hero assuming the role of beneficent protector of his country and leading the nation to victory and glory. David, by adopting this genre, ascribed to Bonaparte not only the traditional role of the leader/military hero, he placed him in a line of succession with preceding monarchs and absolute rulers of a legendary ancient and medieval past, and thereby, through very effective and powerful visual means, helped to legitimize for Spain and, by extension for Europe, Bonaparte's claims to the high governmental office of First Consul.

Through the structure of the composition and the depiction of Bonaparte himself, however, the artist expresses the adamant Republican claims of this new political leader and offers as well a form of biography: Bonaparte, the self-made, self-determined common man, rose to greatness from the ranks of the artillery which figures prominently in this painting. He is not at the head of his army but parallels the artillerymen who struggle up the mountainside—he accompanies his men as he shows them and us the way to the top. David depicts metaphorically the common struggle of the leader and his people to overcome obstacles, the historic event of crossing the alps expresses the age-old universal metaphor of the struggle of life as the heroic climb up the mountainside.

What is perhaps most striking about the image is its visionary qualities, for David, through the use of an extraordinary plurality of styles, differentiates the natural and historic from the legendary and mythic. The monumental figure of Bonaparte and his rearing stallion dominate the space in a remarkable way. We look up at the equestrian group as though we were looking up at a sculpted monument from the level of its pedestal (akin to the experience of viewing an equestrian group such as Falconet's *Peter the Great*) and by looking upwards at the hero we physically mimic, and therefore experience corporally, the thrust of all of the figures and forms that move in a diagonal ascendent line to the summit. Indeed, we follow the direction of Bonaparte's right hand which points far above the summits to the skies and heavens above—David here vividly portrays that his journey across the alps is a movement from time to eternity. An earthbound, temporal history inscribed in the mountainside juxtaposes Bonaparte with two of the great fearless conquerors of the past (Hannibal and Charlemagne) but this

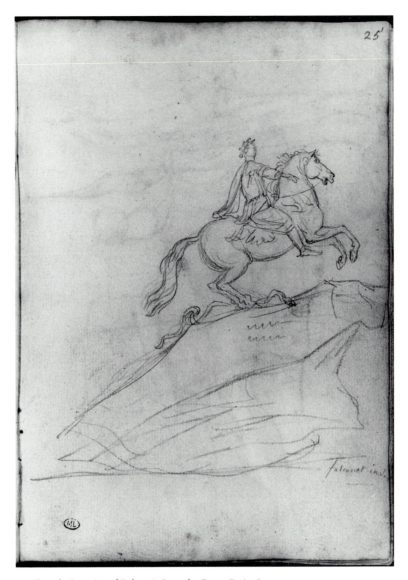

94. David, *Drawing of Falconet's Peter the Great*, Paris, Louvre

history has been determined by the stars, the invisible, directing powers of fate. Bonaparte is the agent of fate for the French Republic.

Some observers were disturbed by the peculiar and jarring perspective and the puzzling disparity in size between foreground and background figures[11]—Bonaparte and his steed are monumental while the artillerymen who march in a diagonal ascent parallel to the equestrian figure, though apparently close, are nevertheless diminutive. Only fragments of a few men are represented at the viewer's eye level—the principal

181

group pulling a canon up the steep mountainside in the space beneath the horse's body and Bonaparte's boot. These figures, as well as those seen from behind, winding their way up to the summit, are painted in a very different style than the equestrian group. David, in fact, employed a daring multiplicty of styles in this painting. For the equestrian portrait he revived the Italian Renaissance style associated with Raphael by employing a bright palette of saturated colors and attending meticulously to details of the materials, including textures, volume, density, and weight, as well as reflection and refraction of light—the entire group is represented in a highly polished, finished style. Bonaparte and the stallion are illuminated in a bright yet even light and, although wind-blown, the group seems impervious to other atmospheric conditions of light and air that bathe the background landscape and the army. The precise, high finish of the foreground group stands in dramatic contradistinction to the fluid, loose, and sketchy style of the army who are much more convincingly depicted as part of their mountain setting. In addition, the style and execution of the soldiers climbing up the mountain path differ from that of the sublime alpine site behind them which is rendered in a very delicate and monochromatic manner. The background landscape style is closer to watercolor than to oil and through this means David has been able to capture the sense of chill at this high altitude, as well as the coldness and desolation of the mountain rocks, the distant snowcovered peaks, and the dazzling yet cloudy sky. Through style David distinguished the historic, the "real" event—the artillerymen struggling up the narrow and treacherous alpine path—with the apotheosis, the vision of the hero who has sent them in this direction. Further distinction between the two worlds—the natural and historic contrasted with the visionary (or mythic history)—is made by the complete absence of communication between Bonaparte and his army. Bonaparte looks out at us and invites us to view the historic event which appears small in contrast to the individual who has made this event possible. He is a vision we see, but the artillerymen, absorbed in their climb, are unaware of the heroic apotheosis of their leader.

The face of the hero constitutes the single still point in the flux and movement of the composition. Bonaparte looks directly at the spectator with obduracy, sternness, will, determination, and absolute calm. The composed features of his face, seemingly fixed in place by the weight and stability of his three-cornered hat, are made more pronounced by his wind-blown hair, perhaps expressive of the tumult and passion of his inner ideas and emotions which he refuses to reveal and by the exact juxtaposition of his head with that of his terrified, wild-eyed horse, whose nostrils flare with fear and who neighs in fright and confusion at the sublime sight of the summit and the cold, fierce winds that have whipped its mane and tail. The stallion also responds in terror to the intensity and power of the individual who sits easily and gracefully in the saddle in complete and steadfast control.

Bonaparte's young, pale, handsome, soft, and delicate face, which is rendered with great subtlety in the texture of the skin and transitions of the planes from mouth to cheek and nose to forehead contrast vividly with the determined expression of his eyes

and the obdurate purse of the lips (David, like many of his contemporaries, was captivated by the beautiful, "classical" features of Bonaparte's face which were often compared to those of Alexander the Great). This softness, delicacy, and beauty reveals the sensitive and even vulnerable qualities of his character. David depicts the psychological dimensions of the leader as complex, multivalent, and mysterious—he seems completely self-contained and his youthfulness, with its concomitant confidence and fearlessness, provides the perfect analogue for the young French Republic struggling to survive the climb to success and victory. Bonaparte's ornate and richly colored costume with its finely wrought details, the costume he wore at Marengo which he lent to David for the purposes of the painting,[12] reveals additional qualities of Bonaparte's character, his pronounced interest in costume, his love of fine and rich materials.

The artist, who, we remember, had been involved extensively with costume design during the Revolutionary period, promoted a belief in costume as the embodiment of historical, cultural, and psychological truths. In the *Encyclopédie*, costume in painting had been defined in the following terms (in his *Dictionnaire des beaux-arts* of 1806, Millin closely paraphrased this definition).

> *Costume* is the art of treating a subject in all its historical truth: it is thus the exact observation of that which constitutes, according to the time period, the genius, custom, laws, taste, wealth, character and the habits of a country or where one situates the scene of a painting. Moreover, costume includes everything concerned with chronology and the truth of certain facts known throughout the world; in short, everything concerned with the quality, nature and essential characteristics of objects that one represents.[13]

Bonaparte's functional and ceremonial costume, worn at Marengo, expresses all these qualities and more for David has added to the multiple cultural and historical meanings of costume the dimension of individual psychology. The costume expresses the culture but also the man; it reveals to us the essential nature of the individual. To this ornate and practical costume which functions as a historic, cultural, and psychological metaphor, David added an element of his own invention—the thick, soft cape that enfolds and protects the hero and billows dramatically in the wind. The animate cape with its sculpturesque, multi-layered folds, appears to have a life of its own: it functions as an analogue of the substantiality, amplitude, and multiple layers of the hero's character and complex personality.

The dynamism and complexity of this composition with its unsettling innovations in style and scale would be surpassed in David's subsequent depictions of Napoleon in the monumental paintings of the ceremonial, Imperial pageants. But never again would Bonaparte appear in such an uncompromisingly heroic form. In September of 1804, Napoleon asked David to depict the Coronation (fig. 95); he subsequently requested the execution of three additional monumental paintings that would document and commemorate the most significant events of the inauguration of the Imperial realm—the

Enthronement, the *Distribution of the Eagles* (fig. 105), and the *Arrival at the Hôtel de Ville* (fig. 96).[14] The commission was never put in writing, neither price nor destination was ever confirmed, something typical of Napoleonic commissions, and hence David's ensuing, terrible, and continual struggle to secure payments (the ultimate placement of the paintings was an issue that was never resolved).[15] On December 18, 1804, two weeks after the Coronation, Napoleon named David First Painter of the Empire, a position the artist readily accepted (he had refused to become "Painter of the Government" in 1800). He began work immediately on the *Coronation*, the first in the series of which only two works were completed (the *Coronation* was finished in 1808 and the *Distribution of the Eagles* in 1810—David wrote that "for political reasons the other two were never made").[16]

Again, we know very little of the inception of the paintings and almost nothing of the development of ideas in terms of choice of subjects, iconography, and style. David and Napoleon very likely made joint decisions concerning these issues; it would be illuminating to know of these interchanges between the Emperor and his First Painter concerning thematic and artistic choices. After the *Coronation* and the *Distribution* were completed, Napoleon intervened (typically through the dictatorial and intractable Vivant Denon) and asked for specific changes in the compositions, but prior to this it appears that David had considerable freedom in the planning and execution of the paintings. In a very important letter to the Minister of the Interior Daru of June 19, 1806, David described the four projected works in considerable detail and it is clear from this letter that he conceived of the group as an interconnected series of different types of homages that would celebrate the various symbolic, cultural, and social structures of the newly created Empire (he even alludes to two additional subjects he hoped to add to the series).[17] Each of the works was to share the same enormous dimensions, 30 × 19 feet, confirming what David indicated in a note that survives in manuscript form, namely, that Napoleon had in mind a special room in which to install the paintings:

> The Emperor told me that in commissioning these works, he wanted to have a room consecrated for this purpose, where all these works would be brought together.[18]

This project was confirmed in the 1824 biography, *Notice sur la vie et les ouvrages de M. David*, likely written under David's direction.

> Bonaparte believed he was consolidating his government and making it more imposing through this religious ceremony which gives kings a character in some manner more divine. Filled with this idea he resolved to have his coronation and drew up a plan to consecrate a room of this name that he would decorate with four large paintings; immediately they were commissioned from his first painter.[19]

We know from the special conditions of the exhibition of *The Sabine Women* that David had become profoundly concerned with the viewing of his works and it would be

95. David, *The Coronation of Napoleon and Josephine*, 1805–1807, Paris, Louvre

fascinating to know what the artist had in mind as an exhibition space for these Napoleonic commissions. The room itself would have had to be vast not only to accommodate the huge canvases but also to establish the necessary viewpoint for the appropriate visual experience of all four works. David was familiar with the popular genre of the painted series that developed interrelated themes, works that were executed for a specific setting or exhibition space (the most important precedent was, of course, Rubens' series celebrating Marie de Medici). David was confronted with a very special type of subject matter and scale, but he certainly had in mind the group as a series, as his lengthy report to Daru of June 19, 1806, makes clear. In this letter in which he clarifies his asking price (which Denon would find exorbitant), he offers a description of each composition and discusses the thematic content of the group as a whole. The artist makes clear that he had a specific order in mind for the paintings, one that quite expectedly follows the chronology of events—"The Coronation, Enthronement, the Distribution of the Eagles on the Champs de Mars, and finally his arrival at the Hôtel de Ville," but he also states the theme that unites the series: "Through these paintings I designate the different orders of society."[20]

In each painting David was concerned with the representation of the new structures of French society that had been dramatically and unexpectedly reorganized when Napoleon transformed the Republic into an Empire. And each painting was intended to

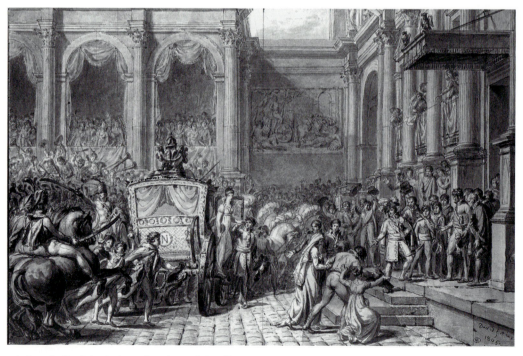

96. David, *Sketch for the Arrival at the Hôtel de Ville*, 1805, Paris, Louvre

celebrate and commemorate different groups of society. He planned the *Coronation* as an homage to the Emperor who had forged this new society. Napoleon was to be depicted crowning himself with the attendant crowds, including different levels of the court, the clergy, and the people, filled with surprise, awe, and admiration at the nation's new protector and leader.

> After the tradition of the decoration of the Emperor by the Pope, his Majesty, ascending to the altar, takes the crown, places it on his head with his right hand, then with his left he presses his sword tightly against his heart. This great movement recalls to the astonished spectators this generally acknowledged truth: that he who knew how to conquer the Crown will know as well how to defend it. The attitude, the gesture, the gaze of the sympathethic crowd, all indicate the feeling of admiration that penetrates everyone.[21]

David originally planned to represent the dramatic moment when Napoleon as a soldier/hero, pressing his sword to his heart, crowned himself (an event that the crowd did not expect since tradition dictated that the Pope do the crowning); numerous drawings attest to variations of this initial idea (figs. 97, 98). This complex and emblematic gesture reveals the Emperor as a modern, self-made man who can legitimately make himself a monarch (an office that was not his by birthright), because he has saved the nation through his military prowess and personal genius and vision. This act signals the new order of French society. The old hierarchical system of king and aristocracy based on inherited titles and wealth is now replaced by a new hierarchy based on the talent and genius of the individual who rises to the top by virtue of his abilities, who makes extraordinary decisions and is able to impose them readily on an admiring public who experience feelings of tenderness for their hero. Thus, the composition was to make clear not only the establishment of a new order and type of monarchy, it would also depict the relationship between the Emperor and his people, the people from whose ranks he arose.

The second painting, the *Enthronement,* was to celebrate Napoleon as chief legislator of the nation, as defender and upholder of the Constitution and the law.

> The Emperor, seated, the crown on his head and his hand placed on the Gospel, pronounces the Constitutional oath in the presence of the president of the Senate, the president of the legislative body, of that of the tribunal and of the oldest of the presidents of the Consul of State, who had presented him with the oath.[22]

By this act, Napoleon, although enthroned, demonstrates his obeissance to the laws of the land. He was to be depicted at the solemn moment when he takes the constitutional oath, thereby demonstrating that, although Emperor, he willingly submits to the established laws of the nation, especially to the Constitution, and that, like all citizens, he respects the legal and governmental system and structures already in place—the

98. David, *Sketch of Napoleon Crowning Himself*, Cambridge, Mass., Fogg Art
Museum

97. David, *Sketch of Napoleon Crowning Himself*, Bibliothèque Thiers—Fondation
Dosne-Thiers

senate, the legislature, the tribune, and the Conseil d'Etat (the Tribunat had proposed that Bonaparte be named Emperor and be placed in charge of the Gouvernement de la République; on May 18, 1804, the Senate adopted a new Constitution confiding the Republican Government to the new Emperor).[23] Napoleon is now the individual who leads the country but the laws and those who enforce them still preside.

David declared that the third in the series, the *Distribution of the Eagles*, provided yet another type of homage.

> The third day of the festivities of the Coronation is consecrated to valor and fidelity. It is the distribution of the eagles to the army and to the national guard of the Empire.[24]

The particular valor and fidelity are, of course, marshall. The colonels, standing on the steps before the Ecole Militaire, swear to sacrifice their lives in defense of their country (in his letter David records the oath they took before Napoleon). At this stage when David was still working on the *Coronation*, he expresses the most excitement about the *Distribution* which proffered yet another opportunity to represent a fervent oath.

> Never was an oath better observed: what differences in attitudes, what varied expressions! Never was the subject of a painting more beautiful![25]

The final painting in the series, *The Arrival of the Emperor at the Hôtel de Ville*, constituted an homage to the people and was to express the Emperor's benevolence and generosity towards the people whom he serves as ruler and who revere him.

> Through these paintings I designate the different orders of society. This one is for the people. This is the first act of allegiance towards their sovereign. The governor of Paris places the keys of the city in the hands of his Emperor. . . . The Emperor has just traversed the steps of the hotel when citizens of all classes, impelled by gratitude, fling themselves down at the feet of his Majesty, thanking him for the pardons that they have obtained in advance for the serious offenses committed by their children. Another group, seeing the Empress descend from the same carriage like the life-giving sun, fling themselves equally at her feet, they thank her for the help they have received for the relief of their families and for the payments of the debts of the wet-nurse. The people who are the spectators of this imposing and at the same time emotional scene evince their delight with a general cry of Long live the Emperor, the Empress and the imperial family.[26]

David emphasizes the new ruler and his wife as protectors of French society seen as an extended family. This is the only one of the compositions that actually takes place in the public arena, the street, the square, and in which the people play a major role. David's drawing, dated 1805, one year earlier than the explanatory letter to Daru, reveals that he planned to integrate the figures of the Emperor and Empress with those of the people;

they are on a human scale, approachable, dressed in simple modern costume, here assuming roles as contemporary individuals involved in a public festival given in their honor, who share in the common life of the French nation.

David's much neglected letter to Daru revealed that he planned to use the commemoration of specific events and the individuals involved in them to represent the new structures of society and the nature of good leadership and good government. In fact, his conception of the entire series in 1806 appears to have been as an allegory of good government, reminiscent of the famous frescoes of Lorenzetti. But the completed works reveal that this original, rather straightforward concept became transformed and what seemed simple and direct in his written descriptions evolved into extremely complex and ambiguous paintings. David's statements to Daru in his important letter of June 19, 1806, reveal that from the beginning he thought in terms of the transcendent, metaphorical meaning of the ceremonial events—he was not interested in mere historical illustration. Delécluze later denigrated the emergence of what he considered a deplorable type of "illustration" of history in the Napoleonic commissions.

> Denon oversaw the execution of his master's orders; but this immense series of paintings of ceremonies, battles and interviews, executed over a period of ten years by a crowd of mediocre artists and offered to the multitudes like a type of illustrated *Moniteur* [the government journal] in which the depicted fact captured all the attention and the artist's work did not claim the slightest importance, is one of the circumstances which was the most detrimental during this period to the development of what was considered serious art. [27]

David, unlike the "crowd of mediocre artists" working for Napoleon, wanted to transcend the idea of the historical painting as chronicle, an illustrated *Moniteur*. He realized that his monumental compositions would, on one level, always be seen as documentary images of extremely significant events in French history with principal participants recorded for posterity. But in these works he has above all emphasized the complexity of the images, their symbolic, metaphorical, and allegorical content which compel the spectator to meditate upon the meaning. Thus, although he was confronted with new challenges in the representation of contemporary historic events, David thought of the *Coronation* and the *Distribution* as belonging to the genre of history painting as he had helped to redefine it in the last two decades of the eighteenth century, that is, history painting as philosophy, as visual meditation, the expression of thought and cultural ideas.

David, accordingly, had to take a great deal into consideration as he developed his ideas for the composition of the *Coronation*. The complex rites of the ceremony had been devised by the grand master of ceremonies, Ph. de Ségur, along with his advisors. David's student Isabey designed the elaborate costumes and Percier and Fontaine created the temporary architecture, a transformation of the facade and interior of the cathedral of Notre Dame. [28] The objectives and scale of this monarchic festival recalled and equalled,

if not surpassed, the Revolutionary festivals that David himself had organized. Napoleon and his advisors had to invent and organize an entire court (his family members and ministers were all given new titles) that would not be seen as closely filiated with the former Bourbon monarchy. Symbols (such as the eagle and the bee), emblems (such as the new insignia uniting the Emperor and the Pope), sacred objects (the sceptre crowned with an eagle, the hand of justice, the Imperial globe), all that would link Napoleon to the Merovingian and especially Carolingian dynasties, were created or "rediscovered."[29] Elaborate new costumes were designed which, in their luxuriousness and extravagance, would help to consolidate the new titles and roles of the nascent Napoleonic court which was born on December 2, 1804, the day of the Coronation. Then David also had to consider the role of the Pope and his retinue and the remarkable and awe-inspiring setting of Notre Dame. The artist's role in the ceremony as observer and recorder had also been carefully considered—David was given a choice seat with a good view in one of the tribunes constructed for the spectators who were seated according to a hierarchy of importance established by Ségur.[30] What is perhaps most striking about David's monumental composition, filled with a vast number of life-size and over life-size figures, is the sense of immediacy that the artist conveys to the spectator, who, standing before the painting, is fictively situated within the south transept arm of the crossing of the cathedral, an observer of what David ultimately chose as the most significant moment of the ceremony—namely, when Napoleon, who has already crowned himself Emperor, is just about to crown Josephine who humbly kneels before him in prayer. We immediately notice that David does not offer a traditional vanishing point which we might expect in a painting of this size and complexity. Instead, the composition follows the neoclassical format of the stage setting, thereby emphasizing the theatrical (in a pejorative sense) elements of this Napoleonic spectacle (Percier and Fontaine had literally transformed the cathedral into a type of stage for the performance of the ceremony which was planned like a play in successive acts) and the protagonists of this performance—the Emperor, Empress, their retinue and court, the Pope and the Clergy—were placed in the foreground. The painted spectators, seated hierarchically in horizontal tiers, watch the show from the tribunes; they directly face us, the current viewers. That the viewer of the painting who observes the ceremony is confronted by representations of the spectators of the actual event contributes to the sense of immediacy and participation and also reminds the viewer that she or he is attending a staged performance. Napoleon's siblings, his ministers and marshalls, Josephine's attendants, the Pope, the cardinals, prelates and priests, form a semi-circle around the principal protagonists. All the figures are bathed in a mysterious filtered light that softens and makes hazy many of the forms and that leaves many figures in semi-darkness and contributes to the hushed solemnity of the moment. Light does fall on the three principal figures of Josephine, Napoleon, and the Pope whose faces, forms, and costumes can be most clearly discerned.

David must have meditated at great length on the moment chosen (we remember

that as late as 1806 he planned to depict Napoleon crowning himself), on the number and size of figures to be included, the setting and the viewpoint. In a manuscript note David records that he made many sketches and also took detailed notes during the ceremony.[31] His final decisions for his painted version are brilliant. The groups and individuals are based on a system of contrasts and comparisons that make vivid and clear the multivalent meanings. We also know that David consulted engravings and drawings, especially of the church interior, made by Percier and Fontaine, that he studied the costumes and ritual objects, and that he requested portrait sittings from as many participants as possible (his encounter with the Pope during the portrait sittings made, perhaps, the greatest impression upon him). On a basic level, of course, the painting is a magnificent, vast group portrait, and fulfills one of David's objectives that he had set for himself originally in the aborted *Oath of the Tennis Court*—namely, to combine on a monumental canvas, the commemoration of a great contemporary political event that changed the course of modern French history with compelling portraits and characterizations of the individuals who participated in the event. As in the majority of the Napoleonic paintings, David combined the depiction of the historic event with his idea of the significance of this event in history. David made a supreme effort to achieve historical accuracy in the details of the composition, including facial features, costume, and architectural setting, and it is most often his brilliant technical rendering of these specific details that captivates and enthralls viewers and historians of the work. But attention to detail, naturalism, and technical mastery in the representation of figures and forms were just the beginning for David. As visual historian he hoped to communicate a number of ideas that transcended the incarnation of the event.

One of the most noteworthy elements of the composition is the massive architectural setting, the cathedral interior which spiritually and physically dominates the Napoleonic pageant. One sees that the cathedral will remain long after this spectacle has passed. The timeless and the ephemeral are thereby strikingly juxtaposed. This is the first, indeed, only time in David's oeuvre that he ascribed such importance to an architectural setting and gave it such prominence. And it is within this massive and impressive religious and sacrosanct setting that David redefines the status of two preeminent and historically established classes of French society—the monarch and his court with the clergy. This painting constitutes, in fact, a profound statement of Napoleonic policies concerning the church and the state, including the role of the church in France and its relationship to Rome. The poet Villers wrote a short poem commemorating David's brilliant portrayal of the Throne and the Altar.

> In this touching painting David offers to our gaze
> That which is most venerable in the Church
> Greatest in the throne
> Most likeable in Majesty.[32]

Two elements contribute to the venerable characterization of the Church both in the abstract (i.e., the rituals and institutions of the religion, its history, and its adherents)

and in this specific setting of the cathedral of Notre Dame filled with actors and their audience: namely, the representation of the most sacred part of the building with great fidelity to detail and the depiction of the most important religious figures, the Pope and his extensive retinue. David privileged the sacred objects and symbols of the Church—a gold cross held aloft by an elaborately dressed bishop constitutes the center point of the composition and directly confronts the spectator. This cross is echoed in the massive, towering gold crucifix of the splendid altar adorned by monumental candles which shelter and protect it. These two stark yet ornamental images of the dead or dying Christ on the Cross, the central symbol of the Catholic religion and the basis of the sacrifice of the mass, are aligned with Coustou's eloquent and moving sculpted group of the dead Christ of the Deposition—the Pietà—which forms the apex of a diagonal that moves from Josephine and her retinue to the head of the dead Christ. Through this insistent and repeated image David emphasizes the nature of the religious setting. Remarkably, only one participant of Napoleon's retinue looks directly at the sculpted Christ who lies prostrate in Mary's lap—this is General Junot. His gaze redirects that of the spectator away from the secular event to the principal mystery of Catholicism.

In this painting which represents Imperial policy concerning the role of the Church it is difficult to determine whether or not Napoleon had encouraged David to emphasize to this degree the religious setting and the religious meaning and implications of the Coronation. He had chosen the Cathedral of Paris and wanted the Pope present to establish links with earlier monarchical coronations, especially that of Charlemagne, in order to help consolidate and legitimize his new Imperial court. Ostensibly the ceremony was also intended as a way of conveying the reunification of the Emperor of France with the Pope and the Catholic Church (therefore, as a means of confirming the terms of the Concordat). But Napoleon actually stripped the Pope of his principal role by crowning himself (had he let the Pope crown him as was traditional, this act would have symbolized the supremacy of the Church's power over the secular power of the Emperor and the Imperial court). The Pope blessed the crown but this was the extent of his participation in the actual Coronation. He also absented himself from the part of the ceremony in which Napoleon swore the secular oath to uphold the Constitution (the Enthronement). In the painting, one could argue that David has subverted Napoleon's attempt to diminish the idea of the church's power by giving the cathedral interior a prominent role. One of David's early drawings for the composition, signed and dated 1805, reveals close attention to detail in the depiction of the crossing and altar of the cathedral (he even included two of Cayot's angels, who hold instruments of Christ's passion, figures that he suppressed in the final painting).[33] The descriptive details of Notre Dame in this drawing, which are represented with clarity and evenness of lighting, assume a different importance in the painting in which David emphasizes the massiveness and solidity of the walls of the lower arches and the mysterious lighting from the clerestory windows which create an atmosphere of darkness and semi-obscurity. A number of critics highly praised the lighting effects which, they claimed, precisely replicated the light within the hallowed cathedral. Boutard, for example, who

acclaimed David for his truthful portrayal of the cathedral setting, especially the high altar and the architectural details, praised the lighting as one of the greatest merits of the painting.[34] Others criticized the "ton grisâtre" of the lighting and its effect on dimming the brilliant colors of the costumes.[35] Certain critics did not understand why David attempted to represent and reproduce the special qualities of the dim light in this area of the cathedral, the light that characterizes the church interior and gives it a distinct character and personality. Prior to this moment in his career David had only once represented a Christian image on a monumental scale—the *Christ on the Cross* executed for the Chapel of Madame de Noailles in 1782.[36] The commission of the *Coronation* led him to experience and to meditate upon the cathedral of Notre Dame, a Gothic church associated with the distant recesses of the French historical past.

David's use of the Gothic cathedral was related to a larger discourse concerning the revaluation of Gothic art. The reassessment of the Gothic cathedral and of the medieval period in French history and art was given strong impetus during the 1790s soon after the destruction of religious art and artifacts when governmental efforts were made for their preservation. This revaluation continued to be inspired to a considerable extent by Lenoir's collection of tomb sculpture and related medieval works in his Musée des monuments français which made a profound impact on David and his contemporaries (many works had been rescued, removed from their original church context, and displayed in Lenoir's museum and picturesque garden on the Quai des Augustins).[37] In the early 1790s David had strongly supported the preservation of medieval sculpture and was certainly aware of its popularity in the early years of the nineteenth century. Just after 1800, in fact, a group of students who flourished in his atelier began to execute small genre scenes of historical, religious, and legendary events, as well as images from daily life in the Middle Ages. These artists—principally Pierre Révoil and Fleury Richard (who would become known as the Troubadour painters) represented the interiors of Gothic crypts, cloisters, chapels, and churches with an emphasis on the melancholy and mysterious qualities of light. In order to evoke more effectively the lyricism of the distant medieval past, they assiduously studied medieval manuscripts preserved in the libraries of Paris.[38] David, too, studied this newly rediscovered source and resource for the development of the *Coronation* composition. It is extremely telling that he would look to the small-scale images of illuminated manuscripts as well as to the brilliantly colored medieval genre paintings of his students. During this period he copied figures from the *Grandes Heures d'Anne de Bretagne* such as St. Lifard (fig. 99), who became a model for one of the prelates in his painting, and also copied seventeenth-century engravings after psalm books such as Gautier's engraving of *Henri IV en prière* (fig. 100) from the *Psaumes de David*,[39] in which he faithfully enframes the image to indicate that it is an illustration from a book page. David's drawings based on manuscripts reveal that he examined closely details of costume, as well as overall contour and line, pose, and gesture. In order to imbue the religious participants in the *Coronation* with a true sense of religious emotion he had to look back to images from an age that believed naively and

100. David, *Drawing of Henri IV Praying*, from an engraving by Leonard Gautier from *Psalms of David*, Paris, Louvre

99. David, *Drawing of St. Lifard from the Grandes Heures d'Anne de Bretagne*, Paris, Louvre

sincerely in religion, an age of religious faith. The active, taut, muscular, and energetic figures he had studied from antique sources were of no avail to him here. David had to seek an alternative source for the life-size religious figures in his monumental painting and he found it in manuscript illumination. Of course, he could have looked elsewhere—saints and prelates abounded, after all, in Renaissance and Baroque paintings, in compositions well-known to the artist. That he was not especially interested in this source (although he did adapt the pose of Marie de Medici in Rubens' *Coronation* for his figure of Josephine) suggests strongly his propensity for the archaic and the naive (the simplicity and directness of late medieval imagery had become popular and a true article of faith with another group of young artists who were nurtured in his atelier circa 1800—the sect of the Primitifs).[40]

David's artistic interest in the Gothic had undoubtedly been kindled by the necessity of studying the interior of Notre Dame for his grandiose commission. His portrait of the choir and the crossing, the reverence with which he attended to details of religious architecture, sculpture, and emblems, the prominence he gives to the setting which overwhelms the figures suggests that he, like his contemporaries, was considerably influenced by the Gothic revival in French literature. Chateaubriand's extremely successful *Le Génie du Christianisme*, which appeared in 1802, popularized the Gothic revival and propounded that Christianity was just as valid a stimulus to literary inspiration as the classics. Chateaubriand privileged above all the visual and pictorial elements of religious experience; he extolled at length the richness, pomp, and grandeur of the sacred ceremonies and liturgical events which express great beauty and inspire profound psychological and emotional responses. He described in rhapsodic detail the effects of religious passion and he extravagantly praised the poetry of Gothic religious architecture (for which he offers a rather fanciful and imaginative history). In one particularly eloquent passage he wrote the following.

> In vain will they build elegant Greek temples, filled with light, to gather together the *good people* of Saint Louis and make them adopt a *metaphysical* god—they will always miss these Cathedrals of Notre Dame of Rheims and Paris, these mossy basilicas filled with generations of dead and the souls of their fathers; they will always miss a Montmorency tomb, on which they *were wont* to kneel during Mass, not forgetting the sacred fonts where they were carried at their birth. The fact is that all those things are essentially bound to our mores; a monument has value only to the extent that a long history of the past is, so to speak, indelibly imprinted beneath the time-blackened vaults. That is why there is nothing marvelous in a church you have seen built and whose echoes and domes have been formed before our eyes.[41]

Chateaubriand uses the cathedrals of Notre Dame of Reims and Paris as principal examples of how the Gothic cathedral embodies the long past of French history and how this history becomes part of the individual's personal biography through the round and

rituals of life from baptism to burial. The passage also makes clear that the Gothic church is filled with the memories of centuries of individual lives of those who came to pray, and who thereby participated in the history of the church itself. David was very likely directly influenced by these ideas concerning the poetry and national history embodied in the cathedral of Notre Dame (which would be commemorated so memorably in Hugo's great romantic celebration of the cathedral in *Notre Dame de Paris* of 1830), especially when he was confronted with the challenge of linking Napoleon and the Coronation ceremony itself to an extremely remote medieval past.

But the beauty, richness and pomp that David expresses in his depiction of the Coronation ceremony within the magnificent, time-honored cathedral, which enthralls the spectator even today, constitutes only one level of meaning of this composition. For within this putative mingling and unification of the Imperial and Catholic courts another type of drama is unfolding, one that is expressed through the dynamic contrasts of the secular and religious figures portrayed. Critics in 1808 and again 1810 (when the *Coronation* won the *Prix décennaux* for the best representation of a national historic subject) agreed almost unanimously that the altar groups in the composition were far superior to the court depicted opposite it. One observer summarized the criticisms in the following way.

> They also vigorously criticize the right part of the painting, we mean all that which is opposite the altar [our left]. The facial expressions are not very pleasing, the skin lacks truth, the poses have no elegance, the shadows are heavy, the forms do not turn, the color tones are dry and pale. But the principal scene is very beautiful, the materials are superlatively executed; one admires above all the groups that surround the altar.[42]

In the *Journal de Paris* in 1808, another critic wrote:

> One still admires this magnificent painting, the right part of which is a masterpiece of composition. We thought that M. David would retouch the group on the left and the background representing several tribunes. These two parts of the painting still leave something to be desired.[43]

David, however, apparently had no intention of altering either the group of the court figures or those in the tribunes. He made no changes in these areas that we know of for the 1810 exhibition and he only thought of transforming them in his repetition of the work executed in Brussels in 1822, a much brighter composition (which is, however, very difficult to assess since it has greatly suffered from its arduous itineraries and much over-cleaning).[44]

In his 1808 composition David emphasized the figures before the altar, the most sacred part of the cathedral. Opposite the Pope, prelates, and priests, who are depicted in a relatively clear light, stand the figures of the secular Imperial Court; most are literally (and metaphorically) represented in a much dimmer light, including the two

prominent individuals in the far left foreground, Joseph and Louis Bonaparte. So too, to the far right, in the foreground, Napoleon's ministers, all with new titles—the Arch-treasurer Lebrun, the Archchamberlain Cambacérès, Marshall Berthier, and the Grand Chamberlain Talleyrand—stand in a dim light and are enveloped, in part, by deep shadows, but, their vulgar, naturalistic, yet almost caricatural profiles depicted in sharp detail, are clearly visible and pronounced enough to convey their pomposity, arrogance, and self-importance. They wear plumed hats and outlandishly ornate knee-length, medieval looking robes whose heavy folds make them appear weighted down; they seem to be a parliament of strange and stationary birds, self-satisfied with their new position in society and with their finery and their pavonine plumage. The shadows that partially obscure their forms come to symbolize a state of mind and character (David here revives a device he was so proud of having invented for the *Brutus*). And, in a spectacular caricature of Enlightenment values and class hierarchies, the secular are the un-enlightened creatures.

The figures of the Imperial court, dressed in their ornate costumes which were invented for the occasion, form a dramatic contrast to the majority of the religious figures. The Pope and many of those near him, dressed simply and unostentatiously, share in common a care-worn, concerned, melancholy expression; some appear thought-ful and meditative. David continued to use costume metaphorically in the *Coronation* to express character and mores. The Pope, in particular, does not wear his ornate tiara which is held by the sympathetic Roman prelate behind him; he wears instead a simple skullcap and constitutes a dramatic contrast to the ornately dressed Cardinal Braschi who served as the liaison between the Pope and the Emperor in the organization of the Coronation and who, through his golden cope and bejeweled golden tiara and his arrogant demeanor, is associated with the ministers of Napoleon's court (more will be said of the Emperor's "new clothes" shortly).

Throughout the vast composition, David brilliantly employs differences in effects and intensity of light as well as differences in stylistic and technical effects to help convey the meaning. Critics frequently noted these differences which they characterized as discrepancies, most ultimately condemning the lack of unity in the lighting and in the style of the figures as weaknesses or flaws. Thus, lapses of taste and talent were observed in the left-hand side of the composition in which the figures of the new court are obscured by dim light. But the sketchiness of the figures in the central tribunes was particularly denounced, especially those depicted in the tiers above Madame Mère and her entourage (Napoleon's mother who refused to attend the event, was painted in apparently at the Emperor's insistence).[45] Critics attacked the almost illegible figures in the artist's box—the central tier of the tribune where the spectator can barely discern David's portrayal of himself observing and sketching the event. The artist represents himself accompanied by his wife and two daughters and by a group of artists, writers, musicians, and intellectuals (including Rouget, David's principal assistant in the execu-tion of the painting, Mongez, Quatremère de Quincy, Grétry, and the poet Le Brun).[46]

In the tier above the artist's box the "people" peer over the railing; they are depicted in monochromatic tones in an extremely summary manner. Several critics denigrated David for depicting these background groups in such an unfinished and sketchy manner, thereby rendering them indistinct. The following comments appeared in the *Journal de Paris* of September 3, 1810.

> The greatest reproach that can be made to the artist is to have sacrificed the background to the foreground to such an extent that it appears only to have been sketched in. The tribunes placed opposite us are truly of a color that is practically non-existent. One has difficulty believing that M. David willingly neglected painting a line that is not very far back in space. The drawing itself is as weak as the chiaroscuro there is misunderstood.[47]

Very few observers made any attempt to understand what David's intentions might have been in rendering this area of the composition in such a summary way. One exception is provided by Boutard who, at its first exhibition in 1808, enthusiastically acclaimed the composition in its entirety and praised aspects of the work that others had condemned.

> The naive style of this part of the painting [the tribunes] comprises the third step in the progression that we have observed between the invented figures and the historical portraits of the principal subject. Besides, this was the only means of obtaining portraits that were good likenesses at such a distance and which were already in the haziness of perspective.[48]

Boutard attributed David's use of a "naive style" to his concern for naturalism and the vagueness and haziness of forms that would result from them being viewed at such a distance. But Madame Mère and her entourage, although almost as distant from the spectator, are depicted in much greater detail. This suggests that David's use of a naive, unfinished, sketchy style and filtered light in the upper two tiers of the tribunes conflates naturalism of light and atmosphere with metaphorical meaning, just as does the multiplicity of styles and lighting effects in the foreground figures and in the architectural setting. We remember that in his letter to Daru of 1806 David stated that he intended in this series to represent the "different orders of society." Is he not expressing this precisely in the *Coronation*? What he represents, in fact, is a new reordering of the Three Estates brought about by Napoleon's abrupt restructuring of government and society. Clearly, the Monarch and the First Estate—the new Emperor and his court—predominate the new society, which, in spite of Napoleon's constitutional oath, is no longer a Republic. The importance of the Second Estate—the Clergy—has been re-established in this new hierarchical society (which David depicts as a renascence of the Ancien Régime), and the Third Estate, the middle class, including official artists of the Institut, such as the First Painter himself, writers, musicians, composers, intellectuals, and the almost indistinct lower classes above them, are relegated to the role of almost insignificant observers; they are barely discernible, subser-

vient spectators to the splendor and glory of the new powers reordered on the old. David made the contrasts between the Estates stark and vivid in a painting constructed on multiple and complex contradistinctions.

As we have seen, many of the juxtapositions in this composition are subtle, refined, and emerge only after careful reflection in an effort to understand the multiple meanings. The most overt contrast, however, is that between Napoleon and the Pope, figures that David differentiates from one another in almost every way. But David knew that in portraying the Pope and the Emperor he would ineluctably be making his contribution to the nineteenth-century dialectic devoted to the confrontation between the throne and the altar. A particularly fascinating drawing makes clear that David conceived of these two figures as a group (fig. 101). The drawing dates from an early period in the development of the composition when Napoleon crowns himself, having wrested this sacred function from the Pope (the perspective grid suggests that David was ready to transfer the group to his canvas). In the drawing David represents Napoleon in a dynamic stride, he presses his sword to his heart, and arrogantly, though solemnly, crowns himself. The energetic pose and gesture of the Emperor, who appears to struggle to move against the cumbersome weight of the animate drapery folds of his costume, stand in dramatic contradistinction to the inert, stooped figure of the seated, motionless Pope who does not look at the self-crowning and who does not bless the event (his hands remain motionless on his knees). The Pope, still, self-contained, enveloped in his ample cope, a simple tiara on his head, is seated behind Napoleon, but so uncomfortably close that the Emperor's clothes overlap and flow over his. Although in the final composition David altered pose, gesture, and costume in these figures he retained the dramatic contiguity between them and he rendered the Pope far more sympathetic than the Emperor.

In the painting the Pope cannot bring himself to look at the Emperor's gesture which he seems reluctantly to bless—the blessing hand is lifeless and completely lacks energy. In the original version of his painting David apparently depicted the Pope with his hands on his knees but Napoleon was unhappy with this and compelled David to give the Pope a gesture of blessing.[49] In the painting, the Pope looks inwardly, absorbed in what seem to be sad reflections. It was no secret that he was displeased with the ceremony and what it signified. He had learned only a few hours before the ceremony that he would anoint but not crown the Emperor, that a number of liturgical features had been suppressed and he realized that he had been used as a pawn in the Emperor's game.[50] David, in fact, reveals in the painting what had been censored in the press—namely, that the pope was a political prisoner, an unwilling and unhappy participant in Napoleon's Coronation. David's extremely insightful and sympathetic portrayal of Pope Pius VII in the *Coronation*, as well as in his other depictions (the remarkable double portrait of the *Pope with Cardinal Caprara* painted on wood over an oil sketch of the *Coronation* [fig. 102]) and his famous individual portrait of the Pope (fig. 103),[51] reveal the deep interest in and sympathy for this abducted religious leader that David had

101. David, *Sketch of Napoleon Crowning Himself with Pope Pius VII*, Paris, Louvre

experienced as a result of their encounter. Delécluze believed that David had been profoundly inspired by the Pope and his retinue and that his meeting with the Pope had led the artist to emphasize the religious figures and the religious aspect of the entire ceremony (as mentioned earlier, caution is necessary when assessing Delécluze's statements, but here the evidence of the painting bears him out).

102. David, *Pope Pius VII and Cardinal Caprara*, c. 1805, Philadelphia, Philadelphia Museum of Art

103. David, *Pope Pius VII*, 1805, Paris, Louvre

Indeed, it suffices to see the composition of the *Coronation* in order to realize that this latter figure [the Pope], the cardinals, the priests and all those attached to the religious part of this ceremony, constitute the principal group to which David instinctively directed the efforts of all of his talent.[52]

Delécluze also recounts at length the reasons for David's great admiration: for a man of his prestige, power, and high office—that of a world religious leader—the Pope was unexpectedly simple, humble, and sincere (he was, in fact, renowned for these qualities). Pope Pius VII had grown up in poverty and it seemed to David that he had retained the noble qualities that resulted from his humble beginnings.

In the *Coronation*, David represents the Pope as a type of modest priest who embodies the naive, sincere, and simple, in other words, true religious feeling and intentions. And he depicts him as a middle-aged man rather than the sixty-three-year-old individual he was in 1804; in so doing he demonstrates that the Pope retained the personal traits and qualities of the younger priest that he had been—the power and trappings of his office had not changed him. This is also conveyed quite remarkably in his frontal, individual portrait of the Pope of 1805 (fig. 103), whose brilliant execution and perceptive characterization led it to serve for most subsequent depictions of this individual who later became a hero in Italy for his defiance of Napoleon.[53] The portrait and its two repetitions also became an object of contention between Napoleon and David—the Emperor refused to acknowledge the commission of the portraits and thus also refused payment, further evidence of the hostile rapport between the emperor and the pope and Napoleon's disapproval of his First Painter's monumental and sympathetic representation of the religious leader.[54] In his depiction of Pius VII in the *Coronation* David seems to prefigure the Pope's future defiance of Napoleon for he has done everything in his power to make him appear tense, uncomfortable, and extremely unhappy with the events unfolding before him. Napoleon seems much less heroic and important by virtue of his juxtaposition with this melancholy figure seated behind him who cannot bring himself to look upon the crowning, thereby revealing Napoleon's cynicism.

And, as the studies for the figure of Napoleon and his rendering in the final painting reveal, David had great difficulty in creating a wholly heroic figure of the Emperor. The Emperor's "new clothes"—his Imperial regalia—the sign of his new office, simply do not "fit"; he appears encumbered by the massive, heavy robes which hang in dense, sculpturesque folds and serve to thwart and suppress the dynamic energy he had radiated when represented as a military leader (one has only to think of the perfect union, the natural "fit," of costume and corporal form in *Bonaparte Crossing the Alps* to realize the great differences between the consular and Imperial incarnations). The "ill-fittedness" of the Imperial regalia that we observe in the *Coronation* is heightened and exaggerated in David's oil sketch of *Napoleon in Imperial Robes*, the only surviving indication of his full-length portrait destined for Genoa (fig. 104).[55] Napoleon hated

this portrait and, in a great affront to his First Painter, canceled the commission. After seeing it in early July 1806, the Emperor wrote to his Minister of the Interior Daru:

> This portrait is so bad, so filled with flaws, that I cannot accept it at all and I do not want to send it to any town, above all in Italy where it would give a very poor idea of our school.[56]

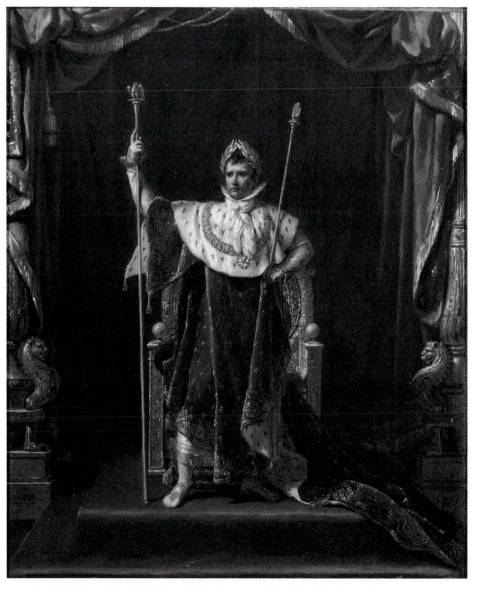

104. David, *Napoleon in Imperial Robes*, oil sketch, 1805, Lille, Musée des Beaux-Arts

Napoleon was probably responding to the pronounced anti-heroic and aniconic qualities of the portrait that characterize so vividly the sketch. David departs radically from the monumentality, nobility, and hieratic stillness of the extensive series of painted Imperial icons, many of which were executed by his students. Ingres' strange and rebarbative *Napoleon Enthroned* of 1806 and Gérard's banal , though extremely successful, *Napoleon in Imperial Robes*, 1805, are among the best-known examples.[57] David does not represent the individual transcendence and absolute power that characterized the majority of the Imperial portraits. Instead, he depicts the Emperor as a diminutive individual whose forward stride is checked by the weight of his massive costume which thwarts, encases, and imprisons the figure. Napoleon, the man of energy, is hampered by the heavy institution of the Emperor. The Imperial robes, together with the inordinately oversized, almost monumental golden laurel leaf crown, serve to accentuate the short stature of Napoleon. In addition, the ornate, luxuriant, heavy materials of the costume form a jarring and disjunctive contrast with the naturalism and mobility of the facial features; the head itself does not seem to be integrated harmoniously with the body. Then, too, the figure is set back at a considerable distance from the spectator and is not conceived monumentally—it does not dominate the space. The portico that shelters the throne, covered with heavy drapery, seems to confine and oppress the figure of the Emperor who appears to maintain precariously both his dignity and his balance.

This absence of monumentality is emphatically pronounced and constitutes one of the most extraordinary and puzzling features of the second monumental work completed for the Napoleonic ceremonial commissions: *The Oath of the Army to the Emperor after the the Distribution of the Eagles on the Champ de Mars, December 5, 1804* (fig. 105), finished in time for the 1810 Salon. David's homage to the valor and courage of the French army is one of his strangest and most experimental paintings. The relatively small number of critics who wrote about it in 1810 were confused and surprised by its unexpected structure and its peculiar and contradictory details (the only completely positive account was offered by Denon who, in a letter to Napoleon of November 11, 1810, sought to reassure him about the painting's merit—this letter was clearly written to counter criticisms).[58] David was originally planning to execute *The Arrival at the Hôtel de Ville*, when, in 1808, Napoleon asked him to paint the *Distribution* instead.[59] By 1808 Napoleon was probably much more interested in a painting that could serve as propaganda for his military rule and control. One critic of the time wrote that the *Distribution*, like the *Coronation*, was an "event that also relates to the institution of imperial power."[60] In 1808 Napoleon wanted images produced that would consolidate ideas of Imperial power and celebrate him as omnipotent leader of the great French armies.

This is not, however, the kind of image we see in the 1810 painting, for one has to look hard to find the Emperor at all when one first gazes at the composition. Napoleon, lost in the crowd of his court and his marshalls who surround him, impotently confronts the colonels of his armies who have charged up the long flight of stairs before the Ecole

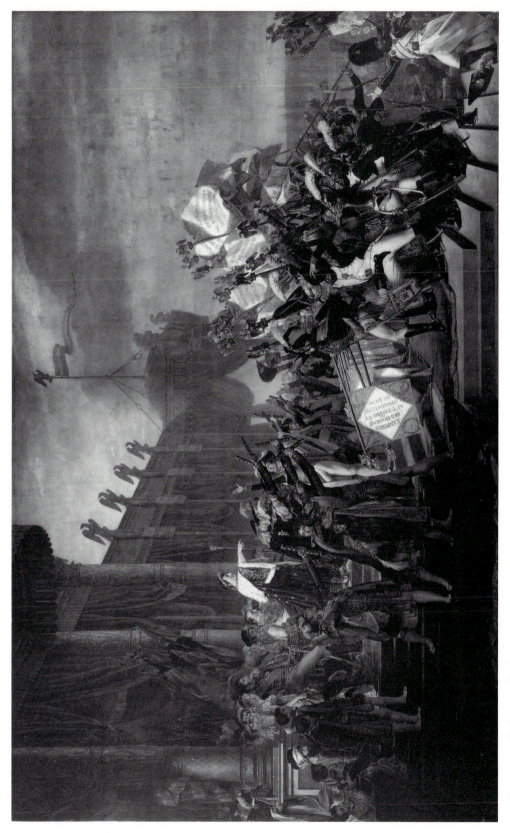

105. David, *Distribution of the Eagles*, 1810, Versailles, Musée National du Château

Militaire (temporarily redecorated by Percier and Fontaine as a type of oriental pavillion) to swear an oath of fidelity to him.[61] The dynamism and vitality of the colonels who balletically leap, lunge, and thrust forward, stand in dramatic contradistinction to the inergetic Napoleon, his listless court, and static, histrionically posing marshalls. As so often in David's representations of the Emperor, Napoleon appears completely imprisoned by his massive Imperial robes, the gesture of his noticeably short and unimpressive arm is weak and ineffectual. David, master of corporal expressivity and the gestural sublime, conceived of a stiff, awkward, and marionette-like figure of the nation's leader who does not appear to be in command of the fervent and disorderly troops who form a dense, clotted, jumbled mass which seems to be moving forward towards the court as if propelled by an unstoppable energy.

This image of a chaotic army confronting the Emperor, which looks more like a insurrectionary mob charging their leader and his minions rather than one engaged in an orderly oath-taking (the whole constituting a shocking breach of military discipline) was severely denigrated by contemporary observers.[62] A critic for the *Journal de l'Empire*, an official mouthpiece of the government, attempted to answer some of the most damning charges in the following terms.

> Several critics claimed that the Marshalls should be at the head of the troops, like them their faces turned towards the Emperor who receives their oaths. They do not think that enthusiasm can *serve* as an excuse for disorder, for a disarray that is contrary to military discipline, even in a painting. The action, they say, is equivocal, there is nothing to keep us from understanding it as a seditious movement that the monarch and his generals are attempting to quell. The movement and the expression of all the figures evince as well that this has to do with an oath taken with joy and nothing to do with *seditious rage* [my emphasis].[63]

This passage indicates that several critics of the time had observed that the painting was, indeed, seditious and politically subversive. When examined closely the *Distribution* reveals the extent to which David had become disillusioned with the Emperor and his court and the contempt in which he held the institution of the monarchy. The members of the court appear fatuous and ineffectual in contrast to the energetic and vital colonels, the fighting men who are the true, active participants in the Napoleonic battles.

And we remember that David's original intention in this monumental composition was to create an homage to the army, not to the Emperor. According to David, Napoleon had compelled him to suppress an extremely significant figure in the composition, a winged Victory flying above the colonels and dropping laurel wreaths down on their heads.[64] This Victory was the only known allegorical figure David ever planned in a monumental historical composition (we remember the appearance of the winged Victory in his allegorical composition of the *Triumph of the People* for a putative opera

curtain design—see figs. 60, 61). The winged Victory, here a visionary figure and originally the central focus of the composition, would have detracted attention even further from the diminutive Emperor, who would have been completely upstaged by the colonels and their "Victory"; Napoleon, in fact, would himself have been in a position of homage to his own army. It must have been for these reasons that he ordered the Victory removed, but he probably did not expect David to make its absence palpable—the disorderly colonels remain the focus of the composition and many of the marshalls still gaze with ardor and heartfelt wonder at the (now invisible) vision of victory above the colonels' heads in the sky.

A drawing of the composition from 1808 (fig. 106), executed in a naive, almost folk-art style, with the winged Victory in place, reveals that David originally thought of a very orderly, almost static oath-taking, with the colonels on the stairs joined together in a cohesive and unified group. Although the Victory is the most prominent figure in the composition, Napoleon is nevertheless central and highlighted at the head of his army and his marshals (who, even here, however, point their raised swords or gaze fervently towards the Victory rather than the Emperor). The allegorical meaning is simple and direct—Victory crowns the fighting men whom all, even the monarch himself, honor. David was very angry at the changes he had been forced to make; on the reverse side of a drawing for the Victory figure he wrote the following.

> The Victory rains upon the flags/ their head/ a rain of laurels presage of the new triumphs that await them.[65]

And, on another drawing (fig. 107) he noted:

> This figure was destined to enter the painting of the eagles, the emperor did not want it, one can see by the poses of the marshalls that it was indispensable.[66]

The artist's notes reveal that, in the final painting, he wanted to make the absence of this "indispensable figure" felt by the viewers of the work whose gaze is directed towards the empty sky by the fervent glances and sometimes histrionic poses of the marshals.

Why did David want, for the first time in his career, to employ an allegorical figure in a monumental history painting? Once again we find him engaging one of the most controversial aesthetic issues of the time. We know from his *Bonaparte Crossing the Alps*, as well as from his written plans for the Napoleonic pageant paintings, that David sought to enrich the meaning of his compositions through the mulitvalent levels of symbol and metaphor used in an allegorical mode (he originally conceived of the series of four works, we remember, as a type of allegory of good government and, concomitantly, a series of homages to the different groups that make up society). The introduction of the allegorical figure makes more emphatic that we are not witnessing an historic event unfolding on the canvas before our eyes (history painting is not an "illustrated *Moniteur*") but a metaphorical vision.

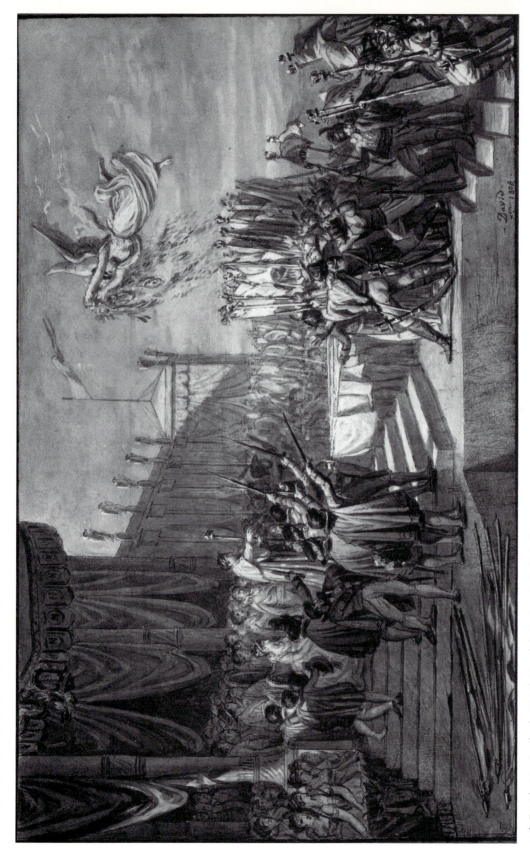

106. David, *Drawing for the Distribution of the Eagles*, 1808, Paris, Louvre

107. David, *Drawing of Victory for the Distribution*, Paris, Louvre

By using the allegorical Victory in the *Distribution*, David was making an extremely significant statement concerning the potential function and impact of overt allegory in history painting. Like many of his contemporaries, he was meditating on the meaning of allegory and its position in the arts during the early years of the nineteenth century when a heated debate on this issue was taking place. This complex and multi-faceted debate has been unjustly neglected in the study of French art of this period. As discussed earlier, the language of allegory in painting and sculpture had been revitalized during the Revolutionary years which witnessed a remarkable renascence of allegory in art (David, we remember, had been very much involved with this movement in certain categories and artistic modes). In the *Distribution* we see David once again defining one of the most critical aesthetic debates of his time, or, indeed, determining its outcome.[67]

Like his contemporaries David was aware of Winckelmann's broad and vague definition of allegory which included symbols and emblems—such a comprehensive definition appealed in particular to artists who were seeking to broaden and redefine the new metaphoric language of painting circa 1800 in France.[68] But during this period a number of stringent warnings were issued to artists concerning the potential "abuses" of allegory. In the second edition of the dictionary of art of Watelet and Levesque published in 1792 grave concern is expressed in particular with the "improbability" and obscurity of allegory.[69] And the archaeologist, mythographer, and aesthetician Millin reiterated these reservations in his lengthy definition of allegory in his *Dictionaire des beaux-arts* of 1806.

> The images chosen by the artist must not be arbitrary, they must be like a universal language, intelligible to all. Because often artists, in wanting to make allegorical figures, have fallen into the trap of only presenting unintelligible compositions or word games.[70]

Other percipient critics, including Chaussard, adamantly opposed allegory in painting because of its arcane meaning which made impossible a universal language of art (one of the utopian objectives of late eighteenth-century aesthetics in France).[71]

David's introduction of a Victory in the *Distribution of the Eagles* was not an attempt on his part to salvage or reinstate the traditional, complex language of allegory in history painting, a language understood by the initiated, the cognoscenti. Instead he wanted to introduce a symbolic figure whose meaning would be immediately comprehensible to all. The Victory figure provides a remarkable, salient example of ingenious artistic ideas and continual experimentation with pictorial devices that led to consistent metamorphoses in David's art. David was seeking to create a type of symbolic language that would embody popular ideas, whose meaning would be absolutely transparent. In an unexpected reversal of academic norms and conventions, allegory here became popular art. This helps to explain the naive "folk art" elements of the completed drawing (fig. 106) and also those of the separate sketches for the Victory itself. In the *Distribution* David was again seeking to set art in a new direction, here his attempt was abortive

because of the interventions of Napoleon and Vivant Denon (the conflation of allegory and popular art in history painting would be realized, however, in the works of the romantics—Delacroix's *Liberty Leading the People* immediately comes to mind as an exemplar of this new mode). If Napoleon and his advisors had not intervened, the flying Victory in the *Distribution* would have demonstrated that representations of very simple and direct symbolic figures in history painting could be effective and useful in helping to clarify the metaphorical meaning of a composition.

David's interest in creating a popular allegory provides further evidence that in his early nineteenth-century oeuvre he had begun to distance himself dramatically from the concept of painting as an imitation of nature and a window on the world. And, in spite of great naturalism in attention to details of costume and corporal configuration, many elements that were retained in the final painting of the *Distribution* make it impossible for the spectator to accept the composition as a view of an actual historical event.

At first glance the painting appears to be as compositionally stable as the *Coronation*—the spectator is fixed somewhat below the figure of Napoleon and looks upward at some of the figures but down at others (such as those still climbing the steps). The principal figures of the marshalls and colonels are placed close to the foreground plane, bringing the spectator up close to the tumult of the army's oath-taking on the upper stairs and platform. This increases the viewer's experience of participation in the event, an illusion made more vivid by the naturalism in the costumes, figures, and faces of the large group of individuals David has portrayed. This participatory response, however, begins to dissolve immediately upon closer observation and reflection—for we find ourselves placed as viewers in a very odd position indeed—we hover at the top of a very steep flight of forty stairs and witness a scene that is filled with puzzling, contradictory, and sometimes impossible actions and forms. One critic, who was shocked by the disarray of the colonels, summed up these contradictory elements in space, perspective and figural proportions as inexplicable flaws.

> In considering with some attention the element of drawing, this element that is usually so perfect in David's paintings, one is completely astonished to see a throng of mistakes amid great beauty.
>
> Here the viceroy of Italy in military costume is in such an equivocal pose no one can define it. Some believe he is seated, others believe he is only leaning on his sword. Whatever way he was supposed to be represented, it is only too clear that his *pose* is constrained and that he is poorly drawn.
>
> There, at the top of the stairs he has just climbed, we see a young hussar, running on the balls of his feet and raising a leg nimbly behind him, as if, in the difficult direction from *lower to higher*, he had the same freedom of action as in a race in the open country.
>
> Further down, and in the foreground, well in front of the principal group, a sapeur, who looks like he is mounting an assault, stretches out a

huge arm to the right, the extremity of which is hidden behind other figures
at least five feet away.[72]

We can only agree with the critic's assessment of the departures from the norm in these
different parts of the composition but it cannot be that they are the result of flawed
draughtsmanship. David self-consciously refused to let the viewer believe in the fiction
of the painted space as an illusion of nature. Once this illusion is broken the spectator is
compelled to reflect on the odd disparities, the anti-naturalistic elements, and to puzzle
over the meaning of the composition as a whole. And David used the deletions he was
forced to make as an opportunity to render the composition even more politically and
aesthetically subversive. As we have seen, when David was compelled to delete the
Victory figure he refused to alter the pantomime of the marshalls who still marvel at the
position formerly occupied by this apparition in the sky. Similarly, when Denon forced
David to replace Josephine and her ladies in waiting because of Napoleon's recent
marriage to Marie Christine of Austria, the artist called attention to this change by
replacing Josephine with the awkward, anatomically distorted figure of Eugène de
Beauharnais who is accompanied by the fatuous Hortense de Beauharnais—she looks
out at us with a strangely ambiguous and almost ironic expression. David also replaced
Josephine's ladies in waiting with a motley and picturesque group of non-French out-
siders, who stand in a very odd position on a level beneath the court (this group includes
Cardinal Caprara, the envoy from Denmark, and the ambassador from the Ottoman
Empire). In a note, David wrote of these changes he had been forced to make in the
following terms.

> I was even compelled to make changes in that [the composition] of the Oath
> of the eagles, the Empress Josephine was represented in it seated, her daugh-
> ter the Queen of Holland and her son the viceroy of Italy behind her. It took
> a great deal of art to free myself from the difficulty that this change
> necessitated.[73]

In this note David claims that the changes necessitated great skill. The transformations
and replacements in the final composition, therefore, must be viewed as intentional and
not adventitious or the result of expediency or haste. Through the oddness of these
changes, however, David drew attention to his own discomfort and increased the unease
of the spectator.

Even further subversive elements can be found in the painting which Denon,
Napoleon, and the critics themselves seemed to have overlooked. These include the
insidious messages conveyed by the former flags of the Republican army. The new,
opulent, ostentatious flags which carry both the title and emblem of the Emperor (the
replacement of the former regimental flags by uniform, imperial standards—the
eagles—accompanied by an oath of fidelity was the purpose of the ceremonial event)
stand in dramatic contradistinction to the stately, much more subdued relinquished
flags that David has given a fictive place of honor behind Napoleon and his court (the

108. David, detail from the *Distribution*

confiscated flags were apparently not displayed at the distribution of the new ones).[74] The relinquished flags are unique and individual, each is inscribed with the name of a battle that distinguished a regiment while the new flags are virtually uniform (only the regiment number varies on each). The uniformity of the new flags conveys the power of centralized control, the new bureaucracy that Napoleon established for the military as he did for society as a whole, while the relinquished flags carry a specific message associated with an illustrious, individualized, particularized history—three are inscribed with the names of places where the Republican army enjoyed its greatest victories—Lodi, Rivoli, Marengo (military victories which, in his pre-Imperial days, helped construct Bonaparte's rise to power). Thus, the former flags that stand erect behind the court, yet seem to preside nevertheless over the new Imperial standards, communicate a distinct narrative in themselves, a narrative that is concerned with Napoleon's assumption of political power based on his military capability and his qualities as leader of a great army. There is still another flag in the composition that has usually been overlooked. In the space between the sapeur and the colonels (we remember the important, anecdotal usage of the interstices in *The Sabine Women*), a young soldier, his back turned towards us, carries off a folded flag on which can be read in fragmentary form, "La République" (fig. 108). The soldier strides away from the Emperor (to whom

he has turned his back), the court, the marshalls, and the colonels. He does not take the oath (one wonders, in fact, where he is really located in space since he seems to be only slightly below the sapeur near the top of the very steep flight of stairs) and the Republican flag is not relinquished. David's message is both subversive and proleptic, for the Republic would, indeed, return, although the artist would not live to see it.

The subversive elements of the *Distribution* and, in particular, the diminutive and ineffectual figure of Napoleon who does not seem capable of either commanding respect or control from his own army, reveal the extent to which David struggled with and, indeed, was refractory to representing the Emperor as monumental or heroic. But his final representation of Napoleon during the Empire period reveals that if he refused to make the Emperor iconic, glorified, and omnipotent in Imperial regalia, he separated the office and mantle of Emperor from the earlier incarnation of the self-made individual, the civic and military leader who had changed the direction of French society through his legal and social contributions. David's great masterpiece, *Napoleon in his Study* of 1812 (fig. 109, colorplate V)), commissioned in 1811 by a private patron in Scotland, Alexander Douglas, who shared with many a cult for Bonaparte as First Consul, constitutes the artist's final homage to an individual whom he revered as one of the true "grands hommes" of his epoch because of the contributions to French culture he had made during the early stage of his career.[75] It is not surprising that in this portrait the references to Napoleon as Emperor are minimal (the embroidered bees on his chair, the eagle on the pilaster against the back wall being the most obvious allusions), for David here returns to the iconography of the Consular portraits and, in fact, depicts the leader busy at work on the Civil Code, a contribution of the Consulate years, described by Alfred Cobban as "the most effective agency for the propagation of the basic principles of the French Revolution."[76] David would always honor the legacy of the First Consul, the incarnation of so many of the ideals of the French Revolution.

Not surprisingly, David used costume and setting metaphorically and symbolically in this brilliant psychological portrayal of the "grand homme." David celebrates the First Consul for his intellectual accomplishments, for his ideas and mental energy that have contributed to reshaping French society in a positive way. The artist returns to a traditional Renaissance, Baroque, and eighteenth-century vocabulary of the heroic portrait in which details of the setting convey a series of messages about the character and accomplishments of the individual portrayed. He conflates this with the genre of the writer-intellectual depicted in his study. In this life-size portrait David depicts the First Consul as a monumental figure who, presented standing in the immediate foreground, easily dominates the space of the setting. The artist privileges the face of the leader which is luminous and imposing. The details of the head and facial features are remarkably precise and the expression itself is complex—resolute, determined, yet reserved. The First Consul directs his thoughtful, penetrating gaze towards the spectator; he seems approachable, human, a modern individual whom we can recognize and greet and with whom we can identify. David depicted the leader in the blue and white costume of

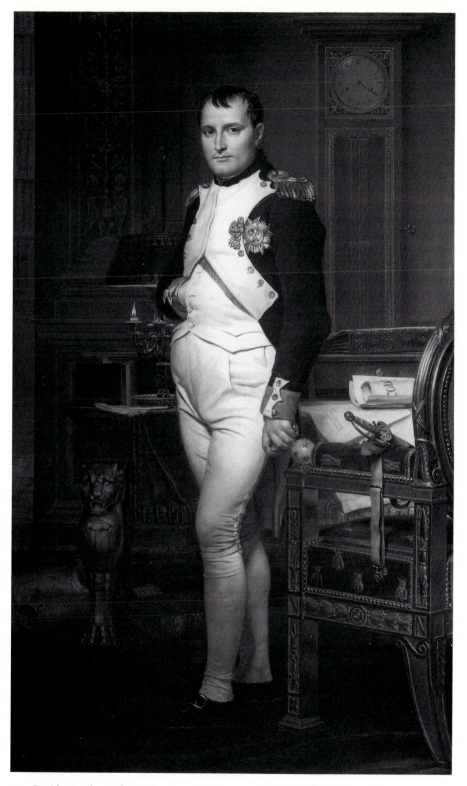

109. David, *Napoleon in his Study*, 1812, Washington, D.C., National Gallery of Art

the grenadiers, with its references to military glory and victory (along with the red details, of course, the costume refers to the Republican tricolor), as precisely as he has depicted the face. He has not tried to transform or ameliorate the physical characteristics of the middle-aged man that Napoleon had became by 1812. The thinning hair, the heavy jowls, the portly waist and abdomen, the slightly slumped posture, are all clear indications of bodily transformations that occur with the passage of time and help to render the leader more accessible, more human. Even the great and handsome age and, like all mortals, gradually lose their beauty and noble form and bearing. Yet the great individual's character has not changed with age but has remained just as resolute and indomitable, his powerful will with its mesmeric power is remarkably compelling. It is telling that David depicts the middle-aged Napoleon as he may have looked in 1812 (as we shall see, in one of his letters to Douglas, David insists on the extraordinary "resemblance" of this portrait to its sitter), but places him, paradoxically, at a much earlier moment in his career—when, as a young man, during the Consulate, he was working on the Civil Code, which we see on the desk. David emphasizes that Napoleon Bonaparte's greatest accomplishment was the Civil Code and that even as Emperor, and though middle-aged, this remains the timeless contribution that makes him worthy of an apotheosis as a "grand homme" of contemporary civilization. With remarkable insight into the judgments of posterity and the future unfolding of history, David appositely perceived in 1812 that Napoleon would be most remembered, or rather, best remembered, for his contributions to the civic structures and the legal code, that this would remain his indelible (and consummately Republican) contribution to French society and history. In this encomiastic portrait, to a greater extent perhaps than in any other of his paintings, David was directly concerned with ideas of time passing and the timeless. The clock that marks the precise hour of 4:13 (in the morning) and the candles that are almost burned out convey the idea of a very specific historic moment but also, in the traditional iconographic vocabulary inherited from the the Renaissance and the Baroque, these still-life elements express the transitoriness of life and mortality; the gutted candle and the clock serve as momento mori. The aging body of Napoleon also expresses mortality and reminds us of the body's ultimate degeneration and decay, the transformation in time from youth to old age. But what will remain is the written word, the individual's record of his ideas that will continue to exert influence long after death. Thus, David eloquently juxtaposes the quill with the almost extinguished lamp and the First Consul's Civil Code hastily left on the desk (one double sheet seems almost about to slip off the desk, precariously held in place by the sheets on top of it, and is poignantly positioned behind the sword that rests diagonally on the chair as though to indicate that the sword protects or ensures the laws). Large tomes, records of individual thoughts that survive from the past, are found throughout the composition, on the shelves glimpsed to the far left in the adjacent library and underneath the desk by Napoleon's feet. We also see that David has signed his own name in Latin on a scroll by this large volume. In so doing he expresses the belief that his portrait, like the Civil Code, will endure.

The artist's presentation of his ideas in the painting, just as the hero's presentation of his ideas in writing, are timeless and will enter history and its records in an enduring way.

In a letter to Douglas of September 20, 1811, David accepts the commission to depict Napoleon engaged in an "event" that made him immortal (i.e., writing the Civil Code).

> I have received from the hands of M. Bonnemaison a letter from your lordship in which I learned that you have deigned to choose my brush to transmit to the canvas the features of this "Grand Homme" and to represent him in one of the events that made him immortal.[77]

This commission offered David an unexpected and unique opportunity to celebrate the First Consul and to commemorate his greatest achievement during the Consulate. Unlike his other commissioned representations of Napoleon David had great freedom in his invention of the composition—no interference from Imperial patrons and advisors and no concerns of governmental or public censorship since the work was not destined for a French audience. In many ways, however, the painting belongs to David's subversive iconography of Napoleon for his celebration of the First Consul at this late date implies a direct criticism of the Emperor. It is telling that in his letters to Douglas David repeatedly refers to the First Consul, not the Emperor, as a "grand homme"; Bonaparte's earlier intellectual, cultural, and civic contributions have rendered him immortal. In a lengthy letter written to Douglas on May 8, 1812 after the painting was completed and exhibited briefly in his atelier before being sent to Scotland, David describes his composition in detail and reveals some of the ideas he was trying to express in the portrait.

> I can thus assure your lordship (by repeating to him the expression of public opinion) that no one until now has ever made a better likeness in a portrait, not only through the physical features of the face, but also through this look of kindness, of composure and of penetration that never left him.
>
> I have represented him at a moment in his life that was most customary—work. He is in his study, having spent the night writing his Napoleonic Code. He is only aware that it is daybreak by the candles which are consumed and going out and by the clock that has just sounded four in the morning. Thus, he gets up from his desk to put on his sword and to go to review his troops.[78]

We see in this letter David's deep admiration for certain of Napoleon's qualities that remained unchanged. As we have seen earlier, however, the evidence of his paintings reveals that his admiration was tempered with deep doubts and anxieties concerning Napoleon's efforts at self-aggrandizement. The artist remained profoundly ambivalent towards the Emperor. David was able to tell the truth about the "Emperor's new

clothes" without denigrating the leader's previous incarnations as soldier, general, and First Consul. In Napoleon one witnessed, in George Steiner's phrase, "the historicization of the personal which is the commanding truth and legacy of the French Revolution."[79] Napoleon's apostasy, however, by arrogating to himself the office of Emperor, was something that for David even the glorious past could not completely exculpate. David grew increasingly uneasy with the Emperor and his monarchical and megalomaniacal ambitions. His uneasiness resulted in problematical paintings censured by perceptive political critics of the time. We remember that he juxtaposed the spiritual qualities of the Papacy with the more mundane and, to David, slightly comic pretensions of the Emperor. The dynamic individual, the embodiment of pure energy, whom David immortalized crossing the alps, became the figure entrammeled in the trappings of institutionalized office. The tenor of the paintings David produced concerning Napoleon and his reign suggests that this chaotic and ill-advised assumption of power was fraught with dangers and its eventual failure was strongly implied.

V

ART IN EXILE

The Instauration of Romantic Hellenism

IN THIS concluding chapter I will examine the final phase of David's brilliant artistic trajectory. During the last years of his life, exiled in Brussels for his regicidal vote of 1793, David, while consistently rejecting attempts by his students and friends to engineer his official return to France, nonetheless retained an active interest in French artistic, cultural, intellectual, and political life. Although in Belgium he was largely immersed in a French milieu. Accompanied by his wife, surrounded by fellow exiles with whom he intimately associated, continually visited by French family, students, and friends with whom he kept up a very active correspondence, David painted several monumental works which were destined principally for a French public. In his correspondence David repeatedly refers to the artistic benefits of his exile—new stimuli from a different environment and a certain artistic freedom—but he always wanted to share these new developments with his French audience. After altruistically exhibiting the works in Belgium for the benefit of the poor, he made concerted and successful efforts to have several of his major Brussels paintings shown in Paris in order to elicit responses from French observers (an impressive and significant corpus of journal criticism and letters attests to the success of this venture). David's letters from Brussels to his students reveal that he was particularly concerned with the situation of French art; by sending his works to Paris he hoped to influence the future direction of the French school. David's last works are replete with new ideas and are remarkably rich in compositional, stylistic, and thematic innovations. Yet no period of his art has been so denigrated as that of his exile in Brussels. With rare exceptions these great and neglected works have been the object of reiterative animadversions since their first exhibitions and, largely owing to the deleterious influence of Delécluze, they have remained mistakenly maligned ever since. However, one early and powerful voice among pre-eminent art critics sounded their defense—Baudelaire described David in Brussels as a "colosse injurié par des mirmidons" and he saw no qualitative difference between David's early and late works;

221

for him, as for Delacroix, David remained the "grand maître" of the French school and the central force in the development of nineteenth-century French painting.[1]

The essential characteristics of David's final corpus of works executed in Brussels can best be defined by terms such as experimentation, exploration, innovation. This brief period in the artist's career—1816–1825—witnessed an intensification of his already formidable transformative methods of creating art. As we have seen throughout this study, experimentation and change characterized David's entire oeuvre, but in his final years this process is compressed and accelerated. It is as though knowing he was at the end of his life and naturally uncertain as to the length of time left him (a typical plangent theme of his letters during this period), David had to give form as quickly as possible to a number of newly developing aesthetic ideas without sacrificing quality, mastery, or genius. These original and often experimental explorations of subject, style, technique, and composition find expression in his late portraits, in his unexpected genre paintings, in his corpus of drawings, and, above all, in his major mythological paintings. We find David in Brussels greatly expanding his artistic vision, working simultaneously in a variety of styles that differ dramatically from his prior modes.

In his brilliant and often problematic late portraits which are executed in an astounding range of styles, David, celebrated since the late eighteenth century for his ability to capture personality in a vivid and almost uncanny manner, becomes a master psychologist, probing and seeking to express the profound depths of an individual's thought, feeling, and experience, the distilled essence of individuality etched in the face and figure, revealed in the details of hair, costume, and familiar objects that function as emblems or attributes of the sitter. These qualities are manifest in his penetrating portrait of E.-J. Sièyes (fig. 110), author of *Qu'est-ce que le Tiers Etat?*, former conventionel and leading participant with Bonaparte in the 18th Brumaire, who shared David's exile in Brussels along with many others who had voted for the death of the king during the First Revolution. In this remarkably eloquent and powerful depiction which represents Sieyès in a deceptively simple, informal pose, holding his snuffbox and handkerchief, David demonstrates a new level of intensity, insight, and psychological subtlety achieved in the facial expression, posture, and carriage as well as in a number of details that conjoin to express Sieyès' character, will and, moral certitude, as well as the profound melancholy of long experience. Sieyès confronts us directly with an expression of obstinacy and determination, disappointment, wisdom, and sorrow, the energetic, turbulent waves of his hair indicative of an electric intensity of thought. The painting, executed in 1817, ostensibly commemorates Sieyès in his sixty-ninth year, "aetatis suae 69," yet David presents us with the face and figure of a much younger man, the middle-aged Sieyès in his prime, at the height of his political involvement (we remember that the artist had used this device a number of times, such as in his *Portrait of Pope Pius VII*). By choosing to depict the former political hero in this way, David offers to posterity Sieyès as a "grand homme," an historic figure worthy of the French Pantheon of great individuals who had helped to shape civilization, a theme that had preoccupied the

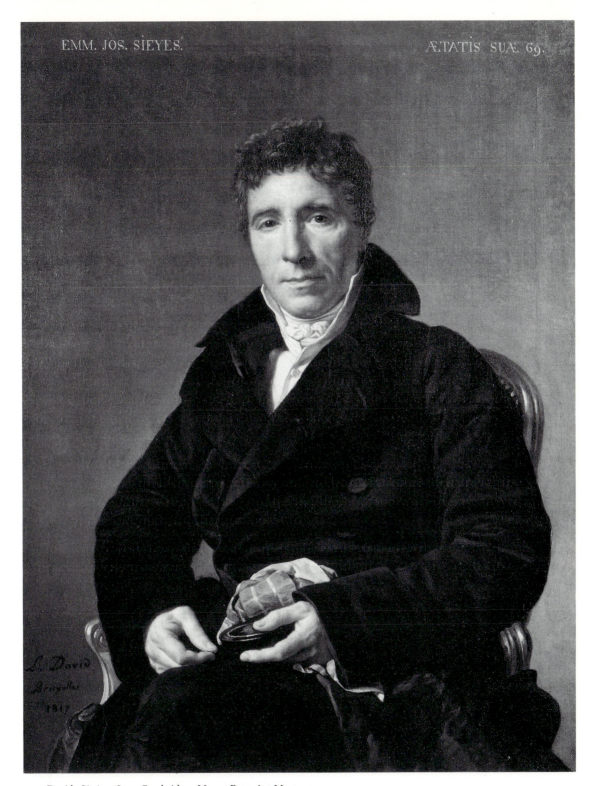

110. David, *Sieyès*, 1817, Cambridge, Mass., Fogg Art Museum

artist since the Revolution. In this encomiastic portrait we see Sieyès at the most significant period of his life when he offered his greatest contributions to French culture and society—through his intellect, character, morality, and will.

Nothing could be more stylistically divergent from the magnificent Sieyès than David's beautifully rendered depiction of the daughters of Joseph Bonaparte who had visited him in Brussels, *Zénaïde and Charlotte* (fig. 111), 1821. Painted in a hard, smooth, enamel-like finish, the composition recalls the portrait style of Ingres, a principal source of inspiration for certain types of portraits in David's oeuvre since as early as 1810 in his representation of *Mme Daru* (fig. 112). The linear qualities and brittleness of execution in the rigid, formal portrait of the Bonaparte sisters stand in significant contradistinction to the softness, painterly technique and informality of pose in the Sieyès. David has characterized differences in the personalities of the two sisters—exiled princesses who both wear diadems—through their expressive juxtaposition as well as through their attire. The modest blue dress with its high collar of the more sympathetic and reticent sister complements the modesty, timidity, and innocence revealed in her deferential pose while the elegant, lowcut attire of her forthright sibling and her more aggressive posture and pose convey her more ostentatious, extroverted, and domineering character and temperament. As in many of his preceding nineteenth-century portraits, such as that of Mme Daru and his 1813 depiction of his wife Charlotte David (fig. 113), whose startling, frank homeliness is equalled by the extraordinarily youthful presentation of her face and figure (she has virtually no wrinkles and does not seem to be in her late 40s), in the Bonaparte sisters, David has not flattered his sitters. The plainness of Zénaïde and Charlotte is only further emphasized by the generalization of form in the faces and hands, a remarkable linearity and absence of detail that contributes to their rather vacant expressions. This double portrait is as psychologically revealing as the Sieyès yet David has used vastly different stylistic and compositional means to achieve similar expressive objectives. A great innovation of the Brussels portraits is that David typically suits the style to what he perceives to be the personality of the sitter. This leads to an unexpected plurality of styles, sometimes within the same composition.

This is certainly true of his brilliant and compelling representation of *Madame Morel de Tangry and her Daughters*, sometimes called the *Three Ladies of Ghent* (fig. 114). In this penetrating and ruthless psychological portrait the elderly and powerful matriarch, depicted in a meticulous, naturalistic style that does nothing to conceal the ravages of age, confronts the spectator with a searing, almost terrifyingly stern gaze that reveals her indomitable character and strength of personality. The remarkable severity of her facial expression is further emphasized by the constrast with the elaborate curls of her hair which emerge from an ornate bonnet—these elements clash sharply with her otherwise somber attire. The depiction of this willful and shrewd individual constitutes one of the great masterpieces in the history of portraiture. Through her force of character, expressed through her carriage and posture as well as her face, although seated, she

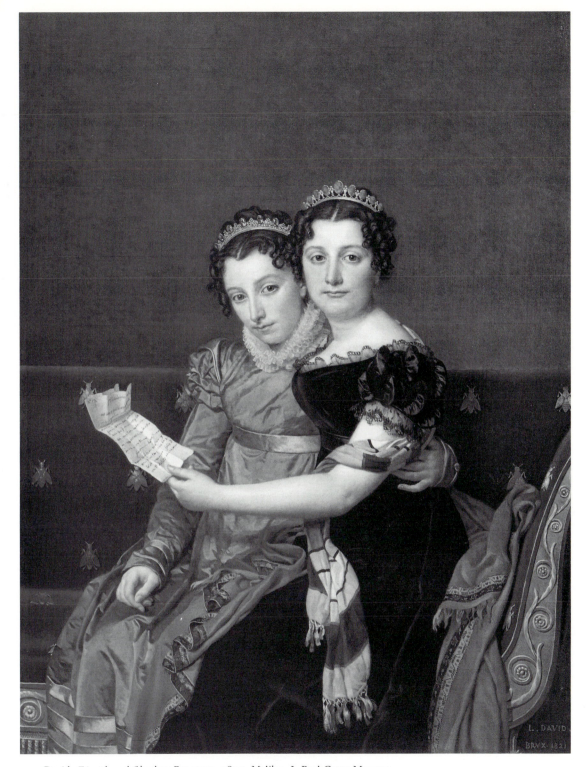

111. David, *Zénaïde and Charlotte Bonaparte*, 1821, Malibu, J. Paul Getty Museum

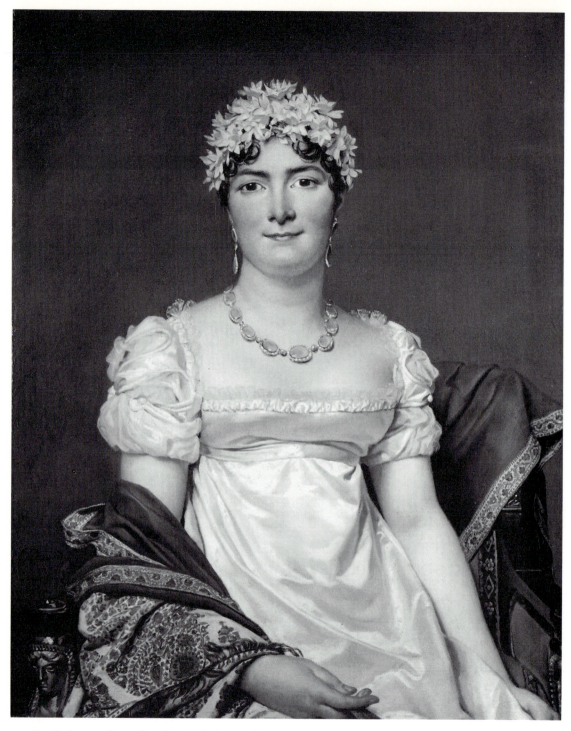

112. David, *Madame Daru*, 1810, New York, The Frick Collection

226

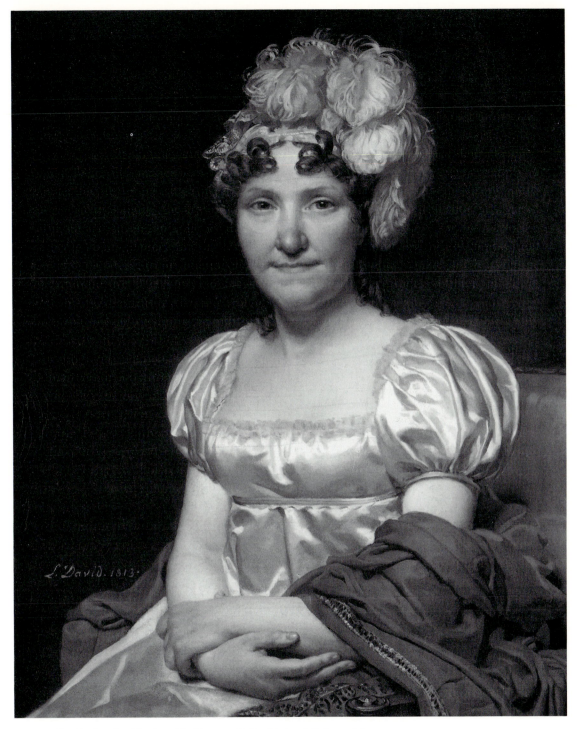

113. David, *Charlotte David*, 1813, Washington, D.C., National Gallery of Art

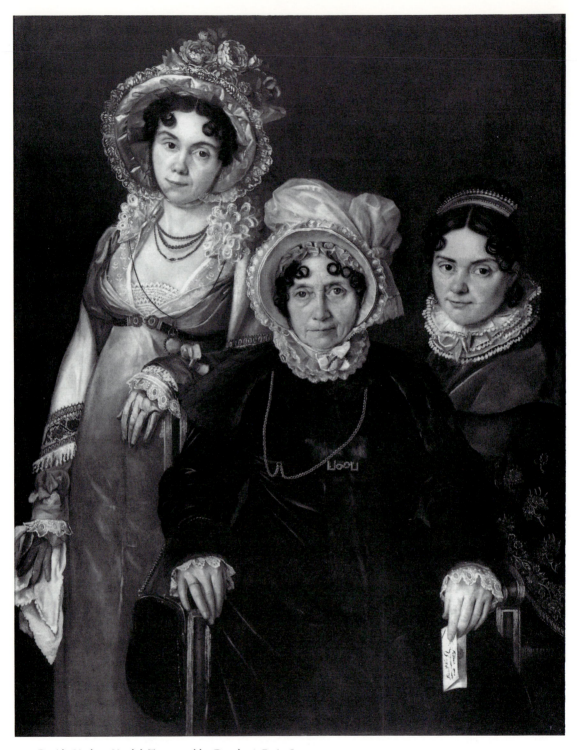

114. David, *Madame Morel de Tangry and her Daughters*, Paris, Louvre

228

clearly overpowers her two young daughters who are placed behind her and are painted in a hard, enamel-like finish, a style akin to that of Zénaïde and Charlotte Bonaparte whom they resemble in other ways as well—as in the Bonaparte sisters David has here emphasized further the plainness of the Tangry sisters through the elegance and frills of their costumes and has skillfully differentiated their characters and temperaments through posture and attitude as well as attire. The daughter to our left who stands and leans on her mother's chair and looks at us with an expression of resignation is dressed in a rich and elaborate bonnet and dress (that is also décolleté); she also wears fashionable jewelry. This type of ostentation contrasts dramatically with the simplicity of her facial expression and her seeming passivity. The more aggressive and forthright seated daughter to our right resembles much more closely her mother whose face and form she echoes. She sits adjacent to the matriarch and the relative austerity of her costume and the fixed and somewhat rigid expression of her face reveal that she is psychologically and temperamentally her mother's daughter. Her dress is much more austere than that of her sister and her high and frilly collar only serves to intensify, by contrast, the homeliness of her face.

This painting, a brilliant and magisterial psychological portrait of a mother and her daughters has recently been disattributed to David on the basis that it is a "clumsy work whose realism smacks intentionally of caricature, the very opposite of David's habitual dignity and nobility."[2] In other words, this portrait was disattributed solely on the basis that it is not representative of David (no other artist, however, has even been suggested as a possibility for having painted this work). *Madame Morel de Tangry and her Daughters* certainly does not stylistically or compositionally resemble David's corpus of late eighteenth-century portraits but it does resemble in every way his great portraits executed in Brussels which are characterized by an intensification of psychological effects and often an experimentation in style and composition, sometimes even leading to a plurality of styles used in the same composition. As we have seen, the Tangry sisters are comparable in many ways to Zénaïde and Charlotte Bonaparte.

It should not surprise us that the type of experimentation in style, technique, and composition that we find in David's late portraits characterizes as well his entire Brussels production, including his startling new developments in the categories of genre painting and drawing. *The Fortune Teller* of 1824 (fig. 115), a strange and unexpected subject for David executed in a strange and unexpected style, provides a typical example of the artist's experiments with theme, composition, style, and technique in Brussels.[3] As in a number of his paintings, including *Bara* and *Madame Récamier*, David has left us a work that appears more sketch-like than complete. Yet, in this case, we have no reason to believe that the painting is unfinished. The application of paint is very thin and the textured surfaces are rough; David has left the brushstrokes visible, thereby calling attention to his role as maker of the composition. The very sketchiness of the work, as we shall see, accords well with its theme; the category itself—that of genre painting— offered David an opportunity to diverge even further from stylistic norms and conven-

tions that governed history painting. For the first time in his career David turns to a category of art—genre painting—which, as a history painter, he had hitherto ignored (he apparently executed another genre painting in exile—a crouching bather—but this work unfortunately, is lost).[4] David turned to this category, which was held in such low esteem in the academic hierarchy of genres, because it offered an alternative mode of expression, and, at the end of his career, David continued to search for alternatives—new methods of achieving meaning. He realized that genre painting—images from daily life—could offer an expressive freedom and immediacy, since it did not have the same ties to academic codes and doctrine that burdened representations of history and myth.

In this enigmatic painting, fraught with psychological tension and ambiguity, David presents a scene from daily life in antiquity, in the format of a family portrait. By conflating the categories of genre and portraiture and by representing the subject in such a sketch-like style David reveals his questioning of the traditional hierarchy of genres

115. David, *The Fortune Teller*, c. 1824, San Francisco, The Fine Arts Museum

and the stylistic modes appropriate to each. As we shall see, this type of questioning and blurring of boundaries will characterize much of his production in Brussels. In the *Fortune Teller* the Roman matron responds with suspicion, annoyance, and aloofness (which belies her anxiety) to the hesitancy of the bewildered gypsy who attempts to ponder the future inscribed in the lines of the hand. For perhaps the first time in his career David explores the ambiguous and contradictory psychological states associated with superstition and the occult, in this case, chiromancy. *The Fortune Teller* is a painting about the meaning of destiny, for in this disturbing and uneasy composition David depicts a recurrent and universal anxiety—the individual's hopes and fears for the uncertain future. The gypsy cannot seem to read clearly the progress of life's unfolding and this puzzlement of the seer which so worries her client, expresses, of course, the precariousness of the human condition. We all walk this tightrope and are continually faced with, in T. S. Eliot's words, "decisions and revisions that a moment can reverse." This profound and metaphorical painting that represents the mystery of destiny and the human condition through ontological questioning, probing, and puzzlement tran- scends the category of genre painting as it had been defined in France—it is not a mere domestic scene from daily life. This work, in fact, belongs to a principal direction that informs David's entire Brussels production—namely, an intense and overriding interest in the portrayal of extremely complex and mysterious psychological states brought into being by supremely decisive moments in life, when the direction of fate hangs in the balance—liminal moments of transformation when boundaries are about to be transgressed.

This interest in ambiguous psychological states characterizes yet another avenue of David's innovations and explorations in exile—that of drawing. The style, composi- tional format, and subject of the *Fortune Teller* are akin in many ways to David's late drawings. It is revelatory that David would continue to experiment with the expressive possibilites of this medium, the foundation of his art and teaching, which, as we have seen, had constituted for him a quasi-independent experimental mode since the late 1770s. His corpus of late drawings reveals that he now sought to expand even further the possibilities of *dessin*, to push the limits of drawing beyond its normative restrictions and to extend it fully from a subordinate, utilitarian medium that serves the making of higher art, into an independent art form that exists on its own terms. David's late drawings which constitute an independent category in his art, detached from painting, can be divided into two distinct categories. One group consists of an astonishing range of expressive heads which, taken together, explore the entire spectrum of expression from caricature—the exaggerated, grosteque, and ugly—to a profound subtlety and compression of psychological expression (figs. 116, 117).[5] When confronted with these strange and often disturbing heads, we are led to wonder what purpose they serve. The vast majority were made independently of any major work; these are not preparatory sketches for portraits or history paintings. David did not assign them either subjects or titles and he gave many to friends, often recording his dedication of these gifts on the

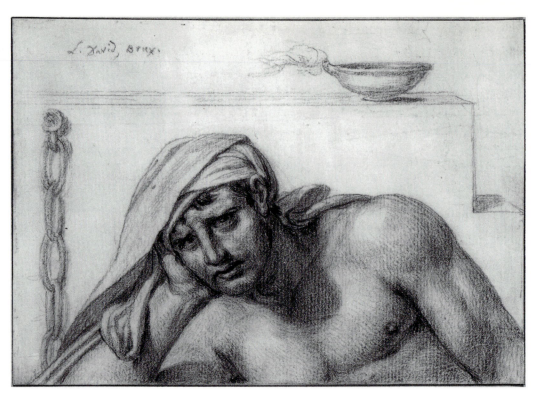

116. David, *The Prisoner*, 1819, Cleveland, The Cleveland Museum of Art

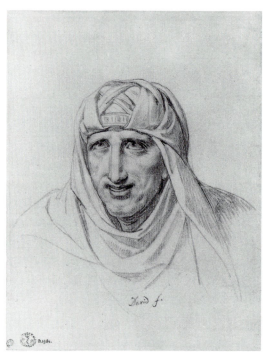

117. David, *Head of a Man with a Turban*, Besançon,
Musée des Beaux-Arts et d'Archéologie

drawings themselves. We are told by Jules David that the artist drew these heads daily, working in an almost obsessive manner; the great number of them that have survived suggests that this was, indeed, the case.[6] The drawings constitute meditations on expression—on the limitless possibilities of physiognomy and phrenology to communicate an infinitude of thought and feeling—and they belong to an independent, private register of art. At this moment in progressive directions in French art, in fact, drawing as an independent and private art form was beginning to emerge—one thinks principally of the private drawings of Géricault and Delacroix and their contributions to the development of the romantic sketch.

It is also significant that at the end of his career David would reinterpret to this extent and transform a category of art—the *tête d'expression*—that had been emphasized and valued above all other aspects of the human figure in academic theory, doctrine, and practice when he stood at the beginning of his career. It is only with difficulty that one can even call these drawings *têtes d'expression,* for David's late heads radically diverge from the stereotypes and conventions of eighteenth-century examples. In his Brussels drawings he explores the possibilities for nuanced communication offered by the human face. Before these strange and often disturbing depictions we can question what is being

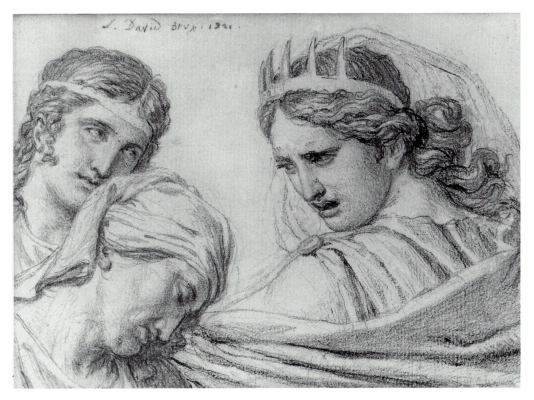

118. David, *Study of Three Heads*, Denver, Denver Art Museum

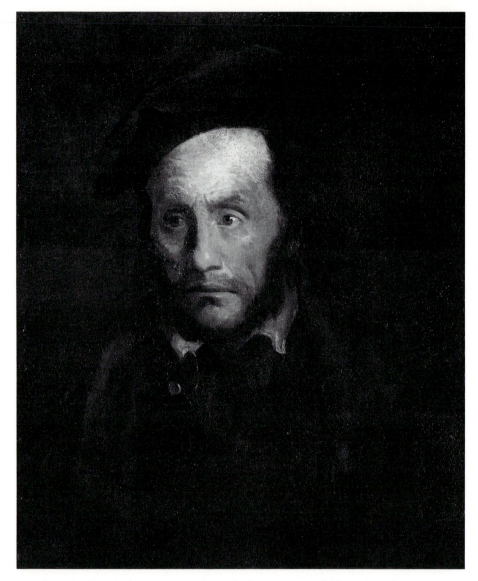

119. Géricault, *Portrait of an Insane Man*, Springfield, Mass., Springfield Museum of Fine Arts

conveyed. In the examples of caricature the answer is simple and direct. In the case of most of the examples, the answer is complex, ambiguous, and open to argument, for the meanings are multivalent and cannot be understood in a simple and direct manner.

In his fascinating corpus of late drawings David also combined heads, whose relationship with one another becomes transformed into a narrative (fig. 118). We see in these examples the extent to which a story can be told, through the poignant juxtaposition of faces that express an eloquent panoply of emotions and ideas—fury, humiliation,

anxiety, and sorrow. In these works David leaves us to meditate upon the fact that the expression of the human face, in which we expect to read individual thoughts and emotions, remains mysterious and ineffable.

David's transformative reinterpretations of the *tête d'expression* at the end of his career immediately call to mind the remarkably subtle and penetrating psychological portraits of the insane by the great romantic artist, Géricault (fig. 119). It is no accident that Géricault painted these portraits subsequent to a warm visit he had paid David in Brussels, an artist whom he revered and consistently emulated—Géricault must have seen a number of David's late *têtes d'expression* which were part of the master's daily production. On November 10, 1820, in a letter to his pupil Couder, David wrote of this heartening visit from Géricault and Horace Vernet (who apparently delivered the letter to Couder in person).

> two skillful painters, Monsieurs H. Vernet and Géricault . . . have over-
> joyed me with their presence. They came to Brussels in order to see me again
> and to embrace me. We drank to the health of my students who have never
> grown cold in their filial attachment to me.[7]

This letter reveals the warmth and intimacy of David's rapport with these two painters. It seems likely that Géricault, after seeing David's drawings of expressive heads during

120. David, *Scene of Mourning*, 1819, San Francisco, The Fine Arts Museums

235

this visit, was directly inspired by the intense, almost scientific explorations of physiognomy in which the artist achieves penetrating and subtle insight into and expression of the mysteries and complexities of the human character, mind, and spirit. It is important to note that a description of the most eloquent of David's heads could be applied as well to Géricault's portraits of the insane.

The majority of David's remaining drawings in Brussels are characterized by qualities similar to those found in his expressive heads. David creates small, psychological vignettes that are self-contained, that have no immediate destination, and that offer themselves as meditations of meaning (fig. 120). And the subjects, seemingly taken from antique narratives, are difficult to identify with any specific, unitary literary source. In these compositions we discover the same interests of the late *têtes d'expression*, only expanded usually to groups of half-length figures who interact in disquieting ways. These drawings are inspissated with the utmost psychological tension—complex states of grief, anger, frustration, desire, jealousy, fear, and hatred are eloquently explored. David uses caricature as well as expressive distortion—an exaggeration of form in the heads, facial features, and hands, in the elongation or truncation of limbs and torsos—for greater psychological impact. An anticlassical canon is often juxtaposed or even combined with both naturalistic depiction of detail as well as idealized form. These psychological vignettes, which assume the format of a family portrait, are difficult to interpret because, as in the *têtes d'expression*, their purpose and function have nothing to do with clarity and immediate accessibilty of meaning. They are meditative works whose compelling forms puzzle the mind and haunt the imagination. Like the expressive heads, David certainly intended these compositions to have a disturbing impact on the viewer for he uses them principally as a vehicle for exploring the darker recesses of human character and psychology.

In fig. 120 we see what appears to be a grief-stricken group, perhaps a family, responding in a variety of ways to catastrophe—possibly the death of a loved one. Yet the precise meaning remains obscure, multiple interpretations seem both possible and plausible. The entire corpus of late drawings typically lend themselves to multiple interpretations—meaning is not fixed but, rather, open-ended. David, in fact, confronts the viewer with the dilemma of discerning and deciding the meaning, and an understanding of the image may change and develop with each new viewing which can raise further questions as prior, tentative answers dissolve.

It should not surprise us that the profound psychological complexity and ambiguity of the works we have briefly examined, which make the spectator an active participant in the dilemma of decoding meaning, should characterize as well the best-known and, until recently, most mistakenly maligned of the Brussels works, the major mythological compositions that have troubled viewers since their first exhibitions: *Amor and Psyche* (fig. 121, colorplate VI), *The Farewell of Telemachus and Eucharis* (fig. 122), *The Anger of Achilles* (fig. 123, colorplate VII) and *Mars Disarmed by Venus and the Graces* (fig. 124, colorplate VIII). In these four major works David continued to explore ambiguous

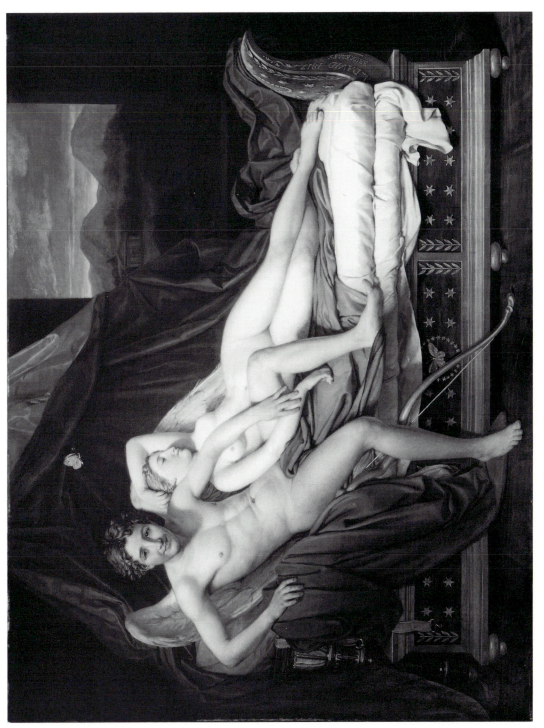

121. David, *Amor and Psyche*, 1817, Cleveland, The Cleveland Museum of Art

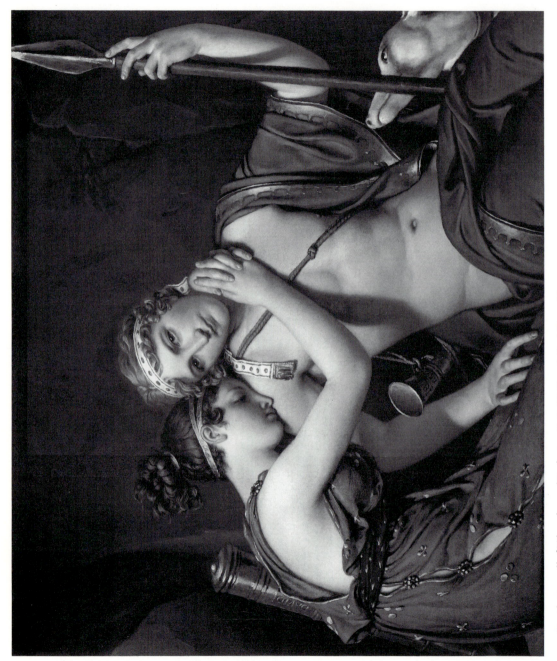

122. David, *Farewell of Telemachus and Eucharis*, 1818, Malibu, J. Paul Getty Museum

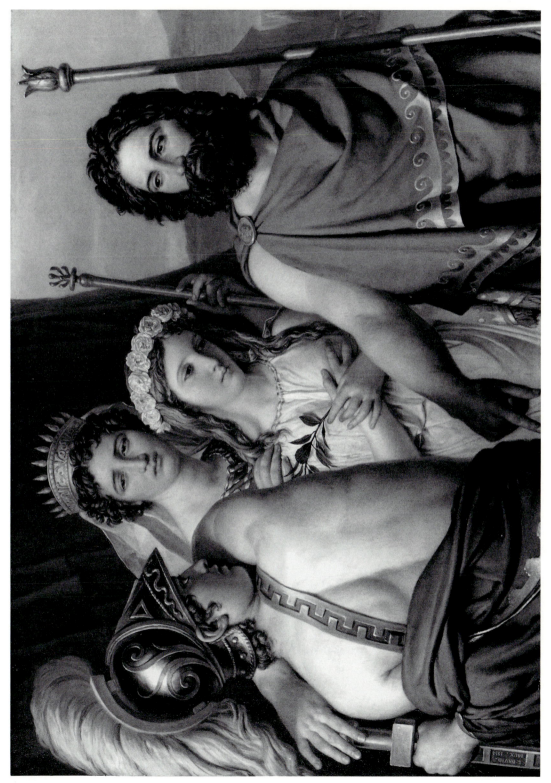

123. David, *Anger of Achilles*, 1819, Fort Worth, Kimbell Art Museum

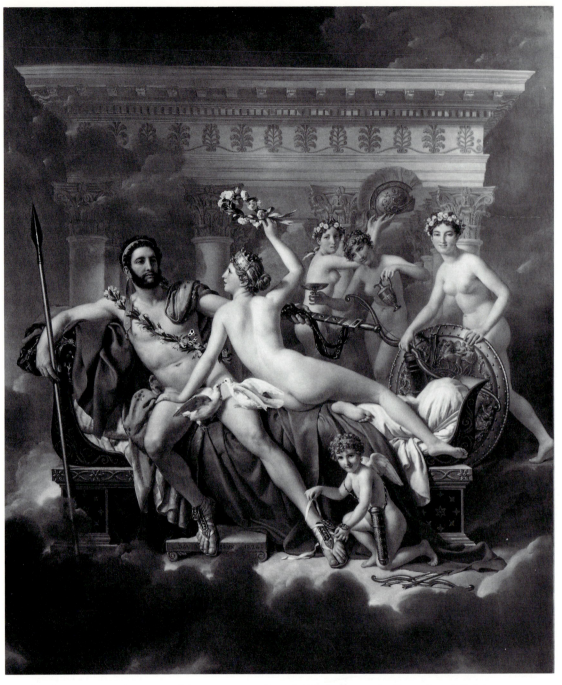

124. David, *Mars Disarmed by Venus and the Graces*, 1824, Brussels, Musées Royaux des Beaux-Arts de Belgique

and often contradictory psychological and emotional states, through innovations and experimentation of form, compositional format, style, and technique. In so doing, he radically violated prevailing academic theory and practice in France that he had largely shaped and determined, in a manner that far exceeds the more tentative deviations of the early Géricault and Delacroix. In these late paintings, David interrogates, in a daring and sometimes brutal and shocking way, and to a far greater extent than in his preceding nineteenth-century production, the very nature, limitations, and possibilities of representation itself.[8]

This interrogation into the nature of art and representation and the concomitant and problematical role and function of the artist was announced in a transitional work that David began around 1813 and took with him to Brussels (but never completed): *Apelles Painting Campaspe before Alexander* (fig. 125), a small composition in oil on wood.[9] In this fascinating and troubling depiction of the artist in his atelier David included many of the thorny issues and problems that beset the ancient Greek (and, by analogy, the modern) artist. Apelles sits in a slumped and dejected posture before his large canvas where he has drawn in *contour* a life-size simulacrum of the nude Campaspe (a type of Venus), Alexander's beautiful mistress, who sits tentatively on the edge of a rumpled bed

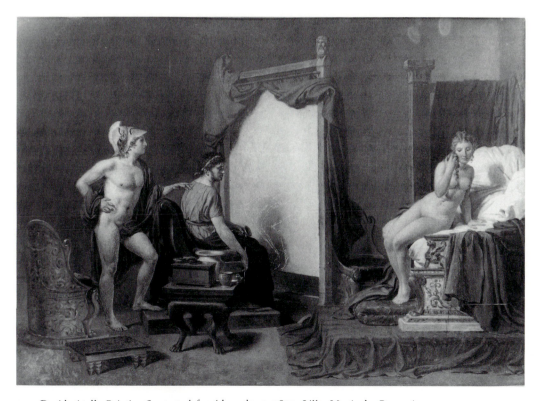

125. David, *Apelles Painting Campaspe before Alexander*, c. 1817, Lille, Musée des Beaux-Arts

and recoils timidly from the artist's intense and contemplative gaze. Apelles appears incapacitated, arrested before the great beauty of the live model (the model in nature) while Alexander, also a beautifully rendered nude (the male nude opposes the female at opposite sides of the bedroom/atelier), gazes ardently at his mistress and seems to urge Apelles on (the legendary narrative relates that Apelles had fallen in love with his model and that Alexander gave her to him as a gift). Thus David engages the themes of nature, art, representation, the nude, and the complexity of the artist's rapport with his patron. The studio itself—the intimate bedroom where lovemaking has recently taken place— underscores the theme of sexuality and the corporal, erotic inspiration of art.

David was not satisfied apparently with the possibilities of his composition for exploring adequately these themes that had begun to emerge as most critical to his art. After he arrived in Brussels in 1816 he turned his attention almost exclusively to the mythic subject as the most suitable mode for conveying his newly developing ideas on art and aesthetics. This privileging of myth in his Brussels works has typically been viewed as strong evidence of his not being in touch with the progressive trends in the art of his time, that his interest in myth was retrogressive and looked back to early eighteenth-century Rococo concerns. And yet nothing could be further from the truth. During the first two decades of the nineteenth century the Salons literally teemed with sculpted and painted representations of mythological subjects that were of overriding interest and importance for artists and their audience. This extraordinary phenomenon has been virtually overlooked by historians of the period.[10]

By the end of the eighteenth century in France, in fact, a dramatic transformation had taken place in the attitude towards and the interpretation of mythology. Mythological discourse, given impetus since mid-century by the revival of interest in classical art and civilization, had develped into an area of "scientific" investigation. A dramatic resurgence of mythological studies occurred in the 1790s and early 1800s—a plethora of dictionaries, treatises, and manuals as well as new scholarly editions and translations of classical authors appeared. An examination of these works reveals that by 1800 mythology had developed from a compendium of stories about the gods to an intellectual and philosophical inquiry into the origins and significance of these stories— modern mythography was inaugurated.

In order to understand more clearly the changing attitudes toward myth we might follow the example of Jean Starobinski who recently addressed the transformations in mythological thinking in late eighteenth-century France.[11] He aptly used the differentiation between "la fable" and "la mythologie" in the *Encyclopédie*.[12] "La fable" signified the body of information about pagan divinities based on classical sources which was characterized by a distinct ahistoricism in that all events and situations take place simultaneously within a Greco-Roman "space." "La mythologie," on the other hand, was interpretive, based on a comprehensive historical and cultural system concerned with the importance of the origins of mythic individuals as well as the intellectual, moral, and psychological pertinence of their narratives. Thus, while "la fable" extended

to the repertoire of stories about antique divinities and legendary figures, "la mytho-logie" signified the intellectual investigations into the meaning of mythic themes. We must keep this useful distinction in mind as we examine the development of the mythic theme in the art of David.

As is well-known, the erotic celebration of the loves of the gods and goddesses, exemplified in the works of Boucher, was gradually replaced after mid-century with more serious moral themes.[13] The advent of neoclassical subject matter and interests tended to suppress the overt celebrations of sensuality, feminine beauty, and erotic situations that we associate with a principal direction in Rococo art. When La Font de Saint Yennes in 1754 declared the loves of the gods and goddesses to be unfit subject matter for the serious moral mission of art, he seemed to sound the death knell for the representation of an arcadian fantasy world of pastoral dreams and frolics whose protago-nists engage in seductions untroubled by the consequences of their behavior.[14]

Representations of the hedonistic adventures of the gods and goddesses and legend-ary heroes and heroines dwindled, in fact, at the very moment when the study of mythology as a "scientific" discipline was beginning to develop. The new, philosophical reflection on the significance of mythological themes discouraged the ludic and the fantastic. When amatory mythic subjects did reappear in French art at the end of the eighteenth century, they embodied completely new interpretive strategies expressed in content as well as form.

It should not surprise us that David would be the catalyst for this transformation of mythological painting in late eighteenth-century France. The renewed interest in the meditative possibilities of myth, in fact, was inaugurated by David in his *Loves of Paris and Helen* of 1789 (fig. 126), which constitutes one of the earliest reinterpretations of erotic subject matter from antiquity in the late eighteenth century.[15] We can see at once that this work, in content as well as style, belongs in a completely different category from the amatory escapades of mythological figures that we find in earlier eighteenth-century examples (as in the works of Boucher or even Vien). David represents this subject in a very serious manner. His efforts at greater archaeological accuracy in the rendition of the bedroom,[16] its objects, and its decorative details are equaled by his attempt to express the psychological and emotional truth of the lovers' situation, something not emphasized in earlier paintings that represent themes of love and seduc-tion. An atmosphere of melancholy pervades this somber, hieratic image, executed in subdued tones, in which the ephebic Paris is dominated by the robust yet lanquid Helen, who leans over him as a type of inspiring muse. Their harmonious, interlocking forms and the intensity of Paris' gaze, as well as his powerful, almost desperate grip on Helen's left arm, lead us to meditate on certain disquieting aspects of passionate love. This love affair will certainly have dire consequences for it will result in the fall of a city. The somber display of the lovers' rapport leads us to consider them as pawns of an overpowering force, as they are indeed described in the antique sources, for no pagan deities are as irresistible as Venus and her malicious offspring (who are represented in

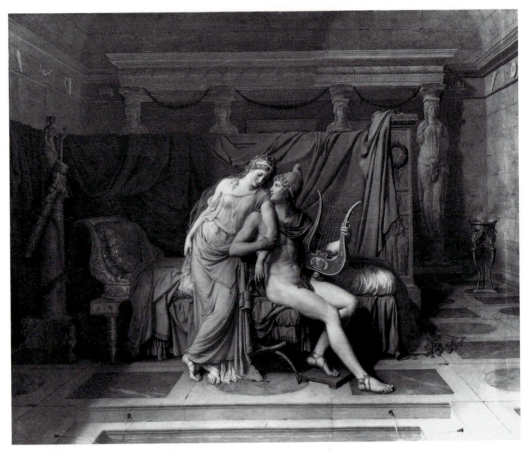

126. David, *The Loves of Paris and Helen*, 1788–89, Paris, Louvre

the image in sculpted form). This reinterpretive fascination with the psychology of mythic passion and epiphany announces innovations in content as well as style that will become principal characteristics of works produced by David's pupils. For, after *Paris and Helen*, David's students and followers seriously addressed such themes and created major masterpieces of great subtlety and originality. Girodet's *Endymion* of 1791, Gérard's *Psyche and Amor* of 1798 (fig. 128), and Broc's *Death of Hyacinthus* of 1801 are but a few examples that mark the beginning of an intense period of mythic representation for the entire French school.

David, however, would explore the amatory mythic theme in ways that greatly diverged from the directions taken by his students and followers. In his first mythological painting of the nineteenth century, for example, *Sappho, Phaon and Amor* of 1809 (fig. 127), painted for the Russian Count Youssapoff, he creates a work that is compelling in its strangeness and startling divergence from other mythic compositions of the time. Ostensibly similar in theme and elements of composition to *Paris and Helen*—an amo-

244

rous legendary/mythic couple adjacent to a bed in a palace room in which decor and
accoutrements are archaeologically "accurate"—in *Sappho, Phaon and Amor* an entirely
different meaning is conveyed. Instead of the lyricism and melancholy of *Paris and Helen*
we see figures bathed in bright daylight and the use of saturated colors and tones; the
protagonists are placed in the immediate foreground very close to the picture plane and
the space of the room is remarkably compressed, the rumpled bed itself in which
lovemaking has recently taken place is dramatically foreshortened. Equally divergent
from *Paris and Helen* are the position, placement, and forms of the figures who are
depicted in a completely different style from that of the Homeric lovers. The elegance,
delicacy, idealization, and grace of Paris and Helen are here replaced by heavier, denser
corporal forms that seem closer to that of the live model and a much more naturalistic,
almost portrait-like treatment of physiognomy that contributes to what amounts to a

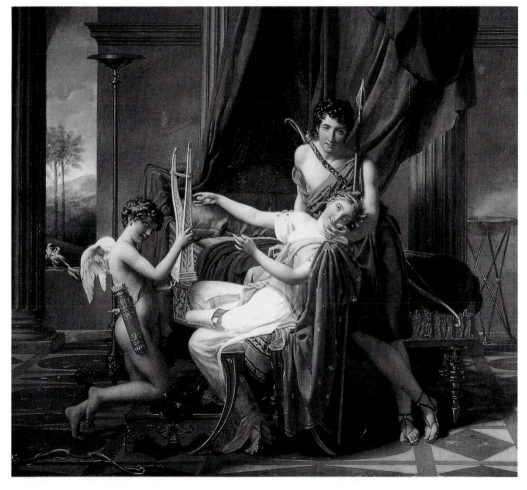

127. David, *Sappho, Phaon, and Amor*, 1809, St. Petersburg, Hermitage Museum

rather disturbing psychological confrontation—Sappho and Phaon both gaze directly at us; Phaon with an intense, serious demeanor and Sappho, her head thrown back and cradled in her lover's left hand, with a sensual, self-satisfied and somewhat fatuous smile. It seems as though we have just walked in on the legendary lovers who pose for our benefit and who thereby seem to have emerged from the mythic into the modern world. Even before our intrusion Sappho had been interrupted in her song by the figure of the graceful, sensual adolescent Amor who has, unbeknownst to the poetess, taken her lyre. We see from the position of her hands that Sappho still believes she is playing on the strings. A lyric poet known for her lovesongs, she has been singing a poem to Phaon (in the first line written in Greek on the parchment in her lap we find his name). It seems that her love for Phaon will not lead to further singing. Unlike the more masterful and domineering Helen in the 1789 painting, the great poetess is completely subservient to her lover and seems to have given herself up to his erotic power. Rather than choose the moment of her suicide, a popular theme in French painting circa 1800 (the most famous example being Gros' *Sappho* of 1801), David was much more interested in revealing the psychological situation that led to the poetess' death. The subject of this disturbing composition is the power of erotic love, how it transforms the individual and what it can lead to.

This painting announces many of David's explorations of myth in exile and prefigures a number of his thematic, compositional and stylistic innovations in his great masterpieces executed at the end of his career. In his first Brussels painting, *Amor and Psyche* of 1817, as well as in his subsequent mythic works, David emphasizes several aspects out of the welter of subjects susceptible to mythological analysis, namely, psychology, eroticism, and aesthetics. For example, in *Amor and Psyche*, David presents a remarkably disturbing and original interpretation of the myth inspired by the narrative of Apuleius and La Fontaine. Before David, painterly depictions of the period, following principally La Fontaine, tended to be lyrical and poetic. Gérard's *Psyche and Amor* (fig. 128) provides but one of many examples that explore the theme of innocence and beauty embodied in young love. [17] But David has changed all this. In his painting he presents a brutally frank image of profound sexual disquiet. How has he achieved this startling effect? Most painters of the period, including Gérard, represented the beautiful adolescent Amor, the *bel Eros grec*, but David presents the antithesis of this image, the *crudelis Amor* as described in the mythological discourse of the time, the powerful, cruel, and starkly sexual god of the ancient Greeks, for whom love was no laughing matter. We are disconcerted by this terrible conjunction of a realistically depicted, saurean god of love, and the idealized, beautiful young woman by his side who is under the dominion of this loathsome monster. The contrast between the dark, sinister, ugly Amor, whose cynical, leering, self-satisfied grin is directed at us, with the sensual yet vulnerable Psyche, also causes much disquiet. David, in fact, designs everything in this composition to disturb the viewer whom he challenges to meditate on the psycho-sexual relations of the lovers whose antithetical natures are expressed through their opposing forms.

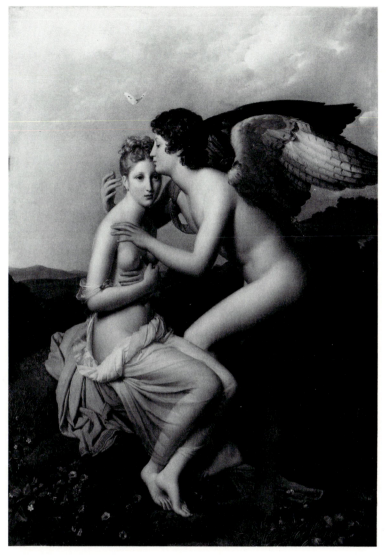

128. Gérard, *Psyche and Amor*, 1798, Paris, Louvre

The critics who first viewed *Amor and Psyche* were most surprised and troubled by the depiction of Amor. Even Gros, David's most loyal supporter who was in charge of the master's atelier in Paris, considered the figure of the god of love singularly inapposite and found that "the head of Amor has a somewhat faun-like character, the hands are somewhat dark and above all not refined enough."[18] The perceptive critic Miel (described by David as an "amateur zélé des beaux-arts") included the painting in his Salon criticism of 1817 and even had it engraved but, although he recognized the merit and importance of the work, he was puzzled by it and was especially critical of the figure of Amor.

This Amor is not at all a god, he is not even a beautiful adolescent. He is the model, an ordinary model, copied with a servile exactitude, and in which the expression of happiness is nothing more than a cynical grimace.[19]

These criticisms are understandable, for David has created one of the most rebarbative and realistic sexual renderings of Amor, the antithesis of the traditional comely progeny of Venus and, perhaps, the most repulsive figure of his entire oeuvre. The brutal characterization of the god brings to mind an Amor equally shocking in its realism—Caravaggio's *Amor Vincit Omnia*—a work well-known to David and his contemporaries and it may well be that the artist thought back to his early lessons learned from the seventeenth-century master when he was a student in Italy in the late 1770s. In David's depiction of the god, so troubling to Gros and others, his unhealthy complexion, coarse facial features, thick hands and feet and immature physique, are as disturbing as his cynical, self-satisfied leer that is shocking in its candor and intensity. The aeruginous tones of his flesh with its brown and and purple highlights are similarly unsettling—we do not expect such an unhealthy appearance in a seemingly vigorous youthful figure. Equally disturbing is Amor's action, for he seems to be about to step out into our space as if he were a disquieting intruder in our world and not safely contained in a remote mythological past (that the figure is life-size contributes to this impression).

To the French public of 1817, Miel characterized Amor as the major flaw of the painting: "One cannot conceive of such an oversight in a painter whose style is habitually so pure and elevated."[20] We can see that this problem has been "corrected" in Giboy's engraving, published by Miel, in which the figure of Amor has been edulcorated, transformed into one clearly more palatable to David's contemporaries (fig. 129): the "cynical grimace" has been replaced with a rather dulcified, innocent smile and the immature torso and limbs appear more muscular and fully developed. Two years after the painting was first seen in Paris, Kératry, an art critic and aesthetician, discussed David's *Amor and Psyche* at length in his salon criticism of 1819.[21] He, too, was puzzled and disturbed by Amor, which he believed did not "fit" in the composition. He described in some detail what he perceived to be the conflicting expressive qualities of the figure but he could not find fault with the perfection of execution and even noted the remarkable scientific exactitude in the rendering of Amor's torso and limbs.[22] The bewildered critic concluded that "not the brush but the imagination of M. David has gone astray."[23] Kératry expressed the malaise that the majority of critics and the general public felt before this work—few, it seems, were prepared to accept this troubling god of love depicted in such an unexpected realistic manner.[24]

As the early critics were so taken aback by the figure of Amor they tended to overlook an essential aspect of the composition, for in this painting it is not merely the repellent god of love who accounts for our disquiet, it is his relationship (in all its senses) to the beautiful figure who lies next to him (even when the critics did note this peculiar contrast of the mythical figures, they could not fathom David's purposes). The volup-

tuous Psyche, surprisingly vigorous in spite of her grace, reclines lanquidly in a pose clearly reminiscent of Titian's and Correggio's recumbent goddesses. Apparently asleep (her right eye is barely opened as if she were trying to catch a glimpse of her departing lover), with her left arm brought up around her head, she displays to best advantage her physical charms. The subtly rendered delicate tones of her skin and appealing roundness of her contours are heightened by the jarring contrast with the hard-edged, leathery Amor, whose clumsiness and vulgarity are accentuated by his awkward pose and the manner in which his large left foot is entrammeled in the drapery. Enfolded in the god's powerful wing (whose meticulously executed feathers in conjunction with his real-istically depicted form produce a monstrous effect and provoke a physical sense of disgust), she seems completely vulnerable both to Amor's sexual whims and our intrud-ing gaze. The rumpled draperies of the couch, the unkempt hair of both figures, and their rubescent cheeks and hands compel us to imagine that this beautiful young woman, a mortal "Venus," had just coupled with a god who appears more bestial than divine. This jarring contrast serves to give Psyche, in spite of her voluptuousness, a type of "sensually intense innocence."[25] The artist has also forcefully conveyed her dual nature as a type of sacred and profane Venus—for Psyche traditionally was both sexual and spiritual—through the subtlety of her pose and form and the sensual purity of her

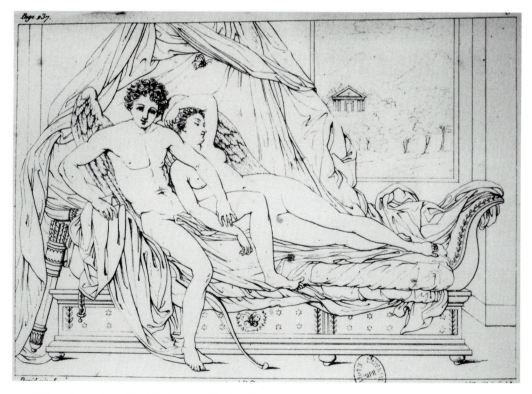

129. Giboy, Engraving of David's *Amor and Psyche*, 1817

face. This innocence and spirituality are precisely what Amor lacks. It is the contrast of soulless sensuality reigning over a sensual yet essentially innocent young woman that is so unpleasant to witness. That this is not a neoteric interpretation based on modes of seeing that would have been unlikely for critics of the time can be amply demonstrated by the analysis of Kératry, who noticed the couple's lack of coadunation and described the relationship between the figures as "painful"; he decried "this dominion of an ignoble nature over idealism, it saddens and wrings the heart."[26] David dramatically employed antipodal styles to express the antithetical nature of the figures in bed, to communicate their disjunction—to borrow a phrase from Mallarmé, their "mal d'être deux." These unexpected stylistic contrasts—Amor realistic and vulgar, based on the model from nature, Psyche much more idealized, based on a celebrated prototype in art—has a powerful and disturbing effect on the spectator.

David had surprised and confused his public in several ways with this painting and to understand better why David's painting so shocked his contemporaries we must turn to the literary sources of the myth and the popular pictorial representations of the time. In the principal literary versions of the fable, those of Apuleius and La Fontaine, Amor daily leaves his lover's side at sunrise. He conceals from her both his identity and his appearance. Confined to his palace and forced to remain "blind" to his true nature and shape, Psyche is finally moved to kill Amor whom she imagines to be a monster. Her attempt, of course, fails, the enraged god abandons her and the rest of the tale is largely concerned with Psyche's efforts to recover her lost love. This myth enjoyed immense popularity throughout the eighteenth and nineteenth centuries in France and many painters and sculptors of the time represented it.[27] From an early period in his career David shared this interest of his fellow artists in exploring the nature of Psyche and the significance of her rapport with Amor. In the 1780s David had painted a half-figure of *Psyche Abandoned* (recent claims of its rediscovery are suspect)[28] and he had represented the famous Capitoline *Amor and Psyche* as a sculpted relief on the bedpost in *The Loves of Paris and Helen*. Several drawings in a small notebook in the Louvre (figs. 130, 131, 132), filled principally with ideas for *Leonidas at Thermopylae*, demonstrate that David was thinking again about an Amor and Psyche while working on this major composition. The sketches present the mythic couple embracing on a bed in a variety of amatory poses, reminiscent of sixteenth-century examples of a series of stained-glass windows respresenting Psyche that were well-known to David (preserved at the Musée Condé in Chantilly).[29] Though as large as his mistress, Amor still has the pudginess of a child while Psyche is characterized as a mature, voluptuous woman. In one of the drawings, Amor raises his left leg while Psyche firmly clasps his upper thigh with her right hand; it is similar to the position in the painted version, but the mood of the drawings is playful, erotic. The painting, executed several years later, demonstrates a development in David's ideas about the subject for the artist decided to represent Amor as an adolescent, which was the more typical way of depicting the god in French art circa 1800.

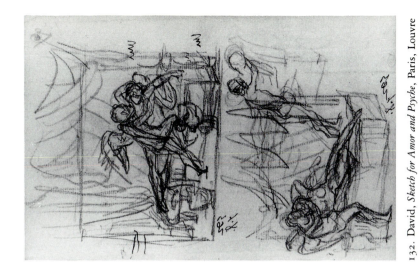

132. David, *Sketch for Amor and Psyche*, Paris, Louvre

131. David, *Sketch for Amor and Psyche*, Paris, Louvre

130. David, *Sketch for Amor and Psyche*, Paris, Louvre

What was not typical, of course, was David's rejection of the normative graceful, comely, idealized adolescent figure, such as the one we see in Gérard's *Psyche and Amor*. For French artists circa 1800 working in the neoclassical mode, the famous antique precedents for the idealized, adolescent Amor embodied the *beau idéal*, a quality they considered to be the principal characteristic of the greatest productions of antique sculpture. We remember that this prevailing notion of ideal beauty, tirelessly promulgated by Quatremère de Quincy, was challenged early in the nineteenth century by the archaeologist Emeric-David with his alternative—the *beau réel*; the ultimate goal of both theories, however, was the beauty of forms. The ugly, imitated from a flawed, imperfect model in nature, was simply not a choice available to artists working in the neoclassical style. It is not surprising then that David, still considered to be the leader of this school, shocked his followers and his public by depicting a repulsive deity rather than the beautiful god they expected to see.

David rejected the neoclassical formula of the idealized figure and chose instead to depict an anticlassical god of love because he wanted to add greater complexity and subtlety to his interpretation of the myth, which, although inspired by Apuleius and La Fontaine, can only be understood on its own pictorial terms. So many elements of the composition contradict the literary descriptions, in fact, that we are compelled to compare the two versions. In both Apuleius and La Fontaine, Amor is described as an exquisitely beautiful youth with an ideal form, an exceptionally handsome face, golden curly locks, and a dewy, roseate complexion. Psyche is so captivated by his beauty that when she glimpses him for the first time she becomes transfixed. In David's painting we find the antithesis of these descriptions. Amor's dark brown and green color repulses us and his realistically depicted feathers are scarcely the magnificent white pinions described by Apuleius. But what is most troubling is Amor's leering grin, a parody of the seventeenth- and eighteenth-century category of the *tête d'expression*, *Le Ris*, which tends to be sinister even in its most caricatural form (see fig. 73). In the face of Amor David demonstrates the degree to which the stereotypical expressive head can be developed and transformed. Amor's troubled expression is so ambiguous and challenging to define that, as we have seen, engravers could not capture it and replaced it instead with a conventional, sweetly smiling face. The face of Amor expresses a nexus of ambiguous and conflicting emotions and ideas—it is sinister, troubled, and comic at the same time—and the facial expression functions in conjunction with the studied pose and gesture of the figure to convey the artist's radically new interpretation of the god of love as a being who is cynical, cruel, mocking, and self-satisfied—this is conveyed through his vulgar, realistic form and pose just as Psyche's "classical" purity, innocence, and sensuality are conveyed through hers. Amor's lack of beauty and grace only intensifies these very qualities in Psyche, and David demonstrates that this juxtaposition of the real and ideal, the jolt that such an unexpected confrontation produces, can be a powerful means of immediate and dramatic communication.

To achieve this immediate impact on the spectator David used not only the contrast

of forms but color as he had never used it before for dramatic effect. The contrast in color of the figures expresses their antithetical nature and character. David used the juxtaposition of the sinister Amor with the comely Psyche as well as other disturbing elements of composition (such as the claustral, oppressive space and atmosphere of the room and extremely narrow bed in which the lovers barely seem to fit) in order to communicate more powerfully his psychological interpretation of the theme. David has used an ironic reversal of the aubade tradition—the regret of lovers parting at dawn—to express a disturbing psychological truth that underlies the charming surface of the literary versions of the myth; he has represented Psyche as a sexual slave, captive of the leering, satiated Amor. The psychological significance of Psyche's confinement in Amor's palace was an element of the myth not emphasized in the literary sources, nor did it seem to be of great interest to other artists of the time who represented the theme. David, however, thought deeply about the meaning of Psyche's sojourn in the palace of luxury in terms of the male-female psychosexual relationship and used compositional and stylistic devices to convey more effectively her imprisonment. This helps to explain the penumbral canopy that overhangs the bed like a brooding, funereal force, the claustral ambience of the room—the stark green floor and brown walls more befitting a prison than a palace— and the problematic landscape (perhaps it is a painting on the wall) that offers little hope of escape. But, of course, Psyche, at this moment in the myth, does not wish to escape for she is still complaisant and has not yet chosen to revolt.

David's interpretation of the essence of the myth at this point in the story, his insistence on Psyche's enslavement by the concupiscent Amor, is given its corroboration by the great twentieth-century psychoanalytic interpretor of the myth—Eric Neumann. Neumann describes Psyche's situation in the palace of Amor as one of "servitude," her existence is a "non-existence, a being-in-the-dark, a rapture of sexual sensuality, what may fittingly be described as a being devoured by a demon, a monster."[30] This is exactly what David has shown in the painting. Amor is not a beautiful god whom Psyche mistakenly believes to be a monster, as in the literary versions of the myth. David shows us that because Amor limits Psyche's existence to her sensual nature, he is, indeed, psychologically and morally speaking, monstrous. This explains Amor's "cynical grimace" and David's pains to make him repulsive. David has perfectly embodied in Amor's outward appearance what he perceived as the brutal sexual nature of the god.

Through this penetrating psychological interpretation of the mythic lovers, David, ever in passionate colloquy with the art of his predecesors and contemporaries, has also entered in meditative dialogue with the tradition of the Odalisque, a popular subject in art and letters in France throughout the eighteenth and nineteenth centuries. At the moment of the fable David has chosen to represent, Psyche has in common with the Odalisque the situation of being a sexual slave to the whims of a despotic master. The master-slave rapport implicit in the harem is particularly pertinent on a psychological level to David's *Amor and Psyche*. We remember that the primary deprivation of Psyche is that she may not look upon Amor although he can satisfy his voyeuristic desires

whenever he chooses. This ocular imperialism is one of the principal ways in which Amor demonstrates who is master and who is slave. That Psyche not see him is an inviolable rule, the example of his power in all its arbitrariness. Alain Grosrichard has shown that this was one of the essential features of the suzerainty of the sultan.

> To be the master, therefore, means to see. The despot can be stupid, mad, ignorant, drunk, sick, it doesn't matter: he sees. Not to see is to be condemned to obey. In the despotic regime, where one always obeys "blindly," the blind person is the emblematic figure of the subject."[31]

David diverges from the Odalisque tradition, however, in which the female figure offers herself to the voyeur's delectation (Ingres' Odalisques immediately come to mind) for he does not allow us to forget that the captive female is not just an object of beauty and desire, but a sexual slave, a possession, just one more luxury item amongst many. It is the lubricious Amor in David's painting who, as he triumphantly, yet nervously, invites the viewer to gaze upon the "object" of his desire, arrests the aesthetic and erotic enjoyment of Psyche's enticing form. For Amor's leering grin, directed at us, implies our complicity in the sexual imprisonment of his beautiful mistress, whom we cannot perceive merely as an object of desire, for her innocence and vulnerability, conveyed through her figure, pose and color, confirm that she possesses a soul. If Ingres presents to the viewer an Odalisque for pure visual and erotic appreciation David presents the psychosexual implications of what it means to look at an Odalisque. Thus, David's interest in the complex nature of viewing itself, announced in *The Sabine Women*, is here further developed and expanded upon. David's penetrating psychological exploration of the myth of Amor and Psyche and his skillful manipulation of the viewer's reactions to it, anticipate the problematics of sexual exploitation raised by Manet's *Olympia* as well as modern psychoanalytic interpretations of the mythology of desire. David understood and demonstrated the essence of the Odalisque theme—male domination over, and imprisonment of, a captive woman who is reduced to a sexual slave and denied an existence independent of her sensuality.

If there is any doubt about the psychological and moral implications of *Amor and Psyche* we need only look to its pendant of 1818, *The Farewell of Telemachus and Eucharis* (fig. 122). This, too, is a parting scene of mythic lovers, albeit in style, composition, and theme diametrically opposed to *Amor and Psyche*. In *Telemachus and Eucharis* (in style and format a family portrait) we see again what appear to be the same youthful models David used for the Amor and Psyche, but here completely transformed by expression. Telemachus, whose face is both sensitive and sad, like Amor looks out directly at us, but with a gaze that inspires our compassion and pity. Eucharis is sorrowfully conjoined to her lover in a tender embrace, while the hunting dog, compassionately gazing at his master, although he figures in the myth, comes to symbolize the fidelity of the couple's love. The soft, rounded forms of the figures and the beautiful, interlocking curves on which the composition is based communicate the wholeness and completeness of their

union. We learn from the booklet of the painting's first exhibition (written by Cornelissen in accordance with the directives of David) that the couple has just enjoyed the "delights of a reciprocal passion but still chaste and pure."[32] Unlike that of Amor and Psyche, this sexual union is expressive of a higher spiritual force, the lovers remain chaste and innocent. In the *Telemachus and Eucharis* David presents a relationship that includes physical love but is not limited to it. And the male does not hold the female captive; Telemachus and Eucharis belong to each other, the sincerity of their rapport is explicitly conveyed by their interlocking forms (a sketch preserved at the Ecole des Beaux-Arts [fig. 133] shows another idea for the theme in which the sorrowful, downcast Eucharis sits on the lap of Telemachus who looks up at her with anxiety and devotion).[33] These two paintings, taken together, form a meditation on two different stages of love, love that is purely sensual and does not embody higher moral obligations and love that is sensual yet also spiritual, not ruthlessly bereft of moral significance.

That the public and critics were deeply dissatisfied and uncomprehending of David's interpetation of the mythic couple of Amor and Psyche is evinced by the critical acclaim for Picot's depiction two years later of the same moment of the story (fig. 134).[34] His *Amor and Psyche*, exhiibited at the Salon of 1819, may be understood as the

133. David, *Telemachus and Eucharis*, drawing, Paris, Ecole Nationale Supérieure des Beaux-Arts

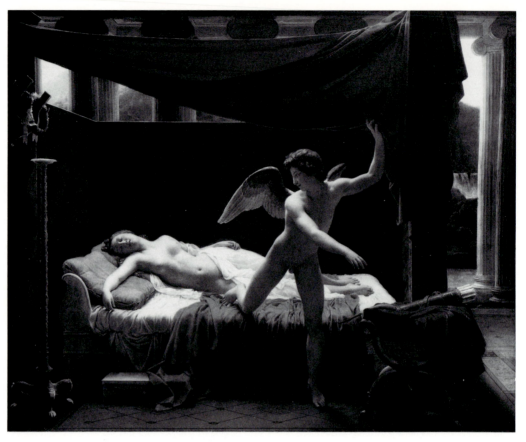

134. Picot, *Amor and Psyche*, 1819, Paris, Louvre

neoclassical antidote to David's interpretive poison. Here the lovers are presented in the bedroom of a magnificent "antique" palace. The idealized, ephebic Amor gracefully steals away but looks back with longing at his languid, voluptuous mistress who swoons on the bed. Picot's Amor has delicate wings, almost pavonine in their profusion of color, as opposed to the heavy, greasy feathers of David's god of love. He embodies the *beau idéal* but with enough modifications from the model to show that he is not just copied from an antique prototype. Psyche's figure, unobstructed by Amor, unlike David's version, is here clearly meant to provide unalloyed titillation. Indeed, Amor looks like the youthful innocent who has been seduced by a lascivious young woman.

Picot offers a much more conventional, normative version of the love story of Amor and Psyche, one that immensely pleased its audience, but David was clearly parodying a tradition of mythological painting that had prevailed until he initiated reforms in the representation of the mythic theme. Parody, as we shall see, would become a major element of several of his Brussels works. It is certainly parodic to present the figure of

256

Amor as grotesque and ridiculous at the same time. We have already seen how David took great pains to make an ugly, awkward god, how he made him look foolish and inept. Amor's foot is caught clumsily in the drapery and, what is even more parodic, his dull, greasy wing is pinned by Psyche's body. In a scene that is supposed to represent the god of love silently slipping away without waking his mistress, we have instead a god, who, if he continues to rise (as we imagine he will), will either rip off his wing or hurl Psyche from the bed. The butterfly is also certainly meant to be parodic. The soul of this beautiful woman is not represented by an equally beautiful butterfly but by a hovering, grey insect that resembles nothing so much as it does a moth. This realistic depiction, which looks like a textbook illustration, is certainly ironic and provides further evidence that David now rejected rigid allegorical attributes in his portrayal of the myth (attributes often employed without question by his contemporaries). As we have seen, David has shown that Psyche's complex essence must be rendered principally through the expressive qualities of her form, contour, pose, color, and, of course, her jarring contrast with Amor.

Kératry, who, as we have seen, had been troubled by this painting in 1819, wrote a reassessment of the work three years later in his important and neglected treatise, *Du beau dans les arts d'imitation*, Paris, 1822.[35] In this new discussion Kératry realizes not only the psychological import of the composition, he recognizes its parodic elements as well.

> here there is no god; there never was one. There is no woman who would not be frightened by the sight of the being who has usurped his place.
>
> In this scene where a crass nature triumphs and toys with the most gentle emotions granted in life, the heart constricts; it feels oppressed by an overwhelming weight. Thought turns in on itself, wonders and asks with bitterness if the happinees promised here below in which tender goodness is sometimes interspersed with our sorrows, is nothing other than the miserable parody offered by the brush of M. David.[36]

The parodic elements of *Amor and Psyche* manifest the uneasy relationship the artist had developed with a classical mythology whose content and structures were being reexamined and reassessed circa 1800. This tension is certainly present in a subsequent Brussels masterpiece, *The Anger of Achilles* of 1819 (fig. 123, colorplate VII), in which he again compresses figures into a narrow space and uses an equally disturbing conjunction of the real and ideal for expressive effect. In *The Anger of Achilles*, four large half-figures occupy the foreground in a space in which they barely seem to fit. Achilles and Agamemnon are the antagonists, the young warrior about to draw his sword on the king, while Clytemnestra and Iphigenia stand directly behind them, witness to the momentous dispute. At first glance, the most startling and disturbing aspects of this work are the intense and complex expressive qualities of the figures. In a letter to Gros of May 13, 1819, Mme David described the painting in the following terms.

At this moment he is finishing a painting which represents the wrath of Achilles at the moment when Iphigenia is led to her sacrifice. It is composed of four half-length figures; it is harmonious overall. The expressions are of the greatest beauty. The head of Clytemnestra unites fear and hope to a most eminently beautiful degree. The majestic calm of that of Agamemnon is also of a rare beauty. The resignation of Iphigenia is of an admirable sensibility. In short, our friend makes his exile enjoyable with his cherished painting and I assure you that the paintings he will have executed in Flanders will mark another epoch in his painterly life.[37]

In this description one immediately notices an intense valuation of multifarious emotional states and complexity of expression. Like the *Amor and Psyche*, this is a painting charged with psychological significance for we witness the psychic forces inherent in what appears to be an imminent confrontation between the two great warriors.

David was inspired to depict this confrontation, fraught with anxiety and tension, by one of the most performed plays in Paris in the early nineteenth century, Racine's *Iphigénie en Aulide*.[38] In this brilliant and complex play Racine privileges the psychology of behavior and also diverges from the principal antique source, Euripides, by having Agamemnon and Achilles appear together in a spectacular confrontation scene (Act IV, scene VI). David not only knew Racine's play from theatrical performances, he was also involved in the illustrations to Racine for the publishing house of Didot. In 1801 Didot published a three-volume edition in monumental folio of the *Oeuvres de Racine* that included fifty-seven engravings. David's role in the illustrations for this publication, in which two of his favorite students—Gérard and Girodet—were involved, was paramount.[39]

In his representation of this psychologically explosive mythic moment David depicts a profound and heart-rending family crisis that constituted the primary matter of Racine's play. He has chosen to express the psychological significance of the confrontation between Achilles and Agamemnon when the future of the family is at stake. This scene occurs just after Achilles has learned that his bride-to-be, whom he ardently loves, is to be a sacrificial victim rather than a spouse, and that her father has given his blessing to this cruel event. It is during this scene that Achilles threatens the king. When the young warrior asserts that his bond of love to Iphigenia is stronger than those owed to father-in-law, king and country, Agamemnon aggressively breaks all family ties, thus abjuring his oaths, promises, and familial obligations. Achilles does not slay the king, however, for motives that are ambiguous. David's contemporary, La Harpe, reserved special praise for the climactic "immortal scene, one of the most imposing known in any theater and one of the masterpieces of the heroic genre."[40] And Raymond Picard, one hundred and fifty-three years later, points out that the scene unites all the essential elements of Racine's play.

This scene has just dramatically brought into play all the elements that had been patiently gathered before. In its unfolding everything had been foretold, the arguments employed by one another as well as the reactions to these arguments. This necessity gives to the spectator the satisfaction of a reassuring intelligibility.[41]

David has manifested brilliance of invention and interpretation in choosing to represent the Racinian family conflict that is expressed, in concentrated form, in this momentous scene. He presents a harrowing image of the entire family constrained and compressed into a shallow space, enacting a drama violently inspissated with psychological tension, in which the interrelationships are masterfully described. One of the most remarkable facets of the composition is Agamemnon's masterful subjugation of Achilles who is rendered immobile through the command and power of the king's gesture and gaze. In order to convey the psychic energy of the king's will to stay Achilles' hand David again turned to mesmerism (a device, we remember, he had used in the *The Oath of the Horatii*). We witness the overt effects of mesmeric power in this composition in which the invisible magnetic fluid emanates from Agamemnon's peremptory gesture and gaze to arrest Achilles' murderous intent, rendering the unarmed king victor in this battle of wills. Achilles' action, reaching awkwardly with his right hand over his left shoulder to draw his sword, is held frozen in a moment of utmost tension. He is immobilized by the indurate gaze of the king to which his eyes are riveted, as Clytemnestra looks on, dolorous witness to this mesmeric drama that will decide the fate of her beloved child.

David has brilliantly portrayed Iphigenia and Clytemnestra as audience to the dramatic confrontation. Iphigenia is at the heart of David's painting, as she is at the heart of Racine's play. In the dress and pose of a martyr, her right hand expressively pressed against her heart, she is wearing her wedding dress which is, with bitter irony, to be her funeral attire. She inclines her head towards her father which suggests her emotional inclination—namely, that of being her father's loving and devoted daughter (in Racine's play it is her obstinate submission to her father's will that complicates efforts of the other family members to save her). Though she is lost in contemplation and expresses resignation and sorrow, Iphigenia's sturdy, upright posture conveys firmness of will and intent; as in Racine, she is filled with sadness but also with courage.

Clytemnestra is an imposing figure in David's painting, as she is in Racine's play. Taller even than Agamemnon, though she stands in the space behind him, it is she who wears the crown of royal authority. She shelters Iphigenia with her body and hamate sceptre, whose tendrilous hooks are expressive of her grasping, maternal devotion. Her thick, masculine hand is placed possessively on her daughter's right shoulder. The queen's gesture and pose in the painting parallel her emotional position in Racine, for the queen has vowed that Agamemnon's soldiers will have to tear her daughter from her

bloody arms and slay the mother first (Act IV, scene IV). She cannot keep her promise, however, and this is manifest in the magnificent characterization of her face. Her contumelious yet sorrowful eyes are red and swollen, congested from weeping. She gazes at Achilles with resignation and sadness as well as contempt, for she has just realized his impotence before the will of the king and recognizes at this moment that her daughter is doomed.

As in the *Amor and Psyche* (and in several late portraits), David used a daring plurality of styles in order to express differences in character and emotional states. As we can see, Clytemnestra and Iphigenia stylistically clash with the more classical mien of Achilles and Agamemnon, as well as with each other. The simplified, sharply outlined features of Iphigenia's face recall Botticelli or Raphael (she certainly seems to prefigure the fey Pre-Raphaelite maidens in distress), while Clytemnestra looks disturbingly realistic—the portrait of a contemporary woman out of place in the company of these mytho-historic figures.[42] The unusual characterization of her face makes Clytemnestra the focus of attention in the painting. She also expresses the most psychologically: her poignant and tragic awareness of the import of this moment is almost too painful to witness.

By bringing the figures into the most complete propinquity, David has also eloquently compressed the complex interactions among the four family members *and* the heart of the narrative into one significant moment. He presents us, in fact, with a distilled "drame bourgeois," an emblematic portrait of a family riven by grief and strife, exposing the "fury and the mire of human veins." The psychological and narrative compression is expressed through spatial as well as anatomical compression—the crowding together of the figures into a narrow foreground space and the flattening of forms (especially Achilles' face and arms). These elements give the painting a haunting, static quality that invites the spectator to meditate and reflect on the meaning.

The daring mythic reinterpretations accompanied by the stylistic and compositional innovations of his first three major works in Brussels establish David's significant position in the development of Romantic Hellenism. In his final masterpiece, however, *Mars Disarmed by Venus and the Graces* (fig. 124, colorplate VIII), a bold and brilliant painting, David surpasses the aesthetic and thematic experiments of any of his previous compositions. The remarkable range of artistic problems and aesthetic and philosophical ideas explored in the previous Brussels paintings are brought to an even greater level of intensity in this work, which David considered his adieu to painting. On October 21, 1823, he wrote to Gros:

> I believe, with God's help, that I will be able to complete the painting of Mars and Venus before my last day. This is my final adieu to painting.[43]

And, two months later, *L'Oracle* published the following excerpt from one of David's letters.

It is the last painting that I want to do, but I want to surpass myself in it. I am putting into it the experience of my 65 years and I do not want to touch a paintbrush again.[44]

David considered the *Mars Disarmed by Venus* to be his last attempt to distill his ideas concerning art and aesthetics.

A handful of perceptive observers believed David had realized his objectives. One of these was the most neglected of the first generation of romantic sculptors—Théophile Bra—a highly original writer and thinker, as well as sculptor. Bra considered the *Mars Disarmed by Venus and the Graces* to be one of the greatest masterpieces in the history of art. After describing the image in considerable detail Bra wrote:

> Such a beautiful conception cannot be described. This admirable work will mark an epoch in the annals of painting, it takes first place among the works of the artist who knew how to bring art back to its true principles.
>
> The artist transported himself to Olympus to see Mars and Venus there and, while there, to come upon the most graceful scene that poetry could invent. He has reached the sublime.[45]

Bra goes on to hail the undiminished brilliance of David's intellect in creating this work of genius.

> One could not have expected to see such a beautiful thing. Nature granted to David what she has granted to no other genius, in any genre: not only does she preserve intact his intellectual faculties, but she gives all the strength and the bloom of youth to his talent and his ideas.[46]

Bra perceived that the painting was a radically innovative work, teeming with ideas, conveyed through stylistic and technical brilliance and mastery. Nowhere has there been a more forceful denial of the thesis of David's precipitous senescent decline in Brussels.

Unlike Bra, most observers of the work at its exhibition in Paris in the spring of 1824 were too puzzled and surprised to decode its meaning (the painting had created a sensation at its first exhibition in Brussels).[47] Even David's former pupils, in their written responses, reveal that although they recognized the work as a "tour de force" and hailed it for its genius, brilliance, and poetry, none could fathom the artist's intentions.[48] The history painter Angélique Mongez, a former pupil and close friend, whose opinion David held in high esteem, wrote him that she was overwhelmed by the painting whose overpowering expressive effects left her incapacitated for several days.

> Your Mars is truly a god, his head is divine and of an admirable hue; the pose, the drawing of the entire figure, leave nothing to be desired. Venus, whose forms are so graceful and delicate and whose coloring is so subtle, contrasts with the warm tones of Mars in a way that could not be better expressed. . . .

The aerial effect appears to me to be perfectly understood and very misty. You could not have done better, my dear teacher, than to send this painting to us in Paris. . . . in short, it paralyzed me and for several days incapacitated me—to such a great extent did I feel my worthlessness. But at least I have the pleasure of seeing that the staggering blow will fall on many others as well.[49]

Others used similar language. Even A. Thiers, who wanted to promote the burgeoning Romantic movement at the expense of the school of David, expressed his confusion before the painting to which he devoted a long article in the *Revue européenne*. He repeatedly praised its spectacular color and technique. Like so many observers, Thiers was overwhelmed by the subtlety in the rendering of Venus' flesh and skin and the "carnation" in the torso of Mars, but he objected to many of the, to him, incomprehensible contradictory elements of the composition.

The body, the head and the entire figure of Mars were judged to be of a great beauty and it is difficult, in fact, to produce anything better in terms of drawing and flesh-tones. But Venus, even though she displays a beautiful body and admirable skintones, is scarcely voluptuous; there is more anxiety than charm in her face. The three Graces smile disagreably and Amor's finesse is here out of place.

Finally, his [David's] color is more brilliant than it has ever been. But it is necessary to take a moment to get accustomed to it, it surprises the gaze to such an extent with its brightness. The color is unquestionably the most astonishing part of this painting.[50]

Thiers, like most observers of the painting in Paris, was taken aback by David's use of brilliant, saturated colors which were so bright, he claimed, that the eyes had to adjust to them. But, like many others, he was puzzled by the unexpected treatment of the thin, anxiety-ridden Venus and the disagreable Graces who contrast unpleasantly with the graceful, lithe Amor. Thiers concludes his review, however, by awknowledging that David had, once again, created a metamorphic "revolution" in his art: "[the artist] suddenly had the courageous and noble idea of changing his palette and of creating a revolution in his talent."[51]

Like the critic Thiers, most of David's students recognized the radical aesthetic innovations of David's composition. But most were similarly puzzled and did not know how to express their surprise and confusion. Even Gros, who delayed writing to David in Brussels, diverged from his typical responses by not going into detail at all; he merely flattered his former teacher by exclaiming the painting was "worthy of Homer" and a "Greek painting."[52] Others hail the master's imagination, verve and brilliance, claim the work as a sublime masterpiece, and continually remark on the "beautiful lesson" that he has taught them. But the "lesson" they perceived seems to be related to the remarkable technical brilliance of the painting rather than to the interpretation of its subject or

its contradictory and highly unusual expressive elements which most avoided mention-ing at all.[53]

This confusion before the work is not surprising. As in the *Amor and Psyche* and the *Anger of Achilles*, opposing elements of style and technique, brought together in an unexpected reinterpretation of a traditional subject, have an extremely disquieting impact on the observer. As most critics justly noted, David surpassed himself and all of his contemporaries in the delicacy and nuanced treatment of skin and flesh in the figures of Mars and Venus. One observer exclaimed that these were "real gods" who appear to emerge from the composition and belong to our world, the world of nature rather than art.[54] Yet, as we can see, the supremely beautiful naturalism of the couple on the bed is contrasted with the opposing effects in the ungainly Graces whose crowns of delicate and magnificently described flowers only serve to intensify the coarseness of their faces and figures. Such ironic conjunctions and parodic effects inform the entire composition, even to the smallest details. Venus' doves, for example, which comically occlude the genitals of her lover, are nothing more than common pigeons with scruffy, unkempt feathers, red, beady eyes, and red beaks and claws that are depicted with great natural-ism (we are reminded here of Psyche's parodic moth). The sandals of Mars are decorated with small red hearts, a comic detail that seems to undercut more serious aspects of the composition. The parodic elements of the painting, which are both comic and disturb-ing, are, of course, to be taken seriously. For in his final painting, his adieu to art, David charged every detail with meaning.

The comic and parodic elements of the painting may be related to the antique literary sources of the myth. The passionate love affair of Mars and Venus, recounted in Homer and Ovid, emphasizes principally their entrapment by the cuckolded husband Vulcan. In both descriptions, the lovers are embarrassed and become the laughing stock of the other gods. Completely overlooked as a source, but far more closely related to David's painting, is the interpretation offered by the great poet of the French Renais-sance, Ronsard. In his ode entitled *A son lict*, he describes a painting in which Mars and Venus are depicted nude in a distinctly erotic and amatory manner.[55] Unlike the more comic versions involving Vulcan, this poem concerns sexual conquest through another variation of the theme of *carpe diem*. It also engages us in the dialectic of the real and ideal, in earthly and divine love. The real lover, through her intense, earthly beauty, becomes worthy of a sidereal apotheosis, of being forever fixed among the stars. Al-though Ronsard's *Ode* clearly deals with the confluence of the real and the ideal, David was not in any way restricted by his literary sources. His last work is a tremendously complex composition which far transcends its sources but which employs them in a fascinating manner. In this painting the conflation of Homer, Ovid, and Ronsard helps to explain the odd conjunction of the comic and the serious, parody and philosophy— aspects of the composition that make it so difficult to comprehend. Various episodes involving Mars and Venus were also frequently represented in painting[56] and numerous Italian and French Renaissance, Baroque, and eighteenth-century examples were well-

known to David. But he had in mind, in particular, various depictions of Mars and Venus created in the sixteenth century by the School of Fontainebleau which witnessed a revival in the early years of the nineteenth century—a number of works were on display in A. Lenoir's Musée des monuments français and emphatically influenced the stylistic development of Ingres among others.[57] In this painting, in fact, David, in his choice of subject (from Ronsard) and his style, alludes overtly to the French Renaissance and the reign of François I which was understood in the early nineteenth century as the great transformative historical moment in the creation of the French school of art. In his introduction to the *Musée des monuments français* Lenoir himself hailed the sixteenth-century king for these very contributions—François I was credited with saving French art from barbarism and setting it forth in the direction of greatness that would be realized in successive periods. The French Renaissance had become particularly revalued during the Restoration with its projects to promote the history of the French Monarchy at all possible cultural, intellectual and artistic levels. Sixteenth-century French litera-ture and art were being studied with an avid interest not seen before (witness Sainte-Beuve's *Tableau historique et critique de la poésie française et du théâtre français au seizième siècle* of 1828).[58] In his final monumental work, an homage to the instauration of the French school of painting, David placed himself in the great tradition of French art, as the latest continuator of the French school, at a critical juncture when the very objectives of this school were being challenged by a new generation of French artists and critics. In Brussels David never ceased thinking about France and his own heroic, pivotal, and transformative role in her art history.

But although the School of Fontainebleau may have provided David with an initial impetus and a frame, even a cursory examination of possible visual sources reveals the extent to which he stylistically and thematically diverged from any precedents. For, in his final work, the artist insisted upon the uniqueness of his own interpretation, upon invention and imagination, qualities his enemies had often accused him of lacking.

In an attempt to penetrate this difficult and seemingly opaque painting, it may help to examine first several of David's drawings that reveal the development of his ideas concerning the composition. We know from an exchange of letters that, after a brief visit from Gros in 1822, David completely altered his composition and that he was very proud of the exciting and daring changes he had made.[59] A drawing in the Fogg Museum probably indicates his initial idea for the painting (fig. 135). Thematically it recalls his *Amor and Psyche* of 1817. David was thinking in terms of the sexual rapport of the divine lovers for he depicted a voluptuous, sensual, lanquid goddess sprawled on the bed in three-quarter view, her physical charms exposed fully to the viewer. Her gesture is clear and legible. She removes the helmet of her virile young lover (he is beardless and youthful), who appears quite cheerful at the prospective romp in bed with the goddess of love. In this highly erotic image Mars offers no resistance to Venus' seductive charms and the outcome, the sexual fulfillment of the lovers, is assured. In the painting David altered the position of the god of war. Mars sits upright still holding the very sharply

135. David, *Drawing for Mars Disarmed by Venus*, Cambridge, Mass., The Fogg Art Museum

pointed spear in his right hand but no longer embraces Venus. Instead, he extends his scabbard although no one is there to receive it, and is self-absorbed, seemingly unaware of the seductive intentions of the goddess by his side. He is also mature, bearded, and middle-aged. Though extremely powerful and vigorous, he is perhaps less susceptible to sexual enticements than the youthful Mars of the drawing. The god of love who unties the sandal is not the repulsive adolescent of David's 1817 painting, but instead is a cloying, immature, winged child. He is Cupid rather than Amor/Eros (the distinction between these developmental phases of the god of love was strongly emphasized in the mythological discourse of the time). David has moved Cupid to the right of Mars' leg and has made him into a choric figure, one who directly engages our attention. It is the figure of Venus, however, that David has radically transformed from his early idea to the final composition. He has reversed her position, depicting her from the back, thereby concealing many of her celebrated sexual charms but revealing others—he has turned her into a *Vénus aux belles fesses*, a Callipygean Venus famed for her beautiful buttocks. At the same time he has replaced her voluptuous, sensual forms with a slim and almost

265

boyish figure (we remember that this puzzled and disturbed many of the first viewers of the work). Venus no longer removes the helmet but instead raises a crown of flowers that she hesitates to place on the head of Mars (the motif of the lover crowned, an emblematic expression of the consummation of sexual desire through intercourse, was well-known from eighteenth-century examples). Venus' hesitation and anxious expression lead us to wonder whether this love will be consummated or not. She certainly seems uncertain of the outcome. Cupid himself seems not to have quite decided, since his bow is lying on the ground with his arrow of gold (to inflame the heart) and his arrow of lead (to make the heart immune) lying side by side, apparently neither yet used. This may help to explain Cupid's curious smile of complicity directed at us. He appears to be asking what we think he is going to do. Major decisions regarding the outcome of this affair have apparently not yet been made and the spectator is placed in the dilemma of trying to decide what might occur, how things will turn out. This type of dilemma, which pervades every aspect of the work, is another important key to its meaning.

In the painting David has also added three principal figures not present in the early drawing—the remarkably graceless Graces who are placed on a middle ground of an extremely solid cloud-bank in an extraordinarily compressed space, behind the bed but in front of the ornate Corinthian pavillion. We are hard pressed, in fact, to understand this very odd space and are led to wonder where the figures are in relationship to the architectural structure. In a later drawing (fig. 136), one that is very close to the final composition, a simple, severe Doric pavillion is clearly placed behind the figures. In the painting, however, the bed seems to float in front of the structure whose columns, we assume, must extend beneath the lower clouds that conceal its forms. The Graces defy all expectations based on their canonical representation from antiquity through the Renaissance, Baroque, eighteenth, and early nineteenth-century examples. The Graces, the handmaidens of Venus (and, in some accounts, her children, the result of her affair with Bacchus), are consistently described in the mythic sources, both antique and contemporaneous, as manifestations of grace, harmony, beauty, and charm. David presents us with the antithesis of this idea. The Graces, rather than dance or stand with arms intertwined, as they are expected to do as emblems of harmony and beauty, are forced to work at clearly unaccustomed tasks. They have become active participants in the drama but do not know exactly what to do. One lifts the helmet of Mars with her fingertips as if it were as light as air (an incredible feat of physical prowess), but looks back questioningly towards Venus—where is she supposed to put it? In fact, there is no destination for the helmet possible in this area of the composition. The middle Grace tries to serve refreshments, but the precarious pitcher seems about to pour nectar on her foot. And she extends a cup, but to whom? Neither Mars nor Venus has a free hand to receive it. The third Grace, rolling a shield (to what purpose?), looks out at us with a fatuous smile, pleased with her accomplishment, proud of her job, her new position as participant in the narrative. She is the silliest of all.

David represents the Graces as remarkably homely and plain, clearly based on

136. David, *Drawing for Mars Disarmed by Venus*, Besançon, Musée des Beaux-Arts et d'Archéologie

unidealized live models. Why has he portrayed such unpleasant, graceless Graces? It makes no sense to assume that David could not have painted delicate Graces. For, in this very painting, in the figure of Venus, he has depicted one of the most stunningly beautiful female nudes in all of art. The answer to this perplexing problem can, perhaps, be found in the painting's relationship to aesthetic debates of the time. In fact, three aesthetic categories whose merit was being hotly contested in the critical discourse of the period are juxtaposed—the *beau idéal* (idealized beauty all'antica) manifest in the Cupid, the *beau réel* (beautiful forms taken from nature) in the figures of Mars and Venus, and the *réel*, the natural, the ugly, the plain, in the Three Graces. David's studies for the Graces reveal that he explored different possibilities for their figures—the lissom, fluid dancing forms in one drawing (fig. 137) stand in dramatic contradistinction to the exploration of the awkward, off-balance and the homely in another (fig. 138). His final choice was to transform them ontologically. He assigns them roles they cannot fulfill and makes them antigraceful and comic in their clumsiness. Their silliness and awkwardness serve to heighten by contrast the hesitancy and anxiety of Venus and the stony aloofness

137. David, *Drawing for the Graces*, Paris, Louvre

138. David, *Drawing for the Graces*, Besançon, Musée des Beaux-Arts et d'Archéologie

of Mars. None of these figures appears or behaves in the appropriate, expected ways, as we might say of space and form in the composition. But to what purpose?

A drawing of the head of Venus offers a clue to one of the many levels of meaning in this work (fig. 139). Above the head of Venus David wrote, "l'art partout," art everywhere. In David's final painting, art is, indeed, everywhere. This is a composition devoted to exploring the nature of art, its possibilities and limitations. The entire composition calls into question the rules of painting established in Italian Renaissance theory and practice, rules that had governed art in France since the seventeenth century,

139. David, *Drawing for the Head of Venus*, Lille, Musée des Beaux-Arts

269

rules, as we have seen, that David had begun to challenge in several works beginning with the *Sabine Women* in 1799. These rules assure that through mastery of the science of perspective and the canon for making the beautiful, perfected human figure, through skill in harmoniously combining compositional elements and appropriate choice of subject the painting becomes a window on the world; art is the imitation of perfected nature. But in this painting David parodies all these rules; he breaks them at every turn. He demonstrates in his final work that painting is no longer to be limited to the imitation of idealized forms from nature, that it can be something more.

His method of exhibiting the painting in Paris provides evidence that this was the case. David instructed his son Eugene to rent several rooms for this purpose (he found a suitable apartment at 115 rue de Richelieu).[60] In the first room the spectator saw *Andromache Mourning Hector*, studies of Hector, Patroclus, and Romulus, and David's copy of Valentin's *Last Supper* he made as a student in Rome. This antichamber or prelude to the exhibition of his final mythological painting served as a reminder of the artist's aesthetic journey from the beginning to the end of his career. The second room one entered was covered with green drapery and *Mars Disarmed by Venus and the Graces* hung on one wall. Opposite it was a mirror cut to size so that the entire composition was reflected in it but the frame was not. The mirror reflection appeared to float in a dark green space. Angélique Mongez, who, along with Naigeon and Michel Stapleaux helped to mount the exhibition, commented on the extraordinary impression this made.

> a large square room, hung with dark green drapery. In this room is a mirror opposite the painting in which one sees it when entering. And, since one does not perceive the frame, one believes he is seeing all of Olympus. This creates the most beautiful effect.[61]

The third room simply contained a few chairs and was intended as a meditation or discussion space for what had just been experienced.

This type of precise planning indicates the importance David attached to the painting being exhibited alone in a carefully arranged room with its mirror reflection (we remember how he had first used the very device of the large rectangular mirror for similar purposes in his private exhibition of *The Sabine Women* in 1799 and then again in the *Coronation*). The choice of the mirror here brings to mind once again a principal aesthetic idea that had prevailed in the Western tradition since its codification in Renaissance theory and practice; namely, that art is the mirror of nature. This principle had informed David's artistic education and his early canonical works. We have seen how in *The Sabine Women* and subsequently in *Leonidas at Thermopylae* David had begun to challenge this concept. In his last painting he completely rejects this mode of making, thinking about, and viewing art. The *Mars Disarmed by Venus and the Graces* does not mirror nature, and seems impenetrable only if we expect it to do so. David, through the uncanny intensity and truth of naturalistic details, including the forms, texture, and

coloring of flesh, flowers, feathers, satin sheets, and bronze reliefs, encourages these expectations which he then thwarts by creating figures who behave in an odd, awkward, and comic way in a space that is unnatural. The painting does not reflect or mirror nature, but, in an ironic reversal, the mirror reflects the work of art. Thus, the reflexive nature of art is clearly manifest. In the mirror the composition becomes even more oneiric, a floating vision against a green ground.

It should not surprise us that David created his final composition during the very period—1822–1823—when a debate was being waged in Paris over two major aesthetic issues—the nature of the beautiful in art and the role of imitation in painting. As mentioned earlier, in 1822 the art critic and theorist, A. Kératry, published a radical treatise, *Du beau dans les arts d'imitation*, in which he denied the existence and even the possibility of the *beau idéal*.[62] He denigrated Plato and Winckelmann and declared the imperfect or flawed beauty of modern individuals superior to antique depictions of the goddess of beauty herself. Kératry's arguments, which lent support to the new definitions of the Romantic during this period, were counterattacked by the arch defender of the *beau idéal*, the indefatigable Quatremère de Quincy, who, in 1823, synthesized much of his previous writing on the subject in his *Essai sur la nature, le but et les moyens de l'imitation dans les beaux-arts*.[63] To counter what he perceived as the great threat of Romanticism Quatremère wrote an eloquent neoplatonic manifesto in defense of a universal theory of beauty—the *beau idéal*—as it was developed and codified in ancient art. One tenet of Quatremère's theory was that art should never seek to imitate vulgar nature but should represent instead universal archetypes of beauty that could be conceived only in the mind.

David's painting rejects the narrow, restrictive arguments of both of these theories of the beautiful—the neoclassic and anticlassic points of view. In his *Mars Disarmed by Venus and the Graces* David includes everything—the *beau idéal*, the *beau réel*, and the *réel* intermingle. Grace, beauty, harmony, and strength, expressed in the couple on the bed, are juxtaposed with their opposites in the Graces. Color is given equal consideration to line. Forms behave in unexpected ways—clouds are solid and massive in spite of their apparently light and smoke-like substance, and very heavy, massive objects, such as the temple and bed, incomprehensively float. Actions and emotions are ambiguous; hesitancy and confusion reign. In this painting is David not manifesting the dilemma of the French school in the early 1820s—a moment of great uncertainty and indecision about the future of the art of painting itself?

David's response to this dilemma was to emphasize, in his final representation, that it is not a question of either/or. The real and ideal can exist side by side (as Delacroix perceptively observed when he described David's work as "a singular composite of realism and the ideal").[64] The oneiric can be conjoined with an absolute realism. Multiple meanings do not conflict. The work of art can express psychological, cultural, political, and aesthetic ideas all at once. In his final masterpiece David provides, as we have seen, a convincing refutation of several aspects of Renaissance aesthetic theory. The

composition also constitutes, among other things, a profound statement about the nature, possibilities and limitations of mythological painting itself. A trenchant criticism of mythological painting of the time, including celebrated works by his students Gérard, Ingres, and Girodet, whom David alludes to throughout the painting in stylistic and formal details (Ingres' *Jupiter and Thetis*, of course, immediately comes to mind), the *Mars Disarmed by Venus and the Graces* provides as well a deconstruction of its mythological framework that calls into question the premises of its artistic primacy. David, in his final work, demonstrates that the category of mythological painting should not be privileged unquestioningly but should be used for subtle purposes, such as engaging current aesthetic debates.

It might be objected that I am reading too much into these late paintings, that I am making David in Brussels into a Romantic rather than a Neoclassical artist. There is good reason for this. I believe that David's work in Brussels can only be understood as pointing forward to Romanticism and not backward to a retrogressive Neoclassicism. In fact, it represents a crucial development in Romantic Hellenism in French painting. As we have seen, in his late paintings David subtly utilized many of what would become the mainstays of Romantic art. He used color symbolically for expressive emotional effect; he disrupted the expected dialogue with Renaissance and Baroque perspective and illusion by employing a disquieting ambiguity of space and form; and he rejected the Neoclassical doctrine of the *beau idéal* by offering works that often include ugliness, realism, and vulgarity that astonish and disconcert (this valuation of the ugly being a hallmark of Romanticism). He used these anticlassical elements along with parody to often involve the spectator in a psychosexual exploration of differing aspects of the male/female relationship. In *Amor and Psyche*, for example, the quintessentially Romantic theme of innocence and experience (ugliness defiling purity), combined with a rather dark eroticism, was eloquently explored.

The inability to understand David's fascinating artistic production in Brussels comes from judging it as if he had not progressed or changed from the time of his canonical paintings of the 1780s. Critics and observers tend to want an artist to repeat himself incessantly because we are comfortable with the easily intelligible. As a study of his entire oeuvre makes amply manifest, David was a relentless experimenter, an artist in constant evolution, the awesome power and range of his art is readily apparent, as is its perpetual stylistic and thematic metamorphosis. After David left the limelight of Paris it was easy to assign the works he produced in Brussels, because of their strangeness, to critical oblivion. But David's exile in Brussels was a rich and productive one in which the artist tested the very boundaries of art and expression. A leitmotif of his letters and conversations refers to the benefits and opportunities of his artistic freedom in exile. The extraordinary result of this freedom was a ten-year period filled with fascinating works which reveal to us that, to the end, David never lowered his artistic intensity and remained one of the greatest minds in the history of art, an artist impassioned by the intellectual imagination.

NOTES

The spelling, grammar, and punctuation of the citations correspond to the originals. All translations, which are as literal as possible, are the author's unless noted otherwise.

INTRODUCTION

1. E. Delacroix, *Journal 1822–1863* (Paris, 1980), 768.

2. D. Johnson, "The Eloquent Body: Jacques-Louis David and the Formation of a Gestural Aesthetic" (Ph.D. diss., University of California, Berkeley, 1987).

3. A. Brookner, *Jacques-Louis David* (London, 1980); A. Schnapper, *David, témoin de son temps* (Fribourg, 1980); W. Roberts, *Jacques-Louis David, Revolutionary Artist* (Chapel Hill & London, 1989).

4. D. and G. Wildenstein, *Documents complémentaires au catalogue de l'oeuvre de Louis David* (Paris, 1973); E. Delécluze, *Louis David, son école et son temps*. 2nd ed. (Paris, 1983).

5. J. L. Jules David, *Le peintre Louis David, 1748–1825, Souvenirs et documents inédits*. vols. I, II (Paris, 1880, 1882).

6. L. Hautecoeur, *Louis David* (Paris, 1954).

7. D. L. Dowd, *Pageant-Master of the Republic: Jacques-Louis David and the Revolution* (Lincoln, 1948). R. Herbert, *David, Voltaire, "Brutus" and the French Revolution* (London, 1972).

8. *David e Roma* (Rome, 1981); P. Bordes, *"Le Serment du Jeu de Paume" de Jacques-Louis David: le peintre, son milieu et son temps de 1789 à 1792* (Paris, 1983).

9. *Jacques-Louis David. 1748–1825* (Paris, 1989). A. Sérullaz, *Inventaire général des dessins. Ecole française. Dessins de Jacques-Louis David, 1748–1825* (Paris, 1991).

10. Robert Rosenblum, *Transformations in Late Eighteenth-Century Art* (Princeton, 1967).

11. T. Crow, "The *Oath of the Horatii* in 1785: Painting and Pre-Revolutionary Radicalism in France," *Art History* I, no. 4 (1978): 424–471. See also T. Crow, *Painters and Public Life in Eighteenth-Century Paris* (New Haven and London, 1985).

12. D. Johnson, "'Some work of noble note': David's *La Colère d'Achille* Revisited," *Gazette des Beaux-Arts* (December 1984): 223–230; "Desire Demythologized: David's *L'Amour quittant Psyché*," *Art History* 9, no. 4 (December 1986): 450–470; "Corporality and Communication: the Gestural Revolution of Diderot, David and the *Oath of the Horatii*," *The Art Bulletin* 71 (March 1989): 92–113.

13. A. Boime, "Jacques-Louis David, Scatological Discourse in the French Revolution and the Art of Caricature," *Arts Magazine* (February 1988): 72–81; N. Bryson, *Tradition and Desire: from David to Delacroix* (Cambridge, England, 1984) and "David et le Gender," in *David contre David*, ed. R. Michel (Paris, forthcoming). See also E. Lajer-Burcharth, "David's *Sabine Women*: Body, Gender and Republican Culture Under the Directory," *Art History* 14, no. 3 (September 1991): 397–430 and A. Potts, "Beautiful Bodies and Dying Heroes: Images of Ideal Manhood in the French Revolution," *History Workshop* (Autumn 1990): 1–21.

14. T. Puttfarken, "David's *Brutus* and Theories of Pictorial Unity in France," *Art History* 4 (1981): 290–304; S. Germer and H. Kohle,

"From the Theatrical to the Aesthetic Hero: on the Privatization of the Idea of Virtue in David's *Brutus* and *Sabines*," *Art History* 9, no. 2 (1986): 168–184.

15. *David contre David*, ed. R. Michel (Paris, forthcoming).

16. P. Chaussard, *Sur le tableau des Sabines par David* (Paris, 1800), 3.

17. Baudelaire, "Salon de 1859" and "L'oeuvre et la vie d'Eugène Delacroix," in *Oeuvres complètes*, ed. C. Pichois, vol. II (Paris, 1976), 610–611 and 743–744.

CHAPTER I

1. Diderot, *Lettres sur les sourds et les muets à l'usage de ceux qui entendent et qui parlent* (Paris, 1751), published in Diderot, *Oeuvres complètes*, ed. J. Assézat and M. Tourneux (Paris, 1875), 354. See also D. Johnson, "Corporality and Communication: the Gestural Revolution of Diderot, David and *The Oath of the Horatii*," *The Art Bulletin* 71 (March 1989): 92–113.

2. See Madame de Vandeul, "Notice historique sur Sedaine," in F. M. Grimm, *Correspondance littéraire, philosophique et critique par Grimm, Diderot, Raynal, etc*, ed. M. Tourneux, XIV (Paris, 1877–1882) and also, V: 205, 210–212; VI: 438–446; and XVI: 234–246. See also E. Guieysse-Frère, *Sedaine, ses protecteurs et ses amis* (Paris, 1907), 208, 222 and M. Fried, *Absorption and Theatricality: Painting and Beholder in the Age of Diderot* (Berkeley, Los Angeles, London, 1980), 138, 232. Diderot's friendship with Sedaine is discussed by A. M. Wilson, *Diderot* (Oxford, 1972), 498–49, 687. See also D. Johnson, "Corporality," 110–111.

3. C. Le Brun, *Conférence sur l'expression générale et particulière* (Paris, 1698). Discussed in A. Fontaine, *Les doctrines de l'art en France* (Paris, 1909), 68–69. In the early eighteenth century several theorists modified Le Brun's rigid codifications although the face was consistently considered the seat of the passions. See Roger de Piles, *Conversations sur la connoissance de la*

peinture (Paris, 1677) and *Cours de peinture par principes* (Paris, 1708), 164–168. These ideas are discussed by T. Puttfarken, *Roger de Piles' Theory of Art* (New Haven and London, 1985).

4. Le Brun, *Conférence sur l'expression*, 47.

5. See J. M. Wilson, *The Painting of the Passions in Theory, Practice and Criticism in Late Eighteenth-Century France* (New York and London, 1980), 32–40. And most recently, see T. Kirchner, *L'Expression des Passions: Ausdruck als Darstellungsproblem in der französischen Kunst des 17. und 18. Jahrhunderts* (Mainz, 1991).

6. The prize-winning expressive heads from the 1760s and 1770s preserved at the Ecole Nationale Supérieure des Beaux-Arts reveal an adherence to the stereotypical paradigms of Le Brun.

7. M.-F. Dandré-Bardon, *Traité de peinture suivi d'un essai sur la sculpture* (Paris, 1765), repr. Minkoff (Geneva, 1972), 57–61.

8. The privileging of the face over the body suggests parallels with prevailing moral and religious doctrine in France, in which the face was considered the window of the soul whereas the body represented instinctual, animal life. Ample evidence of this is provided by the seventeenth-century *moralistes*.

9. This criticism has been studied in terms of its social and political connotations by T. Crow, *Painters and Public Life in Eighteenth-Century Paris* (New Haven and London, 1985).

10. See the Abbé Leblanc, *Lettre sur l'exposition des ouvrages de peinture* (Paris, 1747), 36.

11. Numerous examples could be cited. See, in particular, *Jugement d'un amateur sur l'exposition des tableaux. Lettre à M. le Marquis de *** (Paris, 1753), 14; Mathon de la Cour, *Lettres à Madame ** sur les peintures, les sculptures et les gravures exposées dans le Sallon du Louvre en 1763* (Paris, 1763) and *Lettres à Monsieur ** sur les peintures, les sculptures et les gravures exposées au Sallon du Louvre en 1765* (Paris, 1765); J. de la Porte, *Sentimens sur plusieurs tableaux exposés cette année 1755, dans le grand Sallon du Louvre* (Paris, 1755).

12. "Composition belle et sage; idées nobles et vraies; exécution grande et vigoureuse; dis-

position bien entendue; bel accord; on se promène, et l'air joue autour des figures; caractère de chaque personnage bien prononcé; beau ton de couleurs; heureux choix de draperies; pinceau fier, mâle, large et facile; beaucoup d'harmonie, style pur et sévère." Mérard de St. Just, *Lettre d'Artiomphile à Madame Mérard de St.-Just sur l'exposition au Louvre en 1781*, XII, *Collection Deloynes*, no. 277 (Paris, 1782) 31–32.

13. See, for example, H. Dieckmann, "Le thème de l'acteur dans la pensée de Diderot," *Cahiers de l'Association Internationale des Etudes Françaises* 13 (June, 1961): 157–172.

14. H. Josephs, in *Diderot's Dialogue of Language and Gesture: Le Neveu de Rameau* (Columbus, Ohio, 1969), 59ff., discusses the significance of corporal language for Diderot.

15. "Il a l'air violent, insolent et fougueux; il a le bras droit élevé du côté de son père, au-dessus de la tête d'une de ses soeurs; il se dresse sur ses pieds; il menace de la main; il a le chapeau sur la tête, et son geste et son visage sont également insolens . . . Le jeune libertin est entouré de l'aînée de ses soeurs, de sa mère et d'un de ses petits frères. Sa mère le tient embrassé par le corps; le brutal cherche à s'en débarrasser, et la repousse du pied. Cette mère a l'air accablé, désolé." J. Seznec and J. Adhémar, *Diderot, Salons* (Oxford, 1957–67), vol. II, p. 56. Diderot mistakes the raised hand that is to our right but we know he was working from memory.

16. "La fille aînée, assise dans le vieux confessional de cuir, a le corps renversé en arrière, dans l'attitude du désespoir, une main portée à sa tempe, et l'autre élevée et tenant encore le crucifix qu'elle a fait baiser à son père. Un de ses petits-enfans, éffrayé, s'est caché le visage dans son sein. L'autre, les bras en l'air, et les doigts écartés, semble concevoir les premières idées de la mort." Ibid., 157.

17. A typical reaction can be found in *Troisième lettre à Monsieur X sur les peintures, les sculptures, et les gravures, exposées au Sallon du Louvre en 1765*, VIII, *Collection Deloynes*, no. 110, 12–13.

18. Naigeon informs us that Diderot habitually gave his manuscripts of the *Salons* to his friends, who in turn circulated them among their acquaintances. See *Mémoires sur la vie et les ouvrages de Diderot* (Paris, 1821), 409–411. Mme. Necker expressed her delight in reading Diderot's *Salons*. See *Mélanges, extraits des manuscrits de Mme Necker* (Paris, 1798), I: 342. And Diderot, in a letter to Mme. Necker of September 6, 1774, writes that he is perfectly aware that she has copies of his *Salons*. See d'Haussonville, *Le Salon de Madame Necker* (Paris, 1882), I: 76. The circulation of Diderot's *Salons* among his friends in Paris is discussed by Seznec and Adhémar, *Diderot, Salons*, I: 15.

19. Very specific, limited aspects of this discourse have been studied by J. P. Seigel, "The Enlightenment and the Evolution of Signs in France and England," *Journal of the History of Ideas* 30 (1969): 96–115; J. R. Knowlson, "The Idea of Gesture as a Universal Language in the XVIIth and XVIIIth Centuries," *Journal of the History of Ideas*" 26 (1965): 495–508. Knowlson wrote a larger study as well, *Universal Language Schemes in England and France* (Toronto and Buffalo, 1975). The eighteenth-century discourse is so vast that it would require a lengthy bibliography, but such a list would include Warburton, *Essai sur les hiéroglyphes des Egyptiens* (Paris, 1744); Condillac, *Essai sur les origines des connoissances humaines* (Paris, 1746); Noverre, *Lettres sur la danse et sur les ballets* (Stuttgart, 1760) and *Lettres sur les arts imitateurs en général et sur la danse en particulier*, 2nd ed. (Paris, 1807). Recently an attempt was made to privilege sign language for the deaf as having an important specific impact on corporal communication in eighteenth-century French art but no convincing visual evidence was presented. See N. Mirzoeff, "Body Talk: Deafness, Sign and Visual Language in the Ancien Régime," *Eighteenth Century Studies* 25, no. 4 (summer 1992), 561–85. The interest in sign language for the deaf was just one more example of the utopian quest for a universal language in the eighteenth century.

20. De Cahusac, *La danse ancienne et moderne ou traité historique de la danse* (La Haye, 1754).

This work influenced the celebrated reformer of the ballet, Noverre. See *Lettres sur la danse*. Later in the eighteenth century, de l'Aulnaye, in *La saltation théâtrale* (Paris, 1790), elaborated upon the significance of antique dance and pantomime.

21. "Mouvement extérieur du corps et du visage: une des premières expressions du sentiment données à l'homme par la nature. L'homme a senti dès qu'il a respiré; et les sons de la voix, les mouvemens divers du visage et du corps, ont été les expressions de ce qu'il a senti: ils furent la langue primitive de l'univers au berceau; ils le sont encore de tous les hommes dans leur enfance; le *geste* est et sera toujours la langue de toutes les nations; on l'entend dans tous les climats; la nature, à quelques modifications près, fut et sera toujours la même." De Cahusac, "Geste," in *Encyclopédie ou dictionnaire raisonné des sciences, des arts et des métiers, par une société des gens de lettres*, ed. Diderot and d'Alembert (Paris, 1760), VII: 571–572.

22. De Cahusac still gives more importance to facial expression. What is innovative about his definition is the renewed emphasis he places on the body and that the body and face together represent "gesture." One can find something similar in Noverre, "Lettre XXIII," in *Lettres sur la danse*.

23. "Il est indispensable de le voir toujours comme expression: c'est-là sa fonction primitive; et c'est par cette attribution, établie par les lois de la nature, qu'il embellit l'art dont il est le tout." De Cahusac, "Geste," 571–572.

24. Diderot, *De la poésie dramatique, Oeuvres esthétiques* (Paris, 1968) describes at length his invention of a new dramatic genre that lies "entre la comédie et la tragédie," 189–268. See also "Entretiens sur le fils naturel," in *Oeuvres esthétiques*, 119.

25. Diderot, *De la poésie dramatique*, 100.

26. "J'ai dit que la pantomime est une portion du drame: que l'auteur s'en doit occuper sérieusement; que si elle ne lui est pas familière et présente, il ne saura ni commencer, ni conduire, ni terminer sa scène avec quelque vérité;

et que le geste doit s'écrire souvent à la place du discours." Ibid., 269.

27. See Seznec and Adhémar, *Diderot. Salons*, II: 200–201; III: 83, 115, 116, 286, 325.

28. La Font de St-Yenne, *Réflexions sur quelques causes de l'état présent de la peinture en France* (The Hague, 1747).

29. For the most comprehensive discussion of the *exemplum virtutis* as a pan-European phenomenon, see R. Rosenblum, *Transformations in Late Eighteenth-Century Art* (Princeton, 1967), 50–106.

30. The first major eighteenth-century studies of Poussin were inspired by a ceremony held at the Pantheon in Rome in honor of the artist in 1782; they reflect contemporary thinking about Poussin as an artist of ideas. See N. Guibal, *Eloge de Poussin* (Paris, 1783) and J. Cambry's biography, *Essais sur la vie et les tableaux de Poussin* (Paris, 1783). For a study of the importance of Poussin's *Testament of Eudamidas* in the eighteenth century, see R. Verdi, "Poussin's *Eudamidas*: Eighteenth-Century Criticism and Copies," *The Burlington Magazine* 113 (1971): 513–524.

31. Discussed by J. Leith, *The Idea of Art as Propaganda in France, 1750–1799* (Toronto, 1965); 74–77 and Crow, *Painters and Public Life*, 154–156.

32. Seznec and Adhémar, *Diderot. Salons*, II: 61–62, 87–88.

33. "Rien de fini, ni dans les mains, ni dans les bras." Ibid., 82–83.

34. "M. Hallé, votre Trajan, imité de l'antique, est plat, sans noblesse, sans expression, sans caractère. . . . Les jambes de Trajan sont de bois, roides, comme s'il y avoit sous l'étoffe une doublure de tôle ou de fer-blanc. . . . Mais c'est le bras et la main de cet empereur qu'il faut voir; le bras pour le roide, la main et le pouce pour l'incorrection de dessin. Les peintres d'histoire traitent ces menus détails de bagatelles." Ibid., 105–106. Diderot exprimed disappointment throughout the Salons with trivial poses and gestures. A spectacular denigration can be found in his review of

Greuze's *Septimius Severus*, ibid., 105–106. Discussed in D. Johnson, "Corporality," 98–100.

35. See D. Johnson, "Corporality," 100–101.

36. *Jacques-Louis David. 1748–1825* (Paris, 1989), 105–108.

37. Seznec and Adhémar, *Diderot. Salons*, 4: 377.

38. P. Chaussard, *Le Pausanias français* (Paris, 1806), 149.

39. Seznec and Adhémar, *Diderot. Salons*, IV: 377.

40. "Votre Bélisaire a les même beautés comme expression et comme exécution; il est d'un caractère plus noble; le bras, les mains sont d'une beauté, d'une vérité au-dessus de tous les éloges." *Le pourquoi ou l'ami des artistes*, XII, *Collection Deloynes* no. 262 (Geneva, 1781).

41. For the location and placement of Puget's *Alexander and Diogenes* in the Louvre in the eighteenth century, see Archives Nationales, Paris, 01 1980–10; J. F. Blondel, *Architecture françoise* (Paris, 1756), IV: 28; L.-V. Thierry, *Guide des amateurs et des étrangers ou voyageurs à Paris* (Paris, 1787), I: 336. See also Dandré-Bardon, *Traité de peinture*, II: 54. In his autobiographical notes written for J. J. Sue in 1793 David writes how proud he is that his St. Roch will be placed next to a Puget in Marseilles. Reproduced in P. Bordes, *Le Serment du Jeu de Paume de Jacques-Louis David* (Paris, 1983), 174.

42. See P. Rosenberg and U. Van Sandt, *Pierre Peyron, 1794–1814* (Neuilly, 1983), and A. Boime, "Marmontel's *Bélisaire* and the Pre-Revolutionary Progressivism of David," *Art History* 2, no. 1 (March 1980): 81–101.

43. "En 1781 il fit pour son agrément à l'Académie de peinture, Belisarius demandant l'aumone, et ce sujet si bien rendu par le Vandick, David eut l'art de le rendre nouveau par le groupe neuf et sentimental du petit qui demande l'aumone, par la manière singulière avec laquelle il le serre l'infortuné Belisaire." Cited in Bordes, *Le Serment du Jeu de Paume*, 174.

44. See Rosenberg and Van Sandt, *Pierre Peyron*.

45. Le Brun, *Conférence*, 47–53.

46. See *Jacques-Louis David. 1748–1825*, 146–153.

47. Ibid., 146. Denon had the painting devarnished and sent to David's atelier. The artist kept the painting from late January 1804 until March 12, 1804 when he returned it to Lavallée, etc.

48. "Il y a plus de dix-huit ans que je souffre d'y voir certains défauts faciles à reparer . . . les côtes d'Hector qui sont trop sorties et qui en font plutôt le corps d'un écorché que celui d'un héros que Vénus protégeoit encore après sa mort jusqu'à lui conserver les mêmes formes qu'il avoit avant d'avoir cessé de vivre. J'ajouterai encore la demi-teinte du bras d'Hector du côté de la lumière qui est trop noire . . . enfin je veux simplement retoucher et non pas repeindre." Ecole Nationale Supérieure des Beaux-arts, Ms. 316, no.11.

49. "Le tableau des regrets d'Andromaque sur le corps d'Hector est de l'effet le plus imposant. L'Hector est effrayant, par le caractère de la mort qui est parfaitement exprimé. Le groupe d'Andromaque et du jeune Astyanax est admirable; on ne peut draper d'un plus grand style. La plus grande sévérité de dessin et vigueur de couleur est ce qui caractérise M. David. C'est le Peintre qui rend le mieux les extrémités." *La critique est aisée, mais l'art est difficile*, XIII, *Collection Deloynes*, no. 287.

50. "Le cadavre du Héros est couché horizontalement sur un lit qui ressemble un peu à une longue chaise. Ce corps a des détails très vrais. La tête et les pieds sont du plus beau rendu." *Le Véridique au Sallon*, XIII, *Collection Deloynes*, no. 298 (Paris, 1783).

51. *David e Roma* (Rome, 1981), 24–41.

52. Dandré-Bardon, *Traité de peinture*, 79–86.

53. Ibid., 82–85.

54. Ibid., 60–75.

55. See "Dessein," in *Encyclopédie, Recueil de planches*, Part 2 (Paris, 1763), 2–3.

56. Ibid.

57. See, for example, C.-A. Jombert, *Méthode pour apprendre le dessin* (Paris, 1755), 56–57.

58. "C'est une erreur de croire, que le beau caractère de Dessein consiste dans l'assemblage des traits jettés hardiment et prononcés d'un stile dur et quarré . . . La souplesse et la légèreté des contours sont les qualités principales du caractère de Dessein, parce qu'elles entrent essentiellement dans les vérités de la nature." Dandré-Bardon, *Traité de peinture*. 21–22.

59. The ideas on antique sculpture and the contour style propounded by Winckelmann in his influential *Gedanken über die Nachahmung der griechischen Werke in der Malerei und Bildhauerkunst* (Dresden, 1755), reprinted in a German-French edition, trans. Léon Mis (Paris, 1984) were discussed in L. Hautecoeur, *Rome et le Renaissance de l'antiquité à la fin du XVIIIe siècle* (Paris, 1912), 26–34, 92ff. and R. Rosenblum, *The International Style of 1800: a Study in Linear Abstraction* (New York, 1976), 55–58. See also Rosenblum, *Transformations*, 163–164. A. L. Millin, in his *Dictionnaire des beauxarts* (Paris, 1806), 429, defined the *dessin au trait* as "celui qui est tracé seulement au crayon ou à la plume, sans aucun lavis et sans ombre."

60. See A. Clark, *Pompeo Batoni: A Complete Catalogue of His Works* (New York, 1985).

61. Hautecoeur, *Rome et la Renaissance de l'antiquité*, 26–34.

62. Ibid., and Rosenblum, *Transformations*, 163.

63. Recent catalogues of French neoclassical drawings reveal the great variety of experiments in the contour style during the 1770s. See especially the drawings by David's teacher Vien, as well as those of Vincent and Peyron, in *Le Néo-Classicisme français* (Paris, 1974) and *Autour de David* (Lille, 1983).

64. Rosenblum, *The International Style of 1800*, 55–58.

65. Winckelmann, *Gedanken*.

66. Discussed in J. Seznec, *Essai sur Diderot et l'Antiquité* (Oxford, 1957), 103–105.

67. Seznec and Adhémar, *Diderot. Salons*, 3: 57.

68. Diderot edited Hemsterhuis. See F. Hemsterhuis, *Lettre sur l'homme et ses rapports avec le commentaire inédit de Diderot*, ed. Georges May (New Haven, 1964).

69. Hemsterhuis, "Lettre sur la sculpture," in *Oeuvres philosophiques*, vol. I (Paris, 1809).

70. "Il s'ensuit que l'artiste pourra parvenir au beau par deux chemins différents; par la finesse et la facilité de contour, il peut me donner dans une seconde de temps, par exemple, l'idée de la beauté, mais en repose, comme dans la Vénus de Médicis ou dans votre Galatée: mais si, avec un contour également délié et facile, il exprimoit une Andromède avec sa crainte et ses espérances visibles sur *tous les membres* [my italics], il me donneroit, dans la même seconde, non seulement l'idée de la beauté, mais encore l'idée du danger d'Andromède." Ibid., 24–25.

71. *David e Roma*, 64. A. Lenoir, "Mémoires. David, Souvenirs historiques," *Journal de l'Institut Historique* 3 (Paris, 1835): 3. In his study of David in the *Pausanias français* (Paris, 1806), 148, Chaussard also refers to David's "conversion" in Rome based largely on his study of anatomy—he refers explicitly to Houdon's écorché.

72. "L'étude de l'écorché a sans doute ses avantages; mais n'est-il pas à craindre que cet écorché ne reste perpétuellement dans l'imagination; que l'artiste n'en devienne entêté de la vanité de se montrer savant; que son oeil corrompu ne puisse plus s'arrêter à la superficie; qu'en dépit de la peau et des graisses, il n'entrevoie toujours le muscle, son origine, son attache et son insertion; qu'il ne prononce tout trop fortement; qu'il ne soit dur et sec; et que je ne retrouve ce maudit écorché, même dans ses figures de femmes? Puisque je n'ai que l'extérieur à montrer, j'aimerais bien autant qu'on m'accoutumât à le bien voir, et qu'on me dispensât d'une connaissance perfide, qu'il faut que j'oublie.

On n'étudie l'écorché, dit-on, que pour apprendre à regarder la nature; mais il est d'expérience qu'après cette étude, on a beaucoup de peine à ne pas la voir autrement qu'elle est." Diderot, *Oeuvres complètes de Diderot* (Paris, 1876), 10: 463–64.

73. See Dandré-Bardon, *Traité de peinture*, 4, and "Dessein," *Encyclopédie, Recueil de planches*, Part 2, 3. For a detailed discussion of the serious lapse in the teaching of anatomy at the Academy between 1740 and 1780 (during this time courses were rarely given and when given were considered completely inadequate), see J. Locquin, *La Peinture d'histoire en France de 1747 à 1785* (Paris, 1912), 82–86. Locquin describes periodic failed attempts to reinstitute interest in the teaching of anatomy at the Academy, including the Comte de Caylus' *Prix d'ostéologie* of 1764 and la Tour's abortive *Prix d'anatomie* of 1776. The écorché attributed to Bouchardon was well-known and Houdon's écorché became famous but the impact of these sculpted flayed figures on the teaching and making of art at the Academy is difficult to assess during the 1760s and 70s. Numerous illustrated treatises on anatomy such as those of Bouchardon, *Anatomie nécessaire pour l'usage du dessin* (Paris, 1741), J. Sue, *Abrégé de l'anatomie du corps de l'homme* (Paris, 1748) and *Traité d'ostéologie* (Paris, 1759); Gautier-Dagoty and Jadelot, *Cours complet d'anatomie peint et gravé en couleurs naturelles* (Paris, 1773), C. Monnet, *Etudes d'anatomie à l'usage des peintres* (Paris, 1770), and J. Gamelin's *Nouveau recueil d'ostéologie et de myologie* (Toulouse, 1779) had, perhaps, a limited impact during the period of David's artistic training because students were taught to focus on studies after sculpture and the live model. This would change dramatically in the late 1780s, 1790s, and the early nineteenth century when the study of anatomy would be privileged. J. J. Sue, for example, taught anatomy to art students at the Institut circa 1800. A note preserved at the Archives Nationales, AJ⁵², records his invitation to students to arrive two hours before anatomy class in order to draw.

74. *David e Roma*, 22–23, 66–67, 47, 50.

75. Hautecoeur, *Louis David*, 43–46.

76. "Crois-tu que le dessin gît dans quelques hachures, plus ou moins bien faites? Le dessin est tout dans le trait, met dedans tout ce que tu voudras." Miette de Villars, *Mémoires de David, Peintre et Député de la Convention* (Paris, 1850), 67–68.

77. See my doctoral dissertation, "The Eloquent Body: Jacques-Louis David and the Formation of a Gestural Aesthetic" (University of California, Berkeley, 1987).

78. *David e Roma*, 42–70.

79. "Le trait, . . . renvoie toujours à une force, à une direction; c'est un *energon*, un travail, qui donne à lire la trace de sa pulsion et de sa dépense. Le trait est une action visible." Roland Barthes, *L'obvie et l'obtus, Essais critiques*, II (Paris, 1982), 156–157.

80. "Je fais et refaisais sans cesse, partant d'un point qui était la trivialité et épurant mes traits jusqu'à ce qu'enfin mes contours eussent à peu près la grandeur, la pureté, la finesse et la grâce que je trouvais dans les belles figures antiques et que j'admirais dans l'auteur des Stanze, des Loges." Manuscripts of Delafontaine, Bibliothèque de l'Institut, 3782–3784. Cited in Hautecoeur, *Louis David*, 49.

81. The valuation of Raphael in late eighteenth-century France is analyzed at length by M. Rosenberg, "Raphael in French Art, Theory, Criticism and Practice 1660–1830" (Ph.D. diss., University of Pennsylvania, 1979).

82. In his next academy envoi, probably St. Jerome of 1779, David returned to a stereotypical use of the expressive head, which again reveals his vacillation in style. Illustrated in *Jacques-Louis David. 1748–1825*, fig. 36.

83. This drawing was studied by Jacques de Caso, "Jacques-Louis David and the Style All'Antica," *The Burlington Magazine* 114 (1972): 686–690 and S. Howard, *Sacrifice of the Hero: the Roman Years. A Classical Frieze by Jacques-Louis David* (Sacramento, 1975).

84. Howard, *Sacrifice of the Hero*, 69–70.

85. Ibid.

86. De Caso, "Jacques-Louis David," 689.

87. Diderot, *Oeuvres complètes de Diderot*, 11: 73.

88. Ibid.

89. Seznec and Adhémar, *Diderot. Salons*, II: 61–62.

90. Seznec, *Essai*, 60–62.; Caylus, *Tableaux tirés de l'Iliade, de l'Odyssée d'Homère et de l'Enéide de Virgile* (Paris, 1757).

91. See W. Hofmann, "Un dessin inconnu de la première époque de J.-L. David," *Gazette des Beaux-Arts* (March 1958): 156–168.

92. See Seznec, *Essai*, 45–48.

93. See D. and G. Wildenstein, *Documents complémentaires au catalogue de l'oeuvre de Louis David* (Paris, 1973), 18–22 and Hautecoeur, *Louis David*, 75–79. For a detailed interpretation of the social and political nexus in *The Oath* see T. Crow, "The Oath of the Horatii in 1785: Painting and Pre-Revolutionary Radicalism in France," *Art History* 1 (1978): 424–471.

94. Rosenblum, *Transformations*, 68–74.

95. Discussed in *Jacques-Louis David. 1748–1825*, 146–151.

96. *Correspondance de M. Mesmer sur les nouvelles découvertes du Baquet Octagone, de l'homme-baquet, et du Baquet-Moral* (Libourne and Paris, 1785); Mesmer, *Mémoire sur la découverte du magnétisme animal* (Paris, 1779), 22–23, 74–76 and *Aphorismes de M. Mesmer dictés à l'assemblée de ses élèves et dans lesquels on trouve ses principes, sa théorie et les moyens de magnétiser* (Paris, 1785).

97. Mesmer, *Mémoire*.

98. See, in particular, his letters to Gros from Brussels, dated May 13, 1817 and December 27, 1819, Ecole Nationale Supérieure des Beaux-Arts, Ms. 316, nos. 22 and 38.

99. See R. Darnton, *Mesmerism and the End of the Enlightenment in France* (Cambridge, Mass., 1968). A reliable early source is J. P. F. Deleuze, *Histoire critique du magnétisme animal*, 2nd ed. (Paris, 1819).

100. Rosenblum discusses famous oath-taking scenes of the period in *Transformations*, 69–70 and "A Source for David's *Horatii*," *The Burlington Magazine* (May 1970): 269–273.

101. "Le groupe des trois Horaces est d'un style imposant et d'un mouvement terrible par les trois bras qui se dirigent tous vers le même objet, LES ARMES." *Observations sur le Sallon de 1785, extraites du Journal Général de France*, XIV, *Collection Deloynes*, no. 339, 4–5.

102. "Je conviendrai que c'est une grande conception, et qu'elle est exécutée aussi hardiment que facilement, et je m'extasierai avec vous sur l'action des Horaces, qui se tiennent embrassés pendant leur Serment, expression sublime et symbolique de leur union, de la sainte et forte amitié qui les lient, et de l'objet commun qui rapproche et enchaîne l'un à l'autre jusqu'à la mort ces trois frères guerriers." *Avis important d'une femme sur le Sallon de 1785 par Madame E.A.R.T.L.A.D.C.S.* XIV, *Collection Deloynes*, (Paris, 1785), no. 344, 31.

103. "Aristarque me fit observer avec combien d'âme M. David avoit rendu l'empressement des trois frères, à jurer qu'ils alloient vaincre ou mourir pour la patrie, et le sentiment profond de joie, dont le vieil Horace étoit pénétré en voyant qu'il avoit des fils si dignes de lui, sentiment indiqué avec tant d'énergie dans ses traits, dans ses yeux, dans son attitude, et surtout dans cette expression simple, qui peut-être auroit échappé à tout autre que M. David, celle de presser dans sa main avec émotion les épées dont il alloit armer ses fils." *Promenade du Critès au Sallon de l'année 1785* XIV, *Collection Deloynes*, (Paris, 1785), no. 335, 36. Crow identified the author as Gorsas. *Painters and Public Life*, 215.

104. "Si l'on destine une Palme au Tableau d'histoire le plus vigoureux, on la doit à M. David. Ses Horaces sont les enfants créés du Génie. Ce Tableau a la noblesse, la simplicité, le dessin, la netteté, l'énergie, la vérité des plus grands Artistes . . . Les personnages sont hors de la toile. On voit presque circuler le sang dans leurs veines." *Minos au Sallon ou la gazette infernale par M.L. B.D.B.* XIV, *Collection Deloynes*, (Paris, 1785), no. 345, 22–23.

105. "Il faut absolument le voir pour savoir jusqu'à quel point il mérite d'être admiré . . . Une composition pleine d'énergie, soutenue d'une expression forte et terrible, qui contraste supérieurement avec l'accablement qui règne dans le groupe des femmes. Enfin si je juge de la sensation des autres par la mienne, on éprouve en voyant ce tableau un sentiment qui vous élève l'âme et qui pour me servir de l'expression de J.-J. Rousseau a quelque chose *de poignant* qui vous attire." *Journal de Paris* (Sept. 17, 1785): 519. Grimm provides a summary and assessment of the critical response to

The Oath in *Correspondance littéraire*, XIV: 288–291.

106. For a summary of this criticism see G. Vigarello, *Le corps redressé. Histoire d'un pouvoir pédagogique* (Paris, 1978), 93ff.

107. "Le corps d'un homme bien fait doit être carré, les muscles doivent être durement exprimés, le contour des membres fortement dessinés, les traits du visage bien marqués." George-Louis Leclerc, Comte de Buffon, *Histoire naturelle générale et particulière*, II (Paris, 1749), 518.

108. "Tout annonce dans tous deux les maîtres de la terre; tout marque dans l'homme, même à l'extérieur, sa supériorité sur tous les êtres vivants: il se soutient droit et élevé; son attitude est celle du commandement; sa tête regarde le ciel, et présente une face auguste sur laquelle est imprimé le caractère de sa dignité; l'image de l'âme y est peinte par la physionomie; l'excellence de sa nature perce à travers les organes matériels; et anime d'un feu divin les traits de son visage; son port majestueux, sa démarche ferme et hardie, annoncent sa noblesse et son rang; il ne touche à la terre que par ses extrémités les plus éloignées; il ne la voit que de loin, et semble la dédaigner. Les bras ne lui sont pas donnés pour servir de piliers d'appui à la masse de son corps; sa main ne doit pas fouler la terre, et perdre par des frottements réitérés la finesse de toucher dont elle est le principal organe; le bras et la main sont faits pour servir à des usages plus nobles, pour exécuter les ordres de la volonté, pour saisir les choses éloignées, pour écarter les obstacles, pour prévenir les rencontres et le choc de ce qui pourroit nuire, pour embrasser et retenir ce qui peut plaire, pour le mettre à la portée des autres sens." Ibid., 518–19.

109. For the French reception of and resistance to Winckelmann, see E. Pommier, *L'Art de la Liberté. Doctrines et débats de la Révolution française* (Paris, 1991), 59–76, 331–361. For a recent discussion of Winckelmann's influence in France during the Revolutionary period see A. Potts, "Beautiful Bodies and Dying Heroes: Images of Ideal Manhood in the French Revolution," *History Workshop* (Autumn 1990): 1–21.

110. "Notre corps languit, s'affaibloit et perd les belles proportions reçues de la nature." Vandermonde, *Essai sur la manière de perfectionner l'espèce humaine* (Paris, 1761), II: vi.

111. "L'espèce humaine dégénère insensiblement en Europe." J. H. Ballexserd, *Dissertation sur l'éducation physique des enfants* (Paris, 1762), 25.

112. J. Verdier, *Cours d'éducation . . .* (Paris, 1772), 9–12.

113. Ibid., and A. Riballier, *L'éducation physique et morale des enfants des deux sexes* (Paris, 1785).

114. See Vigarello, *Le corps redressé*, 90–94.

115. "Si l'on compare la force des anciens chevaliers français à celle des héritiers de leur nom, si l'on pèse les armures qu'ils portaient dans les combats, et que leurs descendants pourraient à peine soulever, on est tenté de croire que l'espèce humaine a dégénéré en France, au moins dans la classe des gens de qualité et cette présomption ne sera pas sans quelque vraisemblance si l'on considère qu'une suite de générations d'hommes amollis par l'oisiveté doit donner des hommes moins forts que n'étaient leurs aïeux: Heureusement rien n'annonce cette dégradation dans la force des gens du peuple." A. de Montyon, *Recherches et considérations sur la population de la France* (Paris, 1778), 122.

116. T. Crow had offered other types of evidence in order to demonstrate this point in "The *Oath of the Horatii* in 1785."

117. A drawing of Socrates signed and dated 1782 recently came to light and was published in *Jacques-Louis David. 1748–1825*, 179, fig. 76.

118. See *Observations critiques du Sallon de l'année 1787* (Paris, 1787), 15–17 and *L'Ami des Artistes au Sallon*, par M.l'A.R. (Paris, 1787), 36–38.

119. David wrote in a letter to Wicar of June 14, 1789 that he had just completed "un tableau de ma propre invention. C'est Brutus, homme et père, qui s'est privé de ses enfants,"

Ecole Nationale Supérieure des Beaux-Arts, Ms. 316, no. 3.

120. See *Supplément aux Remarques sur les ouvrages exposés au Salon par le C. de M.M. XVI*, *Collection Deloynes*, (Paris, 1789), no. 4; Grimm, "Suite de Salon de 1789," in *Correspondance Littéraire*, XV: 535ff.; *Affiches* 260 (Sept. 17, 1789): 2657; *Année Littéraire* 6 (1789): 29ff., *Collection Deloynes*, XVI, no. 422. In a letter to Wicar dated September 17, 1789 David wrote "On loue principalement la pensée de l'avoir mis dans l'ombre." Published in *Nouvelles Archives de l'Art Français* (Paris, 1874–75), 401–2. Chaussard hailed David's placement of Brutus in metaphorical darkness in the *Pausanias français* (Paris, 1806), 158–59.

121. Remarkably, almost every critical review of the Salons from 1785 to about 1820 is filled with descriptions of pose and gesture. It could be said that looking at painting was completely dominated by an interest in corporal signs for more than thirty years after the exhibition of *The Oath*.

122. "Le geste, considéré comme un des moyens de l'expression, doit être reconnu en même temps comme étant le plus puissant de tous. Il est facile de le prouver. Ni la physionomie qui réside dans les traits du visage, ni les couleurs, ni le clair-obscur, ni les attributs, ni le site, etc. ne peuvent produire cette grande puissance et cette force émouvante, qui est le résultat de la seule pantomime." Paillot de Montabert, *Théorie du geste dans l'art de la peinture renfermant plusieurs préceptes applicables à l'art du théâtre* (Paris, 1813).

123. Paillot de Montabert, *Traité complet de la peinture*, 9 vols. (Paris, 1829).

CHAPTER II

1. See J. de Caso, *David d'Angers. Sculptural Communication in the Age of Romanticism* (Princeton, 1992), 119–123.

2. As late as 1854 he hailed David's *Oath of the Tennis Court* as a "sublime prologue de la Révolution." See David d'Angers, *Carnets de David d'Angers*, ed. A. Bruel (Paris, 1958), II: 443.

3. In accord with interests in David scholarship of the past 5–10 years, a large number of the papers given at the colloquium, "David contre David," Paris, 1989, were devoted to David's compositions of the Revolutionary period. See *David contre David*, ed. R. Michel (Paris, forthcoming).

4. Discussed by P. Bordes, *'Le Serment de Jeu du Paume' de Jacques-Louis David: le peintre, son milieu et son temps de 1789 à 1792* (Paris, 1983), 17–25.

5. See D. Dowd, *Pageant-Master of the Republic: Jacques-Louis David and the Revolution* (Lincoln, 1948); D. and G. Wildenstein, *Documents complémentaires au catalogue de l'oeuvre de Louis David* (Paris, 1973), 27–140; L. Hautecoeur, *Louis David* (Paris, 1954), 149–162. See also J. J. Guiffrey, "Louis David, pièces diverses sur le rôle de cet artiste pendant la Révolution," *Nouvelles archives de l'art français* (Paris, 1872): 414–428.

6. D. and G. Wildenstein, *Documents complémentaires*, 56–58; Dowd, *Pageant Master of the Republic*, 30–34; *Jacques-Louis David 1748–1825*, 214–217.

7. Wildenstein, *Document complémentaires*, 92–96; *Jacques-Louis David 1748–1825*, 217–218; Guiffrey, "Louis David."

8. Dowd, *Pageant Master of the Republic*. See also M. Ozouf, *La fête révolutionnaire. 1789–1799* (Paris, 1976).

9. Dowd, *Pageant Master of the Republic*, 107–108.

10. Bordes, *Le Serment du Jeu de Paume*, 53–54.

11. Ibid., 107.

12. Wildenstein, *Documents complémentaires*, 27–112.

13. "Je désire que ma proposition de frapper les médailles ait lieu pour tous les événements glorieux ou heureux déjà arrivés et qui arriveront à la République, et cela à l'imitation des Grecs et Romains qui, par leurs suites métalliques, nous ont non seulement donné la connaissance des événements remarquables,

celle des grands hommes, mais aussi celle du progrès de leurs arts." *Procès-verbale de la Convention*, II: 223, cited in Wildenstein, *Documents complémentaires*, no. 382, 44–45.

14. R. Michel and P. Bordes, *Aux Armes et aux Arts! Les Arts de la Révolution 1789–1799* (Paris, 1989); *French Caricature and the French Revolution, 1789–1799* (Los Angeles, 1988).

15. Bordes, *Le Serment du Jeu de Paume*, 25, 137–147.

16. See J. Colton, *The Parnasse François, Titon du Tillet and the Origins of the Monument to Genius* (New Haven and London, 1979); F. Dowley, "D'Angiviller's *Grands Hommes* and the Significant Moment," *The Art Bulletin* 39 (1957): 159–277; M. Ozouf, "Le Panthéon," in *Les Lieux de la Mémoire*, vol. I (Paris, 1984), 139–166; R. Etlin, *The Architecture of Death, the Transformation of the Cemetary in Eighteenth-Century Paris* (Cambridge, Mass. and London, 1984); Chaisneau, *Le Panthéon français; ou Discours sur les honneurs publics décernés par la Nation à la mémoire des Grands hommes* (Dijon, 1792). For a recent discussion of the development of Quatremère de Quincy's ideas for the iconography and program of the Pantheon see E. Pommier, *L'Art de la liberté. Doctrines et débats de la Révolution française* (Paris, 1991), 168–174.

17. Bordes, *Le Serment du Jeu de Paume*, 33ff. See also W. Olander, "Pour transmettre à la postérité: French Painting and Revolution 1774–1795" (Ph.D. diss., Institute of Fine Arts, 1983).

18. Bordes, *Le Serment du Jeu de Paume*, 137–147.

19. Discussed in R. Etlin, *The Architecture of Death*, 214–216.

20. Dowley, "D'Angivillers' *Grands Hommes*."

21. Chaisneau, *Le Panthéon*; Ozouf, "Le Panthéon," Pommier, *L'Art de la Liberté*, 168–174.

22. See Colton, *The Parnasse François*, 88–191 and 203 ff.

23. For David's statements on the "grands hommes" see Wildenstein, *Documents complémentaires*, 116–117, 220, 221.

24. "On définit un *héros*, un homme ferme contre les difficultés, intrépide dans le péril et très vaillant dans les combats; qualités qui tiennent plus du tempérament & d'une certaine conformation des organes, que de la noblesse de l'âme. Le grand homme est bien autre chose; il joint aux talens & au génie la plupart des vertus morales; il n'a dans sa conduite que de beaux et nobles motifs. . . . Le titre de *héros* dépend du succès, celui de grand homme n'en dépend pas toujours. Son principe est la vertu, qui est inébranlable dans la prospérité, comme dans les malheurs.

Enfin, l'humanité, la douceur, le patriotisme réunis aux talens, sont les vertus d'un grand homme; la bravoure, le courage, souvent la témérité, la connoissance de l'art de la guerre, et le génie militaire, caractérisent davantage le *héros*." "Héros," in *Encyclopédie ou dictionnaire raisonné des sciences, des arts et des métiers, par une société des gens de lettres*, ed. Diderot and d'Alembert (Neufchastel, 1760), 8:182.

25. "La plupart auroient pour sujet des traits d'histoire propres à ranimer la vertu et les sentiments patriotiques." See *Procès-verbaux de l'Académie royale de peinture et de sculpture, 1684–1793* (Paris, 1888), VII: 169, 176–178.

26. "Mon dessein étoit aussi de charger quatre sculpteurs de l'Académie d'exécuter chacun pour sa Majesté une figure de marbre, représentant quelque homme célèbre dans la nation par ses vertus, ses talens ou son génie." See Furcy-Raynard, "Correspondance du Comte d'Angiviller avec Pierre," *Nouvelles Archives de l'art français* 21 (1905): 80–81.

27. "La *Sculpture*, dit-il [Falconet], ainsi que l'Histoire, est le dépôt le plus durable des vertus des hommes & de leurs foiblesses. Si nous avons dans la statue de Vénus l'objet d'un culte dissolu, nous avons dans celle de Marc-Aurèle un monument célèbre des hommages rendus à un bienfaiteur de l'humanité.

Cet art, en nous montrant les vices déifiés, rend encore plus frappantes les horreurs que nous transmet l'Histoire; pendant que d'un autre côté les traits précieux qui nous restent de ces hommes rares, qui auroient dû vivre autant que leurs statues, réaniment en nous ce sentiment d'une noble émulation, qui porte l'âme

aux vertus qui les ont préservés de l'oubli. . . .
Le but le plus digne de la *Sculpture*, en l'envisageant du côté moral, est donc de perpétuer la mémoire des hommes illustres & de donner des modèles de vertu d'autant plus efficaces, que ceux qui les pratiquoient ne peuvent plus être les objets de l'envie." "Sculpture," *Encyclopédie*, 14:834.

28. Bordes, *Le Serment du Jeu de Paume*, 13–15. One of the most startling recent analyses of the composition has been offered by A. Boime who perceives in it secret Masonic meanings. See *David contre David*, ed. R. Michel (Paris, forthcoming).

29. I would like to thank Jacques de Caso for calling this to my attention.

30. De Caso, *David d'Angers*, 120–122, fig. 84.

31. Ibid., 3–30.

32. Bordes, *Le Serment du Jeu de Paume*, 55–67.

33. M. D . . . , *Explication et critique impartiale de toutes les Peintures, Sculptures, Gravures, Dessins, etc. exposés au Louvre { . . . }, au mois de septembre, 1791* (Paris, 1791), 20–21.

34. "On croit assister et prendre part à cette scène immortelle qui a préparé le triomphe de la liberté française." *Supplément au Journal de Paris* (June 10, 1791), 1. Published in Bordes, *Le Serment du Jeu de Paume*, 163.

35. "Français, accourez, volez, quittez tout, précipitez-vous pour assister au serment du jeu de paume, et si vous n'êtes pas brûlés, consumés de feu patriotique à ce foyer ardent, assurez-vous bien que vous n'êtes pas dignes de la liberté.

Mais déjà la presse est grande, et n'approche pas qui veut; il faut attendre son tour pour avoir l'honneur de participer à la prestation de ce serment." Ange-Marie Pithou, *Le plaisir prolongé. Le retour du Salon chez soi et celui de l'Abeille dans sa ruche*, XVII, 28–30, *Collection Deloynes*, no. 437. Published in Bordes, *Le Serment du Jeu de Paume*, 72.

36. Bordes, *Le Serment du Jeu de Paume*, 17–26, 62.

37. Ibid., 77–83, 167–173.

38. "O ma patrie! O ma chère patrie! nous ne serons donc plus obligés d'aller chercher dans l'histoire des peuples anciens, de quoi exercer nos pinceaux. Les sujets manquaient aux artistes, obligés de se répéter, et maintenant les artistes manqueraient aux sujets. Non, l'histoire d'aucun peuple ne m'offre rien de si grand, de si sublime que ce serment du Jeu de Paume, que je dois peindre. Non, je n'aurai pas besoin d'invoquer les dieux de la fable pour échauffer mon génie. Nation française! C'est ta gloire que je veux propager. Peuples de l'univers, présents et futurs, c'est une grande leçon que je veux vous donner. Sainte humanité, je veux rappeler tes droits, par un exemple unique dans les fastes de l'histoire. O! malheur à l'artiste dont l'âme ne serait pas échauffée, embrasée par de si puissants motifs!" *Archives parlementaires de 1787 à 1860*, ed. J. Marival, E. Laurent, et al. (Paris, 1862–), 38:247–248. Cited in Bordes, *Le Serment du Jeu de Paume*, 165.

39. Olander, "Pour transmettre à la postérité," 6, 22–31.

40. Ibid., 67–68 and Bordes, *Le Serment du Jeu de Paume*, 24–25, 37–38.

41. L. Gossman, *Between History and Literature* (Cambridge, Mass. and London, 1990), 237–241.

42. Ibid.

43. Marmontel, "Histoire," in *Elémens de littérature. Oeuvres complètes de Marmontel*, ed. J.-F. Marmontel (Paris, 1787), vols. 5–10, cited in Gossman, *Between History and Literature*, 138–139.

44. Bordes, *Le Serment du Jeu de Paume*, 13–15.

45. Ibid.

46. "Nous jurons de ne jamais nous séparer de l'assemblée nationale, et de nous réunir partout où les circonstances l'exigeront, jusqu'à ce que la constitution du royaume soit établie et affermie sur des fondements solides." Ibid.

47. The dynamic gathering also contains figures who are not representatives of the Third Estate—several turn away from Bailly and look disgruntled and bitter. Bordes has suggested that they may be royalist spies, ibid., 40.

48. G. Harnois, *Les Théories du langage en France de 1660 à 1821* (Paris, 1929); H. B. Acton, "The Philosophy of Language in Revolutionary France," *Proceedings of the British Academy* 14 (1959): 199–219; C. Blum, *Rousseau and the Republic of Virtue: the Language of Politics in the French Revolution* (Ithaca, N.Y., 1986).

49. See *Supplément au Journal de Paris*, 1 and M. D. . . ., *Explication*. See also *Nouvelle critique impartiale des Tableaux du Salon par une société d'artistes* 1 (Paris, 1791), 7–8. Cited in Bordes, *Le Serment du Jeu de Paume*, 73.

50. Bordes discusses the genesis and development of the monumental painting that was never completed, including David's renouncement in 1801; he also examines briefly the history of the engraved versions. Ibid., 48–54, 85–90.

51. J. Starobinski, in his brilliant study, *Jean-Jacques Rousseau. Transparency and Obstruction*, trans. A. Goldhammer (Chicago and London, 1988), discussed these issues in Rousseau in detail. See 304–314.

52. David proclaims this in a letter from prison addressed to the "representatives of the people" dated 27 brumaire an III; a draft is preserved in the Ecole Nationale Supérieure des Beaux-Arts, Ms. 316, no. 6. See also his letter to M. de Mainbourg published in Wildenstein, *Documents complémentaires*, 116, no. 1145. The original is preserved in the Bibliothèque Nationale, Ms. 6605, piece 328.

53. "jamais plus beau sujet ne s'est trouvé dans l'histoire des peuples qui nous ont devancé." See Ecole Nationale Supérieure des Beaux-Arts, Ms. 316, no.9; cited in Bordes, *Le Serment du Jeu de Paume*, 177–178.

54. Pommier, *L'Art de la liberté*, 172. See Quatremère de Quincy, *Rapport fait au Directeur du Département de Paris, le 13 novembre, 1792, l'an premier de la République française, sur l'état actuel du Panthéon français . . .* (Paris, n.d.), 17, 26; *Rapport fait au Directeur du Département de Paris, sur les travaux entrepris, continués ou achevés au Panthéon français . . .* (n.d.), 67, 69.

55. Dowley, "D'Angiviller's *Grands Hommes*," 260ff.

56. See J. Colton, "From Voltaire to Buffon: Further Observations on Nudity, Heroic and Otherwise," *Art the Ape of Nature: Studies in Honor of H. W. Janson* (New York, 1981), 531–48, and D. Goodman, "Pigalle's *Voltaire nu*: the Republic of Letters Represents Itself to the World," *Representations* 16 (fall 1986): 86–109.

57. Discussed in Dowley, "D'Angiviller's *Grands Hommes*," 270–275.

58. "Portrait," *Encyclopédie*, 13:153–56.

59. The manuscript list of David's paintings written by the artist is published in Wildenstein, *Documents complémentaires*, no. 1938, 226–227.

60. "Héros, autrement dit *demi-dieu*. On appelloit ainsi généralement les hommes illustres, que leurs grandes actions firent placer dans le ciel après leur mort. . . . La promotion des *héros* au rang des dieux, étoit due aux dogmes de la philosophie platonique, qui enseignoit que les âmes des grands hommes s'élevoient jusqu'aux astres, séjour ordinaire des dieux, par-là devenoient dignes des honneurs qu'on rendoit aux dieux mêmes, avec lesquels ils habitoient." "Héros," in *Encyclopédie*, 8:182.

61. *Jacques-Louis David 1748–1825*, 288–289.

62. Ibid., 219–22. For a recent discussion of the political circumstances of the event and its impact on the image see R. Simon, "David's Martyr Portrait of LePeletier de St. Fargeau and the Conundrums of Representation," *Art History* 14, no. 4 (December 1991): 459–485. See also D. Hunter, "Swordplay: Jacques-Louis David's Painting of 'Le Peletier de St. Fargeau on his Deathbed,'" in *Representing the French Revolution: Literature, Historiography, Art*, ed. J.A.W. Heffernan (Hanover and London, 1992), 169–191.

63. The Convention's decree to engrave the *Lepelletier* is published in Wildenstein, *Documents complémentaires*, no. 427, 50.

64. Simon, "David's Martyr Portrait," 463; Wildenstein, *Documents complémentaires*, no. 427, 50 and no. 409, 48. See *Ordre de la Marche et des cérémonies qui seront observés aux Funérailles*

de Michel le Pelletier, député à la Convention Na-tionale, à qui l'Assemblée accorde les honneurs du Panthéon français (Paris, 1793).

65. J. McManners, *Death and the Enlighten-ment* (Oxford, New York, 1981).

66. Rosenblum, *Transformations*, 50–106.

67. Simon, "David's Martyr Portrait," 463ff.

68. "Je suis satisfait de verser mon sang pour la patrie. J'espère qu'il servira à consolider la liberté et l'égalité, et à faire reconnaître ses en-nemis." *Jacques-Louis David 1748–1825*, 219–21.

69. "Il semblait qu'il n'était pas mort. On voyait sa plaie qui était large de trois doigts, cela faisait un spectacle attendrissant et qui fit pleurer bien du monde et je ne pus retenir les miennes.

On n'a jamais porté ainsi à découvert un homme mort en public. C'est un spectacle nou-veau. C'est un enterrement d'un nouveau genre." *Journal de Célestin Guittard de Floriban, Bourgeois de Paris sous la Révolution, 1791–96*, ed. R. Aubert (Paris, 1974), 220.

70. Wildenstein, *Documents complémentaires*, no. 409, 48.

71. Ibid., no. 427, 50.

72. "J'aurais rempli ma tâche si je fais dire un jour au vieux père, entouré de sa nombreuse famille: Venez, mes enfants, venez voir celui de vos représentants qui, le premier, est mort pour vous donner la liberté: voyez ses traits comme ils sont sereins; c'est que quand on meurt pour son pays, on n'a rien à se reprocher. Voyez-vous cette épée qui est suspendue sur sa tête, et qui n'est détenue que par un cheveu? eh bien, mes enfants, cela veut dire quel courage il a fallu à Michel Lepelletier, ainsi qu'à ses généreux col-lègues, pour envoyer au supplice l'infâme tyran qui nous opprimoit depuis si longtemps, puisqu'au moindre mouvement, ce cheveu ro-mpu, ils étaient tous inhumainement im-molés." Archives Nationales, C.248, no. 332, cited in Wildenstein, *Documents complémentaires* 50, no. 427.

73. "Une espèce de crypte funèbre où ils furent admirés pendant six semaines." "Exposi-tion dans la cour du vieux Louvre des tableaux de Lepelletier et de Marat," Coll. Deloynes, vol. LIV, no. 1584.

74. See most recently, M. Bleyl, *Das Klassizistische Porträt, Gestaltungsanalyse am Beispiel J.-L. Davids, Bochumer Schriften zur Kunstgeschichte*, vol. 1 (Frankfurt and Berne, 1982), 147–148, 152–158; J. Traeger, *Der Tod des Marat. Revolution des Menschenbildes* (Munich, 1986); K. Herding, "Davids *Marat* als dernier appel à l'unité révolutionnaire," *Idea. Jahrbuch des Hamburger Kunsthalle* 2 (1983): 89–112. See also Herding's essay in *David contre David*, ed. R. Michel (Paris, forth-coming) as well as those by N. Bryson and J. Traeger.

75. Archives Nationales, C 262, no. 578. Cited in Wildenstein, *Documents complémen-taires*, no. 462, 55.

76. "La veille de la mort de Marat, la société des Jacobins nous envoya, Maure et moi, nous informer de ses nouvelles. Je le trouvai dans une attitude qui me frappa. Il avait auprès de lui un billot de bois sur lequel étaient placés de l'encre et du papier, et sa main, sortie de la baignoire, écrivait ses dernières pensées pour le salut du peuple. Hier, le chirurgien qui a em-baumé son corps m'a envoyé demander de quelle manière nous l'exposerions aux regards du peuple dans l'église des Cordeliers. On ne peut point découvrir quelques parties de son corps, car vous savez qu'il avait une lèpre et que son sang était brûlé. Mais j'ai pensé qu'il serait intéressant de l'offrir dans l'attitude où je l'ai trouvé, écrivant pour le bonheur du peuple." *Procès-verbale de la Convention*, XVI: 183, cited in Wildenstein, *Documents complémentaires*, 55, no. 463.

77. "Il sera inhumé aujourd'hui à cinq heures du soir, sous les arbres où il se plaisait à instruire ses concitoyens. La sépulture aura la simplicité convenable à un républicain incor-ruptible, mort dans une honorable indigence. C'est au fond d'un souterrain qu'il désignait au peuple ses amis et ses ennemis: que mort il y retourne et que sa vie serve d'exemple. Caton, Aristide, Socrate, Timoléon, Fabricius et Pho-

cion, vous dont j'admire la respectable vie, je n'ai pas vécu avec vous, j'ai connu Marat, je l'ai admiré comme vous, la postérité lui rendra justice." *Procès-verbale de la Convention*, XVI: 206, cited in Wildenstein, *Documents complémentaires*, 55, no. 466.

78. Guirault asked David to paint Marat on July 14, 1793. See Archives Nationales, C. 262, no. 578, cited in Wildenstein, *Documents complémentaires*, 55, no. 462. "Accourez tous! la mère, la veuve, l'orphelin, le soldat opprimé, vous tous qu'il a défendu au péril de sa vie, approchez! et contemplez votre ami, celui qui veilloit n'est plus; sa plume, la terreur des traîtres, sa plume échappe de ses mains. Ô désespoir! notre infatigable est mort. . . . il est mort, sans même avoir de quoi se faire enterrer. Postérité, tu le vengeras; tu diras à nos neveux combien il eût pu posséder de richesses, s'il n'eût préféré la vertu à la fortune. Humanité, tu diras à ceux qui l'appeloient buveur de sang que jamais ton enfant chéri, que jamais Marat, ne t'a fait verser de larmes." J. Guillaume, *Procès-verbaux du Comité d'Instruction Publique de la Convention Nationale* (Paris, 1907), 2:839, cited in Wildenstein, *Documents complémentaires*, 71, no. 674.

79. "Le *divin* Marat, un bras pendant hors de la baignoire et retenant mollement sa dernière plume, la poitrine percée de la blessure *sacrilège*, vient de rendre le dernier soupir. . . . L'eau de la baignoire est rougie de sang, le papier est sanglant; à terre gît un grand couteau de cuisine trempé de sang; sur un misérable support de planches qui composait le mobilier de travail de l'infatigable journaliste, on lit: 'A Marat, David.' Tous ces détails sont historiques et réels, comme un roman de Balzac; le drame est là, vivant dans toute sa lamentable horreur, et par un tour de force étrange qui fait de cette peinture le chef-d'oeuvre de David et une des grandes curiosités de l'art moderne, elle n'a rien de trivial ni d'ignoble. Ceci est le pain des forts et le triomphe du spiritualisme; cruel comme la nature, ce tableau a tout le parfum de l'idéal. Quelle était donc cette laideur que la sainte Mort a si vite effacée du bout de son aile?

Marat peut désormais défier l'Apollon, la Mort vient de le baiser de ses lèvres amoureuses, et il repose dans le calme de sa métamorphose. Il y a dans cette oeuvre quelque chose de tendre et de poignant à la fois; dans l'air froid de cette chambre, sur ces murs froids, autour de cette froide et funèbre baignoire, une âme voltige." Baudelaire, "Le Musée classique du Bazar Bonne Nouvelle," in *Oeuvres complètes*, ed. C. Pichois (Paris, 1976), II: 409–410. *La Mort de Marat*, ed. J.-C. Bonnet (Paris, 1986).

80. Traeger, *Der Tod des Marat*.

81. In 1832, when recalling the first Revolution, David d'Angers wrote: "A powerful plough is necessary to fertilize long uncultivated earth in which, consequently, an infinity of useless plants have grown with deep roots. It breaks, cuts and pulls out these plants; sometimes young, beautiful, modest flowers are victims sacrificed to the general interest. Robespierre, Danton, etc. have acted as a plough." David d'Angers, *Carnets*, 203. See De Caso, *David d'Angers*, 131.

82. Thucydides, *History of the Peloponnesian War*, trans. Rex Warner (London, 1972), 242.

83. See, most recently, Am. P. Foissy-Aufrère, J.C. Martin, R. Michel, E. Pommier, and M. Vovelle, *La Mort de Bara. De l'événement au mythe. Autour du tableau de Jacques-Louis David* (Avignon, 1989) and *Jacques-Louis David 1748–1825*, 289–91 and A. Potts in *David contre David*, ed. R. Michel (Paris, forthcoming). See also A. Potts, "Beautiful Bodies and Dying Heroes: Images of Ideal Manhood in the French Revolution," *History Workshop* (Autumn 1990): 1–21.

84. In *La Mort de Bara*, R. Michel argues that the painting was completed. See 66–67.

85. Wildenstein, *Documents complémentaires*, no. 1096, 108.

86. Ibid.

87. T. Crow makes a case for this point in "Revolutionary Activism and the Cult of Male Beauty in the Studio of David," in *Fictions of the French Revolution*, ed. B. Fort (Evanston, 1991), 55–84. See also his essay in *David contre David*, ed. R. Michel (Paris, forthcoming).

88. For a discussion of these precedents see *La Mort de Bara*, 22–23.

89. De Caso, *David d'Angers*, 159.

90. E. Delécluze, *Louis David, son école et son temps*, 2nd ed. (Paris, 1983), 20.

91. Archives Nationales, C 172, fol. 4513, published in Wildenstein, *Documents complémentaires*, 53–54, no. 459. For a discussion of the Colossus of the People see De Caso, *David d'Angers*, 26–30, and L. Hunt, "The Imagery of Radicalism" in her *Politics, Culture and Class in the French Revolution* (Berkeley and Los Angeles, 1984), 87–119.

92. Wildenstein, *Documents complémentaires*, no. 459, 53–54.

93. "Au milieu de la place, sur la cîme d'une montagne, sera représenté en sculpture, par une figure colossale, le Peuple français, de ses bras vigoureux rassemblant le faisceau départemental; l'ambitieux fédéralisme sortant de son fangeux marais, d'une main écartant les roseaux, s'efforce de l'autre d'en détacher quelque portion; le Peuple français l'aperçoit, prend la massue, le frappe, et le fait rentrer dans ses eaux croupissantes, pour n'en sortir jamais." Ibid.

94. "Je propose de placer ce monument composé de débris amoncelés de ces statues, sur la place du Pont-Neuf, et d'asseoir au-dessus, l'image du peuple géant, du peuple français. Que cette image imposante par son caractère de force et de simplicité porte, écrit en gros caractères sur son front: Lumière; sur sa poitrine: Nature, Vérité; sur ses bras: Force; sur ses mains: Travail. Que, sur l'une de ses mains, les figures de la Liberté et de l'Egalité, serrées l'une contre l'autre, et prêtes à parcourir le monde, montrent à tous qu'elles ne reposent que sur le génie et la vertu du peuple. Que cette image du peuple debout tienne dans son autre main cette massue terrible et réelle, dont celle de l'Hercule ancien ne fut que le symbole." Ibid., no. 666, 70. For Quatremère de Quincy's colossus planned for the Pantheon see his third report on the Pantheon, cited in Pommier, *L'Art de la Liberté*, 173.

95. *Convention nationale: Discours prononcé par le citoyen David, dans la séance du 17 brumaire l'an II de la République. . . .* (Paris, s.d.), cited in Wildenstein, *Documents complémentaires*, 70, no. 666.

96. De Caso, *David d'Angers*, 26–30, 166–167.

97. *Jacques-Louis David 1748–1825*, 292–295.

CHAPTER III

1. D. and G. Wildenstein, *Documents complémentaires au catalogue de l'oeuvre de Louis David* (Paris, 1973), publishes many of the documents, letters, and official statements related to David's imprisonments. See 112–135.

2. See especially David's letter to M. de Mainbourg from prison dated November 8, 1794. Bibliothèque Nationale, Ms. 6605, piece 326. Printed in Wildenstein, *Documents complémentaires*, 115–116, no. 1133.

3. The new uses and meanings of the word "civilisation" in France in the 1790s have been discussed brilliantly by J. Starobinski in *Le Rémède dans le mal . . .* (Paris, 1989).

4. See K. Simons, *Jacques Réattu* (Neuilly-sur-Seine, 1985).

5. Jacques-Louis David, *Le tableau des Sabines, exposé publiquement au palais national des sciences et des arts, Paris, an VII* (Paris, 1799). Reprinted in Wildenstein, *Documents complémentaires*, 148–150, no. 1326.

6. See P. Chaussard, *Sur le tableau des Sabines par David* (Paris, 1800) and, most recently, E. Lajer-Burcharth, "David's *Sabine Women*: Body, Gender and Republican Culture under the Directory," *Art History* 14 (September 1991): 391–430; "Les oeuvres de David en prison: art engagé après Thermidor," *La Revue du Louvre et des Musées de France*, nos. 5–6 (1989): 310–321; and her essay in *David contre David*, ed. R. Michel (Paris, forthcoming). S. Germer also discusses in detail narrative strategies in "In Search of the Beholder: on the Relation Between Art, Audiences and Social Spheres in Post-Thermidor France," *The Art Bulletin* 74, no. 1 (March 1992), 19–36. For a different em-

phasis and perspective, see H. Kohle, "Histo-rienmalerei am Scheideweg. Bemerkungen zu Jacques-Louis Davids 'Sabinerinnen,'" *Histo-rienmalerei in Europa. Paradigmen in Form, Funktion und Ideologie von 17. bis zum 20. Jahrhundert*, ed. E. Mai (Mainz, 1990), 121–134. For a recent investigation of the sources see R. Rosenblum in *David contre David*, ed. R. Michel (Paris, forthcoming).

7. J. Griffin, *Virgil* (Oxford and New York, 1986), 49.

8. Rousseau's ideas on the "true" nature of women are discussed by D.G. Charlton, *New Images of the Natural in France* (Cambridge, England, London and New York, 1984) and P. Hoffman, *La femme dans la pensée des lumières* (Paris, 1977).

9. Laclos, *Des femmes et de leur éducation* (Paris, 1903).

10. See T. Lacqueur, "Orgasm, Generation and the Politics of Reproductive Biology," *Representations* 14 (Spring 1986): 1–42 and L. Schiebinger, "Skeletons in the Closet: the First Illustrations of the Female Skeleton in Nineteenth-Century Anatomy," *Representations* 14 (Spring 1986): 42–82.

11. P. Roussel, *Système physique et moral de la femme . . .* (Paris, 1775). See also A. L. Thomas, *Essai sur le caractère, les moeurs et l'esprit naturel de la femme . . .* (Paris, 1803); and G. Jouard, *Nouvel essai sur la femme considérée comparativement à l'homme* (Paris, 1804).

12. David, *Le Tableau des Sabines*.

13. Guizot, *Des beaux-arts en France et du Salon du 1810* (Paris, 1810), 43–45. J. de Caso discussed the influence of the *Sabine Women* on Pradier's Prix de Rome relief. See *Statues de chair. Sculptures de James Pradier, 1790–1852* (Geneva and Paris, 1985–1986), 110–112.

14. F. J. L. de Meyer, *Fragmente aus Paris in IVten Jahr des französischen Republik* (Hambourg, 1797), trans. into French by Dumouriez, 2 vols., (Hambourg, 1798); P. Chaussard, *Sur le tableau des Sabines*, 4. See most recently S. Germer, "In Search of a Beholder," 32.

15. See D. Johnson, "Picturing Pedagogy: Education and the Child in the Paintings of Chardin," *Eighteenth-Century Studies* (Fall 1990): 47–68.

16. For a discussion of the privileging of the adolescent figure in David's *Bara* and in art theory of the time, see A. Potts in "Beautiful Bodies and Dying Heroes: Images of Ideal Manhood in the French Revolution," *History Workshop* (Autumn 1990): 1–21 and in *David contre David*, ed. R. Michel (Paris, forthcoming). See also T. Crow, "Revolutionary Activism and the Cult of Male Beauty in the Studio of David," in *Fictions of the French Revolution*, ed. B. Fort (Evanston, 1991), 55–81, and his essay in *David contre David*. For a discussion of the revaluation of adolescence in the mythological representations of the 1790s, see D. Johnson, "Myth and Meaning: Mythological Painting in France circa 1800," in *Frankreich, 1800: Gesellschaft, Kultur, Mentalitäten* (Stuttgart, 1990), 23–33. Chaussard, *Sur le tableau des Sabines*, 16–17.

17. See especially the anonymous review of Chaussard's "Examen du tableau des Sabines" in *La Décade Philosophique*, vol. 24 (1800), 232–233 and "Le tableau des Sabines par David," *Journal des Débats* (March 4, 1800): 3; *Le Publiciste* (Sept. 7, 1810).

18. "Une objection qu'on m'a déjà faite, et qu'on ne manquera pas de reproduire, c'est celle de la nudité de mes héros. Les exemples à noter en ma faveur sont si nombreux dans ce qui nous reste des ouvrages des anciens, que la seule difficulté que j'éprouve vient de l'embarras du choix. Voici comme j'y réponds. C'étoit un usage reçu parmi les peintres, les statuaires, et les poëtes de l'antiquité de représenter nus les dieux, les héros et généralement les hommes qu'ils vouloient illustrer. Peignoient-ils un philosophe? il étoit nu, avec un manteau sur l'épaule, et les attributs de son caractère. Peignoient-ils un guerrier? il étoit nu, le casque en tête, l'épée attachée à un baudrier, un bouclier au bras, et des brodequins aux pieds; quelquefois ils y joignoient une draperie, quands ils jugeoient qu'elle pouvait ajouter à la grâce de sa figure . . . Actuellement que je crois avoir répondu d'une

manière satisfaisante au reproche que l'on m'a fait, ou qu'on pourra me faire, sur la nudité des mes héros, qu'il me soit permis d'en appeler aux artistes. Ils savent mieux que personne combien il m'eût été plus facile de les habiller: qu'ils disent combien les draperies me fournissoient des moyens plus aisés pour détacher mes figures de la toile. Je pense au contraire qu'ils me sauront gré de la tâche difficile que je me suis imposée, pénétrés de cette vérité, que qui fait le plus peut faire le moins. En un mot, mon intention, en faisant ce tableau, étoit de peindre les moeurs antiques avec une telle exactitude que les Grecs et les Romains, en voyant mon ouvrage, ne m'eussent pas trouvé étranger à leurs coutumes." David, *Le tableau des Sabines*.

19. Chaussard, *Sur le tableau des Sabines*, 37–38.

20. "C'est l'amour, qui est devenu parmi nous le juge suprême de la beauté. Riches des machines que le hazard ou les sciences nous ont données, nous avons négligé le principal agent de nos volontés, le corps majestueux, sensible, agile, robuste, dont la nature a doté l'être qu'elle destinoit à l'empire de la terre. L'attrait irrésistible, qui force les deux sexes à se rechercher et à s'unir; ce sentiment impérieux qui veut jouir, et ne choisit pas; où l'amitié, la vanité, l'espoir, la reconnoissance, déguisent, embellissent les défauts qui pourroient glacer le désir. . . .On diroit que le corps de l'homme n'ait été formé que pour obéir à la loi qui nous commande de nous reproduire." Emeric-David, *Recherches sur l'art statuaire considéré chez les anciens et chez les modernes* (Paris, 1805), 43–45.

21. See "Tableau des Sabines par David," *Journal des Débats* (March 4, 1800): 3. Delécluze remembers that the critics understood this as a severe compositional flaw, *Louis David, son école et son temps*, 2nd ed. (Paris, 1983), 212–213.

22. "Il [David] a senti encore que l'intérêt ou plutôt la magie d'un sujet, était dans le choix et dans le nombre des idées accessoires qu'il réveille. Ici, quel nombre et quelle grandeur d'idées accessoires." Chaussard, *Sur le tableau des Sabines*, 4.

23. A few praised the private exhibition, such as Chaussard, and the author of an article on the *Sabine Women* in the *Journal de Paris* (December 31, 1799), 453–454. The criticisms are discussed by Delécluze, *Louis David*, 212–214.

24. "La salle d'exposition est parfaitement éclairée: ceux qui se plaisent à jouir de la correction des formes les plus délicates, de la finesse du ton, du sentiment de l'exécution, de la précision des détails dans le costume et dans les accessoires, ont la facilité d'approcher de ce bel ouvrage autant qu'ils peuvent le désirer. Plus loin, on a la facilité d'embrasser d'un coup d'oeil l'ensemble de la composition: plus loin encore, une glace qui la répète à une double distance produit une telle illusion, que souvent on est près d'oublier que l'on a devant ses yeux un ouvrage de l'art." C. P. Landon, *Journal des arts, de littérature et du commerce* (December 31, 1799), 4.

25. "Une glace, disposée à l'extrémité de la salle, répète et réfléchit la scène et l'illusion. C'est là qu'on voit combien le peintre a été vrai. Le ton des figures s'y confond avec celui des spectateurs." Chaussard, *Sur le tableau des Sabines*, 19. The mirror was also mentioned by T. C. Brunn-Neergaard, "On a placé une glace en face du tableau dans laquelle il produit un grand effet." *Sur la situation des beaux-arts en France ou Lettres d'un Danois à un ami* (Paris, 1801), 95. It was also noted by an English observer, Miss Berry, who wrote, "It is in a room by itself and a glass so placed as to reflect it," in *Extracts from the Journal and Correspondence of Miss Berry from the year 1783 to 1852* (London, 1866), 2: 183. David would use the mirror again in a very similar manner in his exhibition of the *Coronation* in his atelier. One observer described it in the following terms: "L'effet de ce beau tableau est plus sensible encore quand, après l'avoir considéré de tous les points de vue, on se retourne tout-à-coup vers une glace qui est placée exprès vis-à-vis, pour en doubler la distance; ce n'est plus en quelque sorte une peinture que l'on voit, c'est une scène animée, ce sont des personnages parfaitement détachés qu'on croit voir en mouvement." *Affiches, an-*

nonces et avis divers ou Journal général 340 (December 7, 1807), 1519–20.

26. E. Lajer-Burcharth, "David's *Sabine Women*," 406. In the inventory of David's atelier made after his death, the following was noted: "Une glace psyché servant pour la perspective du tableau." See Wildenstein, *Documents complémentaires* 238, no. 2042.

27. In Emile Littré, *Dictionnaire de la langue française* (Paris, 1960), 4:93, the earlier usage of "glace" for a mirror is defined as "Plaques de verre, de cristal dont on fait des miroirs. . . . Il se dit particulièrement des miroirs de grande dimension." And, in the extremely lengthy *Encyclopédie* entry for "Verrerie" (which is accompanied by splendid and explicit plates), the making of "glaces," huge mirrors used to decorate apartments, is described in technical detail. See the entry for "Glace," *Encyclopédie* (Paris, 1757), VII:687 and "Verrerie" (Paris, 1765), XVII:115–156. In the *Grand Dictionnaire du XIXe siècle* (Paris, 1872), 8:1285, "glace" is defined as "Grande plaque de Verre étamé pour servir de miroir." For David's exhibition of the *Coronation* with the mirror, see above, note 25. In 1824, David had *Mars Disarmed by Venus and the Graces* exhibited in a room with a mirror hung on the wall opposite it cut to size so that the entire composition was reflected in it, minus the frame. This is described by Angélique Mongez in a letter to David preserved in the Ecole Nationale Supérieure des Beaux-Arts, Ms. 318, no. 65. See Chapter V of the present study.

28. Watelet and Levesque, *Dictionnaire des arts de peinture, sculpture et gravure*, vol. 3 (Paris, 1792), 466–67. "Léonard de Vinci et Félibien prescrivent aux peintres de consulter le *miroir* pour reconnoître plus facilement les défauts de leurs ouvrages." A. L. Millin, "Miroir," in *Dictionnaire des beaux-arts*, vol. II (Paris, 1806), 453. See especially Léonard de Vinci, *Traité de la peinture* (Paris, 1796), 221–223. Paillot de Montabert discusses the use of mirrors for establishing perspective and helping to correct flaws in his *Traité de peinture* (Paris, 1829–51), 6:407–410, 418–421.

29. "Du moins ce silence religieux qu'elle observe, soit que l'intérêt de la scène et ses dimensions majestueuses, soit que la réputation de l'homme célèbre et la magie de l'exécution en imposent, ce profond recueillement dont j'ai constamment remarqué l'expression sur le visage des spectateurs, a sans doute plus flatté l'artiste que les plus bruyans applaudissemens." Chaussard, *Sur le tableau des Sabines*, 39.

30. "Tout dans cette remarquable composition est pensé, étudié, cherché et poussé à la limite de la perfection dont l'artiste était capable." T. Gautier, *Guide de l'amateur au Musée du Louvre* (Paris, 1882), 7.

31. Delécluze, *Louis David*, 339. Twentieth-century scholars have taken the composition quite seriously. See M. Kemp, "Jacques-Louis David and the Prelude to a Moral Victory for Sparta," *The Art Bulletin* (June 1969): 178–183; N. Athanassoglou, "Under the Sign of Leonidas: the Political and Ideological Fortune of David's *Leonidas at Thermopylae* under the Restoration," *The Art Bulletin* (December 1981): 633–649; T. Gaehtgens, "Jacques-Louis David: Leonidas bei Thermopylen," in *Ideal und Wirklichkeit des bildenden Kunst in späten 18. Jahrhundert* (Berlin, 1984), 211–251; M. Jonker, "David's Leonidas aux Thermopyles in the art criticism of the Restoration," *Frankreich 1800, Gesellschaft, Kultur, Mentalitäten*, ed. G. Gersmann, H. Kohle (Stuttgart, 1990), 49–63 and, in the same collection, G. Stemmrich, "David's 'Leonidas bei Thermopylen': Klassizistisch vollzogene Kunstautonomie als "Patriotisme sur la toile," 64–80.

32. See Kemp, "Jacques-Louis David"; Athanassoglou, "Under the Sign of Leonidas."

33. Delécluze, *Louis David*, 338–341. See S. Nash, "The Compositional Evolution of David's *Leonidas at Thermopylae*," *Metropolitan Museum Journal* 13 (1978): 101–112; *Jacques-Louis David 1748–1825*, 487–497. T. Crow addressed problems of chronology and the dating of drawings in "Jacques-Louis David . . . , Figure Studies for *Leonidas at Thermopylae*," *Record of the Art Museum, Princeton 42, no. 1* (1983).

34. *Notice sur la vie et les ouvrages de M. J.-L.*

David (Paris, 1824), 57–59; M. A. Th., *Vie de David* (Paris, 1826), 130–131; P. A. Coupin, *Essai sur J. L. David, Peintre d'histoire* (Paris, 1827), 38–40.

35. Suau's letters were published by P. Mesplé, "David et ses élèves toulousains," *Archives de l'art français, Nouvelle période* 24 (1909): 91–102.

36. "Assez souvent il a effacé des figures entières, fait et refait des groupes entiers, de manière que tout cela retarde son travail." Ibid., 102.

37. "Léonidas, roi de Sparte, assis sur une roche au milieu de ses trois cents braves, médite avec une sorte d'attendrissement, sur la mort prochaine et inévitable de ses amis." J.-L. David, *Explication du tableau des Thermopyles* (Paris, 1814), reprinted in *Jacques-Louis David 1748–1825*, 486.

38. "Les Spartiates ne doivent plus désormais avoir aucun rapport avec les mortels: ils vont souper chez Pluton." Ibid.

39. "Ce dévouement de Léonidas et de ses compagnons produisit plus d'effet que la victoire la plus brillante: il apprit aux Grecs le secret de leurs forces, aux Perses celui de leur faiblesse. Le nombre des Spartiates était de trois cents hommes; les Perses en comptaient plus de six cent mille." Ibid.

40. J. J. Barthélemy, *Voyage du jeune Anacharsis en Grèce, vers le milieu du quatrième siècle avant l'ère vulgaire* (Paris, 1843).

41. G. Steiner, *Antigones* (Oxford, 1986), 7.

42. Barthélemy, *Voyage*, 336–349.

43. "Un corps sain et robuste, une âme exempte de chagrins et de besoins, tel est le bonheur que la nature destine à l'homme isolé; l'union et l'émulation entre les citoyens, celui où doivent aspirer les hommes qui vivent en commun." Ibid., 333.

44. See H. Lottman, *Flaubert* (Boston, Toronto, London, 1988), 125.

45. "Outre que la moindre tache imprimée sur une union qui doit être sainte, qui l'est presque toujours, couvrirait pour jamais d'infamie le coupable, et serait même, suivant les circonstances, punie de mort." Barthélemy, *Voyage du jeune Anacharsis*, 345.

46. "C'est alors qu'ils commencent à contracter ces liaisons particulières, peu connues des nations étrangères, plus pures à Lacédémone que dans les autres villes de la Grèce. Il est permis à chacun d'eux de recevoir les attentions assidues d'un honnête jeune homme attiré auprès de lui par les attraits de la beauté, par les charmes plus puissants des vertus dont elle paraît être l'emblème. Ainsi la jeunesse de Sparte est comme divisée en deux classes: l'une, composée de ceux qui aiment; l'autre de ceux qui sont aimés. Les premiers, destinés à servir de modèles aux seconds, portent jusqu'à l'enthousiasme un sentiment qui entretient la plus noble émulation, et qui, avec les transports de l'amour, n'est au fond que la tendresse passionnée d'un père pour son fils, l'amitié ardente d'un frère pour son frère," ibid.

47. Ibid., 353.

48. Ibid., 358.

49. Ibid.

50. Ibid., 357–358.

51. "Les principales armes du fantassin sont la pique et le bouclier: je ne compte pas l'épée, qui n'est qu'une espèce de poignard qu'il porte à sa ceinture. C'est sur la pique qu'il fonde ses espérances; il ne la quitte presque point, tant qu'il est à l'armée." Ibid.

52. "un sentiment de compassion, joint à une fermeté de résolution inébranlable." Boutard, *Journal des débats politiques et littéraires* (December 11, 1814), 3.

53. "Dans cette tête sublime, toutes les expressions sont réunies; c'est le *justum et tenacem*, l'homme viril et plein de courage; toute la grandeur de la patrie est présente à son *âme profonde*; l'invocation fixe ses yeux vers le ciel dans une immobilité qui exprime tout l'étendue de son dévouement." Claire Regius, Comtesse Lenoir-Larouche, *La Grèce et la France, ou Réflexions sur le tableau de Léonidas de David* (Paris, 1815), 27–28.

54. Lenoir wrote a detailed account of David's response to Laugier's engraving of Leonidas which had been sent to him in Brussels for his approval. According to Lenoir David objected to the lack of subtlety in Leonidas' face. See "Mémoires, David, Souve-

nirs historiques," *Journal de l'Institut historique* 3 (1835): 11–12.

55. Moreau de la Sarthe, *L'Art de connaître les hommes par la physionomie, par Gaspar Lavater*, 10 vols. (Paris, 1806–1809).

56. P. Pinel, *Nosographe philosophique, ou la méthode de l'analyse appliquée à la médecine*, 2 vols. (Paris, 1798) and *Traité médico-philosophique sur l'aliénation mentale, ou la manie* (Paris, 1801); Cabanis, *Rapports du physique et du moral de l'homme* (Paris, 1798, 1802); Delaméthrie, *De l'homme, considéré moralement; de ses moeurs et celles des animaux*, 2 vols. (Paris, 1802); Bichat, *Recherches physiologiques sur la vie et la mort* (Paris, 1805). The ideologue Destutt de Tracy was also an important figure. See *Elémens d'idéologie* (Paris, 1803–05). See also F. C. T. Moore, *The Psychology of Maine de Biran* (Oxford, 1970) and E. Kennedy, *A Philosophe in the Age of Revolution: Destutt de Tracy and the Origins of "Ideology"* (Philadelphia, 1978). One of the forerunners of this group was the Swiss naturalist C. Bonnet who wrote of the will, mind, and spirit in *Essai de psychologie* (Paris, 1754) and *Essai analytique sur les facultés de l'âme* (Paris, 1760). Other important figures were Condillac, *Essai sur les origines de la connaissance humaine*, (Paris, 1746) and *Traité des sensations* (Paris, 1754); Helvetius, *De l'homme* (Paris, 1772) and *De l'esprit* (Paris, 1758). These thinkers and their contributions were recently studied by M. Staum, *Cabanis. Enlightenment and Medical Philosophy in the French Revolution* (Princeton, 1980). See also R. Savioz, *La Philosophie de Charles Bonnet de Genève* (Paris, 1948).

57. See M. Bonnaire, *Procès-verbaux de l'Académie des Beaux-arts*, vols. I & II (Paris, 1937).

58. "Le Brun a composé relativement à son art un *Traité des passions* où il s'est attaché à décrire les divers effets qu'elles produisent sur l'extérieur du corps humain. Quelque mérite qu'on reconnaisse à ce Livre vraiment élémentaire, il est facile de concevoir qu'il peut être encore perfectionné et surtout accompagné d'exemples d'un meilleur choix quant aux formes, et un plus grand nombre, afin de suivre l'âme jusque dans les moindres modifications de ses affections." Ibid., I: 30.

59. Gault de Saint-Germain, *Des passions et de leur expression générale et particulière sous le rapport des Beaux-arts* (Paris, 1804).

60. Many of these works are preserved at the Ecole Nationale Supérieure des Beaux-Arts in Paris.

61. This was discussed by Kemp, "Jacques-Louis David."

62. François-Anne David, *Eléments du dessin ou proportions des plus belles figures de l'antiquité . . .* (Paris, 1798).

63. See, in particular, "Observations sur l'état des arts au dix-neuvième siècle, dans le salon de 1814," *Le Spectateur*, no. 25 (1814): 194–195.

64. Ibid., 194. And Miel, *Journal général de France* (November 19, 1814), 4.

65. Boutard, *Journal des débats politiques et littéraires* (December 11, 1814), 1, 4.

66. M. A. Th., *Vie de David*, 130; Coupin, *Essai*, 39.

67. Delécluze, *Louis David*, 339–340.

68. Mesplé, "David et ses élèves toulousains."

69. Emeric-David, *Recherches sur l'art statuaire*.

70. "Chaque artiste peut, à l'exemple des Grecs, se faire à soi-même des canons. La plus grande difficulté ne consiste pas à les composer; elle consiste à s'en servir avec fruit." Ibid., 197. For a comprehensive discussion of proportion, see 178–200.

71. J.-G. Salvage, *Anatomie du Gladiateur combattant, applicable aux beaux-arts . . .* (Paris, 1812). I discussed the significance of this treatise and its impact on art in France in my doctoral dissertation, "The Eloquent Body: Jacques Louis David and the Formation of a Gestural Aesthetic," University of California, Berkeley, 1987.

72. "Pour compléter ce travail, j'ai *anatomisé* un plâtre, très bonne épreuve du Gladiateur, afin de convaincre ceux qui ont longtemps douté que les anciens connaissaient le mécanisme du corps humain, que cette figure n'est vraiment belle que parce que les principes anatomiques y sont fidèlement observés, et que pour un chef-d'oeuvre semblable, l'art et la sci-

72... ence se sont prêtés la main." This statement was from Salvage's prospectus for the *Anatomie du gladiateur combattant* published in the *Nouvelles des arts*, vol. 4 (1804), 77, "Gladiateur anatomisé."

73. "En réduisant ce plâtre à l'état d'écorché, M. Salvage s'est proposé de prouver que cette statue n'est réellement belle que parce que les principes anatomiques y sont fidèlement observés, et qu'il est impossible de faire de pareils chefs-d'oeuvres, si l'on ne réunit pas la science positive de l'anatomie au génie et au talent d'artiste.

Votre Commission pense que les dessins gravés du *Gladiateur Ecorché*, par M. Salvage, peuvent être très utiles pour l'étude du dessin et principalement pour les études nécessaires aux peintres et aux sculpteurs. Elle pense aussi qu'on n'avait encore rien fait d'aussi exact en ce genre, et que l'auteur mérite d'être encouragé. Il faut la réunion des connaissances anatomiques et du talent de dessinateur pour ces sortes d'ouvrages, et c'est parce qu'elle ne s'est point encore rencontrée dans un degré suffisant, que l'on n'a pas d'ouvrages élémentaires de cette nature qui satisfassent." Bonnaire, *Procès-Verbaux* (Paris, 1940) II: 288. This report was published and discussed by C.-P. Landon, "Rapport fait à l'Institut, Classe des beaux-arts, le 5 brumaire, an 13," *Nouvelles des arts* 4 (Paris, 1804): 73–76.

74. Miel, *Journal général de France*, 3.

75. Emeric-David, *Recherches sur l'art statuaire*, 201–203.

76. Ibid.

77. Ibid. For a recent discussion of Emeric-David's interpretation of Prometheus as the first sculptor, see M. Shedd, "Prometheus the Primeval Sculptor: Archaeology and Anatomy in Emeric-David's *Recherches sur l'art statuaire*," *Zeitschrift für Kunstgeschichte* vol. 57 (1991), 88–106.

78. Emeric-David, *Recherches sur l'art statuaire*, 276–290.

79. Quatremère de Quincy, "Sur l'idéal dans les arts du dessin," *Archives littéraires de l'Europe* II, 6 (1805): 385–404.

80. Ibid., 397.

81. Emeric-David, *Recherches sur l'art statuaire*, 290.

82. "On se battoit corps à corps. La vigueur des membres et la justesse des mouvemens, en déterminant le succès des combats particuliers, décidoient de celui de batailles.

On avoit vu dans les premiers tems, qu'un homme grand et robuste, renversoit, suivant l'expression des poètes, des bataillons de héros: qu'un coureur rapide portoit dans quelques instants, l'importante nouvelle d'une victoire. On remarqua bientôt, avec la même facilité, en considérant l'extérieur de ces hommes utiles, que leur force, leur souplesse, leur légèreté, que leur aptitude particulière enfin pour des exercices différens, dépendoit de la différence de leur conformation. L'instinct avoit reconnu le beau. . . . L'intérêt public et l'émulation des guerriers firent attacher un grand prix aux qualités corporelles." Ibid., 46–47.

83. D. S. Carne-Ross, *Pindar* (New Haven, 1985), 41.

84. "La flamme divine qui s'agite en nous, perçant l'enveloppe qui la contient, arrive et brille à la surface de tous nos membres. On ne peut douter que l'état habituel de l'âme, ne soit visible sur l'extérieur du corps." Emeric-David, *Recherches sur l'art statuaire*, 54.

85. "Qu'est-ce que le corps de l'homme? C'est un instrument destiné à exécuter des volontés bien ordonnées, doué d'organes qui, suivant le degré de leur sensibilité, portent à l'esprit des idées plus ou moins exactes, et soumis à des besoins dont la satisfaction est elle-même une cause de plaisir. Si cet instrument est construit de manière qu'il exécute avec promptitude, avec vigueur, avec justesse et sans embarras, les mouvemens que la volonté lui prescrit; si toutes les parties qui le composent, pleines de sentiment et de vie, conduisent harmonieusement de nombreuses idées vers son intérieur, il est donc évidemment plus parfait que tout autre, puisqu'il peut se procurer et donner à autrui, de plus nombreuses et de plus pures jouissances." Ibid., 64–65.

86. Cabanis, *Rapport du physique*. The re-

view of Cabanis' *Rapport du physique et du moral de l'homme* appeared in *La Décade philosophique* (1802), 39: 455–464.

87. Ibid.

88. J.-B.-P. A. Monet de Lamarck, *Recherches sur l'organisation des corps vivans et particulièrement sur son origine, sur la cause des développements et des progrès de sa composition* . . . (Paris, 1802). The idea of self-preservation in this treatise is discussed by P. Corsi, *The Age of Lamarck. Evolutionary Theories in France, 1790–1830*, trans. J. Mandelbaum (Berkeley, Los Angeles, London, 1988), 121–156.

89. Miel, *Journal général de France*, 3.

90. S. Nash discussed these two drawings in an attempt to establish a chronology, "The Compositional Evolution of David's Leonidas."

91. Vente des tableaux de David, April 17, 1826. Wildenstein, *Documents complémentaires*, 244–247, no. 2061. The following notation is found on the back of this oil sketch: "Esquisse des Termopiles peinte par David et achetée à sa vente par moi David d'Angers. Paris. 18 [2] 7."

92. Discussed in Corsi, *The Age of Lamarck*.

93. Lamarck, *Recherches sur l'organisation des corps vivans*.

94. Lamarck, *Philosophie zoologique* (Paris, 1809); C. White, *An Account of the Regular Gradation in Man, and in Different Animals and Vegetables, and from the Former to the Latter* (London, 1799); J. J. Virey, *Histoire naturelle du genre humain, ou Recherches sur ses principaux fondemens physiques et moraux*, 2 vols. (Paris, 1800). See Corsi, *The Age of Lamarck*, 145–148, 172–174.

95. Salvage, *L'Anatomie du Gladiateur combattant*.

96. Discussed in Corsi, *The Age of Lamarck*, 172–173.

97. Bichat, *Recherches physiologiques*.

98. Ibid.

99. See, for example, Miel, *Journal général de France*, 2 and Boutard, *Journal des débats politiques*, 2.

100. "Je suis en train de terminer un pendant à *mes Sabines*. C'est le passage des *Thermo-pyles* et Léonidas à la tête de ses 300 Spartiates." Wildenstein, *Documents complémentaires*, 195, no. 1689.

101. Delécluze, *Louis David*, 223–225.

102. Discussed in Charlton, *New Images*, 45–84.

103. Winckelmann, *Gedanken über die Nachahmung der griechischen Werke in der Malerei und Bildhauerkunst*, (Dresden and Leipzig, 1756) and *Geschichte der Kunst des Altertums* (Dresden, 1764).

104. Barthélemy, *Voyage*, 327ff.

105. Chaussard, *Sur le tableau des Sabines*, 30–32.

106. Several were published in *Jacques-Louis David 1748–1825*, 500–511.

107. "Le fond présente une montagne escarpée et des rochers pendans en précipices. A droite, sur le devant, un chêne, symbole de la force; plus loin quelques peupliers consacrés à Hercule, de qui descendoient les rois de Sparte. Dans l'éloignement et à mi-côte, un temple d'architecture grecque, qui empêche cette simplicité austère de dégénérer en aridité. Ce temple est celui de Cérès, où les Amphyctions tenoient tous les ans une de leurs assemblées. Tel est le lieu de la scène, solennel comme l'action qui va s'y passer. . . . Ces feuilles, tombées des arbres, en partie dépouillées de leur verdure qui s'évapore, cette lyre suspendue et muette, ces couronnes tressées de pavots, de narcisses et d'hyacinthes, fleurs consacrées aux dieux infernaux, tous ces signes de destruction et d'anéantissement n'annoncent-ils pas avec une éloquence bien énergique la mort des trois cents héros, et ne semblent-ils pas associer la nature à leur destinée." Miel, *Journal général de France*, 4.

108. "Genre de peinture universel auquel tous les autres sont subordonnés parce qu'ils y sont renfermés." Cited by J. de Caso in his review of the Girodet exhibition, "Girodet," *The Art Bulletin* 51 (1969): 85–88.

109. See P. Grunchec, *Le Grand Prix de Peinture. Les concours des Prix de Rome de 1797 à 1863* (Paris, 1983), 97–100 and 163–165.

110. Chaussard, *Sur le tableau des Sabines*, 3.

111. Mesplé, "David et ses élèves toulousains," 95–97 and Delécluze, *Louis David*, 53–57.

Chapter IV

1. A synopsis of these activities is offered in *Jacques-Louis David 1748–1825* (Paris, 1989), 360.

2. See P. Lelièvre, *Vivant Denon, directeur des beaux-arts de Napoléon* (Angers, 1942).

3. See most recently A. Boime, *Art in the Age of Bonapartism* (Chicago and London, 1990).

4. "Je serai exact à remplir les engagemens que j'ai contractés envers Sa Majesté. Je sens trop bien l'importance de pareils ouvrages! Quel peintre! quel poète fut jamais mieux placé que moi: je me glisserai à la posterité à l'ombre de mon héros." Reprinted in *Archives de l'Art français* (Paris, 1855–56), 33–39 and in D. and G. Wildenstein, *Documents complémentaires au catalogue de l'oeuvre de Jacques-Louis David* (Paris, 1973), 171, no. 1474.

5. Schnapper gives a detailed account of these financial difficulties in *Jacques-Louis 1748–1825*, 362–373.

6. The "realism" of the painting was recently analyzed in a thoughtful article by S. Germer, "'On marche dans ce tableau.' Zur Konstituierung des 'Realistischen' in den Napoleonischen Darstellung von Jacques-Louis David," *Frankreich 1800. Gesellschaft, Kultur, Mentalitäten*, ed. G. Gersmann and H. Kohle (Stuttgart, 1990), 81–103.

7. The genesis and destination of the composition as well as its final format remain unknown. See Delécluze, *Louis David, son école et son temps*, 2nd ed. (Paris, 1983), 200–24; Jules David, *Le peintre Louis David 1748–1825, Souvenirs et documents inédits* (Paris, 1880), I: 642; and *Jacques-Louis David 1748–1825*, 359–360, 379.

8. *Jacques-Louis David 1748–1825*, 381.

9. Ibid., 381–386.

10. Ibid.

11. M.A. Th, in *Vie de David* (Paris, 1826), relates that Bonaparte himself scoffed at the perspective peculiarities, 112.

12. *Jacques-Louis David 1748–1825*, 386.

13. "Le *costume* est l'art de traiter un sujet dans toute la vérité historique: c'est donc l'observation exacte de ce qui est, suivant le temps, le génie, les moeurs, les lois, le goût, les richesses, le caractère et les habitudes d'un pays où l'on place la scène d'un tableau. Le *costume* renferme encore tout ce qui regarde la chronologie, et la vérité de certains faits connus de tout le monde; enfin tout ce qui concerne la qualité, la nature et la propriété essentielle des objets qu'on représente." *Encyclopédie ou dictionnaire raisonné des sciences, des arts et des métiers, par une société des gens de lettres*, ed. Diderot and d'Alembert (Paris, 1754), 4:298–9.

14. On September 24, 1804, the *Journal de Paris* records that Napoleon had asked David to represent the *Coronation*. See *Jacques-Louis David 1748–1825*, 361 and 405.

15. Ibid., 361–362.

16. On December 18, 1804, David, who had refused to become painter of the Government in 1800 was named First Painter. Ibid., 361–362. See also, Wildenstein, *Documents complémentaires*, 165, no. 1425. In a note preserved at the Ecole Nationale Supérieure des Beaux-Arts, Ms. 316, no. 12, David wrote "les deux autres n'ont point été faits pour des raisons politiques."

17. See Wildenstein, *Documents complémentaires*, 171–172, no. 1474, and *Jacques-Louis David 1748–1825*, 364–365.

18. Ecole Nationale Supérieure des Beaux-Arts, Ms. 316, no. 12, "L'Empereur en me commandant ces ouvrages, me dit-il, veux faire construire une salle exprès, où seront appelés ces tableaux."

19. "Bonaparte croyait consolider son gouvernement, et le rendre plus imposant par cette cérémonie religieuse, qui donne aux rois un caractère en quelque sorte plus divin. Plein de cette idée, il résolut son sacre et forma le projet de consacrer sous ce nom une salle qu'il devait décorer de quatre grands tableaux; aussitôt ils furent commandés à son premier

peintre." *Notice sur la vie et les ouvrages de M. J.-L. David* (Paris, 1824), 46.

20. "Je désigne par ces tableaux les différents ordres de la société." The letter is reproduced in *Jacques-Louis David 1748–1825*, 364–365.

21. "Le Sacre—1er Tableau. Après la tradition des ornemens de l'empereur par le pape; Sa Majesté montée à l'autel, prend la couronne, la place de sa main droite sur sa tête, puis de la gauche il serre étroitement son épée sur son coeur; ce grand mouvement rappelle aux spectateurs étonnés, cette vérité si généralement reconnue: que celui qui a scû la conquérir, saura bien aussi la défendre. L'attitude, le geste, les regards de la foule attendrie, tout indique le sentiment d'admiration dont chacun est pénétré." Ibid.

22. "Intronisation—2e Tableau. L'Empereur, assis, la couronne sur sa tête, et la main levée sur l'Evangile prononça le serment constitutionnel, en présence du président du sénat, du président du corps législatif, de celui du tribunat, et du plus ancien des présidens du conseil d'Etat, qui lui en a présenté la formule." Ibid.

23. Ibid., 399.

24. "Je désigne par ces tableaux les différents ordres de la société. Le troisième jour des fêtes du couronnement est consacré à la valeur, à la fidélité. C'est la distribution des aigles à l'armée, et aux gardes nationales de l'empire." Ibid., 365.

25. "Jamais serment ne fut mieux observé: que d'attitudes différentes, que d'expressions variées! Jamais sujet de tableau ne fut plus beau." Ibid.

26. "Je désigne par ces tableaux les différents ordres de la société. Celui-ci est pour le peuple. C'est le premier acte d'obéissance envers son souverain, c'est le gouverneur de Paris qui remet les clefs de la ville entre les mains de son Empereur. . . . Déjà l'Empereur a franchi les degrés de l'hôtel, lorsque des citoyens de toutes les classes pressés par la reconnoissance se précipitent aux pieds de sa Majesté, le remercient des graces qu'ils ont d'avance obtenus

pour des fautes graves que leurs enfans ont commises. Un autre grouppe voyant l'impératrice, semblable au soleil bienfaisant, descendre de la même voiture, se précipitent également à ses pieds, ils la remercient des secours qu'ils en reçoivent pour le soulagement de leur famille, et pour l'acquittement des mois de nourrice. Le peuple spectateur de cette scène imposante, et attendrissante en même tems, témoigne son ravissement par un cri général de *Vive l'Empereur, vive l'Impératice, vive la famille impériale.*" Ibid.

27. "Denon veilla à l'exécution des ordres de son maître; mais cette immense série de tableaux de cérémonies, de batailles et d'entrevues, exécutés pendant le cours de dix années par une foule d'artistes médiocres, et offerts à la multitude comme une espèce de *Moniteur visible* où le fait représenté captivait toute l'attention, sans que le travail des artistes en réclamât la moindre part, est une des circonstances qui, à cette époque, a été le plus nuisible au développement de l'art considéré sérieusement." Delécluze, *Louis David*, 319–320.

28. See *Jacques-Louis David 1748–1825*, 403. David mentions his choice seat in a note preserved at the Ecole Nationale Supérieure de Beaux-Arts, Ms. 316, no. 12. The most concise account of Ségur's ceremony, as well as his set and costume design, is given in *Jacques-Louis David 1748–1825*, 399–417.

29. *Jacques-Louis David 1748–1825*.

30. Ibid., 403. See also Ecole Nationale Supérieure des Beaux-Arts, Ms. 316, no. 12.

31. Ecole Nationale Supérieure des Beaux-Arts, Ms. 316, no. 13. One critic relates that David constructed a wooden box that replicated the choir of Notre Dame, *Affiches, annonces et avis divers ou Journal général* 340 (December 7, 1807), 5418.

32. "David offre à nos yeux dans ce tableau mouvant/Ce que l'Eglise a de plus vénérable,/Le trône de plus grand,/La majesté de plus aimable." *Journal des arts, des sciences, de la littérature et de la politique* (May 24, 1808), 387.

33. This drawing is reproduced in *Jacques-Louis David 1748–1825*, fig. 108.

34. See *Journal de l'Empire* (January 24, 1808), 4.

35. See *Le Journal de Paris* 49 (February 18, 1808); *Journal de Paris* 289 (October 15, 1808), 2068; *Journal de Paris* 203 (July 22, 1810), 1435; *Journal de Paris* (September 3, 1810), 1739.

36. *Jacques-Louis David 1748–1825*, 144–145.

37. For a discussion of A. Lenoir's *Musée des monuments français* see Louis Courajod, *Alexandre Lenoir, son journal et le Musée des monuments français* (Paris, 1878–87) and, most recently, D. Poulot, "Alexandre Lenoir et les musées des Monuments français," *Les Lieux de mémoire*, ed. P. Nora, vol. II, *La Nation* (Paris, 1986). See also François Pupil, *Le style troubadour ou la nostalgie du bon vieux temps* (Nancy, 1985), 117–127 and M. Chaudonneret, *La peinture troubadour, deux artistes lyonnais, Pierre Révoil (1776–1852) et Fleury Richard (1771–1852)* (Paris, 1980).

38. See F. Pupil, *Le Style troubadour*.

39. *Jacques-Louis David 1748–1825*, 394–396.

40. See G. Levitine, *The Dawn of Bohemianism: The Barbu Rebellion and Primitivism in Neoclassical France* (University Park, M.D., 1978).

41. This translation was given in R. Switzer, *Chateaubriand* (New York, 1971), 60.

42. "On critique vivement aussi la partie droite du tableau, nous voulons dire toute celle qui est à l'opposé de l'autel. Les expressions de tête sont peu agréables; les chairs manquent de vérité, les poses n'ont pas d'élégance, les ombres sont lourdes, les formes ne tournent point; le ton de couleur est sec et blafard. Mais la scène principale est fort belle, les étoffes sont supérieurement touchées; on admire surtout les grouppes qui entourent l'autel." *Journal de Paris* (September 3, 1810), 1739.

43. "On admire toujours ce magnifique tableau, dont la partie droite surtout est un chef-d'oeuvre de composition. On croyait que M. David retoucherait le grouppe de la gauche, et le fond représentant plusieurs tribunes. Ces deux parties du tableaux laissent toujours quelque chose à désirer." *Journal de Paris* 289 (October, 15, 1808), 2068.

44. *Jacques-Louis David 1748–1825*, 534–539.

45. Ibid., 408–409.

46. Ibid., 414–415.

47. "Le plus grand reproche qu'on fasse à l'auteur est d'avoir tellement sacrifié les fonds au premier plan, qu'ils semblent n'avoit été qu'ébauchés, les tribunes placées en face sont, à vrai dire, d'une couleur presque nulle; on a peine à croire que M. David ait volontairement négligé de peindre une ligne si peu reculée. Le dessin même en est aussi foible que le clair-obscur y est mal-entendu." *Journal de Paris* (September 3, 1810), 1739.

48. "Le style naïf de cette partie du tableau, forme le troisième degré de la progression que nous avons remarqué entre les figures d'invention et les portraits historiques du sujet principal: c'étoit d'ailleurs le seul moyen d'obtenir des portraits ressemblans, à une distance assez éloignée, et déjà un peu dans le vague de la perspective." *Journal de l'Empire* (January 24, 1808), 4.

49. Discussed in *Jacques-Louis David 1748–1825*, 413

50. Ibid., 413. P. F. L. Fontaine recorded Napoleon's request for this change. See *Journal 1799–1853*, 2 vols. (Paris, 1987), 185. This was also alluded to in *Le Moniteur Universel* (January 16, 1808), 63–64.

51. *Jacques-Louis David 1748–1825*, 370, 410.

52. "Il suffit en effet de voir la composition du Couronnement, pour reconnaître que ce dernier personnage, les cardinaux, les prêtres et tout ce qui se rattache à la partie religieuse de cette cérémonie, forment le groupe principal sur lequel David a dirigé instinctivement l'effort de tout son talent." Delécluze, *Louis David*, 249.

53. See R. J. M. Olson, "Representations of Pope Pius VII: the First Risorgimento Hero," *The Art Bulletin* (March 1986): 77–93.

54. *Jacques-Louis David 1748–1825*, 390–393.

55. Ibid. See also P. Bordes and A. Pougetoux, "Les portraits de Napoléon en habits impériaux par Jacques-Louis David," *Gazette des Beaux-Arts* (July-August 1983): 21–34 for a discussion as well of the sketch of Napoleon in Imperial Robes for Cassel.

56. "C'est un portrait si mauvais, tellement rempli de défauts, que je ne l'accepte point, et ne veux l'envoyer dans aucune ville, surtout en Italie où ce serait donner une bien mauvaise idée de notre école." Cited in Bordes and Pougetoux, "Les portraits de Napoléon," 22.

57. *Jacques-Louis David 1748–1825*, 433ff.

58. For these responses see the lengthy critique in the *Journal de l'Empire*, "Salon de 1810" (December 3, 1810), 1–4 and the *Journal de Paris* (November 12, 1810), 2233. Delécluze states that the painting evinces David's weakening talent, *Louis David*, 316. Denon reassures Napoleon in a letter dated November 11, 1810, Archives Nationales, AFIV, 1050, dossier 6, piece 7, cited in *Jacques-Louis David 1748–1825*, 453.

59. *Jacques-Louis David 1748–1825*, 446. Wildenstein, *Documents complémentaires*, 179, no. 1541.

60. "Événement qui se rapporte aussi à l'institution de la puissance impériale." *Journal de l'Empire*, "Salon de 1810," 3.

61. See *Jacques-Louis David 1748–1825*, 443.

62. Especially adamant was the critic in the *Journal de Paris* (November 12, 1810), 2233.

63. "Quelques critiques ont prétendu que M.M. les maréchaux devroient être à la tête des troupes, le visage tourné comme elles vers l'Empereur, qui reçoit leurs sermens; ils ne pensent pas que l'enthousiasme puisse *servir*, même dans un tableau, d'excuse à un désordre, à une confusion contraire à la discipline militaire. L'action, disent-ils, est équivoque, il ne tiendroit qu'à nous de la prendre pour un mouvement séditieux que le monarque et ses généraux s'efforceraient de calmer. . . . Le mouvement et l'expression de toutes les fi-

gures, témoignent aussi qu'il s'agit d'un serment prêté avec allégresse et nullement de *fureur séditieuse* [my emphasis]." *Journal de l'Empire*, "Salon de 1810," December 3, 1810, 2.

64. Suau wrote to his father on October 18, 1810, that David was working feverishly on the *Distribution* and that he had been ordered by Denon to suppress a number of elements, including Josephine and the ladies in waiting. See P. Mesplé, "David et ses élèves toulousains," *Archives de l'Art Français* 24 (1969), 95.

65. "La victoire fait pleuvoir sur ces drapeaux/leur tête/une pluie de lauriers présage des nouveaux triomphes qui les attendent." Reproduced in *Jacques-Louis David 1748–1825*, 449.

66. "Cette figure était destinée à entrer dans le tableau des aigles, c'est l'empereur qui ne l'a pas voulu, on voit par l'attitude des maréchaux qu'elle était indispensable." Ibid.

67. Many allegorical works executed circa 1800 were reproduced and discussed in the exhibition catalogue, *La Révolution et l'Europe 1789–1799* (Paris, 1989), vol. II, nos. 826, 828, and in *Aux Armes et aux Arts! Les Arts de la Révolution 1789–1799* (Paris, 1988), 54–56, 88–89.

68. *De l'Allégorie ou Traités sur cette matière; par Winckelmann, Addison, Sulzer, etc.*, trans. Jansen (Paris, 1799).

69. C.-H. Watelet and P.-H. Levesque, *Dictionnaire des arts de peinture, sculpture et gravure*, 2nd ed. (Paris, 1792), I: 51–57.

70. "Les images choisies par l'artiste doivent ne pas être arbitraires, elles doivent être comme une langue universelle, intelligible à tous; car souvent les artistes en voulant faire les figures allégoriques, sont tombés dans le défaut de n'offrir que des compositions inintelligibles ou des jeux des mots." A. L. Millin, *Dictionnaire des beaux-arts* (Paris, 1838; 1st ed., 1806), I: 24.

71. Chaussard made repeated pleas to painters to renounce this abstract language: "Ces sortes de sujets n'ont-ils pas égarés plusieurs Artistes, et ceux-ci ne doivent-ils pas se méfier de leurs prestiges? Sont-ils bien du

ressort de la Peinture? Un écrivain, un poète, peuvent s'égarer dans les espaces imaginaires des êtres abstraits, des rêves, des ombres, des chimères, et même de la métaphysique; mais un Peintre ne peut guères représenter que des objets pris dans la nature, et pouvant frapper les regards en prenant des formes et des couleurs, etc. . . ; son Art est essentiellement un Art d'imitation." Chaussard, *Le Pausanias français* (Paris, 1806), 268–269.

72. "En considérant avec un peu d'attention la partie du dessin, cette partie qui est ordinairement si parfaite dans les tableaux de M. David, on est tout étonné d'y trouver (parmi de très grandes beautés) une foule d'incorrections.

Ici le vice-roi d'Italie, en costume militaire, est dans une attitude si équivoque que personne ne peut la définir. Les uns le croient assis, d'autres le croient seulement appuyé sur son sabre. De quelque manière qu'on ait voulu le représenter, il est trop certain que sa *pose* est contrainte, et qu'il est foiblement dessiné.

Là, tout au bord des marches qu'il vient de franchir, nous voyons un jeune hussard, courir sur la pointe du pied, et lever lestement une jambe en arrière, comme si, dans la direction pénible du *bas en haut*, il avait eu la même liberté d'action que dans une course en rase campagne.

Plus bas, sur la première ligne du plan, et fort en avant du groupe principal, un sapeur qui a l'air de monter à l'assaut, étend à droite un bras immense dont l'extrémité se cache derrière d'autres figures, à cinq pieds de distance au moins." *Journal de Paris* (November 12, 1810), 2233.

73. "Je fus même obligé de faire des changemens à celui du Serment des aigles, l'impératrice Josephine y étoit représentée assise, sa fille la Reine d'Hollande et son fils le vice roi d'Italie derrière elle. il a fallu beaucoup d'art pour se délivrer de la difficulté que ce changement exigeait." Ecole Nationale Supérieure des Beaux-Arts, Ms. 316, no. 12.

74. See *Jacques-Louis David 1748–1825*, 493ff.

75. Ibid., 474–477.

76. See Bordes and Pougetoux, "Les portraits de Napoléon," 26–27. and A. Cobban, *A History of Modern France 1799–1871*, vol. 2 (London, 1961), 29.

77. "J'ai reçu des mains de Mr. Bonnemaison une lettre de votre Seigneurie par laquelle j'apprends que vous avez daigné faire choix de mon Pinçeau pour transmettre sur la toile les traits du Grand Homme, et le représenter dans un des événements qui l'ont immortalisé." Published in A. A. Tait, "The Duke of Hamilton's Palace," *The Burlington Magazine* (July 1983): 400–402.

78. "Je puis donc assurer votre Seigneurie (en lui répétant l'expression de l'opinion publique) que personne jusqu'à ce jour n'a encore fait un portrait plus ressemblant, non seulement par les traits matériels du visage, mais aussi par cet air de bonté, de sang froid et de pénétration qui ne l'abandonne jamais.

Je l'ai représenté dans le moment de sa vie qui lui est le plus habituel, le travail; il est dans son cabinet, ayant passé la nuit à composer son Code Napoléon; il ne s'aperçoit du jour naissant que par ses bougies qui sont consumées et qui s'éteignent, et par la pendule qui vient de sonner quatre heures du matin; alors il se lève de son bureau pour ceindre l'épée et passer la revue de ses troupes." Ibid.

79. Georges Steiner, *Antigones* (Oxford, 1986), 10.

CHAPTER V

1. Baudelaire, "Salon de 1859," in *Oeuvres complètes*, Vol. II, ed. C. Pichois (Paris, 1976), 610–611.

2. P. Rosenberg, "Ixelles. Belgian neoclassicism," *The Burlington Magazine* (December 1986): 922.

3. H. McPherson recently offered a formal analysis of this painting in "*The Fortune Teller* of 1824 or the Elegant Dilemma of David's Late Style," *Gazette des Beaux-Arts* (July-August 1991): 27–36.

4. L. Hautecoeur, *Louis David* (Paris, 1954), 272.

5. A number of these late expressive heads were published by A. Sérullaz, "Dessins de Jacques-Louis David," *Revue du Louvre*, supplément (1979) 100–104, figs. 7, 15.

6. J.-L. Jules David, *Le peintre Louis David. 1748–1825, Souvenirs et documents inédits* (Paris, 1880), I: 588 and L. Hautecoeur, *Louis David*, 266–267.

7. "MMss. H. Vernet et Géricault qui m'ont ravi de joie par leur présence. Ils sont venus à Bruxelles dans l'intention de me voir encore et de m'embrasser. Nous avons bu à la santé de ceux de mes élèves qui n'ont jamais refroidir pour moi leur attachement filial." The copy of this letter is preserved at the Ecole Nationale Supérieure des Beaux-Arts, Ms. 316, no. 41. I would like to thank Jacques de Caso for showing me the original letter. Géricault's visit to David in Brussels is discussed by J.-L. Jules David, *Le peintre Louis David,* I: 588 and Hautecoeur, *Louis David*, 268.

8. See D. Johnson, "'Some work of noble note': *La Colère d'Achille* Revisited," *Gazette des Beaux-Arts* (December 1984): 224–230; "Desire Demythologized: David's *L'Amour quittant Psyché*," *Art History* 9, no. 4 (December 1986): 450–470; "L'Expérience d'exil: l'art de David à Bruxelles," in *David contre David*, ed. R. Michel (Paris, forthcoming). For an important recent discussion of the responses to David's death, see H. Kohle, "Der Tod Jacques Louis Davids. Zum Verhältnis von Politik und Aesthetik in der französichen Restauration," *Idea: Jahrbuch der Hamburger Kunsthalle* X (1991), 127–153.

9. This painting was recently discussed by Paul Spencer-Longhurst, "*Apelles painting Campaspe* by Jacques Louis David, Art, Politics and Honour," *Apollo* (March 1992), 157–63.

10. See D. Johnson, "Myth and Meaning: Mythological Painting in France circa 1800," in *Frankreich, 1800. Gesellschaft, Kultur, Mentalitäten* (Stuttgart, 1990), 23–33.

11. J. Starobinski, "Le mythe au XVIIIe siècle," *Critique* 366 (1977): 975–997. Impor-

tant studies concerned with the development of mythology during this period include B. Feldman and R. D. Richardson, *The Rise of Modern Mythology* (Bloomington, London, 1972) and F. E. Manuel, *The Eighteenth Century Confronts the Gods* (Cambridge, Mass, 1959).

12. Starobinski, "Le mythe," 980. He summarizes the Encyclopédie's differentiation between fable and myth in the following terms: "Tandis que la fable est elle-même, sous une forme vulgarisée et facile, un moyen universel de 'poétiser' toutes choses, la 'mythologie' l'interroge sur ses origines, sur sa portée intellectuelle, sa valeur de révélation, ses liens avec des institutions et des coutumes." See Diderot and d'Alembert, *Encyclopédie ou Dictionnaire raisonné des sciences, des arts et des métiers*, vol. 10 (Paris, 1765), 924.

13. See R. Rosenblum, *Transformations in Late Eighteenth-Century Art* (Princeton, 1967), 50–59. A large number of eighteenth-century French mythological paintings were reproduced and discussed by C. Bailey in *The Loves of the Gods. Mythological Painting from Watteau to David* (New York, 1992).

14. See La Font de Saint-Yenne, *Sentiments sur quelques ouvrages de peinture, sculpture et gravure écrits à un particulier en province* (Paris, 1754), 65–69.

15. Recent studies of this painting have been concerned with possible political meanings rather than mythological significance. See Y. Korshak, "*Paris and Helen* by Jacques-Louis David: Choice and Judgment on the Eve of the French Revolution," *The Art Bulletin* (March 1987): 102–116 and F. Dowley, Y. Korshak, "An Exchange on Jacques-Louis David's *Paris and Helen*," *The Art Bulletin* (1988): 504–520.

16. The "archaeological" accuracy was studied in detail by E. Coche de la Ferté and J. Guey, "Analyse archéologique et psychoanalytique d'un tableau de David: *Les Amours de Paris et d'Hélène*," *Revue Archéologique* 40 (1952): 129–161.

17. See Johnson, "Myth and Meaning."

18. "La tête de l'Amour d'un caractère un peu faunesque, les mains un peu brunes et sur-

tout pas assez blaireautés." Ecole Nationale Supérieure des Beaux-Arts, Ms. 316, no. 26.

19. "Cet Amour n'est point un dieu, ce n'est même pas un bel adolescent; c'est le modèle, un modèle commun, copié avec une exactitude servile, et en qui l'expression du bonheur n'est qu'une grimace cynique." E.-F. Miel, *Essai sur les Beaux-Arts et particulièrement sur le Salon de 1817* (Paris, 1817), 237–238. For David's letter in which he discusses Miel see *Nouvelles archives de l'art français* (Paris, 1874–75), 429–430.

20. "On ne conçoit pas un tel oubli dans un peintre dont le style est habituellement si pur et si élevé." Miel, *Essai*, 238.

21. A. de Kératry, *Annuaire de l'école française de peinture ou Lettres sur le Salon de 1819* (Paris, 1820), 94–101.

22. Ibid., 99.

23. "Non le pinceau mais l'imagination de M. David s'est égarée." Ibid., 100.

24. For a rare positive assessment see the review by David's friend and close associate in Brussels, Frémiet, in *Le Vrai Libéral* 226 (August 14, 1817), 3 and 233 (August 21, 1818), 3–4.

25. The phrase is Robert Cohen's, used to describe Mallarmé's nymphs of "L'après-midi d'un faune." See *Towards the Poems of Mallarmé*, 2nd ed. (Berkeley and Los Angeles, 1980), 28.

26. "Affligeant"; "cet empire d'une nature ignoble sur l'idéalisme; il contriste, il serre le coeur." Kératry, *Annuaire*, 100–101.

27. D. Johnson, "Myth and Meaning."

28. A. Schnapper recently attributed to David a *Psyche Abandoned* in a private collection, although, as he states in his article, the past 100 years of the painting's history cannot be accounted for. See "Après l'exposition David. La *Psyché* retrouvée," *Revue de l'Art* 91 (1991): 60–66. While this painting is reminiscent of David in terms of its conception, and especially in certain details of the face, other elements suggest a student work—the extremities, for example, and the corporal configuration. Schnapper attributes this painting to David based on its similarities to another

work—*La Vestale*—also in a private collection, but the trivialization of physiognomy and pose in this painting indicate that it cannot be by David. Another mythological composition—an *Orpheus*—was erroneously attributed to David by A. Ryszkiewicz, "At the Tomb of Eurydice," *Pantheon* 47 (1989): 133–137.

29. C. Noireau, *La lampe de Psyché* (Paris, 1991), 236, fig. 58, illustrates the window depicting Amor and Psyche in bed.

30. E. Neumann, *Amor and Psyche. The Psychic Development of the Feminine* (Princeton, 1956), 26.

31. "Etre le maître, donc, c'est voir. Le despote peut être stupide, fou, ignorant, ivre, malade, qu'importe: il voit. Ne pas voir, c'est être condamné à obéir. Dans le régime despotique, où l'on obéit toujours 'aveuglement', l'aveugle est la figure emblématique du sujet," A. Grosrichard, *Structure du Serail*: *la fiction du despotisme asiatique dans l'Occident classique* (Paris, 1979), 73.

32. "Délices d'une passion réciproque mais encore chaste et pure." Cornélissen, "Eucharis et Télémaque," *Annales de Belgique* (Brussels, 1818), I: 383–393 and II: 23–32.

33. Ecole Nationale Supérieure des Beaux-Arts, Ms. 316, no. 28.

34. Curiously enough, the anonymous author of the critical article on *Amor and Psyche* in *L'Oracle* (August 18, 1817), 4, offered a prescription for a more acceptable interpretation of the theme, one that David should have executed (a prescription fulfilled two years later by Picot's *Amor and Psyche* at the Salon of 1819): "j'aurais aimé que l'Amour, au lieu de regarder les spectateurs en face, eût jeté la vue sur sa tendre épouse, que le destin le force de quitter, et que ses regards eussent exprimé à-la-fois la crainte qu'il a de l'éveiller (car il sait combien ce réveil peut lui être fatal), ses regards et cet air de finesse qu'un dieu, plus qu'aucun autre mortel sans doute, doit avoir dans de pareilles occasions."

35. Kératry, *Du beau dans les arts d'imitation* (Paris, 1822).

36. "Ici il n'y a point de dieu; il n'y en eût

jamais. Il n'est pas de femme qui ne fût éffrayée à l'aspect de l'être qui en usurpe la place.

Dans cette scène, où une nature grossière triomphe et se joue des plus douces émotions accordées à la vie, le coeur se serre; il se sent oppressé d'un poids accablant. La pensée se replie sur elle-même, elle s'interroge et elle se demande avec amertume, si le bonheur promis ici-bas, et dont une bonté compatissante entremêla quelquefois nos peines, n'est autre chose que la misérable parodie offerte par le pinceau de M. David." Ibid., I: 97–98.

37. "Il termine dans ce moment un tableau qui représente la colère d'Achille au moment où l'on conduit Iphigénie au sacrifice. Il est composé de quatre figures à mi-corps; il a l'assentiment général. Les expressions sont de la plus grande beauté. La tête de Clytemnestre réunit à un degré éminemment beau la crainte et l'espérance. Le calme majestueux de celle d'Agamemnon est aussi d'une rare beauté. La résignation d'Iphigénie est d'une sensibilité admirable. Enfin notre ami charme son exil avec sa chère peinture et je vous assure que ces tableaux qu'il aura fait dans la Flandre fera [sic] encore époque dans sa vie pittoresque." Ecole Nationale Supérieure des Beaux-Arts, Ms. 316, no. 34.

38. Between 1799 and 1820, 178 performances were offered by the Comédie-Française. See A. Joannides, *La Comédie-Française de 1680 à 1920* (Paris, 1921). For the Racinian revival in painting circa 1800 see J. H. Rubin, "Guérin's painting of *Phèdre* and the Post-Revolutionary Revival of Racine," *The Art Bulletin* 61 (December 1977): 601–618.

39. See C. Osborne, *Pierre Didot the Elder and French Book Illustration* (New York, 1984) and D. Johnson, "'Some work of noble note'," 224–226.

40. "Scène immortelle, l'une des plus imposantes et des plus vigoureuses que l'on connaisse sur aucun théâtre, et l'un des chefs-d'oeuvre du genre héroïque," La Harpe, *Théâtre complet de Jean Racine* (Paris, 1817), IV: 121 and *Lycée, ou Cours de littérature ancienne et moderne,* vol. 3 (Paris, 1813), 343–345.

41. "Cette scène vient de mettre en oeuvre dramatiquement tous les éléments qui ont été patiemment réunis auparavant. Tout, dans son déroulement, est prévu, aussi bien les arguments employés de part et d'autre que les réactions à ces arguments. Cette nécessité donne au spectateur une satisfaction d'intelligibilité rassurante," J. Racine, *Oeuvres complètes*, vol. I, ed. R. Picard (Paris, 1950), 1141.

42. Hautecoeur mentions that Victorine Frémiet posed for Clytemnestra, *Louis David*, 269.

43. "Je crois, Dieu aidant, que je pourrai finir avant le terme fatal le tableau de Mars et Vénus. C'est mon dernier adieu à la peinture." David's letter to Gros dated October 21, 1823 is preserved in the Ecole Nationale Supérieure des Beaux-Arts, Ms. 316, no. 50.

44. "C'est le dernier tableau que je veux faire, mais je veux m'y surpasser. J'y mettrai la date de mes 65 ans et je ne veux plus ensuite toucher un pinceau," *L'Oracle* (December 8, 1823), cited in Wildenstein, *Documents complémentaires au catalogue de l'oeuvre de Louis David* (Paris, 1973), no. 1947, 228.

45. "Une aussi belle conception ne peut se décrire. Cette oeuvre admirable fera époque dans les annales de la peinture; elle se place au premier rang parmi les ouvrages de celui qui sut ramener l'art à ses vrais principes.

L'auteur s'est transporté dans l'Olympe pour y voir Mars et Vénus, pour y surprendre la scène la plus gracieuse que la poésie puisse inventer. Il a atteint le sublime." Théophile Bra, "Tableau de David," *Feuilleton littéraire* 88 (vendredi, May 28, 1824): 2, I would like to thank Jacques de Caso for calling this article to my attention.

46. "On ne pouvait s'attendre à voir une chose aussi belle. La nature a fait pour David ce qu'elle n'a fait pour nul autre génie, dans aucun genre: non seulement elle lui conserve intactes ses facultés intellectuelles, mais elle donne à son talent, à ses idées toute la force et toute la fraîcheur de la jeunesse." Ibid.

47. *Jacques-Louis David, 1748–1825,* 589.

48. Many of these student letters are pre-

served in the Ecole Nationale Supérieure des Beaux-Arts, Ms. 318, 319.

49. "Votre Mars est véritablement un dieu, la tête est toute divine et d'un ton de couleur admirable; la pose, le dessin de toute la figure ne laissent rien à désirer.

La Vénus, dont les formes sont si gracieuses et si délicates et le coloris si fin, contraste, on ne peut mieux avec le ton chaud de Mars. . . . L'effet aérien me paroît parfaitement senti et bien vaporeux. Vous n'avez jamais mieux fait, mon cher Maître, . . . que de nous envoyer ce tableau à Paris. . . . enfin [qu']il m'a pétrifié, et mise hors d'état de travailler de quelques jours: tant j'ai senti mon néant. Mais j'ai du moins le plaisir de voir que le coup d'assommoir tombera sur bien d'autres." Ibid., Ms. 318, no. 65.

50. "Le corps, la tête et toute la personne de Mars ont été jugés d'une grande beauté, et il est difficile, en effet, quant au dessin et aux carnations, de rien produire de supérieur. Mais la Vénus, quoi qu'elle montre un beau corps et des tons admirables, est peu voluptueuse; il y a plus d'anxiété que de charmes dans son visage. Les trois Graces sourient désagréablement, et l'Amour n'est là qu'une finesse déplacée. . . . Sa couleur enfin est plus brillante qu'elle ne l'a jamais été. Mais on a besoin de s'y habituer un moment, tant elle surprend les yeux par son éclat. La couleur est sans contredit la partie la plus étonnante de ce tableau," A. Thiers, "De Monsieur David et de son dernier tableau." *Revue européenne*. I (June, 1824): 335–339.

51. "Il a tout-à-coup la courageuse et noble pensée de changer sa palette et de faire une révolution dans son talent." Ibid., 338.

52. Ecole Nationale Supérieure des Beaux-Arts, Ms. 318, no. 34. Gros' letter is dated July 19, 1824.

53. See especially the letters from Degeorge, Couder, and Naigeon, Ecole Nationale Supérieure des Beaux-Arts, Ms. 318, nos. 15, 16, 52.

54. Ibid., Ms. 317, Chauffer to David, a letter dated August 9, 1824.

55. Pierre de Ronsard, *Oeuvres complètes*, vol. I (Paris, 1914), 257–259.

56. See E. H. Gombrich, *Symbolic Images* (Oxford, 1972), 66–69, 215.

57. Several of these works from the sixteenth century are discussed by R. Schneider, "Le mythe de Psyché dans l'art français depuis la Révolution," *Revue de l'Art ancien et moderne* 32 (July-December 1912): 244–245. See also *Fontainebleau, Art in France 1528–1610*, vol. I (Ottawa, Canada, 1973) figs. 50, 78, 182, 183 and *L'Ecole de Fontainebleau* (Paris, 1972), fig. 204. See also A. Janson, "The Sources of David's Anacreon Paintings," *Source: Notes in the History of Art* (fall 1983), III: 19–22. For the valuation of François I, see Alexandre Lenoir, *Description historique et chronologique des Monumens de Sculpture, réunis au Musée des Monumens français*, 6th ed. (Paris, 1802), 14, 29ff.

58. C. A. Sainte-Beuve, *Tableau historique et critique de la poésie française et du théâtre français au seizième siècle*, 2 vols. (Paris, 1828). The second volume contains *Oeuvres choisies de Pierre de Ronsard* with notes and commentary by Sainte-Beuve.

59. See the letter to Gros from Madame David, dated October 30, 1827, Ecole Nationale Supérieure des Beaux-Arts, Ms. 317, no. 10. And the discussion in J.-L.-Jules David, *Le peintre Louis David*, 587.

60. Ibid., 590 and Ecole Nationale Supérieure des Beaux-Arts, Ms. 318, no. 65.

61. "Un grand salon quarré [sic], tendu d'étoffe vert-foncé; dans ce Salon est une glace qui fait face au tableau et dans laquelle on le voit en entrant; et comme on n'aperçoit pas le cadre, on croit voir tout l'Olympe; cela fait le plus bel effet." Ecole Nationale Supérieure des Beaux-Arts, Ms. 318, no. 65.

62. A.-H. Kératry, *Du beau*.

63. Quatremère de Quincy, *Essai sur la nature, le but et les moyens de l'imitation dans les beaux-arts* (Paris, 1823).

64. "Un composé singulier de réalisme et d'idéal." Delacroix, *Journal. 1822–1863* (Paris, 1980), 767.

SELECT BIBLIOGRAPHY

Athanassoglou, N. "Under the Sign of Leonidas: the Political and Ideological Fortunes of David's *Leonidas at Thermopylae* under the Restoration." *The Art Bulletin* (December 1981): 633–49.

Autour du Néo-Classicisme en Belgique, 1770–1830. Ed. D. Coekelberghs and P. Loze. Brussels, 1986.

Bailey, C. *The Loves of the Gods: Mythological Painting from Watteau to David.* New York, 1992.

Baudelaire, C. *Oeuvres complètes.* Ed. C. Pichois. Paris, 1976.

Bleyl, M. *Das Klassizistische Porträt. Gestaltungsanalyse am Beispiel J.-L. Davids, Bochumer Schriften zur Kunstgeschichte.* Vol. 1. Frankfurt and Berne, 1982.

Boime, A. *Art in the Age of Bonapartism.* Chicago and London, 1990.

Boime, A. "Jacques-Louis David, Scatological Discourse in the French Revolution and the Art of Caricature." *Arts Magazine* (February 1988): 72–81.

Boime, A. "Marmontel's *Bélisaire* and the Pre-Revolutionary Progressivism of David." *Art History* (March 1980): 81–101.

Bonnet, J. Cl., et al. *La Mort de Marat.* Paris, 1986.

Bordes, P. "Jacques-Louis David's *Serment du Jeu de Paume*: Propaganda Without a Cause?" *Oxford Art Journal* (October 1980): 19–25.

Bordes, P. *David.* Paris, 1988.

Bordes, P. *'Le Serment du Jeu de Paume' de Jacques-Louis David: le peintre, son milieu et son temps, de 1789 à 1792.* Paris, 1983.

Bordes, P., and Michel, R. *Aux Armes et aux arts! Les arts de la Révolution 1789–1799.* Paris, 1988.

Bordes, P., and Pougetoux, A. "Les portraits de Napoléon en habits impériaux par Jacques-Louis David." *Gazette des Beaux-Arts* (July–August 1983): 21–34.

Brookner, A. *Jacques-Louis David.* London, 1980.

Bryson, N. *Tradition and Desire: from David to Delacroix.* Cambridge, 1984.

Cantinelli, R. *Jacques-Louis David, 1748–1825.* Paris and Brussels, 1930.

Carroll, S. "Reciprocal Representations: David and Theatre." *Art in America* (May 1990): 98–206, 259–61.

Caso, J. de. "Jacques-Louis David and the Style All' Antica." *The Burlington Magazine* (October 1972): 686–90.

Chaussard, P. *Le Pausanias français.* Paris, 1806.

Chaussard, P. *Sur le tableau des Sabines par David.* Paris, 1880.

Coupin, P. A. *Essai sur J.-L. David, Peintre d'histoire.* Paris, 1827.

Crow, Th. E. "*The Oath of the Horatii* in 1785: Painting and Pre-Revolutionary Radicalism in France." *Art History* (December 1978): 424–71.

Crow, Th. E. *Painters and Public Life in Eighteenth-Century Paris.* New Haven and London, 1985.

Crow, Th. E. "Revolutionary Activism and the Cult of Male Beauty in the Studio of David." In *Fictions of the French Revolution,* ed. B. Fort. Evanston, 1991.

Cuno, J. "Obscene Humor in French Revolutionary Caricature: Jacques-Louis David's *The Army of Jugs* and *The English Government.*" In *Representing the French Revolution: Literature, Historiography, Art,* ed. J. A. W. Heffernan. Hanover and London, 1992.

David. J.-L. *Le tableau des Sabines, exposé publi-*

quement au palais national des sciences et des arts Paris, an VIII. Paris, 1799.

David. J.-L. *Explication du tableau des Thermopyles*. Paris, 1814.

David, J.-L. Jules. *Le peintre Louis David, 1748–1825, Souvenirs et documents inédits*. Vols. I and II. Paris, 1880–1882.

David contre David. Ed. R. Michel. Paris, forthcoming.

David e Roma. Rome, 1981.

Delécluze, E. *Louis David, son école et son temps*. 2nd ed. Paris, 1983.

Dowd, D. L. *Pageant-Master of the Republic: Jacques-Louis David and the Revolution*. Lincoln, 1948.

Dowley, F. "D'Angiviller's 'Grands Hommes' and the Significant Moment." *The Art Bulletin* 39 (1957): 159–277.

Dowley, F., and Korshak, Y. "An Exchange on Jacques-Louis David's *Paris and Helen*." *The Art Bulletin* 70 (September 1988): 504–20.

Ettlinger, L. "Jacques-Louis David and Roman Virtue." *Journal of the Royal Society of the Arts* 115 (January 1967): 105–23.

Foissy-Aufrère, M. P., Martin, J. Cl., Michel, R., Pommier, E., and Vovelle, M. *La Mort de Bara. De l'événement au mythe: Autour du tableau de Jacques-Louis David*. Avignon, 1989.

Frankreich, 1800: Gesellschaft, Kultur, Mentalitäten. Ed. G. Gersmann and H. Kohle. Stuttgart, 1990.

Fried, M. *Absorption and Theatricality: Painting and Beholder in the Age of Diderot*. Berkeley, Los Angeles, and London, 1980.

Gaehtgens, T. W. "Jacques-Louis David: Leonidas bei Thermopylen." In *Ideal und Wirklichkeit der bildenden Kunst im späten 18. Jahrhundert*, ed. H. Beck, P. Bol, and E. Maek-Gérard. 211–51. Berlin, 1984.

Germani, I. Les métamorphoses de Marat." In *Les Images de la Révolution française: Actes du colloque des 25–27 octobre, 1985*, ed. M. Vovelle. Paris, 1988.

Germer, S. "In Search of the Beholder: on the Relation between Art, Audiences and Social Spheres in Post-Thermidor France." *The Art Bulletin* 74 (March 1992): 19–36.

Germer, S. "'On marche dans ce tableau': Zur Konstituieren des 'Realistischen' in den Napoleonischen Darstellung von Jacques-Louis David." In *Frankreich 1800. Gesellschaft, Kultur, Mentalitäten*, ed. G. Gersmann and H. Kohle. 81–103. Stuttgart, 1990.

Germer, S., and Kohle, H. "From the Theatrical to the Aesthetic Hero: on the Privatization of the Idea of Virtue in David's *Brutus* and *Sabines*." *Art History* 9, no. 2 (1986): 168–84.

Hamilton-Hazelhurst, F. "The Artistic Evolution of David's Oath." *The Art Bulletin* 42 (March 1960): 59–63.

Hautecoeur, L. *Louis David*. Paris, 1954.

Herbert, R. David. *Voltaire, Brutus and the French Revolution: An Essay in Art and Politics*. London, 1972.

Herding, K. "Davids *Marat* als *dernier appel à l'unité révolutionnaire*." *Idea. Jahrbuch der Hamburger Kunsthalle* 2 (1983): 89–112.

Holma, K. *David: son évolution et son style*. Paris, 1940.

Howard, S. *Sacrifice of the Hero: the Roman Years: a Classical Frieze by Jacques-Louis David*. Sacramento, 1975.

Hunter, D. M. "Swordplay: Jacques-Louis David's Painting of *Le Peletier de Saint Fargeau on his Deathbed*." In *Representing the French Revolution: Literature, Historiography, Art*, ed. J. A. W. Heffernan. Hanover and London, 1992.

Jacques-Louis David, 1748–1825. Paris, 1989.

Johnson, D. "Corporality and Communication: the Gestural Revolution of Diderot, David and the *Oath of the Horatii*." *The Art Bulletin* 71 (March 1989): 92–113.

Johnson, D. "Desire Demythologized: David's *L'Amour quittant Psyché*." *Art History* 9, no. 4 (December 1986): 450–70.

Johnson, D. "'Some work of noble note': David's *La Colère d'Achille* Revisited." *Gazette des Beaux-Arts* (December 1984): 223–30.

Kemp, M. "J.-L. David and the Prelude to a Moral Victory for Sparta." *The Art Bulletin* (June 1969): 178–83.

Kemp, W. "Das Bild der Menge 1789–1830." *Stadel Jahrbuch* 4 (1973): 249–70.

Kemp, W. "Das Revolutionstheater des Jacques-Louis David. Eine neue Interpretatione des *Schwurs im Ballhaus*." *Marburger Jahrbuch für Kunstwissenschaft* 21 (1986): 165–84.

Kohle, H. "Der Tod Jacques-Louis Davids. Zum Verhaltnis von Politik und Asthetik in der französichen Restauration." *Idea. Jahrbuch der Hamburger Kunsthalle* 10 (1991): 127–53.

Kohle, H. "Historienmalerei am Scheideweg. Bemerkungen zu Jacques-Louis Davids 'Sabinerinnen.'" In *Historienmalerei in Europa. Paradigmen in Form, Funktion und Ideologie von 17, bis zum 20. Jahrhundert*, ed. E. Mai. 121–34. Mainz, 1990.

Korshak, Y. "*Paris and Helen* by Jacques-Louis David: Choice and Judgement on the Eve of the French Revolution." *The Art Bulletin* (March 1987): 102–16.

Lajer-Burcharth, E. "David's Sabine Women: Body, Gender and Republican Culture under the Directory." *Art History* 14, no. 3 (September 1991): 397–430.

Lajer-Burcharth, E. "Les oeuvres de David en prison: art engagé après Thermidor." *La Revue du Louvre et des Musées de France* 5–6 (1989): 310–21.

Landes, J. B. *Women and the Public Sphere in the Age of the French Revolution*. Ithaca and London, 1988.

Lankheit, K. *Jacques-Louis David: Der Tod Marats*. Stuttgart, 1962.

Lee, V. "Jacques-Louis David: the Versailles Sketchbook." *The Burlington Magazine* (April 1969): 197–208; (June 1969): 360–69.

Lenoir, A. "Mémoires, David, Souvenirs historiques." *Journal de l'Institut historique* 3 (1835).

Levin, M. "David, de Stael, and Fontanes: the *Leonidas at Thermopylae* and some intellectual controversies of the Napoleonic Era." *Gazette des Beaux-Arts* (January 1980): 5–12.

Levin, M. "La définition du caractère républicain dans l'art français après la Révolution: le *Leonidas aux Thermopyles* de David." *Revue de l'Institut Napoléon* 137 (1981): 40–67.

Michel, R., and Sahut, M. C. *David, l'art et le politique*. Paris, 1988.

Miette de Villars. *Mémoires de David, peintre et deputé de la Convention*. Paris, 1850.

Notice sur la vie et les ouvrages de M. J.-L. David. Paris, 1824.

Outram, D. *The Body and the French Revolution: Sex, Class and Political Culture*. New Haven and London, 1989.

Pommier, E. *L'Art de la Liberté. Doctrines et débats de la Révolution française*. Paris, 1991.

Potts, A. "Beautiful Bodies and Dying Heroes: Images of Ideal Manhood in the French Revolution." *History Workshop* (Autumn 1990): 1–21.

Puttfarken, T. "David's *Brutus* and Theories of Pictorial Unity in France." *Art History* 4 (1981): 290–304.

La Révolution et l'Europe, 1789–1799. Paris, 1989.

Roberts, W. *Jacques-Louis David, Revolutionary Artist*. Chapel Hill and London, 1989.

Rosenblum, R. "A Source for David's 'Horatii.'" *The Burlington Magazine* 112 (May 1970): 269–73.

Rosenblum, R. "David's *Funeral of Patroclus*." *The Burlington Magazine* (September 1973): 567–76.

Rosenblum, R. *Transformations in Late Eighteenth-Century Art*. Princeton, 1967.

Rubin, J. H. "Jacques-Louis David's Patriotism, or the Conspiracy of Gracchus Babeuf and the Legacy of Topino- Lebrun." *The Burlington Magazine* (December 1976): 547–68.

Ryszkiewicz, A. "At the Tomb of Eurydice." *Pantheon* 47 (1989): 133–37.

Sauerlander, W. "David's *Marat à son dernier soupir* oder Malerei und Terreur." *Idea. Jahrbuch der Hamburger Kunsthalle* 2 (1983): 49–88.

Schmollgenannt Eisenwerth, J. A. "J.-L. Davids *Vue du Luxembourg* von 1794 als Parabel der Gefangenschaft des Malers." In *Epochengrenzen und Kontinuität: Studien zur Kunstgeschichte*. 156–74. Munich, 1985.

Schnapper, A. "Après l'exposition David. La

Psyché retrouvée." *La Revue de l'Art* 91 (1991): 60–66.

Schnapper, A. *David, témoin de son temps*. Fribourg, 1980.

Sérullaz, A. "A propos de quelques dessins de Jacques-Louis David pour *Mars désarmé par Vénus et les Grâces*." *Bulletin des Musées royaux des Beaux-Arts de Belgique* 21, 1/4 (1972): 107–16.

Sérullaz, A. *Inventaire général des dessins. Ecole française. Dessins de Jacques-Louis David, 1748–1825*. Paris, 1991.

Seznec, J., and Adhémar, J. *Diderot. Salons*. 4 vols. Oxford, 1957–67.

Simon, R. "David's Martyr Portrait of Le-Peletier de St. Fargeau and the Conundrums of Representation." *Art History* 14, no. 4 (December 1991): 459–85.

Spencer-Longhurst, P. "Apelles painting Campaspe by Jacques-Louis David, Art, Politics and Honour." *Apollo* (March 1992): 157–63.

Stafford, B. *Body Criticism: Imaging the Unseen in Enlightenment Art and Medicine*. Cambridge, Mass., 1991.

Starobinski, J. *Les emblèmes de la raison*. Paris and Milan, 1973.

Sue, J. J. "Rapport sur les tableaux de David, lu à la séance publique du 5 mai." *Journal du Lycée des Arts* 3 (May 13, 1793): 9–13.

Th., A. *Vie de David*. Paris, 1826.

Traeger, J. *Der Tod des Marat: Revolution des Menschenbildes*. Munich, 1986.

Verbraeken, R. *Jacques-Louis David jugé par ses contemporains et par la postérité*. Paris, 1973.

Wildenstein, D. and G. *Documents complémentaires au catalogue de l'oeuvre de Louis David*. Paris, 1973.

Wind, E. "The Sources of David's *Horaces*." *Journal of the Warburg and Courtauld Institutes* 4 (1940–41): 124–38.

Zeitler, R. *Klassizismus und Utopia*. Stockholm, 1954.

INDEX